JACKIE SHAW'S
Step-by-Step Painting Course

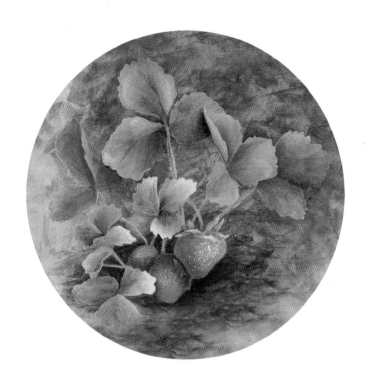

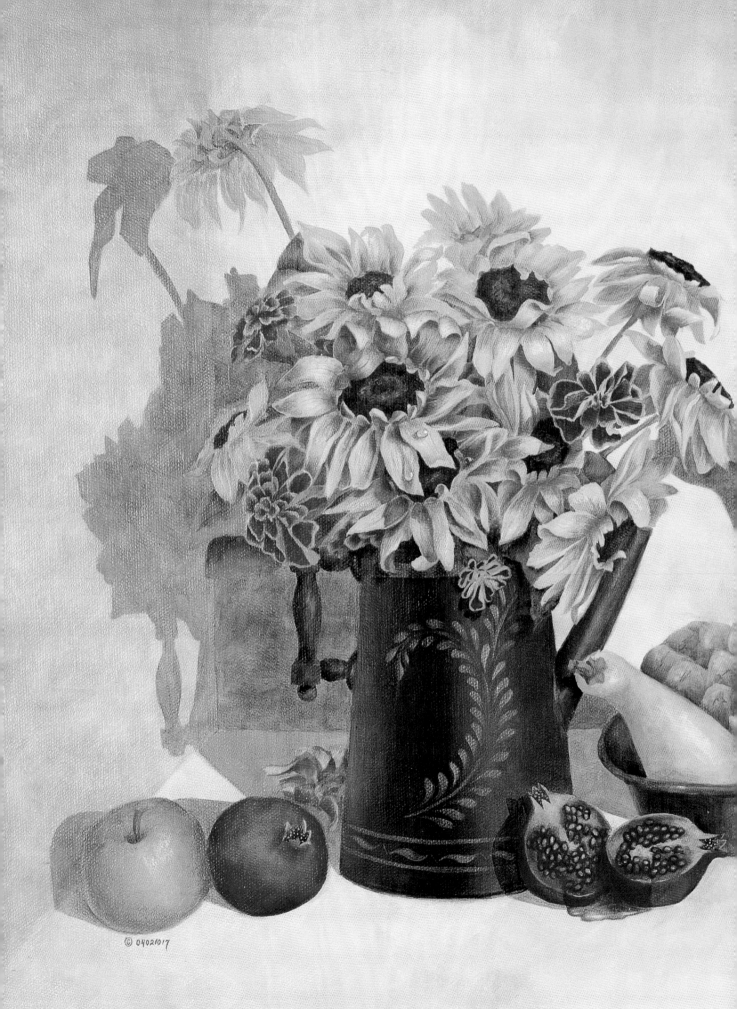

JACKIE SHAW'S
Step-by-Step
Painting
Course

A Beginner's Guide to Color and Composition

Jackie Shaw

WATSON-GUPTILL PUBLICATIONS/NEW YORK

To my husband, Lynn,
who truly is "the wind beneath my wings."

Credits
Photographs of growing bananas (page 91): Howard Johnson
Photographs of pink and white daisy grouping (page 235),
sliced watermelon stack (page 162), and grape hyacinths at
base of walnut tree (page 246): Kathy Graham
All other photography by Lynn and Jackie Shaw.

All art by Jackie Shaw.

Senior Acquisitions Editor: Joy Aquilino
Editor: Michelle Bredeson
Designer: Areta Buk
Production Manager: Hector Campbell

To share your thoughts about this book,
write to me at the following address:
Jackie Shaw
13306 Edgemont Road
Smithsburg, MD 21783
www.jackieshaw.com

Published in 2003 by Watson-Guptill Publications,
a division of VNU Business Media, Inc.,
770 Broadway, New York, NY 10003
www.watsonguptill.com

Library of Congress Cataloging-in-Publication Data

Shaw, Jackie.
 Jackie Shaw's step-by-step painting course : a beginner's guide
to color and composition / Jackie Shaw.
 p. cm.
 Includes index.
 ISBN 0-8230-0537-2
 1. Painting—Technique. 2. Decoration and ornament. I. Title:
Step-by-step painting course. II. Title.
 TT385 .S468 2003
 745.7'23—dc21
 2002152210

Manufactured in Malaysia

1 2 3 4 5 6 7 8 9 / 09 08 07 06 05 04 03

Acknowledgments

Part of the joy of doing a book like this is the opportunity it affords to meet new people while pursuing friends' leads. For this, we are grateful to Betty and Joe Frushour, Harold Stottlemyer, Gary Hoffman, Elsa Hoffman, and Priscilla Harsh.

A large measure of joy results from having to stretch and grow and watching as family also stretches to accommodate an increasingly frenetic schedule and mushrooming needs. This book is as much my husband Lynn's as it is mine. It would have been impossible without his help organizing and managing the computer files; finding things I misfiled (or failed to save) in that wondrous, exasperating electronic vacuum; prodding the computer back into service every time it called "time out!"; keeping track of the hundreds of photographs and illustrations; keying every image and bit of text so they would appear in the proper places in the book; and particularly for loving and appreciating me through it all. Special thanks go also to my mother, Grace Waters Bisese, and to our youngest daughter, Jen Reese, for helping with the manuscript; and to our two other daughters Kathy Graham and Laura Duvall; all three sons-in-law, Andy, John, and David; and grandchildren Savanah, Jimmy, Colton, Madison, Tommy, and Elena, for patiently enduring us while we focused single-mindedly on this book.

An enormous debt of gratitude goes to Mindie Conway who stepped in to relieve my worry and tend all my cherished gardens while I had be content with the images from them on my computer screen.

For their generosity in providing unlimited access to their orchards, great appreciation goes to Clopper's Orchards in Smithsburg, Maryland, and to Margie and Lawrence Johnson in Valley Center, California.

For sharing and caring and patiently waiting for us to return to a normal life, special thanks to Jody and Nicholas Long and Heidi and Steve Lippman.

At Watson-Guptill Publications, my gratitude goes to Joy Aquilino, senior acquisitions editor, who is always a joy to work with; Michelle Bredeson, editor, whose gentle, patient editing skills helped tidy up and tie together the manuscript; and Areta Buk and Hector Campbell for their sensitive, thoughtful handling of the material and the skill with which they put this book together.

And of course, had it not been for all my wonderful students throughout the United States and abroad on whom I practiced and developed techniques, whose needs made me stretch, and whose sharing helped me grow, I would not have been able to do such a book. Special thanks to them all, and to the following magazines in which some of these lessons or variations first appeared: *Decorative Artist's Workbook, Tole World,* and *Quick and Easy Painting.*

Contents

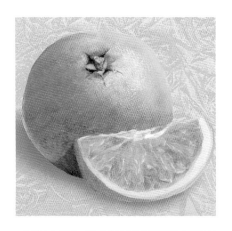

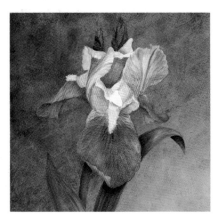

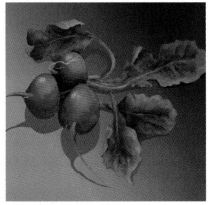

Introduction

"Every child is an artist. The problem is how to remain an artist once he grows up."

PABLO PICASSO

Capturing images, impressions, and emotions that stir us, and expressing them in paint, is one of life's great creative adventures. It gives us the opportunity for self-exploration, as well as creative self-expression. The creative process is an innate part of our being and allows us to indulge the "child" in us. Unfortunately, for many that innate creativity is submerged under fears and insecurities. If we worry about how our art or creativity will be perceived or judged by others, we paint with timidity and fear rather than with the free, exploring spirit we had as children.

Before we learned that we had to color neatly within the lines of the coloring book, and that dogs were not green, and walls were not for drawing on, we were all very creative. If you believe you are no longer creative, you need to know that you can be again; but you must regain your child-like daring and independence. You must be willing to experiment and to attempt the somewhat absurd at times, and to be flexible, nonconforming, and curious. You must redevelop your courage and self-confidence and, above all, be willing to risk failure in order to attain success. Before you learned to walk, you fell down a lot; but you grew stronger and more resolute in the process.

Be bold. Accept that you will paint some failures along the way, but try to learn from them. We learn more from our frustrating mistakes than from our easy successes. Be

positive and expect to succeed. If you continually tell yourself, "I can't do this," you'll soon convince yourself, thus paving the way for failure. Think "I can," and you will!

Learning and Painting Styles

Individuals have such varied learning styles that no single presentation will fill the needs of everyone. If you learn most easily from structured presentations, this book was written for you. As a former kindergarten and first grade teacher, I know how important it is to break down procedures into separate, easy-to-understand steps. But as a former teacher of young, impressionable minds, I have always sought to build—not thwart—innate creativity. Unfortunately, with a "recipe" book such as this, it's easy for students to lose their creativity and get locked into a step-by-step thinking (or perhaps non-thinking) process. The result can be a loss of the spontaneity and freshness, and happenstance that is so much a part of art. So while you're following the illustrated steps, be bold and daring enough to deviate, elaborate, and experiment. Let the steps be a map, not a crutch; a pathway, not a tunnel that keeps you focused on a narrow goal and prevents you from seeing all the other possibilities.

This book grew out of one of my previous books, *The Big Book of Decorative Painting: How to Paint if You Don't Know How—and How to Improve if You Do.* While that book discussed three different painting styles, this book will focus on one style—a somewhat sharp focus realism, achieved through the application of layers of

These tiles, inlaid in the kitchen table my husband, Lynn, built, were painted with china paints and kiln-fired. I used many of the same patterns and techniques of working with paint layers as in the lessons in this book.

thin paint. It's not necessary for you to duplicate my steps and techniques precisely to get satisfactory results. You can paint in a more direct method, using no wash layers at all. You can paint with a looser application and less precise details. Or, you can paint with a heavier application. Just remember that what is illustrated is only one way of doing things. You must eventually find the way that suits you best.

Consider the material in this book as gear that could be useful on a fun adventure. Some you'll use a lot; some may lead you into different territory; some you may try out and decide later to replace. In any case, it should be a fun trip.

Organization of the Book

This book is organized into two parts. The first six chapters contain introductory material to acquaint you with art materials and concepts, and to show you how to use both to your advantage. You'll learn about brush-loading techniques; color theory and mixing; color schemes; shadows, reflected lights, and highlights; composition; and easy faux finish techniques for painting interesting backgrounds. It is a good idea to read these chapters entirely before beginning to paint any of the lessons.

The second part of the book contains three chapters with fifty-two step-by-step lessons (including instructions for many additional variations) for painting fruits, vegetables, and flowers. Each lesson consists of four pages:

- A pattern and hints page, which includes a shaded pattern for the subject illustrated on the worksheet and, when space permits, additional patterns; a list of paints and brushes and mediums used; helpful hints or techniques; and, sometimes, additional sketches showing the subject in different color schemes.
- A full-color worksheet page, illustrating the step-by-step procedure for painting the subject.
- Two pages of reference photographs of the subject to use as resource material for painting additional studies and for creating compositions.

The studies on the worksheets are just that: studies, not full compositions or complete paintings. I hope you will use the studies to help you build complete paintings. It's not necessary to paint the step-by-step lessons in the sequence in which they're presented, but it would be helpful at least to scan the hints for all the lessons. Hints that apply to painting one

subject can usually be applied to painting many others. Among the different fruits, vegetables, and flowers, I have tried to present several ways of creating painted effects. If you find one approach that seems too difficult for you to master, try using a technique from a different lesson to accomplish the same or a similar result. For example, I have given you several approaches to painting leaves. Try them all. Then, if you prefer, choose the technique you are most comfortable with and use it whenever a lesson calls for leaves. Simply adjust the colors to ensure that the leaf is unified with the subject it's supposed to be supporting. By glancing quickly through the hints for the different lessons, you will familiarize yourself with the variety of possibilities, discover there can be many ways of accomplishing the effect you seek, and thus open more paths to explore while you paint.

Becoming familiar with all the hints and tips will make it easier for you to paint not only the lessons in this book but other subject matter not covered. Your unique style will emerge as you depend less on the written instructions and more on your developing use of the techniques. So relax, experiment, and have fun! Foremost in your efforts should be the goal of painting to express and to please yourself.

Painting from the Lessons

My painting process can be broken down into five main steps, which vary in sequence.

1. Undercoat
2. Shading
3. Highlights
4. Color washes
5. Details

The undercoat may be opaque, semi-opaque, transparent, or splotchy, depending upon how much of the background color we want to shine through to create variations in the final effect. We can undercoat leaving ridges to suggest veins and ruffles in flowers. We can undercoat with thick paint to suggest texture on kiwis and oranges. Unless specified in the instructions, it is not necessary to paint the undercoats solidly. In fact, a bit of the background color peeking through often gives an irregular, more natural appearance. Letting the background show through also helps relate the color of the subject matter with the color of the background.

Undercoat

Color washes

Shading

Highlights

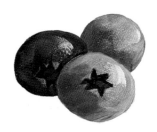

Details

For these blue-berries I applied the color washes before the shading and other steps.

Thin white applied over red (top) will appear slightly different than when thin red is applied over white (bottom).

Shading colors may be applied with sideloaded or doubleloaded brush strokes (explained in depth in Chapter 1) or thin layers (washes) of paint. Highlights may be added with sideloaded brush strokes, thin washes, or drybrushing (to be explained later). Color washes are used to slightly adjust underlying colors, to add accent hints of other colors, and to create a "glowing-from-within" effect.

After applying the undercoat, the order of the remaining steps may be interchanged and even repeated. In other words, we could switch sequences and apply color washes in step 2, shadings in step 3, and highlights in step 4. Then maybe another color wash or two, and more shading, and finally the details. As you learn to observe subtle variations in colors, you will see how a change in the sequence of the washes will affect the outcome.

You can create lovely, luminous results by building up several layers of thin washes of different colors. If you apply a shading, highlighting, or accent color, and the color is too heavy or too intense, you can merge it into the underlying area by applying a thin wash of the underlying color over it. With thin color washes, there are many wonderful ways to play with color!

Working with Photographs

Photographs provide a valuable resource, allowing us to study our subject matter in depth, particularly when we don't have access to the real thing. With photographs, we can not only study at our leisure, but we can, through experimentation, interpret the subject matter with a variety of techniques. Study the photograph reference pages with an awareness of your personal reaction to the subject matter and how you'd like to interpret it.

I have tried to give you a wide range of possibilities through the photographs, including not only different perspectives and colors, but also produce and flowers in varying stages of development, and views of sliced produce and their foliage. The photographs will help you see details you may otherwise overlook. They will sometimes suggest compositional possibilities. And photographs shot from different angles may help you better understand perspective and foreshortening. Using the photographs in the book—and ones you take yourself—as inspiration will give you endless opportunities for combining the book's many lessons into interesting compositions.

Working with the Real Thing

I urge you to work not only from the photographs and worksheets but also with the actual subject matter in front of you. If you're painting, for example, the artichokes lesson, buy some artichokes to study. You may have different varieties where you live. And yours may have more interesting shapes, petals, scars, and thorns than mine. The techniques in the lessons, however, should help you discover ways of creating whatever effects you seek to accomplish.

Besides, painting from the "real thing" gives you opportunities for study and observation that photographs can only hint at. With the actual flower or produce close by, you'll not only be more inspired, but you'll also be able to study the subject from several viewpoints and eye levels. If it's a fruit or vegetable, you can slice one

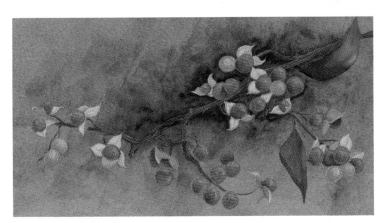

The orange of the bittersweet is enhanced by the complementary blue background. In Chapter 3, "Color Schemes," you will learn how to combine colors in such ways for pleasing effects.

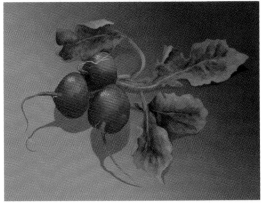

Radishes make interesting subjects for the study and painting of their cast shadows, which are explained in Chapter 4, "Shadows, Highlights, and Reflected Lights."

open in a variety of ways: across horizontally, vertically from stem to blossom end, in slices, in wedges. You can study different lighting effects and experiment with different background colors. And just smelling an apple or a gardenia while painting it can be inspiring. The more senses you involve in the learning process, the more thorough your learning will be. And when the lesson is complete, you can even eat the subject matter, thus involving one more sense!

It's OK to Be Different

It's not important that your work and colors exactly match the worksheets. In fact, it would be most difficult for either you *or* I to exactly duplicate my printed worksheets. Photography and printing processes often alter colors (sometimes slightly, sometimes greatly). So even if you use the exact paint color and brand I specify, fresh from the container, it may not exactly match the color shown in the color swatch. Hence there will be a comparable shift in your painted colors from those on the worksheet. The thickness of the application of washes, and the sequence of applying them, can also have tremendous effects on the final result, and can make it difficult to obtain exact matches. Don't get frustrated. Just be pleased to create something that is recognizable as what you set out to paint, using the information given on the worksheets as a guide to getting there.

In painting a lesson, you may opt to paint either the leaves or the fruits/flowers first and almost in their entirety. However, for best results in unifying the colors, values, and intensities, it's a good idea, near the end of the painting session, to work back and forth between both components. That will help ensure that your painting holds together well. It will give you an opportunity to work some of the fruit or flower color into the leaves; to coordinate highlights and shadows so they seem to result from the same light source, and to tie reflected lights to the surfaces reflecting them.

Often, you'll find that the painting of your subject matter does not come alive until you add the textures and colors of surrounding elements such as leaves. Consider the plums on page 149, for example. Without the leaves, they melt into the background. Once the leaves are added, the plums appear much more vivid and exciting.

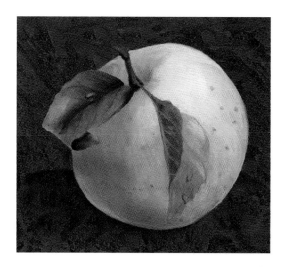

The "marbleized" background in this sketch was created using techniques explained in Chapter 6, "Backgrounds."

Variety is the Spice of Art

In working with thin layers of wash colors, results can vary greatly; but that's the beauty of the technique. It allows for great variation and fun surprises and keeps the painting from becoming stagnant, predictable, and overdone looking. Remember, a road map usually offers several routes to your destination. What I offer you here is *one* route. Not the *only* route. Wherever you end up cannot be totally wrong as long as you enjoy the trip. So relax, have fun. If you are too concerned about getting it "right" (since there is no one "right" way) you could well be setting yourself up for disappointment.

Knowing When to Stop

When you think you've almost "got it," stop. Don't succumb to the temptation to try one more thing or to redo something to make it a little bit better. Doing so often creates more problems, and you'll end up redoing so many areas that you'll lose the lovely, fresh look you had before you began trying to "fix" it.

Leave it. Close the book and walk away! Enjoy a cup of tea, take a walk outside. When you're totally refreshed (maybe even a day or two later), come back. Don't look at the lesson. Rather, look at your own painting, and chances are you'll be delighted. The longer we work on something, it seems the more dissatisfied and frustrated we become. But when we see it after an absence from it, we amaze even ourselves.

Once you're satified with your painting, let the paint cure for a couple of days. Then protect your work by applying one or two thin coats of water-based varnish, such as DecoArt's Satin Varnish.

You've made a smart choice on your painting...

Jackie Shaw

Getting Started:
Supplies and Basic Techniques

"The journey of a thousand miles begins with one step."

LAO-TSE

When investing in supplies for your painting hobby, consider what a win-win situation your hobby is for you, your family, and your friends. They'll never be at a loss for a gift to give you on special occasions—a gift certificate to your favorite art supply store will score a hit every time. And after a few practice sessions, you'll generate lots of paintings to give them for their special events.

To get this wonderful interchange into motion, you'll need only a few basic brushes and paints. For the other supplies, you can "make do" with common household items to keep your initial expenses down. You don't even have to be able to draw, because I'll tell you several ways you can transfer patterns onto your surface. You may need to return to this chapter frequently in the beginning if the brush techniques discussed are new to you. So mark its location with a tab or ribbon for quick reference.

You've taken the first step on your painting adventure by picking up this book. Now let's get you started collecting supplies and learning how to use them.

Scrolls and Brushes
9 × 12 inches, acrylic on paper

Shading, cast shadows, and highlights, added to decorative strokework, create the illusion of dimension and distance. Notice how the cast shadows suggest how far the strokework is from the surface—whether touching the surface or hovering above it. (To learn all about strokework, see my Big Book of Decorative Painting.*)*

Supplies

Purchasing art supplies always gives me the same exciting sense of fresh beginnings and unknown, awaiting adventure that I experienced as a child, buying supplies for the new school year. What promise there was in a brand new box of crayons! Such potential in an unspoiled composition book! Well just wait 'til you see what promise your paints and sketchbooks hold for you.

Basic Supplies

You can get started on your lifetime of creative self-expression with just a small investment. Your most important tools are brushes and paints, of which there is a wide range of price and quality. Pamper yourself with the best quality you can afford. Your brushes, if well cared for, will last a long time. And quality paints (with lots of pigment) will help you achieve the results you seek, and are a joy to work with. Inferior products will undermine both your efforts and your confidence.

While it is handy to have an assortment of brush sizes, you can get by substituting the basic brushes listed below for other brushes and sizes suggested in the lessons. And, if you are willing to learn how to mix colors, you can use the color swatches on each worksheet page to help you create the colors you need, or close approximations. I've created the lessons and worksheets to make it as easy as possible to paint each subject without having to worry about too many mixtures. However, it will require that you purchase a greater variety of paint colors.

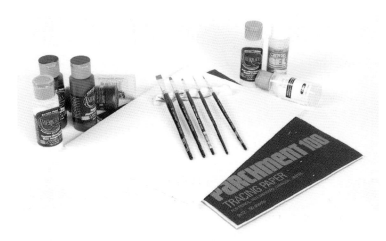

A few basic supplies to get started.

You may already have some of the items you need around the house.

PAINTS: DECOART AMERICANA ACRYLICS
- Primary Red
- Primary Blue
- Yellow Light
- Titanium (Snow) White
- Lamp (Ebony) Black

BRUSHES: LOEW-CORNELL SYNTHETIC TAKLON BRUSHES
- Flats: Nos. 2, 6, and 10 (Series 7300)
- Round: No. 2 (Series 7040)
- Liner: No. 1 (Series JS)

MISCELLANEOUS
- Painting medium (Easy Float, Brush 'n Blend Extender, and/or Canvas Gel, all by DecoArt)
- Pad of 9- by 12-inch Bristol board (art paper), watercolor paper (hot pressed), or poster board to paint on
- Tracing paper for copying patterns

HOUSEHOLD ITEMS
- Jar of water (for rinsing brushes)
- Bottle cap or jar lid (for holding water or painting medium on the palette)
- Paper towels (for blotting brushes)
- Styrofoam or plastic food trays, glossy magazines, or freezer paper (to use as a palette on which to squeeze and mix paints)
- Plastic knife (for mixing paints)

- Pencil or chalk (for sketching and making transfer paper)
- Dead ballpoint pen (for transferring patterns)
- Soap (such as Ivory) for cleaning brushes
- Alcohol, fingernail polish remover, or acetone (for cleaning badly neglected brushes)
- Cotton swabs (for lifting out damp paint)
- Hair dryer (handy for speeding up the drying of paints)
- Old toothbrush (for spattering water onto acrylics on the palette to keep them moist)

Wish List

Take advantage of birthdays and other holidays to increase your inventory of art supplies. Shortly before the special event rolls around, photocopy the wish list in this chapter and leave it in a conspicuous place. Put the name and address of the art store on the list, just to be sure your gift giver doesn't get sidetracked and shop elsewhere.

MORE PAINTS

Add more paints by concentrating first on additional primary colors. That will enable you to mix a wider variety of colors, as you will see on the color wheels featuring different reds, yellows, and blues on pages 32 and 33. Then, there are also hundreds of other premixed colors from which to choose.

MORE BRUSHES

- Flats: Nos. 1, 4, 8, and 12 (Series 7300)
- Rounds: Nos. 0 and 4 (Series 7040)
- Liners: Nos. 2 and 10/0 (Series JS)
- Dagger: $1/4$" (Series 7800)
- Round: No. 8 (Series Fabric Dye)

MISCELLANEOUS

- Brush Tub II by Loew-Cornell (for rinsing brushes)
- Plastic palette storage cups (for holding water and medium)
- Trowel-type palette knife (for mixing paints; either Loew-Cornell's J-11 or J-15 is a good size for small works)
- Disposable paper palette (on which to squeeze and mix paints)
- Chacopaper (artists' transfer paper in blue, white, and graphite for transferring patterns)
- Stylus (for transferring patterns)
- Brush Cleaner for Acrylic Paints by Loew-Cornell (for cleaning brushes)

Some items to include on your "wish list."

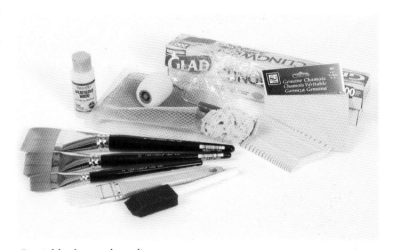

Special background supplies.

- Spray mister (to keep acrylics moist)
- Sta-Wet Palette by Masterson (to keep acrylics fresh longer)

Supplies for Special Backgrounds

There are a number of specialty and household items that can be used to achieve interesting background effects. In Chapter 6, I explain a number of faux finish techniques, which make use of these supplies.

- 1" foam brush
- 2" sponge/foam paint roller
- Chip brush: 1" (Series 2053, for streaking)
- Flat wash brushes: 1", $1^1/2$", 2" (Series 7550)
- Sponges (synthetic or natural)
- Plastic wrap
- Plastic mesh bag
- Weathered Wood by DecoArt (faux finish product)
- Woodgraining comb by Loew-Cornell
- Chamois cloth by Loew-Cornell

About Paints

The paints used throughout the step-by-step lessons in this book are acrylics in squeezable bottles. Be aware that some brands have similar paint names but their colors differ greatly. Or, they may have similar colors but quite different names. Use the paint swatches on the worksheet pages as a guide. If you already have other paints (tube acrylics, watercolors, oils) you can use them, making adjustments to accommodate their different attributes. Tube acrylics, other than needing a little more thinning for the washes and floated colors, will work like the bottled acrylics. Watercolors, which are traditionally used by building up layers of thin washes, respond similarly to the way acrylics work in washes (see the irises on page 218). The greatest difference with acrylics is the use of colored backgrounds and opaque, colored undercoats. Oil paints, because of their slow drying time, do not lend themselves as readily to the buildup of thin layers. However, this technique was inspired by the old masters and their use of glazes over light undercoats to create luminous "glowing-from-within" effects. It just took longer drying periods and the use of drying agents added to their paints. A newer oil paint, Genesis, can be heat set to hasten the drying time, thus allowing it to be used much like acrylics. I painted the compositions on pages 60 and 82 with Genesis oil paints and the same techniques described in the lessons to show you how similar effects can be achieved with different types of paints.

Labeling Your Paints

To reduce the amount of text on the worksheet pages, I have referred to colors by letters. This leaves more room for the step-by-step illustrations, and also makes it easier if you are using different paints from the ones suggested. The letters correspond to the list of paints needed for that lesson, found on the patterns/hints page. To easily identify the color needed as you're painting a lesson, label your paints with a set of stickers, made as follows:

1. Cut masking tape or other opaque tape into lengths approximately 1 inch long.

2. Turn under $1/4$ inch of the tape, pressing the sticky sides together to make a grab tab for easy removal.
3. Letter the tapes from A to R. (Most lessons will use only the first seven to ten letters.)
4. Attach the corresponding label to the lid of each bottle of paint as listed for the lesson.
5. Upon completion of the lesson, remove the lettered labels and attach them to a slick surface for easy reuse.

Prolonging the "Open Time"

The beauty of acrylics is that they dry quickly on our paintings. The frustrating thing about acrylics is that they dry quickly on our palettes. You can delay the drying time by mixing in a painting medium (see below) or by keeping a spray mister handy to mist the puddles of paint on your palette. Otherwise, flick water onto the paint piles with a wet toothbrush. You can also keep the paints workable longer by using a Sta-Wet Palette—a plastic box containing a sponge to be soaked in water and special water-absorbent palette paper that wicks water up into the puddle of paint. Create a makeshift wet palette by dipping a folded paper towel in water and covering it with a piece of deli paper—the somewhat slick, slightly translucent paper you use to grab a doughnut at convenience stores. Paints squeezed onto that paper "sandwich" will dry more slowly than those squeezed onto a regular disposable palette.

Using Painting Mediums

You will encounter three in this book: Easy Float, Brush 'n Blend Extender, and Canvas Gel. I often use them interchangeably. All three are designed to extend the "open," or "working," time of the paint, rendering it more flexible and easier to work with when using techniques that require slower drying paints, such as applying washes. Some lessons include mention of particular mediums. These may be used, or omitted, or substituted with another medium of your choice. Any one medium can be mixed with acrylic paint to prolong the drying time. The medium can be applied

directly to the surface or over layers of dry paint, and paint can then be worked *into* it while it is still wet. All three mediums can also be used to render the paints more translucent: The greater the proportion of medium to paint, the more translucent the paint will be. Once the paint/medium mixture starts to set up on your painting, or feels like it's beginning to drag, avoid stroking over it further. It will no longer react smoothly. To prevent reactivating paint layers which have had medium added to them, dry them thoroughly with a hair dryer before making additional paint applications. Otherwise, moisture may cause the previous paint layer to lift off.

Easy Float is the thinnest of the three mediums. Mix a drop or two into an ounce of water, and use the mixture to moisten the brush and/or painting surface, or to thin the paints. It will help the paint flow more easily and travel longer distances. In effect, it seems to "stretch" the paint, facilitating the application of very thin hints of color.

Brush 'n Blend Extender is a little heavier—approximately the thickness of bottled acrylic paint. Use it directly from the bottle or thin it with water if a finer application is desired. Mix a little into your puddle of paint, or pick some up on the edge of your brush along with a little paint and blend them together on the palette.

Canvas Gel is the heaviest of the three mediums. Applied directly to the painting surface or mixed into the paints, it allows you to move the acrylic paint around much like working with oil paints. This thicker medium gives the acrylics more body and thus helps hold the paint in piles, rather than thinning it down into puddles.

Creating Paint Mixtures

The lessons and worksheets are designed to make it as easy as possible to paint each subject, without having to worry about too many color mixtures, and whether or not you've mixed exactly the right color. But it is important to learn how to mix colors, so I have included some opportunities for you. When you see in the instructions, for example, "Mix **A+B**," that means to start with color **A** and gradually add **B** to it, adding no more than an equal amount. Thus, the mixture **A+B** will contain either

more **A** than **B** or about the same amount. If **A** is yellow and **B** is blue, your mixture would be a green, with possibly a yellowish cast. On the other hand, if the mixture called for **B+A**, it means we want the blue mixed with less yellow or just about the same amount. The resulting color would be green with possibly a bluish cast. If a third or fourth color were added to the mixture, it would be added in increasingly smaller amounts. Therefore, **A+B+C** (yellow + blue + red, for example) would result in a yellow-green with just a hint of red to dull it slightly. **D+A+B+C** (say **D** is white) would give you a very pale, dull, yellow-green. (See Chapter 2, "Understanding and Mixing Colors" for more explanation of color mixtures.)

Note: When you know the color you're trying to create, it's best to start with the lighter or weaker color and add the darker or stronger one to it. Some colors are more intense or have more overpowering pigment than others. If you wanted to mix pink, for example, and did so by adding white to red, you might end up with enough mixture to paint a room in your house before you achieved the light pink tint you wanted. Instead, add red to white, mixing in small increments at a time.

About Brushes

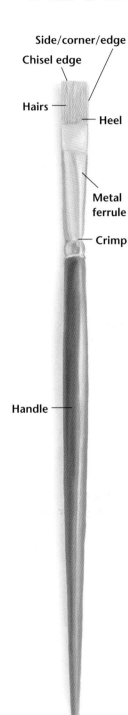

Side/corner/edge
Chisel edge
Hairs
Heel
Metal ferrule
Crimp
Handle

Take a minute to learn the names of the parts of a brush. They will be referred to throughout this book.

The Loew-Cornell series of brushes I recommend are composed of synthetic Taklon filaments, ideal for use with acrylic paints. They do not get easily waterlogged and limp as lesser quality brushes often do. In fact, they are quite resilient and snap back to their original shape after stroking with them. The flat brushes are evenly formed with sharp chisel edges, which are vital for painting careful details. Likewise, the round brushes form fine points, with no stray or uneven hairs to spoil your painted effects. The handles of the brushes are held snugly in their metal ferrules—a wobbly brush is no fun to paint with! These moderately priced brushes will serve you well if you treat them with the care they deserve. If you are unable to find the recommended series of brushes, look for the features described above in your substitutes.

Getting to Know Your Brushes

Your brushes can last a very long time, or become practically useless after your first painting session (that should get your attention!). Let's make sure yours last and remain in excellent condition, because it's difficult—to nearly impossible— to do great work with poor brushes.

Before using your brushes the first time, take a few minutes to familiarize yourself with them in their new condition. It will make it easier for you to keep them like new. First, remove the factory applied sizing that stiffens the hairs and protects them in shipment. Dip the hairs in water and squeeze them gently between your thumb and forefinger to loosen the sizing. Rinse the brush well, then dry it by stroking it on both sides on a soft cloth or paper towel. Notice how the bottom edge of the hairs form a sharp, chisel edge. The hairs lie straight and tight together and have no outward curl. This tight grouping of the hairs makes managing paint easy. Curly hairs cause problems. A good quality, new brush should be resilient, with hairs that snap back quickly to their original shape after use, and no stray hairs. A waterlogged brush, or an inferior quality brush will have limp, unresponsive, uneven hairs.

Next, notice the smooth transition from the metal ferrule to the hairs. Slide your thumb and forefinger along the ferrule and off onto the

hairs. Do this several times. Memorize the smooth feel of the transition. You don't notice any lumpy formation at the junction of the ferrule and the hairs. If paint is not meticulously cleaned from your brushes each time you use them, and even *while* you're using them, it will dry in the hairs at the base of the ferrule. Over time, a thick, hard knot will form, causing the hairs to splay out and open a sort of tunnel when looked at from the hair end of the brush. The hairs may also separate like teeth on a comb. With splayed hairs, it is impossible to get a sharp chisel edge on the brush, making it hard to control where the paint is going to go.

The handle of your new brush fits snugly in its ferrule, held in place by the crimp; and with its highly lacquered finish it is a pleasure to hold. A brush left standing in water, which covers the ferrule and part of the wood handle, will soon loosen, a result of subsequent soaking and drying out. It's hard to control a wobbly handled brush. The swelling and shrinking of the wood will also cause the lacquer to crack and peel, making an unpleasant feeling handle. Left standing too long in water, the hairs of the brush will bend. And as unlikely as it sounds, acrylic paint will harden in the hairs even though they're submerged.

That's the bad news. The good news is you can prevent the premature demise of your brushes with attentive care.

Cleaning Your Brushes

Clean your brushes thoroughly at the end of each painting session. If you're working long or hard with the brushes, take a break and give them a good cleaning during the session. Don't leave them standing or dangling in water. They will become water logged and limp, and the acrylic paints will begin to set, even in the wet hairs.

1. Rinse out as much paint as possible, then stroke the hairs of the brush on a wet bar of soap, taking as much soap into them as possible. Or dip them in Brush Cleaner for Acrylic Paints. Do not scrub the hairs into the bar of soap or in the palm of your hand to load them with soap or cleaner. The scrubbing motion weakens and wears the hairs, causing them to break and curl.

2. With soap in the brush hairs, pinch the hairs between your thumb and forefinger, squeezing the soap up toward the ferrule. Wiggle the brush gently to work the soap amongst the hairs. Do not bend the hairs sharply against the ferrule.

3. Rinse well, then repeat steps 1 and 2 until every trace of color is gone. If any color remains to tint the soap, that means there is still paint in your brush. Tiny amounts left behind after each cleaning soon mount up to a big knot. So keep working.

4. When you're convinced no paint remains in the brush, rinse it well, then stroke it on the clean bar of soap once more. Leaving the soap in the brush, shape the hairs as they were when you first bought the brush: flat brushes to a smooth chisel edge; round brushes and liner brushes to a fine point.

5. Lay the brushes flat to dry. (If you stand them on their ends in a container before they are completely dry, some of the moisture that remains in the hairs and ferrule can drain down to the wood handle.) Once they are dry, it's safe to store them in a jar (hairs up) or in a box or other container. The soap in the hairs will dry stiff to protect them and help them retain their like-new shape. Before using the brushes again, simply rinse them well.

(Whoops!) Repairing the Damage

What do you do if you accidently let paint dry in a brush or store it upside down? Accidents do happen. Distractions undermine our best intentions, and a paint-filled brush gets set aside and forgotten. Even though the paint has dried and the hairs are stiff as peanut brittle, don't throw the brush away.

REMOVING HARDENED PAINT

Soak the hairs in alcohol, acetone, or nail polish remover containing acetone. Remember to do this in a well-ventilated room. Take precautions to keep the fluid off the handle or it will dissolve the lacquer into a sticky mess. An ashtray, a jar lid, or a saucer with a rim makes a good soaking dish. You can use a clothespin or two to elevate the brush at an angle into a saucer or lid. Stand the clothespin on its two "legs," letting the brush be the third "leg" of a tripod. Just be sure that the weight of the brush does not bend the hairs. Or, suspend the brush in a jar, so the

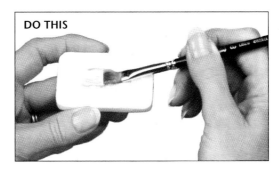

DO THIS

Stroke your brush gently to load with soap.

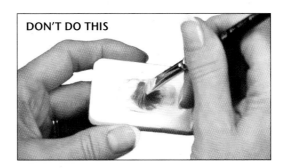

DON'T DO THIS

Do not scrub the hairs in a circular motion!

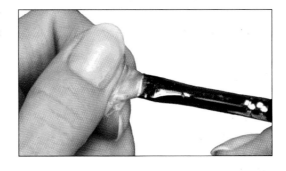

Squeeze the soap gently up toward the ferrule.

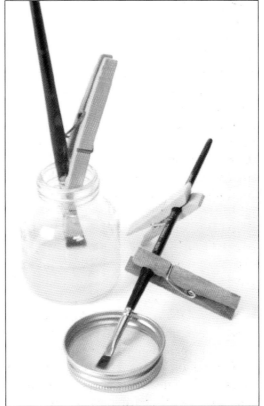

Two ways to soak a damaged brush.

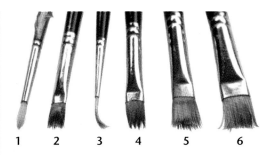

When your brushes look like this, here's what you're doing wrong: (1) Handles split, peel, and wobble when they're allowed to soak in water. (2) Acrylic paint will harden in a brush that is not properly cleaned. (3) Hairs bend in storage or when carelessly left standing in water. (4) Comb-like separation of hairs is caused by dried paint. (5) Tunneling effect is caused by paint hardening near the ferrule. (6) Curling hairs result from rough treatment and rough surfaces.

hairs do not rest on the bottom, by using spring type clothespins to hold the handle. Cover the container with foil or plastic wrap if you can do so without including the brush handle. Concentrated fumes can also soften the lacquer.

After the dried paint has loosened, clean the brush as described above. The solvent soak is a harsh measure, so don't use it as a part of your regular cleaning routine. And as harsh as it is, it will not undo the tunnel or the split-comb type damage caused by paint drying in the hairs, near the ferrule.

STRAIGHTENING CURVED HAIRS

If you left a brush standing on its hairs in water ("tsk, tsk, tsk"), or cramped it in storage so that the hairs are now permanently curved in one direction, there is an easy remedy. Dip the hairs (not the ferrule) quickly in and out of very hot water. (The brush hairs are held in the ferrule with glue that could loosen in hot water, resulting in a hairless brush, which would need no cleaning or care.) Repeat as necessary until the hairs are straight. Then stroke the brush on a damp bar of soap and shape the hairs. This hot-water dip will not straighten fuzzy, every-which-way curls that result from misuse, rough surfaces, and scrubbing.

Which Brush Should You Use?

Ideal brush sizes are suggested for each lesson. If you have not accumulated a range of sizes yet, substitute the largest brushes you can comfortably handle for the ones suggested. If you enlarge or reduce the patterns, then the "ideal" brush sizes would need to be adjusted to correspond. Just remember, though, that the magic is not in a given brush size but rather in your technique.

BRUSH SIZE

If you are using a different brand, there may be some variations between my brush sizes and yours. For example, your size No. 6 may not be the same size as my No. 6. So use my recommendations only as a suggestion, and be guided more by what feels comfortable to you. Just be aware that in the beginning, you will probably choose a slightly smaller brush size than would be most expedient. Try to always use the largest brush you can comfortably handle in any given area. It's more efficient, and you're less likely to fidget your painting to death the way you might using a too-small brush. Learn to trust your intuition. This is true, also, if you're starting with just the three flat brushes listed as basic supplies. If you plan to paint blueberries, you probably would not reach for a 1-inch wide brush. Likewise, you'd be wasting time and effort to paint an eggplant with a No. 2 flat brush—unless, of course, you were painting miniatures.

BRUSH STYLE

As a general rule, you will use flat brushes to undercoat, to apply washes and sideloaded and doubleloaded strokes, to highlight and shade, and, sometimes, to apply drybrushed effects. Use the liner and round brushes to paint thin lines and small details. Sometimes I will suggest you use a flat brush for some details (such as veins of leaves, highlights, pollen . . .) just to keep them from looking too stiff and artificial. Highlights painted with the corner of the flat brush look softer and more natural than the precise, hard little dots applied with the liner brush. Narrow, straight lines can also be painted with the chisel edge of the flat brush when it is held perpendicular to the painting surface (see the persimmons on page 141, step 3, and the pineapple leaf on page 145, step 2). Such lines are softer and less defined than those made with the liner brush. Use the round brushes for painting particular strokes, such as for forming seeds, flower petals, and textured citrus flesh. Use an old, splayed brush (flat or round) with hairs sticking in all directions—we'll call it a "scruffy" or "ratty" brush—to apply drybrushed effects, pollen, furry kiwi hair, and for stippling.

Brush-Loading Techniques

This section explains four methods of loading paint into your brush: full loading, sideloading, doubleloading, and drybrushing. Each technique yields different effects, so it is important to be familiar with all four. Because sideloading is the loading technique that stumps the greatest number of students, I have included especially detailed instructions. Don't be intimidated though; once you have mastered the technique, you can accomplish the loading quickly and efficiently, without having to think about it.

Fully loading the brush.

Full Loading

A fully loaded brush is a brush loaded almost to the metal ferrule with paint generally the thickness it comes from the container. To load the brush, stroke it at the edge of a puddle of paint, working the paint well up into the hairs. Merely dipping the brush in the paint and letting paint cling to the outermost hairs is not fully loading the brush. We will use a fully loaded brush primarily for opaque or textured undercoats.

Sideloading

A sideloaded brush is loaded along one edge with color that gradually fades to little or no color on the other edge. We'll call the edges the "paint edge" and the "water edge," respectively. A sideloaded brush produces strokes of shaded color. Such strokes facilitate the application of thin layers of paint for creating highlights, shadows, and delicate accents of color (such as tinges of red, orange, yellow, blue, and purple on leaves). By loading the brush so the water edge stays fairly free of pigment, we can use that edge to nudge or soften the sideloaded application if necessary, or to smooth a too-obvious edge of paint.

One of the most common mistakes in sideloading is not working enough paint up into the hairs of the brush. A few jabs at the paint puddle and a couple of blending strokes on the palette do not properly and sufficiently fill the brush and distribute the paint. A stroke applied with an inadequately prepared brush will have an area of thick paint laying abruptly next to a swath of water, which will quickly evaporate, leaving a hard-edged stripe of paint where you

were hoping for a gradual blending of tone. A well-loaded brush, on the other hand, will produce several, nicely gradated strokes with just an occasional remoistening with water or painting medium. On your first read-through of the directions, have a flat brush, palette, paper towel, and water handy. Go through the motions as you read, substituting just water for paint. This will help embed the process in your mind before you get down to working with the paint.

1. While it is possible to sideload a variety of brush styles, develop your skill by practicing with a flat brush in excellent condition. At first, work with a No. 8, 10, or 12 brush. As your skill develops, try the smaller flat brushes.
2. Dip the brush in clean water or in clean water to which a drop of Easy Float has been added. (If you're using oil paints, dip the brush in painting medium.) Shake off the excess; then blot the entire length of hairs, on one side only, on a paper towel. Watch the hairs, and as the wet shine disappears, immediately lift the brush. Do not blot the other side. The water or medium remaining in the brush should provide the right amount of moisture for dispersing the paint. Too much water or medium will make the paint too juicy to control; too little will cause the brush to drag and skip.
3. Pick up a little paint on the corner of the slightly damp brush.
4. Stroke the brush back and forth on the palette in a short space (no longer than an inch; even shorter for smaller brushes). Stroke over and over in the same spot, picking up more paint as needed to completely load the hairs on one side of the brush. Moving to a different clean spot on the palette with

every stroke (a common mistake) will use up the paint rather than force it to load well up into the hairs of the brush.

5. Continue to add more paint, a little at a time, until color is worked almost up to the metal ferrule. Avoid loading too much paint at once since doing so will make your blending area messy. It may also make the paint spread too far across the brush, eliminating the clear water edge. Too much paint loaded at once

Sideloading the brush.

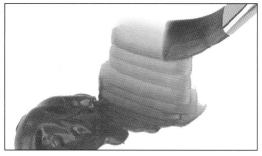

"Walking" the brush away from the paint puddle.

A sideloaded stroke should show a gradual (top), not abrupt (bottom), change in color.

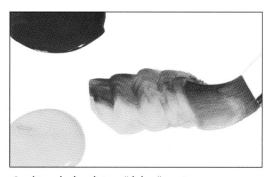

Stroking the brush in a "slalom" motion.

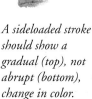

Whoops!

If you accidently get strong color (or in the case of doubleloading, the wrong color) across the entire brush at any time, you need not rinse the brush entirely and start over. Just dip the edge of the brush that was supposed to remain clear into a droplet of water or medium, wipe the paint off by pulling that edge through a paper towel held between your thumb and forefinger. Then pick up a little more moisture, blot it, and continue stroking and loading the brush.

can also force paint into the ferrule area, making brush cleaning a hassle.

6. As you stroke the brush on the palette, stroke on both the top and undersides of the hairs. If you stroke only the bottom side, you will be pushing the paint up toward the top side of the hairs and it will not be worked properly into the hairs. When you flip the brush to stroke the top side, be sure to align the color edge of the brush with the color stroke on the palette.

7. When you think you have loaded sufficient paint in the brush and have blended it so it progresses from a deep color on the paint edge to a pale color or no color on the water edge, make a short test stroke on a clean spot on your palette. The stroke should show a gradual change in color.

8. If the color in your stroke changes abruptly, you need to blend on the palette a little more to distribute the paint gradually across the hairs. Try this: "Walk" the brush gradually away from the edge of paint. If the paint is on the left edge of the brush, walk toward the right by making short strokes parallel to the original stroke, like a series of stripes. Then walk back toward the left, applying pressure on the brush while stroking, gobbling up the trail of stripes. At first, walk only half the width of the hairs of the brush until you are proficient at picking up—on the way back—all the paint deposited while walking away. Walk on both sides of the brush.

9. Another way to soften the abrupt color change in the brush, whether side- or doubleloaded (see below), is to stroke the brush on the palette, moving like a downhill slalom racer in slow motion. Stroke back and forth in this wiggly fashion several times. Then, on the same spot, finish with several straight strokes, stroking on both the top and undersides of the hairs. The wiggle will help move the concentrated paint on the edge of the brush across the hairs.

10. If the paint drags a little, at any time, dip the water edge of the brush into a drop of water or medium and blot the excess. (I like to keep a large drop on my palette so it's easier to see and control how much moisture my brush picks up.) You can also use a bottle cap or a palette cup. Blend on the previous stroking area on the palette to distribute the moisture across the brush hairs.

Doubleloading

A doubleloaded brush is loaded with two different colors or values, one on each edge. After blending the doubleloaded colors on the palette, the brush produces a stroke having three colors or values—two from the two colors loaded onto the edges of the brush and the third as a result of the two colors mixing together in the middle of the brush. The gradation of color in a doubleloaded brush makes possible the application of subtle color transitions such as in painting highlights, reflected lights, and shadow areas. The effect is slightly different from using a sideloaded brush: The color application will be more opaque, and can appear too heavy and flat if not applied thinly over previous thin-layered areas.

To doubleload the flat brush, follow the procedure for sideloading the brush, except in step 3, pick up a different color on each corner of the brush. In the test stroke you make in step 7, you should see the color from one edge of the brush gradate gradually into the color on the other edge. For example, if you loaded yellow on one edge and blue on the other, the colors should merge into green across the center of the brush. If there is an empty space in the middle or a sharp edge where one color abuts another, you haven't blended the colors sufficiently in the brush. Go on to step 8 and/or step 9, being careful not to "walk" or "zig" the brush so far as to let the yellow edge, for example, walk or zig into the blue paint, and vice versa. You will be able to walk only short distances before retracing your steps; the object being to keep the colors on the edges of the brush as pure as possible, while merging the colors in the middle.

If you need to remoisten the brush as in step 10 above, you can pick up water or medium sparsely on either edge. Just be sure to blot the brush before stroking on the palette to continue to blend, or the paint will puddle and you'll lose the distinct colors on the edges.

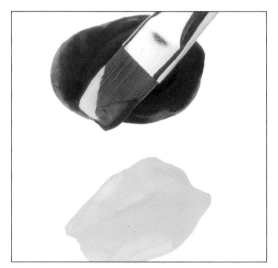

Doubleloaded brush before blending.

A doubleloaded brush stroke should show a gradual (left), not abrupt (right), change in color where in the two colors meet.

Whoops!

If you do lose one color, for example the yellow, it's not necessary to rinse the brush and start over completely. Moisten a small section of a paper towel, and holding it between your thumb and forefinger, pull the yellow paint edge of the brush through. Wipe off the "tainted" yellow leaving the green and blue intact. Then reload the yellow and proceed with the blending.

Brush Blending on the Palette

Palette-knife blending, in which two or more colors are mixed together using a palette knife, is perhaps the most familiar way of mixing different color paints. You can also mix colors by picking up on the brush a little of each color desired in the mixture and stroking—not stirring—them together on the palette. If we avoid overmixing the colors, thereby creating one bland tone, we will have lively mixed colors that retain traces of the original hues. (Palette knife mixing can also yield the same results if not overdone.) In using such a mixture, we would most often work with a fully loaded brush.

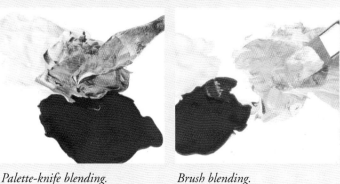

Palette-knife blending. *Brush blending.*

Drybrushing

A dry brush is a brush having no moisture added before picking up very little paint, which is then mostly wiped off. A drybrushed stroke produces glittering or scattered touches of colors or highlights, which cling primarily to elevated portions of strokes painted previously.

Any brush can be used for drybrushing; but this is a great way to use your old, scruffy brushes—those that have separated, splayed, and curled, and that have paint dried in the hairs near the ferrule.

1. To load the brush, dip the tip of the dry hairs in a smear of paint on the palette. Work the paint into the hairs by stroking or rubbing the brush on the palette. (This technique can be rough on good brushes, which is why I like to use old, ratty ones!)

2. Then wipe the brush nearly dry on a dry paper towel.

3. Hold the brush parallel to your painting surface and skim lightly across the area you wish to highlight or add broken color to. If you wiped the brush sufficiently dry, you should not see any paint appear on the surface with your first stroke. It should require several passes, and even then the paint should be barely visible. As you become confident that there is barely any paint in the brush, apply more pressure as you stroke. You should have to work at laying down any color. The harder you work, in fact, the more control you have. To avoid being surprised by a too heavy application, lightly pass the brush over some dried paint on your palette to test the amount of paint in the brush.

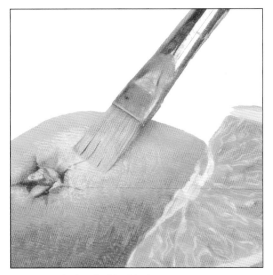

Applying drybrushed highlights.

Not like this

Like this

Experimenting

Don't be afraid to experiment with different brushes and techniques than those I recommend in the lessons. In working through the lessons, you will see that, in painting leaf veins, for example, I have suggested a variety of approaches:

- Using the liner brush.
- Using a sideloaded flat brush.
- Using overlapping, sideloaded strokes to soften the previously painted stroke.
- Painting V-shaped marks to indicate veins.
- Using the chisel edge of the flat brush.
- Using a combination of techniques and brushes.

Try all the variations, then determine the brush and technique that work best for you. My goal is to assure you that there is no one "right" way of doing things. There are many ways to achieve the effects we seek. Have fun testing them all!

If you didn't load the paint sparsely enough, you might lay down an obvious brush stroke rather than barely perceptible glints. Quickly wipe up the paint with a damp towel and dry the area thoroughly; reload the brush and try again. Remember that it's better to apply several inadequate coats, building up to the final desired effect than to apply one, too-heavy, layer.

Special Brush Techniques

Once you are familiar with the different methods of brush-loading, you can use them to create a variety of wonderful effects.

Washes and Floated Colors

A wash (also called a glaze) or floated color is a layer of thin paint usually applied with a flat brush over a dry background or undercoat. You will often see the terms used interchangeably as, indeed, the results are very similar. The paint, thinned with water or water plus a medium such as Easy Float or Brush 'n Blend Extender, is translucent or semi-translucent, thus allowing some of the color of the background or undercoat to shine through. This creates a "glowing-from-within" effect if applied over a light color. When applying a wash (glaze) or floated color, be sure to put it down thinly. Dry it completely with a hair dryer before applying another layer. This will prevent the lifting or dissolving of the previous application. You can build layer upon dry layer until you build up the depth or variety of colors you want.

There are two kinds of washes or glazes: flat and gradated. A *flat wash* creates a thin but uniform color throughout. It is created by fully loading a flat brush with thinned paint. A *gradated wash* is one that progresses from strong to faded color. It is applied by side-loading a flat brush.

Floated color is the application of color over a thin layer of water or water plus medium (such as Easy Float), which has been applied over a dry undercoat or a base coat. Thus, the color is "floated" across the surface on that layer of moisture. The effect can be flat or gradated. When we work with a sideloaded brush, we are actually floating color across the moisture that the water side of the brush lays down with every stroke made. In this book, I make abundant use of washes and floated colors to build up multiple layers of thin paint; to apply shading and highlighting and accent colors; and to adjust colors or submerge them slightly when needed. I use a sideloaded brush for most of these effects, so be sure to master that brush-loading technique. The results are well worth the effort.

Puddly Wash

The "puddly" wash is, like above, the application of a thin layer of paint over a dry undercoat or background. The exception is that it is applied very juicily. It will take a while longer to dry because there will be little puddles throughout the wash, rather than a smooth, thin layer of colored moisture. The paint pigment collects in varying amounts in the puddles. When the puddles dry, the effect is a splotchy application of thin paint. Wonderful for creating spontaneous-looking, natural effects!

Flat wash.

Gradated wash.

Puddly wash.

Scumbling

To scumble paint into an area is to apply it randomly in broken, overlapping patches, somewhat like crosshatching. Scumbling is a convenient way of unifying subject colors in a composition by introducing them into the background or into other areas. I usually like to soften the edges of my scumbled strokes so they don't draw too much attention to themselves. If the scumbling is done wet into wet paint, the edges of brush strokes soften readily. If the scumbling is done wet onto dry paint, it may be necessary to overstroke with a little of the original background color, thinned, to soften brush stroke edges. Scumbling can be done with a fully loaded, a sideloaded, a doubleloaded, or a (nearly) dry brush, depending upon the color(s) being used, how much of it is wanted, and the effect desired.

Scumbling.

Lifting Out Highlights

After applying a wash or floated color, you can lift out some of the still damp color to expose more of the light undercoat. Use a damp cotton swab or clean damp brush. This must be done quickly, before the layer starts to set up, so have your brush or cotton swab already dampened (not dripping) with clean water.

Using a cotton swab to lift out highlights.

Edge-to-Edge Blending

To add highlighting, shading, or accent colors in the middle of an area and avoid having a hard edge of color, use edge-to-edge blending. This can be done with either a sideloaded or doubleloaded brush.

To blend edge to edge with a sideloaded brush, first slightly dampen the area to be highlighted with Easy Float plus water. Place the paint edge of the brush to the center of the area to be highlighted and blend it outward, leading with the water edge. Then quickly return to the starting point, reverse the brush, again placing the paint edge to the center of the highlight area; and this time blend in the other direction, leading with the water edge.

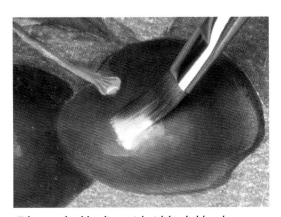

Edge-to-edge blending with sideloaded brush.

To blend edge to edge with a doubleloaded brush, follow the process above, omitting the layer of moisture. I generally use the doubleloaded brush if I wish to highlight or shade something that is painted opaquely. However, for working on subjects built up with thin washes and floated colors, I prefer the transparency of a sideloaded brush.

Edge-to-edge blending with doubleloaded brush.

Transferring Patterns

Each step-by-step lesson includes one or more patterns for you to paint from. To transfer a design onto your painting surface, first copy it onto tracing paper. (I like to use a thin, felt tip marker such as a Sanford Ultra Fine Point Sharpie or a Pigma Micron.) Then use one of the methods described below to transfer the design. Try them all, and use the one that best suits your needs at a given time.

Retracing Pattern Lines

Turn your traced design over, and on the back side retrace your pattern lines using a chalk pencil or a regular graphite pencil. Position the twice-traced pattern, chalk- or pencil-side down, on your surface. Retrace lightly over the felt-tip drawn lines using a stylus or a "dead" ballpoint pen. Avoid heavy pressure. You want to transfer just a faint line of chalk or graphite from the back of the pattern, not dig a ditch in your painting surface.

Chalk or Pencil Rubbing

Turn your traced design over and rub the back side of the pattern area with the side of a piece of cheap chalkboard chalk or the graphite from a No. 2 (or softer) pencil, held almost parallel to the paper. Shake off excess chalk or graphite. Lay the coated side face down on your surface and retrace gently over your pattern lines to transfer the design.

Commercial Transfer Papers

Purchase a package of artists' transfer paper, such as Chacopaper. These papers are designed specifically for use with artists' materials. Do not use regular carbon paper as it will bleed through your paints and spoil your painting.

Artists' transfer papers are available in gray, white, blue, red, and blue-green, depending on the manufacturer. Position the transfer paper between your pattern and your painting surface, making sure the coated side is face down on the painting surface.

When new, the coating on the purchased transfer papers (as well as on the homemade ones described below) is heavy and will transfer a line that is much too thick; so use a light touch in working with them. I like to wipe over the coated side of commercial transfer papers with a paper towel before using them the first time to remove excess coating.

Make Your Own Transfer Paper

Rub the back of a sheet of thin tracing paper with the side of a piece of chalk or with a No. 2 (or softer) pencil, held almost parallel to the paper. Cover your fingertips with a piece of chamois cloth or paper towel and rub the chalk or graphite into the paper. Shake off excess chalk or graphite dust. Fold the coated paper in half, treated side in, for storage.

Whoops!

Avoid frustration! Pay close attention when positioning the transfer paper beneath your pattern and on your painting surface in preparation for transferring your design. It's too easy to place the transfer paper upside down; and if you don't make a habit of checking your progress after copying the first line or two, you might discover after a long, tedious tracing session that you've transferred the entire pattern onto the back of your original pattern. It is helpful to write on the transfer paper in felt tip marker, "This side up!" Or write your name, or draw a smiley face. Do something to remind yourself to be alert.

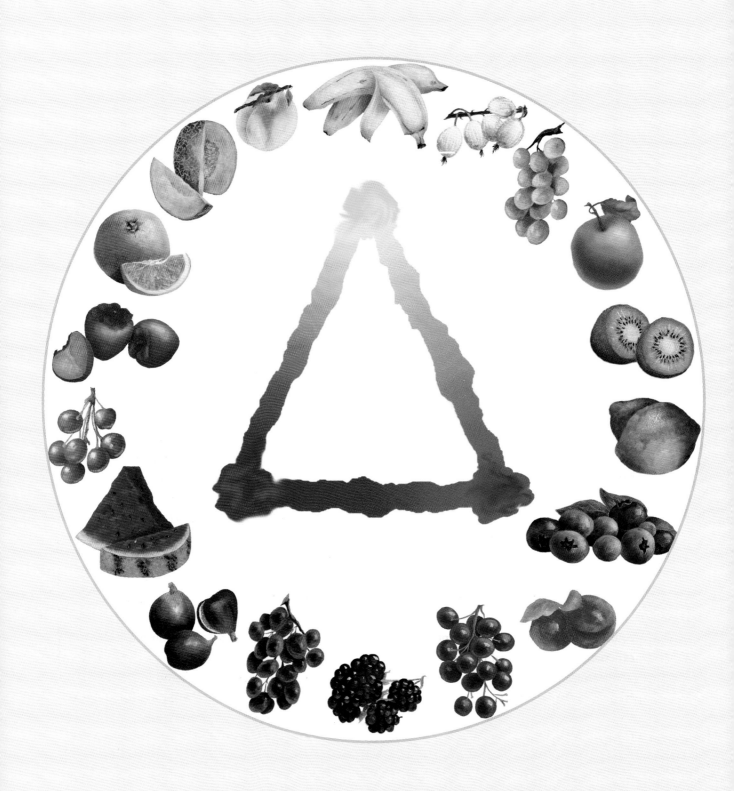

Understanding and Mixing Colors

"A painter is a combination of chemist and magician."

RALPH FARBI

If you want to drive a car, you need a car, keys, and some gas. While you don't have to know what makes the wipers work or the engine combust, you do need driving practice and some basic knowledge (how to apply the breaks, turn on the wipers; when to yield, to stop, to signal). Granted, you could get into a car, turn it on, and take off without ever having learned the basics in the driver's manual. But that could spell disaster, or, at the very least, create a real mess of things.

Painting is a bit like driving a car. If you yearn to be an artist, you need paints, brushes, and a surface to paint on. You don't have to know how the paints and brushes were manufactured, but you do need a basic understanding of how the colors operate in conjunction with one another. And you need practice mixing the colors and using brushes effectively. You could, of course, paint without this basic understanding, but you might end up with a disappointing experience, or even a real mess.

So, consider yourself in the driver's seat. This chapter is your driver's manual, and it contains the keys you need to make all your painting experiences colorful and exciting. In your eagerness to set off on your painting journey, don't skip this part! You won't get far without the keys.

Once we understand how the colors of the fruits relate to—and react with—one another around the color wheel, it's easy to mix them and come up with yummy results.

The Color Wheel

The color wheel is a wonderful and convenient way to study colors; to see how they are related to one another; and to see how they can be mixed from—and with—one another. Seeing the colors arranged around a wheel also makes it easier to imagine, to study, and to create color schemes, as we'll see in the next chapter.

How the Color Wheel Works

For now, let's take a look at how a color wheel is created. The artists' (or pigment) color wheel is based on three primary colors—red, blue, and yellow—which are the basis for creating all other colors. We cannot create our three pure primary colors by mixing together any of our other pigments; we have to buy the primaries. But from those three purchased colors we can mix a wide range of hues. You can see eighteen of those hues on the intermediary color wheel on the following page. If we created gradual gradations between all of the colors on this wheel as well as on the tertiary color wheel, and then created nine additional values by adding black and white to every mixture on the wheel creating shades and tints; and then mixed nine more values of gray, to create tones, and added them to every color as well—wow! Can you imagine how many colors we could create just from our three primaries plus black and white? Hundreds! And what if we bought additional primary reds, blues, and yellows and mixed a color wheel with them, adding the blacks and whites; and then recombined the assorted primaries so we used different reds, yellows, and

blues together. We could mix, literally, millions of colors. It boggles the brain! The color wheels on pages 32 and 33 give a small idea of what happens when we interchange primary colors.

Paint Your Own Color Wheel

To mix colors for your first color wheel, try to use the clearest, purest red, yellow, and blue you can find. Otherwise, you may end up with some colors that are a little disappointing if they're not what you hope or expect to get. For example, there are reds that have a slight orangish cast. If you mix them with blue to make a violet, you will get a brownish violet. And it will be even more brown if the blue you use has a slightly greenish cast. In both cases, even though you are mixing only two paints (red and blue) you are actually mixing all three primary colors together because both the orangish red and the greenish blue already have yellow in them. While the mixture may not be exactly what you had hoped for, it will still be a lively color (a tertiary color, in fact, so called because it includes all three primary colors). It can be an excellent shading and toning color, with much more life to it than using a premixed brown or a black, which tends to deaden colors.

On a piece of sturdy paper (watercolor paper, poster board, Bristol board) draw a circle about 7 inches in diameter. Or photocopy the color wheel diagram on page 45, enlarging it as desired. Divide your circle evenly into twelve pie-shaped segments and write in numerals as on a clock face. Now you're ready to paint your color wheel as shown on the next page. Each time you mix two colors together for the color wheel, try to create a color that appears visually to be exactly halfway between the two colors used in the mixture. For example, in mixing red and blue to make violet, be sure the violet does not appear more red or more blue, but rather just pure violet. It may be hard to see what color you have since it will be very dark. Spread a little of the mixture thinly on your white palette paper to check it before adding it to your color wheel. If it's too reddish, add more blue, and vice versa. Remember: Adding a medium such as Canvas Gel to your paints will prolong their drying time.

Primary Colors

In painting, the three primary colors are always red, blue, and yellow. To create our color wheel, we'll use the following DecoArt Americana acrylic paints:

- Primary Red
- Primary Blue
- Light Yellow

Note that other disciplines work with different sets of primary colors. For example, printers use cyan, magenta, and yellow. Physicists, working with lights, use green, blue, and red as their primary colors, mixing these to create the remaining spectrum colors. The next time you attend a live performance, observe the use of the colored lights on stage. What happens when they mix? What color shadows do they cast? Color is truly exciting, and it's everywhere. Don't miss it!

Imagine the color wheel to be like the face of a clock. We'll use the three primary colors (at twelve, four, and eight o'clock) to mix colors to cover all the remaining numerals, and then some!

Hint
When creating intermediary colors, mix two variations (as I did on the next page): one having more of the primary color, the other having more of the secondary color. Put both mixtures in a single space on the odd clock numerals (for example, yellow-green at one o'clock, close to the yellow; green-yellow also at one o'clock, close to the green.) The first color in the compound name is predominant in the mixture.

The primary *colors cannot be mixed; they must be purchased. Place them on the twelve, four, and eight as shown.*

The primary colors are red, blue, and yellow.

The secondary *colors are created by mixing any two primary colors, and are placed between those two primaries (on the remaining even clock numerals).*

The secondary colors are orange (red + yellow), green (blue + yellow), and violet (red + blue).

The intermediary *colors lie in between the primary and adjacent secondary colors with which they are mixed.*

The intermediary colors are yellow-green (yellow + green), green-yellow (green + yellow), green-blue (green + blue), blue-green (blue + green), blue-violet (blue + violet), violet-blue (violet + blue), violet-red (violet + red), red-violet (red + violet), red-orange (red + orange), orange-red (orange + red), orange-yellow (orange + yellow), and yellow-orange (yellow + orange).

The tertiary *colors are created by mixing any two secondary colors; thus each tertiary color includes all three primary colors.*

Tertiary colors include, among others, citrine (orange + green, thus [red + yellow] + [blue + yellow]), russet (orange + violet, thus [red + yellow] + [red + blue]), and olive (green + orange, thus [yellow + blue] + [yellow + red]). We can also mix subtle variations.

Color Wheel Variations

Each primary color affects all the colors between it and the next primary color. For example, we find red in the mixtures on the three clock numerals both between red and yellow and between red and blue. Look what happens when we exchange our pure primary colors (red, yellow, and blue) with ones that are slightly different.

Note that I have not divided the intermediary colors into two portions on these wheels.

You can imagine how the colors on the odd clock numeral spaces would look if each half of the color had a little more of its neighboring color added to it.

After painting your pure primaries color wheel, make additional wheels substituting different reds, yellows, and blues. Jot notes on the colors you used. That way, if you don't have a color suggested for a particular lesson, you'll have a record of how to mix something close.

Color wheel created from three pure primary colors for comparison.

Here I replaced the primary blue with a blue having a slight greenish cast. The red and yellow remain the same. Observe how the different blue affects all the colors from one o'clock through seven o'clock.

In this color wheel I substituted a soft, muted yellow for the original bright yellow. The red and blue remain the same. Notice how the yellow has affected the three colors on either side of it. Half of our color wheel now is pastel, and the other half contains intense, deep colors. We may want to add a touch of white or creamy yellow to the lower half of the wheel to both tint and lower the intensity of the remaining colors.

Here I kept the original blue and yellow and changed the red. Now we have lovely muted reds, oranges, and violets. If we add to the blue and yellow—and their mixtures—a little of their complementary colors (more about them, soon), the entire color wheel would be made up of low intensity, but lovely, colors.

I replaced all three primary colors in this color wheel. Look at the violet mixtures at five, six, and seven o'clock. They are very grayed. And little wonder: Both the red and the blue contain a good bit of yellow. Thus, when mixing the red and blue to get violet, we've also included the third primary color, yellow; and three primaries mixed together result in a dull, low intensity tertiary color. But doesn't the entire color palette look interesting?

This figure shows another lovely, muted palette. All three of these primary colors are different from our original three. These three primaries give us deep, rich mixtures.

Complementary Colors

Now let's see what exciting things happen in the world of color when we take some of our mixed colors and mix *them* together. Colors that are located directly opposite each other on the color wheel are called "complementary colors." Look at your color wheel, or the one on page 32 (use the one made up of pure primary colors). What color is directly across from yellow? from blue? from red-orange? If you answered violet, orange, and green-blue, respectively, you get a smiley face. It's good to learn, early on, what the complement is of every color. That knowledge enables us to mix beautifully subdued colors, to place certain colors adjacent to others in our painting for strong impact, and to create engaging color schemes.

Finding Complements

A pair of complementary colors consists of all three primary colors: red, blue, yellow. Choose one of the three primaries (for example, red). To determine its complement, mentally mix the remaining two primaries together (blue + yellow = green).

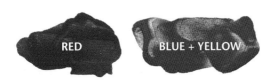

Therefore, the complement of red is blue + yellow and vice versa.

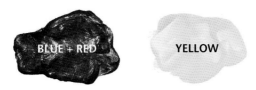

Likewise, the complement of blue + red is yellow and vice versa.

Now you try it:
- What is the complement of blue?
- What is the complement of red-violet? OK, so this is a little harder. It still involves the three primaries. Red-violet is a mixture of mostly red and a little blue. Mix the remaining blue with the third primary, yellow.

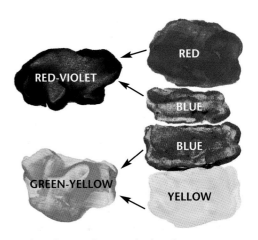

Finding the complement of red-violet.

Thus, we have, again, used all three primary colors, and found that the complement of red-violet is green-yellow (and of course, vice versa).
- What is the complement of orange-red? Check your answer by looking at the color wheel to find the color diametrically opposite the orange-red. Hint: If you've memorized the complementary colors of the three primaries, which thus means you also know the complements of the secondary colors, you can easily solve the question, "What are the complementary colors for the intermediary colors?" Take red-orange, for example. The complement of red is green. The complement of orange is blue. Therefore, the complement of red-orange is green-blue. Easy, right?
- What is the complement of blue-violet? (No fair peeking at the color wheel this time.) Think it through. It will soon become second nature.

Remembering Complements

Until you have memorized the locations of colors around the color wheel, or the pairs of complementary colors, here are some memory aids and interesting facts to help you.
- An aid to memorizing the complementary colors—Think of the holidays:
Christmas—red and green
Easter—violet and yellow
Halloween—orange (pumpkin) and blue (sky)

- The complement of a primary color is always a secondary color, and vice versa. Don't just take my word for it. Look at the color wheel and check it out.
- The complement of a cool color is always a warm color, and vice versa. We'll explore temperature shortly. Just remember to come back to this statement and check it out on your color wheel, as well.
- The complement of a color can be found in its *afterimage*. If all else fails, stare at the color you need to know the complement of until your eyes start to fatigue. (Allow about 20 seconds or so. You'll see a slight, white halo appear around the color and your eyes may feel like they're crossing or looking right through the color.) Then shift your gaze to a white piece of paper or wall. After several seconds, you will see a faint afterimage in the complementary color. It takes some folks a while to learn to see the afterimage, so if you're not successful right away, don't give up. It's fun to do, and you can practice it anywhere, even in a crowd or during a boring meeting. No one will ever know!

Complementary Colors Do Neat Things!

Placing complementary colors side by side intensifies them, each one enhancing the other. Mixing complementary colors together neutralizes them, creating low intensity, subdued, grayed colors.

You can use both of the above attributes together to make your paintings really pop. Say you plan to paint an orange pumpkin. Put it on a blue background to enhance the orange. If you mix a little orange into the blue to subdue the background, its dullness will make the pumpkin appear even brighter.

The conscious use of complementary colors plays such an important role in our paintings that we will visit them again when we explore attributes of color such as value, intensity, temperature later in this chapter; and when we discuss creating color schemes in the next chapter. If you don't quite get it yet, just review these pages once in a while. It *will* begin to make sense.

Notice how the violet and yellow swatches are intensified by their proximity to each other.

Cover up the colors on the right side of this page, then stare at the blue ball above. Next, quickly shift your gaze to the empty box below for a few seconds and wait for the afterimage to appear. What color is the ball? What color are the stripes?

Violet and yellow combined become gray.

Playing in the Mud

Just imagine all the different colors of mud there must be around the world. Wonderful colors. Yet, when we mix a color that disappoints us, we often call it "mud." Well, it's time we showed a little more appreciation for these beautifully subdued, low intensity colors. They have oodles of uses in our paintings. They can actually save a painting from becoming a hodgepodge of too many active colors trying to show off how pretty each is. They can unify a painting that looks like a jumble of unrelated things with not a thread to hold it all together. But we need to understand how those subdued colors happen, and how we can control them; making them happen when we want, and how we want them, and preventing them from happening when we don't want them.

If you've been reading carefully and thinking about what we've covered so far, you know that creating those low intensity colors involves mixing all three primary colors together. When one or two of the three primaries predominate in the mixture,

You can create an array of lovely neutrals from a seemingly dull pile of "mud."

Hint

If you're painting a composition you wish to appear warm, try mixing a little reddish-gray with all the hues you use in that painting. Use the bluish-grays to create a cooler impression. If there is something in the painting you really want to stand out, do not mix the gray into its colors. The contrast of intense colors against the slightly grayed colors will put that subject in the spotlight!

we call it a tertiary color, which is, indeed, what we get when we mix two complementary colors together. When all three primaries are in approximately equal visual amounts, it's hard to distinguish any particular color. (Alright, it looks like mud.)

We can learn tremendous color mixing lessons from working with a pile of muddy looking paint. So let's play in the mud.

1. Squeeze out a bit of all three primary colors and add some medium to prolong their drying time. Then, mix them together. Now, let's try to adjust the color of the pile of paint to make a rich, dark, neutral gray. But first, we need to see exactly what color we're starting with. Depending upon the intensity of your paints, you may have a very dark pile of paint there.

2. With your finger or a palette knife, drag a small amount of paint from the edge of the pile. Mix a little white into it. This will make it easier to see what color is predominant in the mixture.

3. Now add a little of that color's complementary color. If the color smear is a brownish red, mix a very small amount of green into the pile. Then test it again. If the smear looks more bluish, mix in blue's complementary color, orange. And so on. Keep working until you create a gray that appears perfectly neutral—not too red, not too blue, not too violet, orange, yellow, or green. Think about every addition you make to be sure you're adding the complementary color. And, add it sparingly, testing with white on a small smear after each addition. Don't just carelessly dump colors in the pile. You won't learn a thing but how to make that proverbial mud. Instead, make a conscious effort to understand what's happening, and to study each variation of gray you mix. You will see some gorgeous colors when you stretch them out with a little white. You might even want to save swatches of the mixtures to remind you later of the lovely grays you're capable of mixing. Don't just read about it, do it! It's the only way you'll learn.

The Four Properties of Color

There are four properties of color, which we need to understand in order to use color successfully in our paintings. They are:

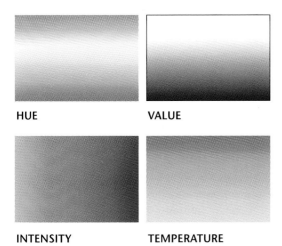

HUE

VALUE

INTENSITY

TEMPERATURE

Hue

Hue is simply another word for color. What hue is it? What color is it? We have already discussed the names of the spectral hues in our study of the color wheel. Those names, combined with the other properties we're about to explore, will help us to accurately describe any particular color.

Value

Value refers to the lightness or darkness of a hue—its relationship to white, black, and the grays in between. For example, pink is a light value hue; burgundy is a dark value hue. The American portrait painter and teacher Albert H. Munsell (1858–1918) determined there were nine distinct, equidistant steps of gray between black and white. The value scale he originated bears his name.

TINTS, SHADES, AND TONES

By adding white or black, we can raise or lower the value of any hue. The addition of white raises the value and creates a *tint*. The addition of black lowers the value and creates a *shade*. Adding a mixture of black plus white creates a grayed *tone*. A tone can also have nine values; more black in the gray mixture would make it a lower value; more white, a higher value.

EFFECTS OF SURROUNDING VALUES

Take a look at the value scale below, paying particular attention to the dots. At first glance, it appears that the dots grow lighter as they proceed down the scale. Wrong! After I finished painting the nine equidistant steps of gray, I took a bit of the middle value gray (No. 5) and painted a dot of that value on each step of the scale. This is a reminder that every hue and value we paint is affected by the hue and value we paint around it. If we paint something dark next to a light object, it will make the light object seem even lighter. Sometimes in painting, if we can't seem to get our lights light enough, we must switch our attention to the darks and push them darker. The contrast will make the lights appear lighter. This effect of contrasts also works with intensity and temperature, which we'll explore shortly.

HIGH VALUES		
LIGHT VALUES	WHITE	
	9	
	8	
	7	
MEDIUM VALUES	6	
	5	
	4	
DARK VALUES	3	
	2	
	1	
	BLACK	
LOW VALUES		

The Munsell value scale specifies nine equal and equidistant steps of gray between pure black and pure white. Pure black is placed at the bottom of the Munsell value scale, and is designated as 0. Each addition of white or light color to that pure black would raise its value upward on the scale. Munsell determined that mixing black and white together would produce nine different shades of gray, each the same interval apart from their neighbors. The numbers simply indicate the position on the scale: The higher the number, the lighter the value.

VALUE AND THE COLOR WHEEL

Refer to the basic color wheel on page 32 and compare the positions of the pure hues as they progress down the wheel. Notice that the lightest hue, yellow, is at the top of the wheel, and would be near the top of the value scale. The medium value hues—oranges and greens—are midway down the wheel and the scale, followed by the somewhat darker hues, red and blue. Finally, the violets or purples, our dark value hues, are at the bottom of the wheel and also the value scale. Make a black and white photocopy of your color wheel and check this out.

ADJUSTING VALUES

Thankfully, the hues don't have to remain in the positions (just described) on the value scale. We can adjust any of the hues and move them up or down the value scale by adding a little of a hue that is above or below it on the color wheel. We can move the hues even higher, to the top of the value scale, by mixing them with plenty of white. Likewise, we can move hues further down the value scale by adding black. We just must realize that the hue may shift. For example, black added to yellow will turn it a greenish hue. To keep yellow in the yellow family, we would need to lower its value with brown, or with its complement, violet. Likewise adding white to hues can sometimes make them look chalky. For instance, adding white to red results in a sugary pink. If you want a light red, instead of "cotton candy pink," add a bit of yellow with the white to lighten the red.

THE KEY TO A PAINTING

Key is a word that describes a collection of related values. Just as a piece of music is said to be in a minor or a major key, or in the key of C or F—in other words comprised of a collection of related notes or tones—a painting is also described as being in a certain key. A *full key* painting uses all nine values on the scale plus black and white. A *high key* painting uses just the values on the upper part of the scale plus white. A *low key* painting uses just the values on the lower part of the scale plus black. A *middle key* painting uses just the values in the middle of the scale.

When we look at a painting, our first perception is its lightness or darkness. From that initial, brief glimpse—even before noting the subject matter—we may develop an impression or have an emotional reaction to the painting. Think of a favorite painting. Determine its overall lightness or darkness. Now imagine it painted in different values. A high key painting (that originally appeared cheerful, bright, and positive) becomes ponderous, heavy, mysterious, maybe oppressive when shifted to the lower, darker values.

Now imagine the most depressed scene you can. You would probably paint that scene in predominately dark hues, and grays and blacks. Slide that same mental picture up the value scale and the immediate reaction (until the subject matter was recognized) would not be one of gloom. Noting the light values of the hues, the viewer would expect a more lighthearted theme. Once the response to the lightness or darkness of the painting has registered, then the viewer must reconcile it with the emotional response to the painting's content. We have power over how the viewer responds to our paintings, but we have to know how use that power to accomplish our purposes in creating the painting.

 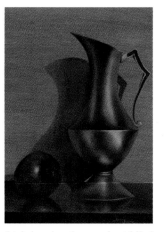 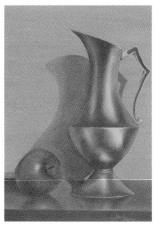

The same painting in four different keys. From left to right: full key, high key, low key, and middle key.

Value Study Exercises

Increasing your awareness of the values around you will make you a more sensitive and successful painter.

AN EXERCISE FOR A BORING MEETING

Study the value changes in the walls, particularly at the corners and ceiling, in drapery, in clothing, in carpets, under furniture. Keep your eyes open wherever you are. You're surrounded by great opportunities to study the effects of light and color.

PAINT A VALUE SCALE IN BLACK AND WHITE

Try it. Mixing black and white to create nine distinct, equal steps is a most beneficial exercise, and an invaluable learning experience. It will help you learn to see minute differences, and to make needed adjustments in your paintings. Strive to make each mixture distinctly different from its neighbors. Such precise mixing will be a great benefit to you in working with all colors. It's not as easy as it looks.

To make a value scale, number a strip of squares from 0 to 10. Paint square No. 0 black; paint square No. 10 white. Then choose either of the mixing methods below to mix the grays. Or, you may want to use a combination of both methods. In any case, mix a medium into your paints to prolong the drying time.

- For square No. 9, mix a tiny amount of black into a pile of white. Paint the square. With the remaining pile of gray paint, add a little bit more black, making it slightly darker than previously. Paint square No. 8. Continue adding more and more black and paint the remaining squares in sequence. Square No. 1 should be almost black; but you should still be able to see a distinct step between it and pure black.
- Mix black and white together to create a gray that is one-half as light as white and one-half as dark as black. Place a sample of this mixture at square No. 5. It is the medium value. Divide the remaining pile of medium value gray in half—one part to mix increasingly lighter, and one part to mix increasingly darker. Now, gradually add white to the medium value as you mix the values going up the scale toward white. Then, gradually add black to the other half of the pile of paint to fill in the values going down the scale.

TEST YOUR ACCURACY

When you finish painting your scale, look at it through squinted eyes to evaluate your accuracy. Chances are you will need to remix and readjust values in some places. If two sections are almost identical in lightness or darkness, then they are not distinct and equidistant in value. One of them needs more black or more white. Correcting it may mean, then, that its neighbor, too, will have to be changed. Don't despair. This is where the real learning comes in. Rework the scale until each section is distinct, and the steps up and down the scale appear to progress evenly—no big jumps from one value to another.

Once your value scale appears accurate, dip the handle end of a paintbrush into value mix No. 5 and press a dot of that value in each square.

PAINT A VALUE SCALE IN COLOR

After painting a white through black value scale, try painting one using a color. Choose any color and hold a smear of it up against your black and white scale or the one in the book. Determine what the value of the hue is. This is easier to do if you squint your eyes when trying to make the comparison. Place the hue in its correct location on the value scale. Then mix increasingly more white to your hue to create tints going up the scale ending in white; add more black to create shades going down the scale, ending in black.

MAKE A VALUE VIEWER

Once your gray value scale is dry, use a paper punch and punch a hole in each section. Look at something in the room (or out the window) and guess what value its color is. Then check to see how closely you guessed by holding the scale at arm's length, and with one eye closed, look through the holes. Match the object's value with the identical value on your scale.

A VALUE-ABLE EXERCISE

OK, the pun was intended. But this exercise will give you valuable experience in seeing and painting values. Set up a small still life and shine a light on it. Make a quick, simple sketch, noting highlights, shadows, and shading. Then with graphite pencils or black and white paint, fill in the sketch with values using the full range of the value scale—full key.

Next, do the sketch again using just the values in the upper part of the scale—high key. What appeared black in your first painting would now be expressed by value No. 6 or 7 as the darkest dark. Do the painting a third time, using the lower half of the scale—low key—and letting value No. 3 or No. 4 be your lightest value. If you're really ambitious, try it a fourth time using values from the center of the value scale—middle key—ranging from No. 6 or 7 to No. 3 or 4.

EXTRA CREDIT

If you completed the last exercise, your extra credit will come by doing the same exercise one more time, this time using colors. Your reward will be the confidence and skill with which you can now express the subtle value changes that your eyes are actually seeing, unhampered by what your brain tells you it "thinks" is there.

Intensity

Intensity refers to the brightness or dullness of a hue and is sometimes called its "chroma" or "saturation." Intense color is fully saturated, pure, strong, brilliant, and unaltered by the addition of other pigments. Used thoughtfully, a very intense hue surrounded by hues of lesser intensity can be riveting. Beware, though, that the use of too many fully saturated hues in a painting can be disconcerting, and can weaken a painting.

LOWERING INTENSITY

Mixing complementary colors together neutralizes the colors or lowers their intensity. An easy and effective way of lowering the intensity of color is to mix it with a little of its complementary color (the color opposite it on the color wheel). In the yellow apple on page 85, you can see how the intensity of the yellow was lowered by mixing in violet for its shadow areas. Remember that a pair of complementary colors, between them, contains all three primary hues. And when all three primaries are mixed together (in equal amounts) we get a neutral color.

INCREASING INTENSITY

Placing complementary colors side by side intensifies their colors. Placing a fully saturated color beside—or surrounded by—its complementary color, which has been lowered in intensity, makes the saturated color appear even brighter. So if you've painted a red apple and you want it to nearly "pop" out of the painting, surround it with a green of lowered intensity.

Understanding how great a role intensity can play in our painting helps us use it effectively both to accentuate the focal point and to lead the viewer's gaze.

The same bright red has been placed on three different colored backgrounds. Notice how those surrounding colors affect the red. The bright green (top) competes with the red for attention. The green's intensity almost makes the red appear dull. The low intensity green (middle) makes the red appear intense. That bright red all but disappears, however, when placed on its neighboring color, orange (bottom).

Mixing a color with its complement lowers its intensity. On either end of the neutral color in this mixture, we can see the gradually lowered intensities of the red and the green. Use your hands to cover all but a small section of the strip as you study it.

HIGH INTENSITY

LOW INTENSITY

NEUTRAL

LOW INTENSITY

HIGH INTENSITY

Temperature

Temperature refers to the suggestive effect of warmness or coolness of a hue. Warm colors (red-violets, reds, oranges, yellows with a slight orange cast) seem to advance, or come forward. They are energetic, agitated, passionate, athletic, reminiscent of fire, sun, and heat. Cool colors (blue-violets, blues, greens, and yellows with a slight green cast) seem to recede, or move away. They are quiet, pastoral, restful, reminiscent of sky, water, distance, and open space. If you were commissioned to do a painting for a cocktail lounge, would you use warm or cool colors? How about for a hospital, a police station, a sunroom, a lodge? Understanding colors' advancing and receding effects further enhances our ability to manipulate colors to suit our purpose in a painting.

RELATING TO THE COLOR WHEEL

Look at the color wheel. If you draw a line through the diameter of the circle, slicing into the yellow and the violet, the hues to the left of the line are warm colors; those to the right of the line are cool colors. The yellow and violet are just about neutral in temperature; but they can be easily shifted from warm to cool by the slight addition of an intermediary hue to either side of them.

Now, notice what happens when we select the complement of a color: The complement of a warm color is a cool color; and, conversely, the complement of a cool color is a warm one. You will notice that in each pair of complementary colors there is a warm and a cool color. Check it out on the color wheel. Now, Look at the poinsettia on page 289. It almost jumps off the page because the red of the poinsettia is a warm, advancing color, and the green background, its complementary color, is a cool, receding color. In addition, the background green is lowered in intensity making it retreat further; and, the poinsettia has quite a bit of detail assuring it will grab attention.

PAINT A MENTAL PICTURE

Suppose you wanted to paint a brass vase full of yellow tulips. How would you work with temperature (as well as, of course, with intensity, value, and hue)? Consider how you might treat the background to show off the tulips. What hue and what kind of texture would you choose? Would you make the background warm or cool? With what? Would you warm the yellow of the tulips? How? The brass vase, if you let it reflect all the wonderful hues surrounding it, could steal the show from the tulips. How could you make the tulips more eye-catching? Lots to think about!

Hopefully by now you can think in artistic terms, which should give you a bit of confidence. Don't worry if you don't master it all right away. Just keep reviewing the material and trying to sort out the possibilities every time you paint. Make a point of trying to describe hues, when thinking or speaking of them, in terms of their value, intensity, and temperature, rather than in the clever names manufacturers give them—like "purple passion fantasy," and "desert grass green." To tell a friend we painted a room "toasted persimmon" would leave the friend wondering: What hue does a persimmon turn when it's toasted? Is the room now a bright orange, a deep, dark orange, a brown? But if we say the hue is a medium, dull, warm orange, we are more accurately describing the value, intensity, temperature and, thus, the hue.

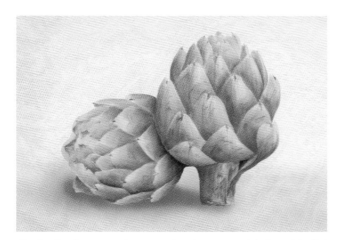 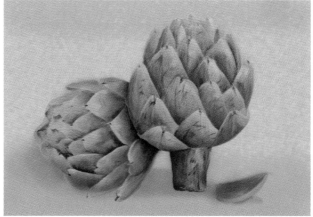

Look what happens when we paint the same artichokes with slight shifts in temperature: warm (left) and cool (right).

Color Schemes:
How to See Them and How to Create Them

*"Children, like animals, use all their senses to discover the world.
Then artists come along and discover it the same way all over again."*

EUDORA WELTY

Once we understand how to mix the colors we need, the next step is to learn how to combine those colors into a color scheme or color harmony—a pleasing group of colors. And whom do we have to please? That's easy: just ourselves! If we're not happy working with a particular palette of colors, that dissatisfaction is going to show in our work. The task of selecting a color scheme, though, can often be intimidating. So in this chapter we'll try to alleviate some of the anxiety associated with choosing colors that work well together. We'll explore traditional color schemes and experiment with a number of color scheme exercises. And best of all, we'll discover ways of seeing and recognizing color schemes all around us.

Our choice of color scheme for a painting helps establish a mood and supports the statement we're trying to make. If we're painting something joyful and exciting, we don't want to use a monochromatic scheme (just a single color), in low values (dark), and low intensities (dull). It would defeat our purpose. We should choose instead clear, bright, vibrant colors with lively interaction among them. The color scheme helps pull together all aspects of the painting.

Midnight Snack
12 × 16, acrylic on canvas

Yellow, red-violet, and blue-violet combine to create a split complementary color scheme. I wanted the yellow flame to warm the cool green of the table covering, the cold tin pan, and the pewter candlestick. I heated up all three by mixing in yellows and reds, leaving cool colors in the metals to echo the cool grapes.

Traditional Color Schemes

There are several traditional color schemes, each having color combinations that are either adjacent (neighboring colors on the color wheel) or contrasting (colors opposite one another on the color wheel). The most common color schemes are monochromatic, complementary, split complementary, analogous, and triadic. In addition to a combination of hues, a color scheme can also include tints, tones, shades, and altered intensities of those hues. Select one color from the scheme to dominate, either in value, intensity, detail, or area, or a combination thereof. Avoid using all the colors in the scheme at their full intensities unless you're aiming for a jarring effect, or trying to create a circus-like atmosphere.

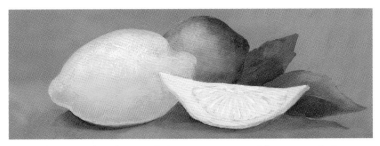

The analogous *color scheme includes any two to seven (if you count the intermediary mixtures each as two) adjacent colors on the color wheel. This sketch shows yellow, yellow-green, green-yellow, green, green-blue, blue-green, and blue.*

The monochromatic *color scheme includes variations on a single hue, in this case green.*

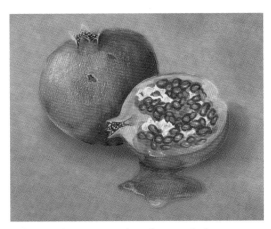

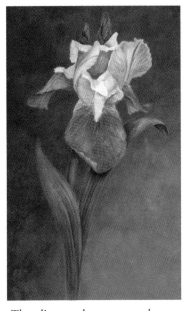

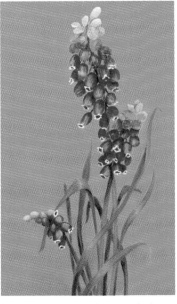

The complementary *color scheme includes two diametrically opposed colors (in this case red and green). Note that even though the green background in this sketch comprises a greater area than the pomegranate, it is of a lowered intensity, thus allowing the bright red of the pomegranate and its busy detail and value contrast to dominate.*

The split complementary *color scheme includes a key color and the two colors on either side of the key color's complement. The colors featured in here are yellow, red-violet, and blue-violet. In the iris, the most eye-catching color (because of intensity, temperature, and value contrasts) is the yellow, even though it's small in area. The green, though larger in area, blends in with the background and is thus less important.*

The triadic *color scheme includes three colors equidistant from one another—in this case, a subdued orange, violet in strongly contrasting values, and green (close in value to the orange).*

Color Scheme Disks

Here are some color scheme selector disks that will aid in your study and selection of color schemes, and help you understand the relationships among colors. This knowledge will add to your confidence and help you create, perhaps, totally new combinations of colors to suit your tastes and purposes. Just don't allow established color schemes to limit your color choices.

1. Photocopy this page and the following one. For sturdiest results, photocopy the disks onto card stock or heavy paper. You can make the disks larger if you wish.
2. Cut out the disks and remove the shaded areas.
3. Paint the color wheel by placing primary colors on the circles, secondary colors on the triangles, and intermediary colors on the odd numbered areas (see Chapter 2, "Understanding and Mixing Colors," for a more detailed explanation.)

4. Laminate both sides of each disk with clear laminate. This can be done at many print shops. Trim the laminate leaving a 1/4-inch border around the circumference of the circle. Do not cut the laminate out of the open areas of the disks.
5. Stack the disks, aligning them evenly. Poke a map tack through the center dot, puncturing all the layers.
6. Separate the stack and tape a piece of cardboard to the center back of your color wheel.
7. Choose a color scheme disk, insert a pin or tack through the center hole and into the center of the color wheel, and play "spin the color scheme disk" any time you want to create a color scheme. The colors that appear in the cut-out areas, along with their tints, tones, shades, and altered intensities, will comprise the type of color scheme named on the disk. Rotate each disk all the way around the color wheel to see all the possibilities.

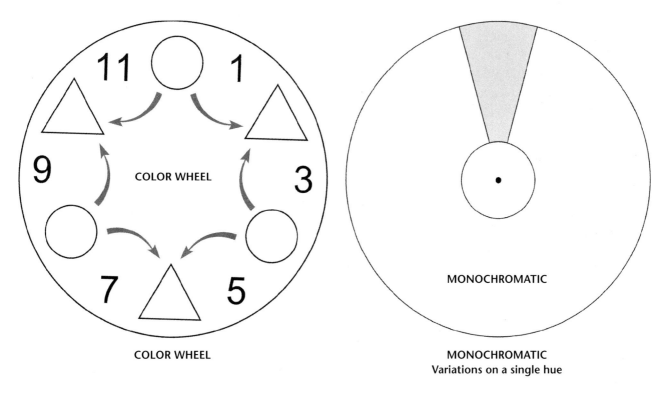

COLOR WHEEL

MONOCHROMATIC
Variations on a single hue

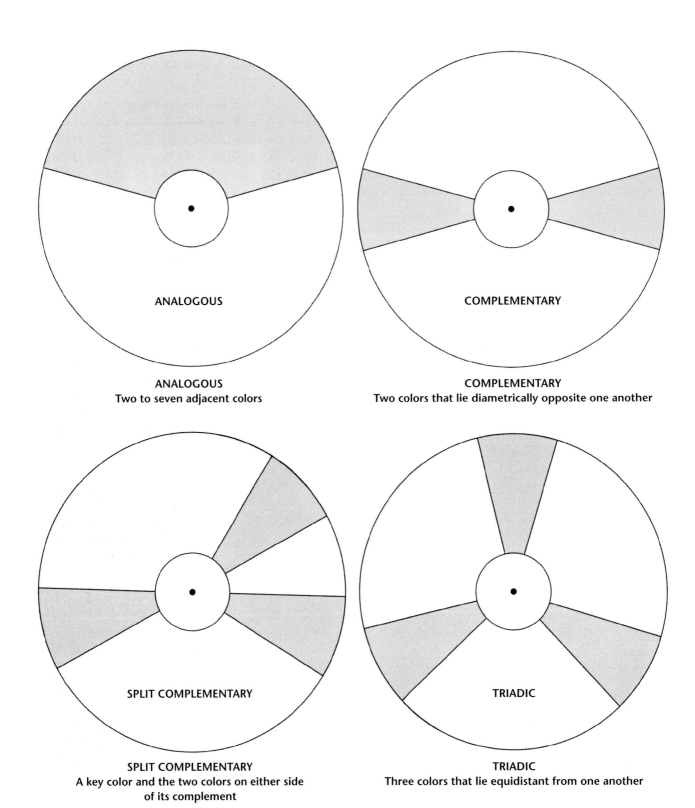

ANALOGOUS
Two to seven adjacent colors

COMPLEMENTARY
Two colors that lie diametrically opposite one another

SPLIT COMPLEMENTARY
A key color and the two colors on either side
of its complement

TRIADIC
Three colors that lie equidistant from one another

Seeing Color Harmonies Around Us

Color schemes are everywhere we look. Unfortunately, we often don't see the trees for the forest. (No, that's not a malapropism.) We miss the details right in front of our eyes because we're caught up in the bigger picture. In these next three pages, we'll take apart those "bigger pictures" and look for the details. We'll see that there are lovely color schemes in things from walls to rooftops, flowers to butterflies, skies to fields, threatening storms to delicate roses. We have only to look and really see!

When you're stuck for color scheme ideas, look through these pages. I have isolated many hues in each photograph. These can be used in creating color schemes for painting anything from the fruits, vegetables, and flowers in this book, to landscapes, portraits, even abstract paintings. Not every hue in a selection need be used. (Often, the fewer we use, the better.) In fact, if you study the photographs, you will find additional hues which, due to space constraints, were omitted. You may even decide that a slight shift in intensity or value in a hue would suit you better.

Imagine that you want to paint a bunch of bananas. Look through the photos in this section. You'll see several variations of yellow—from bright to creamy to low intensity to yellow-orange. Choose one of the yellows. Then imagine how you might use some of the other colors from the same photo to finish the painting. Try it again with hues from another photo.

Can you picture a rendering of the bananas using the blues, beiges, and browns of this stormy sky picture? Too dull? You might want to brighten the dull yellow hue slightly. Let the colors in these pages inspire you but not limit your imagination.

Things to Consider

Ask yourself the following questions before deciding on a color scheme for your painting.

- What value do you want to be dominant (light, medium, dark)?
- Do you want a dark value composition on a light background, or a light composition on a dark background?
- Do you want a strong or weak value contrast between the background and subject matter?
- What temperature do you want the dominant hue to be (warm or cool)?
- Do you want to use harmonious, similar hues or contrasting, complementary hues?
- What sort of intensity contrast do you want (weak, moderate, strong)?
- What mood do you want to create?

As long as our vision is clear, our brain is bombarded continuously with color harmonies. All we have to do is remember to see. Some people listen without hearing. We must be careful that we don't miss the beauty of color because we look without seeing.

SEEING COLOR HARMONIES AROUND US **49**

Thinking About Colors

What
Colors Fit
These
Attributes?

aggressive
airy
angry
busy
comfortable
confused
contemplative
cool
courageous
delicate
despairing
disturbing
energetic
envious
excited
fresh
gentle
happy
heavy
hopeful
immature
innocent
intriguing
melancholy
moody
negative
passionate
passive
peaceful
pompous
positive
pure
raging
resigned
retiring
rich
romantic
rustic
serene
somber
tranquil
vigorous
whimsical
wicked

Color choices can contribute to our paintings or detract from them. They guide the viewer to see what we want to be seen, or direct the viewer's eye elsewhere. They emphasize our subject matter, or call attention to themselves. They cause the viewer to linger longer, or send the viewer scurrying. They create a mood or a feeling, or just express, "Ho hum." And the scary thing is: The choice of colors and treatment is totally up to us. On the other hand, that's also the most exciting part of painting.

Using Color to Create a Mood

Colors have a profound effect on our emotions. Even if you have never painted, you already have some sense of color. See how easily you can conjure up colors to paint a circus scene, or a funeral. You get the idea. We readily associate some colors with certain circumstances, events, and emotions. Those color associations will, of course, be influenced not only by our individual and emotional preferences, but also by our cultural heritage. (For example, white is associated with mourning in China; in the United States, purity.)

Look at the list of moods, sensations, and attributes on the left. What hues, values, and intensities do they suggest to you? Use this list later when you hit a creative block or are unsure what mood you would like your painting to reflect.

If you need to jumpstart your imagination for this exercise, look through a book of paintings—preferably one that spans many painting eras. Look with squinted eyes so you're less likely to be influenced by the subject matter. What feeling does the general color, value, and intensity of each painting engender? And which of these color applications are you most drawn to? Some of us prefer colors in strong opposition to one another (such as the blue and yellow of the bananas on page 89). Others find the strong opposition of colors jarring, and prefer more muted or grayed colors, or colors that lie closer to one another on the color wheel, or colors in fresher, cleaner, lighter tones. What do you like? Do you always like the same thing, or are there times when you're more drawn to something totally opposite?

Color Scheme Exercises

Of course, the best way to learn about painting color harmonies is to work with paint; but we needn't be limited to that one recourse. Listed below are several activities that will joggle the color cells in your brain. You will need, in addition to your painting supplies, a stack of old magazines, photographs, postcards, a sheet of clear acetate, scissors, and a package of colored construction paper—preferably one that has a wide range of colors, values, and intensities. From the package of construction paper, select one sheet of each value and intensity for every color. Cut the sheets in half crossways. Keep one set of half-sheets to represent different background colors. Use the other set to cut into shapes in the second exercise.

CHOOSE A BACKGROUND COLOR

When you need help selecting a background color for a painting, grab your paints and make color swatches—or a quick sketch—of your intended subject on the clear acetate. Hold the acetate against various colored papers. Pick the subject/background color combination that pleases you the most and that will support the effect you wish to accomplish. Keep in mind that you will probably need to adjust the hue, value, or intensity of that background color somewhat in the actual painting. Sometimes, a slight shift in value or intensity means the difference between a background color that supports your design and one that competes with it. Wipe the acetate clean to reuse.

GET OUT OF A RUT

If you seem to be stuck in a comfortable color rut, or are unsure how various colors might react together, get out the package of colored construction papers. Cut out a variety of shapes, both geometric and irregular. Let the kids or grandkids help and enjoy the quality time together. Whatever shapes they cut out will be usable.

On one of the background sheets, arrange a "composition" of the shapes and scraps. Nothing particular. Just shapes and colors. First try a single color of cutouts on one background color, then try the same cutouts on another background color. Which combination do

you prefer? Why? Use your color scheme disks to help you create color schemes.

Next, work with cutouts in two or three different colors/intensities/values. Vary the proportions of the color shapes you use to create interest. Avoid making a static composition with equal amounts of colors. Instead, choose one color to be dominant and use more of it than the other. To see how this can make a difference, create two similar compositions on the same color backgrounds. In one, have more of one color than the other. On the second background, try to have equal amounts of each color. The former should be quite exciting, whereas the latter will probably appear rather boring.

COLLECT COLORS

Start a collection of travel and art postcards and photographs. Collect not only pictures with color schemes that please you but also ones that would cause you to broaden your taste for other color harmonies. Sometime when you want to dabble in your paints but don't really feel like painting anything, try mixing paints to match the colors you see in your postcards (as I did in the photographs earlier in this chapter). On index cards, record swatches of the mixtures and list the paints used to mix them. Use one card for each color scheme. You'll be surprised at how inspiring it can be to have a ready supply of color schemes.

START A NOTEBOOK

Keep a looseleaf notebook in which you paste snips from magazines, ads, wallpapers, printed fabrics, wrapping papers, and so on. Or attach them to large poster boards. Try to analyze each entry to see what it is about that particular combination of colors that tickles your fancy. What makes it work or not work for you? Which color is dominant? How are values and intensities used to support the dominant color? Imagine what sort of painting you might create with each of the color schemes. How would you use those particular colors to create a particular effect? The more you analyze your reaction to the colors you see used together, the more at ease you'll become in creating your own color harmonies.

TAKE NOTE

Buy a set of colored pencils and a small sketchbook. Carry them with you on trips across country, around the world, or just to the garden, local nursery, or museum. Make notes of interesting color combinations.

For more sophisticated note taking, buy a Pantone Color Matching System, or any similar brand. It is composed of color samples, much like a stack of house paint sample cards. Each color is assigned a number. It's easy to match colors you see to the cards and record their numbers in your sketchbook. Back in the studio, you can use paints or colored pencils to recreate the colors recorded. Some color matching systems have tear-off sections, which can be pasted in the sketchbook.

While I was writing notes for this chapter, my husband and I were driving from Maryland to California. The changing landscapes were a kaleidoscope of colors: rocks whose colors and forms changed with the shifting sun; layer after layer of mountain ridges in ever lighter values as they receded in the distance; lush colors of orchards and vineyards; thirsty, washed-out— yet colorful—grasses of the plains and shrubs of the desert; dawn to dusk color changes in the sky; and of course, all the other "stuff" that both enhances or spoils the vistas—fields of wildflowers, streams and lakes, snow, buildings, piles of dirt and broken concrete, rusting farm equipment, cattle . . . Even if a large sign or dilapidated truck spoiled the view, I still noted the colors and effects. I soaked it all up and tried to record my impressions. Sometimes happenstance will ignite a creative spark. We need to be ready, always, to fan the flame.

Stepping Lively Among the Colors

I have covered a dozen 22- by 28-inch sheets of poster board with travel scenes and product ads from magazines. One board contains all low-intensity, early-Americana type colors; one board has bright, clear, pastels; one has predominately softly muted greens and blues; another has vivid primaries; another has all sorts of complementary blue/yellow harmonies; and so on.

When I'm in a creative rut and need a color jolt, I spread the boards all over the floor of my studio and walk among and around them as needed—sometimes a few minutes, sometimes a few days—until the lethargic pigments, which had settled in my veins, begin coursing excitedly through my brain.

Inspired by all the color harmonies, I can hardly wait to get painting again. Although I keep adding to the collection, it's always pleasant and comforting to see some of the old favorites each time I lay the boards out. Try it. I think you'll like it.

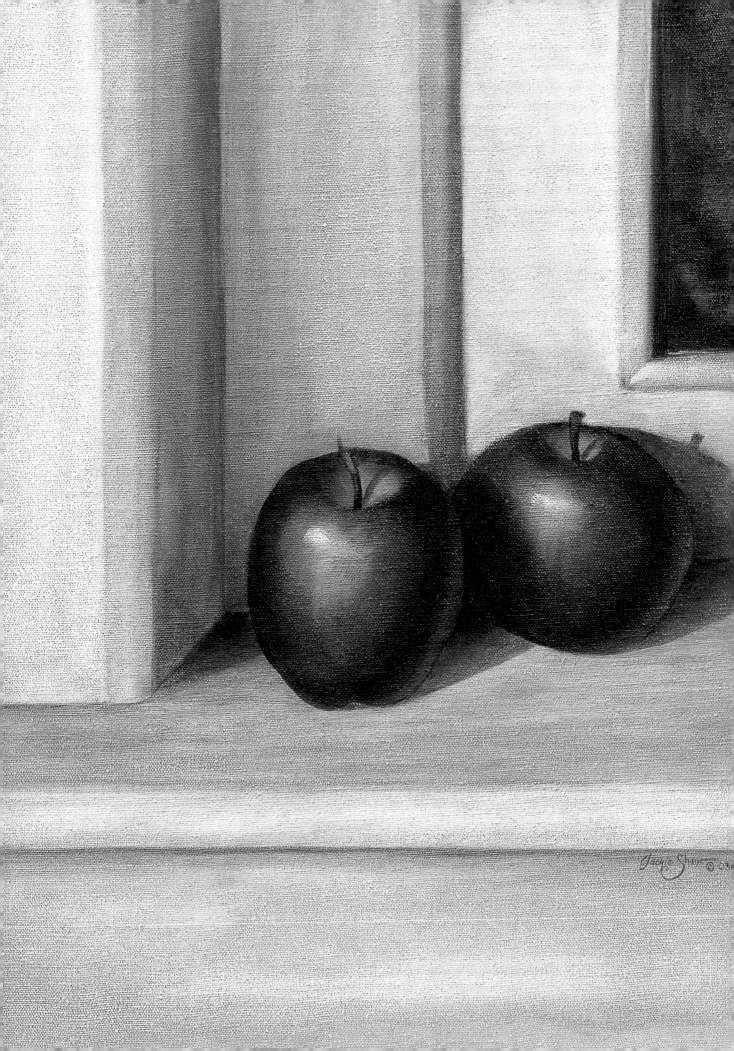

Shadows, Highlights, and Reflected Lights

"Never fear shadows. They simply mean there's a light shining nearby."

RUTH E. RENKEL

In this chapter, you will learn to see color in the dark, and no color in the light. Sound absurd? It's really not as contradictory as it seems. There are wonderful colors lurking in the shadows. As for no color in the light—a strong light shining on an object practically washes out all of the color where it strikes most directly. It's all a matter of perception.

As artists we have the power to alter perceptions. We can draw a circle, fill it with orange paint, and create a flat, orange circle. Or, with a little sleight of brush, we can create a round navel orange. The difference between the two lies in the numbers. To paint a flat circle, we need only one value of a single color. To paint an orange, we need at least three to five values: the main, or local, color and additional darker and lighter values for shadows, highlights, half-tones, reflected lights, and cast shadows. By using several values of a color (or colors) we can model that flat orange circle as if we were modeling a flat slab of clay.

With a lead-in like that, you should expect some exercises to follow. Skip them and you'll miss out on a good opportunity to increase your understanding of lights and shadows. Try them and you'll find yourself looking at everyday things with more observant eyes.

Apples on the Window Sill
16 × 20 inches, oil on canvas

This monochromatic study in browns explores the values found in a simple still life by reducing to a single color the woodwork and the green and red apples. Try such a study on your own after reading this chapter. Once you learn to see and paint the different values, adding color will be much easier.

Light and Shadow Experiments

The mystery of light and shadow, and how they react with one another is a fascinating case, with clues scattered all around us. With just a few tools, we can solve the puzzle; and doing so will have a great impact on the effectiveness of our painting. To learn from this chapter, you're going to have to do some experiments. We learn best by doing. Oh dear, here comes the kindergarten/first grade teacher in me.

You will need:
- Craft clay or PlayDoh (clay should be a solid color)
- A light source (flashlight, desk lamp, table lamp, sunlight through a window)
- Toothpick, match, or small twig
- Colored papers
- An orange and/or assorted objects and fruits
- Your value scale (you did make one in Chapter 2, didn't you?)

Local Color, Shadows, and Highlights

Let's imagine, for a moment, that our clay is a new chunk of orange craft clay. We know that the piece of clay is the same color throughout—no variations, no light tints, no dark shades. The clay's color is called its *local color*. The following exercises will help you to see and understand local color as well as *highlight* (the area facing the light), *shadow* (the area facing away from the light, and *half-tones* (those subtle shifts in value between the highlight and shadow areas).

1. Roll the clay into a smooth, round ball, call it an "orange," place it on a piece of paper, and shine a light on the upper right side. What happens to the local color where the light strikes? We know the entire "orange" is the same color throughout because we formed it ourselves from a single color clay. And yet, if we look carefully and compare, we can see that the ball is no longer that single, local color. The local color appears slightly washed out where the light hits it, and much darker where the light is absent. Look at the half-tone area—the area on which the light glances past at an angle rather than striking directly. Use your value

scale, looking through the punched holes, to see how many values you can identify on your "orange."

2. Now poke your finger in the top of the "orange" to make a depression. Set the "orange" back on the paper and beam the light across the top of it. What happens when the light shines across the depression? Which side of the depression is the highlight on? Which side is in shadow?

3. Next, push a piece of toothpick, match, or twig down in the depression as a stem. (Humor me. I know orange stems don't grow out of deep depressions like apple stems do, but there's something interesting I want you to see.) Move the light source about and note the "stem" shadow and how it changes. Where does it go? How does it flow over the "orange"?

4. Now, gather several solid-colored objects, any shapes. Shine a light on each one separately. Look for the light and dark values and compare them with the local color. Use your value scale to try to determine the values of the local colors, the shadows, and the highlights.

5. Repeat the previous experiment using objects that have several different colors on them; for example, canned goods, a vase with a painted design, a figurine. Notice how each color is affected and how the shape of the object influences the highlight and shadow areas.

6. Check the highlights against the pure white on your value scale. Are they a stark white? Try to determine whether the highlight colors are warm or cool.

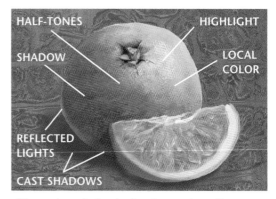

Observe how the local color changes depending on where the light hits the orange.

Cast Shadows

We can further add to the three-dimensional perception by painting a cast shadow. *Cast shadows* are shadows caused by an object blocking the flow of light. Let's return to the clay "orange," and this time study the cast shadow.

1. Once again, shine the light on your "orange." Notice the position and shape of the cast shadow. Move the light source around, raising it higher and lowering it. Place it directly above the "orange." What happens to the shape of the shadow with each move?

2. Try the first experiment again, this time using a collection of other objects of various shapes. (The same ones you used earlier will do.) By paying attention to ordinary things in everyday life, we become more aware of cast shadows and how they're affected by the objects they fall across.

3. Rotate the paper on which your arrangement sits and observe the changes in the shapes of the shadows.

4. Set up your arrangement on a piece of white paper near a south facing window and check it periodically. Watch what happens to the shadows as the sun rises higher in the sky, or sinks, or fades.

5. Periodically throughout the day, study the cast shadow of a tree or telephone pole. Watch the way the shadow's position changes as the sun changes its position. Notice the shape of the shadow as it slips down into a ditch or rut and climbs back up again. See how the shadow helps define the shape of a rock or a shrub as it stretches across it. The length and width of the cast shadow also help us know the position of the light source. Look at how long the shadow is when the light strikes from a low position; and how short and squat it is when the light is directly above it.

6. Now let's look for even finer details. Select a few of your objects, and under the light, study the edges of the shadows. Move the light source closer and then farther away. When is the shadow's edge sharp? When is it more fuzzy? When is the shadow darkest? When is it faint?

7. Unless you're working in the dark with just a single light source, you will probably see other cast shadows, as well. See how many cast shadows you can find for a single object.

What happens when two of those shadows overlap? Each shadow cast by a single object represents a different light source. See if you can identify which light source caused each shadow you see.

8. The cast shadow is affected by the color of the surface on which it falls. Place your object on different colored backgrounds. What happens to the color of the cast shadow? To more easily compare, let the object's shadow fall partially across two or three different colored pieces of paper at the same time.

9. The cast shadow is also affected by the color of the light that casts the shadow. Place an object on a piece of white paper near a south facing window. Make careful note of the color of the cast shadow in the cool light of early morning. Check on it again later in the afternoon when the light is warmer in color.

10. If you have a colored lightbulb (or pieces of colored translucent film or glass you can hold in front of a regular lightbulb), see what happens to the color of the shadows when they are cast by a colored light. For example, if you shine a yellow light on an object, its cast shadow will appear bluish. Shine a red light on an object, its cast shadow will be greenish. (Have you ever noticed a cut of beef displayed under red light at the butcher's? The red light makes the beef look fresh and bright; and the contrasting green cast shadow (the complement of red) amplifies that impression. (If you're not sure why this works, you need to revisit "Complementary Colors" on page 34.)

11. The next time you attend a performance where colored spotlights are used, notice the colors of the shadows that are cast. Security and streetlights will also cast different colored shadows. As you walk from one lighted area to another at night, watch the color of your shadow. In fact, try to become aware of the colors in every shadow you see.

12. Sometimes an intense light will cast a shadow the same color as the object, especially that part of the cast shadow that is closest to the object casting it. Try this: Outside, in bright sunlight, place an orange, a red apple, and a lemon on a sheet of white paper. Arrange them so

you can see each cast shadow separately. If your eyes aren't trained to notice subtle color variations, you may, at first, simply see a dark gray cast shadow. Look again. There are wonderful colors hiding in those shadows.

13. Using the same set up from the previous experiment, hold up something to reflect light back onto the cast shadows. Try a manilla folder, a blue bookcover, a red shirt . . . What happens to the shadows cast by your fruit? Experiment with several different colored items as reflectors.

14. Now, place all the fruit on a piece of colored paper. Place the lemon slightly behind the apple. Shine a light on the apple, letting the shadow from the apple climb up onto the lemon. Notice how the shadow of the apple changes shape to wrap itself onto the contours of the lemon. And what color is the shadow cast onto the lemon?

15. Place the apple so its cast shadow falls simultaneously on the lemon and the orange and onto the background. What happens to the shadow colors?

16. Without moving the fruit from the previous experiment's setup, look at the side of the lemon facing the apple. What color do you see reflected on the lemon? Ah hah! A yellow lemon isn't just yellow. Its color is affected by the color it's sitting on and by other reflected lights. So what are reflected lights, anyway?

Reflected Lights

Reflected lights are lights that are reflected off of nearby surfaces onto an object. The smoother, glossier, and shinier the nearby surfaces are the more likely they are to reflect light onto neighboring objects; a matte, dull surface would absorb much of the light. The reflected light is subtle—neither as strong nor as large as the true highlight area. It will be located adjacent to the surface reflecting it.

1. Place an orange on a yellow surface (a piece of paper, a piece of cloth, a tray). Notice how the light that strikes the yellow surface bounces back up onto the orange's surface. That reflected light area will be a light yellow-orange, located near the edge of the orange, and close to the cast shadow. Try a red background and notice how the color of the reflected light changes. If you do not see the reflected light area, keep trying. Your brain is telling you, "The orange is orange, and that's that." Experiment with different colors and with both shiny and matte surfaces until you find a combination that finally helps you see the reflected light. Once you begin to actually see a reflected light, it will become easier to recognize them.

2. On your yellow background, place a red apple, and a lime, or some other object near your orange. Can you see their colors reflected onto the adjacent surface of the orange? So now your orange has not only

"Worry often gives a thing a big shadow"—Swedish proverb. What kind of light casts a hard, long shadow like this?

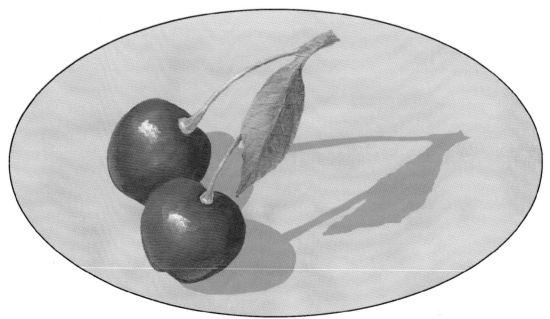

its local color, its washed out highlight color, its half tones, and its shadow colors, it has also colors of the surface on which it sits and colors of the objects surrounding it. That's one colorful orange! But one of the wonderful things about objects being more than just a single local color is that we can use all those other colors to unify the subjects in our paintings. Reflected lights and cast shadows help us build connecting paths of color between the various subjects, thus helping the eye travel through the painting.

3. Now try a few white eggs on different colored backgrounds. See if you can identify the reflected lights using just the available light in your kitchen.

4. Put several white eggs on a white napkin, in a white bowl, on a white tablecloth. Look for all the colors hidden in all that white. For extra credit, after you have worked through several painting lessons, try to paint the eggs. You'll learn invaluable lessons while trying to capture the different whites in all their colors. Have fun!

Some Things to Remember

The list below will remind you of some of the things you should have discovered through your light and shadow experiments. If you haven't worked through the experiments yet, don't peek!

- A gentle light casts a fuzzy shadow.
- A bright light casts a dark shadow.
- A far light casts a soft shadow.
- A close light casts a hard shadow.
- A far light casts an elongated shadow. (Sunlight low on the horizon makes our personal shadow long, lean, and lanky.)
- A near light casts a condensed shadow. (Sunlight directly overhead makes our personal shadow short, squat, and stout.)
- Shadows are darkest near the object casting them.
- Shadows fade the farther they are from the object casting them.
- Shadow colors are affected by: the object casting them; the surface color upon which they are cast; the objects surrounding them and reflecting light onto them.
- Some shadows may be cool; others, in the same arrangement, may be warm.

Hints
- Having trouble seeing the reflected colors? Walk around the arrangement to view it from different vantage points. Try removing and replacing objects while watching the adjacent surface to note subtle color changes. Try it under different lighting.
- To easily paint reflected lights and cast shadows, first slightly moisten the area to be painted with water or water plus Easy Float. Then sideload a flat brush (larger than you think you need) with color thinned with water and Easy Float. Stroke the brush on the palette (over and over in the same spot) to blend the paint partially across the brush. Apply the stroke to the painting, using the water edge of the brush, if necessary, to soften any unwanted hard edges. Resist the temptation to keep fiddling with it. If your application appears too weak, dry the paint completely, then repeat the process. It's much better to apply too little paint than too much. You can easily build up depth of color with repeated layers, but you cannot as easily remove too heavy an application.
- Keep a strong flashlight or high intensity desk lamp handy at your painting table to experiment with lighting variations when you're painting from actual subject matter.
- Learn how shadows and highlights react to various circumstances. Then take liberties (artistic license!) to achieve the effect you want.

- The shadow's shape is affected by: the object casting the shadow; the shape of the object on which it falls; the proximity of the light; the angle of the light.
- Where light strikes, local color is washed out.
- Where no light strikes, local color is darkened.
- Where light is obstructed, a shadow is cast.
- Multiple light sources cast multiple shadows.
- When light passes across a depression, the highlight hits the far side of the depression; the shadow falls into the side of the depression nearest the light.
- Where multiple cast shadows overlap, the shadow will be darkest.
- Sometimes cast shadows will be the complementary color of the light casting the shadow.
- Light reflected by nearby objects onto a subject will affect the subject's local color.
- Highlights are rarely pure white. They may be warm or cool. To make a highlight seem stronger, contrast its temperature with that of the subject's local color. (For example, put a slightly greenish highlight on a red apple or a yellowish highlight on a purple grape.)
- To make a highlight seem lighter, paint the subject's local color darker.

Studying Photographs

These snapshots of lights and shadows were taken with a digital camera, outside, on a sunny day. While they are not intended to replace the opportunity to "do it yourself," studying them will help you learn to see shadows, cast shadows, highlights, and reflected lights. They will also give you a small indication of the wealth of enlightening material you will find when you actually do the experiments. You will, however, learn much, much more by manipulating your own setups and lighting, and being able to view your arrangement from several directions. You may even decide to take some photographs yourself for future resource material, snapping pictures throughout the day to capture different lighting conditions.

Other Photographs to Study

The photo reference pages that follow each step-by-step lesson provide numerous opportunities to study the effects of lights and shadows.

- In the line-up of peppers on page 213, notice how the peppers reflect their colors onto their neighbors. Notice also the different colors in the cast shadows.
- On page 205, look at the two white onions on the red background. Notice how much of the background color is reflected back up onto these onions.
- You can readily see the reflected light of the white background in the tomatoes on pages 216 and 217. Look for the tomatoes photographed under harsh, bright light, resulting in hard dark shadows.

Notice the beautiful colors in these cast shadows: For the orange, look for orange, red, and violet; for the apple, look for deep violet and blue.

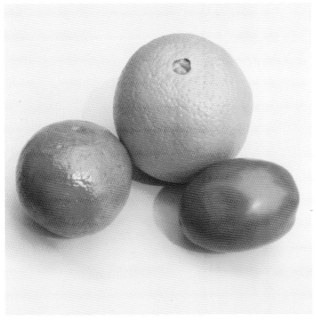

Study the bottom edges of these fruits. Notice how light their color is from the yellow background reflected back up onto them.

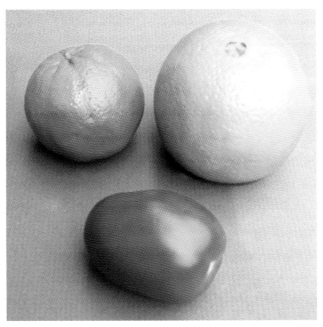

Compare how much darker the lower edges of the fruits are now on the blue background. Study the transition of colors on the orange, from washed out color in the highlight area, to yellow, to yellow-orange, to orange, to red-orange, to red, and to violet along the lower edge.

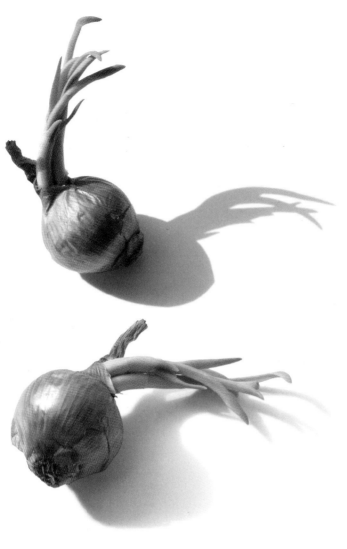

This picture was shot in bright sunlight, resulting in a dark, hard-edged shadow. Where was the sun?

This one was taken a few moments later under an approaching cloud. Notice how the density of the shadow changes.

A few more moments later, and a lot more cloud. This soft edged, lighter value shadow illustrates how much the cloud had filtered the sunlight. Softer light, softer shadow.

The closer an object is to the surface on which its shadow falls, the closer it will be to touching that portion of its shadow. Notice that the sprouted leaves that touch the surface also touch the shadow. (Look for the bit of green reflected in the shadow where they touch.) The leaves that are farther away from the surface are also farther away from their cast shadow.

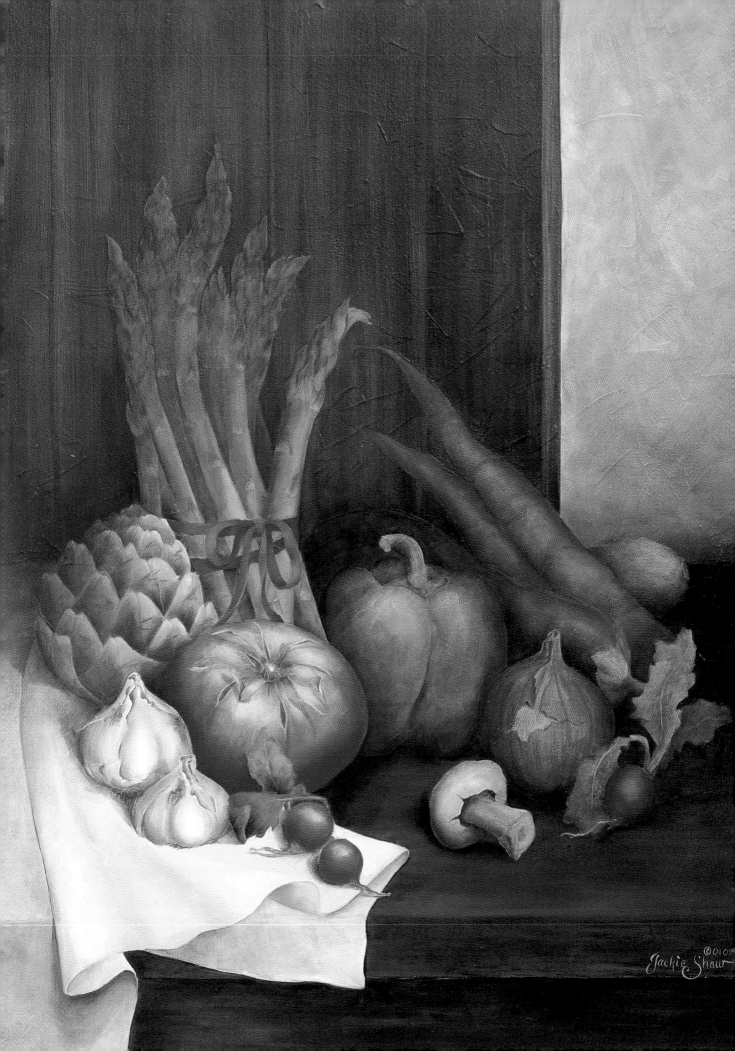

Chapter 5

Creating Your Own Compositions

"If you always do what you always did, you'll always get what you always got."

AUTHOR UNKNOWN

The thought of creating your own compositions can be intimidating, especially if you believe you have no creative abilities. But the longer you rely on someone else's patterns, the more dependent upon them you become. The unknown sage who penned the witticism above knew that it takes a bit of bravery to break out of comfortable routines, but sooner or later, your courage will be rewarded, and you'll get exciting and personally relevant results. Creating compositions, like any skill, can be learned by taking it one step at a time. And like any skill, it requires practice, patience, and the perseverance to endure and learn from one's mistakes.

Creating compositions requires making lots of little decisions, somewhat like ordering fast food: Do we want a hamburger or cheeseburger? Catsup or mustard? Onions? Lettuce? Tomato? Fries or onion rings? Large or small? Lots of little decisions! In ordering a burger, we consider a couple of choices, decide on one, then tackle the next decision. We may end up with an elaborate burger or a plain one. In either case, the decision is ours. Creating compositions is like creating hamburgers; we create to suit our own taste. If we're pleased with our creation, then our painting is certain to reflect our pleasure.

The Tomato
18 × 24 inches, oil on canvas

This composition was painted with Genesis oil paints. I used the same techniques and steps described in the lessons, but substituted Genesis mediums for water, and dried the paint between each step with a heat gun (similar to a hair dryer but with more intense heat). Read about the composition on page 67.

Design Fundamentals

Just as knowing the letters of the alphabet enables us to build words, knowing the elements and principles of design and the effective placement of the focal area will help us build successful compositions. These fundamentals have long been recognized and used by artists, designers, and decorators. Don't be intimidated by their technical sounding titles. You learned your ABCs and you can master these.

Elements of Design

A design is made up of six elements: *line, shape, size, space, color, value, intensity, texture,* and *mass.* If you dissected even a child's crayon drawing, you would find these elements. In describing the elements, I have listed a few descriptive terms—sometimes of opposite extremes (light/dark, large/small, etc.). Not listed, but equally important, are all the variations between, and even beyond, the descriptions (very light, medium light, medium, medium dark, very dark, etc.). The descriptions are meant to inspire your thinking, not limit it to the few adjectives mentioned.

- Line: Straight or curved? Flowing and free or rigid and decisive? Horizontal (resting, tranquil), vertical (strong, rigid), or diagonal (activated, energized)? Blurry or bold? Delicate or sturdy? Actual or suggested (by something pointing, looking, or facing)?
- Shape: Free-form, rectangular, square, triangular, circular, oval, organic?
- Size: Large or small? This can pertain to the objects as well as the spaces or intervals between them.
- Space: Positive (occupied) or negative (empty)? Advancing or receding? Open or closed?
- Color: Warm (advancing) or cool (retreating)? Opaque or translucent? Harmonious, contrasting, or discordant combinations?
- Value: Light, cheerful, and delicate or dark, threatening, and somber?
- Intensity: Saturated (full strength, brilliant) or unsaturated (muted, grayed, subdued) color?
- Texture: Shiny like satin or nappy like velvet? Smooth or rough? Busy with detail or plain?
- Mass: Large or diminutive? Vigorous or delicate?

Focal Area

As we make our design selections based on the various elements, we also need to determine a focal area for our painting. A focal area attracts attention and then leads the viewer to continue looking. The focal area can be emphasized by, among other things, painting it with the strongest value and intensity contrasts, giving it the greatest detail and sharpest definition, and having lines within the composition direct attention to it.

We must be careful, however, not to be too ambitious, trying to make our entire painting full of focal points. When everything in the painting is a focal point, there is no focal point. Water droplets painted on every leaf and flower are useless and distracting unless we're painting a rainstorm. On the other hand, one or two droplets placed strategically on only the focal area will draw the viewer's attention directly to it. (See "Waterdrops" on page 298.)

And how do we decide where to position the focal area? First, we need to decide what

The marbleized texture of this background repeats the flowing lines of the grape hyacinth's strap-like leaves. The deep background color makes a striking contrast to the light flowers.

type of balance we want in the composition: symmetrical (in which both sides of the painting appear almost as a mirror image, with the focal area placed along the center line); asymmetrical (in which the focal area is placed off center); radial (in which lines converge on or radiate from the center); or occult (in which there is no obvious focal area). Since the focal areas for the symmetrical and radial compositions rest on the center line, and there is no obvious focal area in the occult composition, let's focus our attention on asymmetrical balance.

A quick and easy way to determine an ideal location for the focal area is to divide our painting surface into thirds, both horizontally and vertically. Any one of the four points at which the horizontal and vertical lines intersect would be an ideal location for a focal area. You will notice that any one point is located an unequal distance from the top and bottom of the illustrated rectangle, and from the two sides. These same divisions can be applied to square or circular painting surfaces.

Choose one of the four intersecting points for the location of your focal area.

A Hypothetical Painting

Let's imagine that we'd like to paint a composition in warm colors, consisting of a red rose, other predominantly red flowers, a vase, a red ribbon, and maybe an ornate figurine. Let's say the rose is to be our main attraction. Where, within the focal areas, shall we place the rose? With all that competing red, how can we ensure that the rose will be the main attraction? We might set the rose apart by making it a larger, more dominating size; surrounding it with complementary green leaves; using stronger value contrasts within the rose; or subduing the intensities of the other red flowers and the red ribbon to prevent the eye from wandering aimlessly.

We could further ensure that the rose will grab attention by arranging lines, shapes, or colors to lead the eye to it. We could take the rose out of the vase and place it slightly apart. An isolated item will draw the eye, particularly if we also set it off with strong value contrasts. (Look at the photograph of strawberries in the crystal bowl on page 158. Although there are dozens of strawberries in the bowl and on the silver tray, our eye is first drawn to the single berry, made prominent by its isolation from the others.) From that area of isolation, we can guide the viewer through our painting by the thoughtful use of the principles of design, which will help us make all the "lots of little decisions" we need to consider.

Principles of Design

The principles of design include dominance, contrast, rhythm and repetition, balance, transition, and unity. I have included a few thought-provoking questions or points with each principle, but, as with the elements, these questions or points are not meant to be all-inclusive. They are just to spur your thinking. Keep our hypothetical red rose (see page 63) painting in mind as you read through these principles, and try to make some decisions relevant to how you might paint it.

DOMINANCE

Dominance is that which first captures the viewer's attention. When designing a composition, ask yourself, for example, what will be the dominant . . .

- shape (horizontal, vertical, diagonal, circular, triangular . . .)?
- texture (smooth, rough, crisp, bristly, soft, stiff . . .)?
- color (warm or cool)?
- intensity (subdued or brilliant)?
- value (light or dark)?
- line (curving or straight)?

CONTRAST

Contrast is that which conflicts with the dominant shape, value, color, etc., thereby creating variety. A composition of all round fruits would be boring. Throw in a pineapple, all spiky and prickly, to create a bit of tension and excitement. Even something round and large among a collection of smaller round things helps break the monotony a little. An apple, especially one with a stem and leaves, placed among a composition of grapes, gooseberries, currants, and blueberries, adds variety of size and color, and its leaves and stem add some contrast in texture, shape, and line.

So, how shall we use contrast to make our hypothetical painting appealing, interesting, exciting . . . ? Here are some ideas:

- Cool colors in a warm painting? (With our red rose, red flowers, and red ribbon, something a little cooler in color would certainly offer variety and relief.)
- Straight lines among curved ones? (Rose petals are softly curved, likewise the flow of the leaves and the ribbon. Thorny, stiff rose stems, if not totally obscured by the other flowers and leaves, would provide some sturdy, straight lines. Otherwise, perhaps our choice of other accompanying flowers, vase, or background treatment could provide the needed contrast.)
- Lines curving in an opposite direction from the dominant lines?
- Bug-eaten flowers or leaves among otherwise perfect ones?
- Busy, precise details or pattern in an otherwise calm painting?
- Lost or softened edges in a sharply focused painting?
- A dark value in a predominantly light painting?
- A complementary color (green leaves) added to a predominantly harmonious color theme (various reds)?
- Contrasting sizes (our large rose among smaller roses and red flowers)?
- Horizontal elements in a vertical theme (a drape across the table or a horizontal figurine)?

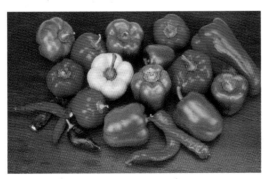

Which principle of design is immediately obvious in this photograph? If you said, "contrast," you are right. The light pepper amidst so much darkness draws our eye instantly. A second or third yellow pepper added to the group would dilute the impact. If we had hoped to have the purple pepper be the focal point, thinking its unique shape and color, and the fact that we had placed it in front would set it apart from the others, we would have been disappointed. Even a dozen purple peppers could not equal the eye-catching power of the contrasting single yellow pepper.

- A geometric form (our vase, perhaps) in a composition of irregular, organic shapes?

RHYTHM AND REPETITION

Rhythm and *repetition* keep the viewer's eye moving through the painting. Which elements (such as shape, size, color, value, texture, line...) shall we repeat to assist the flow of movement through the composition? Be cautious about repeating identical shapes, sizes, colors, and intervals. Such repetition can seem static and boring. Three identical flowers in a line, evenly spaced apart, are predictable and unexciting. Change the spacing between them, putting two closer together. Or bring one of the grouping of two closer to the foreground. Or change the sizes. Or tip one flower in a different direction. We will still keep the viewer's eye moving through repetition from one flower to the next in the overall composition, but the trip will be more interesting.

BALANCE

Balance refers to that combination of elements that creates visual stability in the painting. From birth, we have an innate sense of balance. As a newborn, our perception of impending loss of balance caused a great flailing of arms and legs. Then came the struggle to oppose gravity and balance muscles against one another. As adults, we continue to find a lack of balance distressing, whether it be a physical situation or a visual one. (Most of us feel compelled to straighten a picture hanging crookedly on the wall.) So we want to be sure we create a comfortable balance in our paintings. Think of the distribution of weight on a seesaw: A small child on the end can balance an adult sitting on the opposite side of the fulcrum, near the center. Likewise, too much weight on one side of a painting will make it appear unbalanced. When we place our focal area on the spot we identified earlier, we must balance it with what we do to the other side of the painting. Keep the seesaw effect and the following tips in mind:

- A small, intense colored area can balance a larger area of subdued color.
- A small area of visual texture or more detail can balance a larger, smoother, less busy area.
- A small area of sharply contrasting value can balance a larger area of mildly contrasting value.

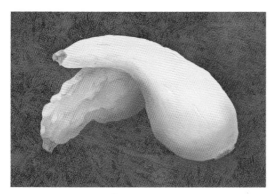

Using yellow's complementary color, violet, to shade the squash anchors the squash to the mottled violet background by providing a transition. Touches of yellow in the background help connect the yellow squash to it. The arrangement of the squashes creates stability in balance; and the warty versus smooth skin provides contrast.

- A small area of warm color can balance a larger area of cool color.
- A small mass near the edge of the painting can balance a larger mass near the center (seesaw).
- A single angular shape can balance a bunch of circles or ovals.
- A small complex shape can balance a larger, simpler shape.

TRANSITION

Transition (sometimes called *gradation*) is that which relates one element to the next, such as the way white on the value scale is related to black by the intervening shades of gray. Transition can be created by the way we use color, value, line, space, texture, and so forth to move the eye through the painting. Imagine a painting made only of colors as they came from the tubes or bottles. The sky would be one shade of blue; the grass, one green; the tree trunks, one brown. With no intermixing, there would be no smooth transition from the tree to the sky or the grass, no transitional color to carry the eye easily from one form to the next. Instead, the jump from brown trunk to green grass or blue sky would be sudden and uncontrolled. We may not end up looking where the artist wanted us to look. Whereas mixing a transitional color by adding a little of the blue from the sky into part of the tree trunk and limbs would provide a visual bridge from the tree to the sky. (Young children painting mix transitional colors automatically until someone instructs them to clean their brushes before dipping into a different color of paint.)

Directing the line of the tree branch to point to or overlap the roof line of a house would provide transition from the line of the tree and carry the eye along from tree to house. Following are some things we can consider to provide transition in our paintings:

- Use color through reflected lights to tie neighboring forms together.
- Use the dark values of shadows to lead the eye from one place to the next.
- Use gradually changing values, colors, lines, shapes, sizes, and spaces to relate one area to the next.
- Bend a branch, curve a drape, fold over a leaf, or angle a prop to lead the eye to the next element or contour.
- Overlap elements to provide transition.

UNITY

Unity (sometimes called *harmony)* is that combination or arrangement of all the elements of the painting to make everything appear to belong together. Through clever use of the elements and principles you could even make a lobster and an Easter basket appear to belong together. (Now there's a creative exercise for the next time you're stuck in traffic.)

For a painting to have unity does not mean that it should be overwhelmed with "sameness." If, in fact, there is too much sameness or equality, then there is no unity or harmony because our attention is equally divided. Variety makes a painting interesting. Variety can be achieved by making adjustments in sizes, values, color, shapes and so on, and still create harmony or unity. Every aspect of the painting must work together and share the load of making the painting a success.

Improving Our Compositions

In our imaginary rose painting, does the figurine add anything to the painting? Does it support the theme? Does its color, texture, value, size, shape, etc., act as a transition to carry the eye to the next part of the painting? Does its ornate design add needed contrast or conflict to, perhaps, an otherwise complacent painting, yet still appear to be in concord with the painting? Does the flow of its line repeat a line of the vase, or the flow of the floral design? Does its shape or direction repeat any other elements in the painting? Or does it just sit there, serving no purpose, having no unity with the other elements of the painting? The supporting actors are vital to the lead players, but any player not contributing to the whole is extraneous and should be pulled from the production. If the figurine isn't doing its job, we must either get rid of it or rework it so it carries its weight. We have to stay open and receptive to possible changes that will improve our original inspiration.

The Fundamentals in Use

Let's consider some of the painted worksheet sketches. While I have tried to keep them uncomplicated to make the step-by-step process easier for you to follow (thus, have not created them as complete compositions), they may help you more easily envision how some of the elements of design and principles of design work together.

- Look at the cluster of blackberries on page 93. Repetition of shape and color pulls the eye along the stem. Notice how the various colors in the berries provide transition from one berry to the next. Those same colors added into the leaves also help that transition and unify the leaves with the berries.

Remember

Each of the principles of design apply to each of the elements. Which line should be dominant; which value should be dominant; which texture should be dominant, etc? How shall we balance the weight of the mass, an area of intense color, a busy texture? How shall we repeat the line of the drape, the color of the ribbon, the subdued intensity of the leaves? And so on.

Quiz

Close your eyes and rest them a moment. Then look again at this painting and notice where your eye is first drawn. Why is that? Think of two reasons. Where do you look next? Make a note of the path your gaze follows. Where do you exit the painting?

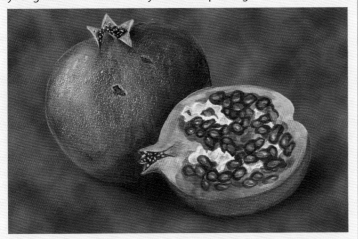

ANSWER: *The eye is pulled to the two large patches of white membrane in the cut half, because of the strong value contrast and the busy detail. Then, the more delicate detail of the stamen in the cut blossom end pulls us along, aided almost imperceptibly by the pointing "arrowheads" there. The upward sweep of the reflected light, on the whole pomegranate and the large blemish carries us to the repeated stamen detail there. Then, the down-turned "arrowhead" helps guide the gaze back downward to the blemish pointing back to the white membrane. Now, perhaps, we see the lighter value at the stem end. And from there, we can exit the painting.*

The unripe berries repeat the shape but add variety and contrast by their different stages of development, their sizes, and their colors. If all the berries on the branch were identical in color, shape, and size, how boring they would be! The thorns and calyxes add texture and pattern to contrast with the slick, smooth berries.

- Now check out the cherries on page 105. They may look delicious, but imagine how much more interesting (and less boring!) the cluster would be if it contained a rotten or withered cherry. If nothing else, it would have made you wonder why I spoiled a tasty bunch by painting a rotten one in its midst. I would have stirred your curiosity through my painting. The rotten cherry would have added contrast or conflict.

- See how much more interesting the figs on page 113 are than the cherries because there is contrast. The split-open fig is in conflict with the other figs, which are whole and unblemished.

- In the pansy cluster on page 285, the large pansy is obviously the dominant one and the focal point. The other two, smaller in size and facing away, are plainly less important. If I were painting these pansies as part of a composition, and wanted to focus attention on the primary one, I would slightly subdue the colors of the two facing away, and possibly soften their edges gently into the background. I would also want to include more pansies in a variety of shapes, positions, and sizes in order to create both variety and a dominance of color. As the sketch stands now, the green of the leaves and the burgundy of the flowers are fairly equally balanced (no dominant color). You may find yourself torn between looking at the leaves and looking at the blossoms.

- In the morning glories on page 281, you'll see that even though there are several blossoms in the sketch, the predominant color is not the blossom color, but the green of the background and leaves. The blossom colors provide contrast. There are two large blossoms, but one is in profile, leaving the other one, which is facing us, to be the dominant flower. Look at the bud near the dominant

flower. See how its more intense yellow helps pull the eye toward the focal flower? On the other hand, because the lower bud on the vertical line is of subdued intensity, it all but goes unnoticed. How would you describe the dominant texture in the sketch—rough, smooth, stiff, thin, delicate? How about the dominant line—straight, precise, gentle, fluid, bold, heavy? Compare the dominant line and texture of the morning glories to those of the holly on page 253.

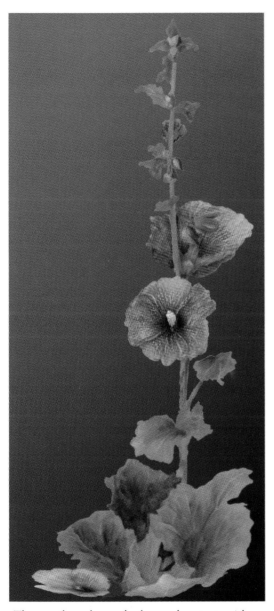

The smooth, cool green background contrasts with— and directs attention to—the warm, complementary-colored hollyhock blossoms with their ruffled edges and pronounced veining. The repetition of the blossoms keeps the viewer's eye moving up the stem until the spent blossom at the bottom pulls the eye to the leaves. The tall stem is balanced by those large, basal leaves, giving it stability.

A Composition Explained

Study the painting on page 60, noting how your eye travels through it. Can you identify the focal area? Study the use of warm and cool hues; the contrasts in values and intensities; the repetition of hues, lines, and textures; the balancing of positive and negative space. Then return here and I'll share with you my thoughts and decisions in painting it.

The tomato, a gift from friends and the first from their garden this year, had so much character, I had to paint it. Wanting it to be the focal point, I surrounded it with green vegetables. Green, a cool hue recedes; red, a warm hue advances, and even more so here since the red of the tomato is the most fully saturated (intense) hue in the painting. The busy detail and round shape of the tomato's calyx also pull the eye right to it like a bull's-eye. I also curved the tablecloth to lead the eye into the focal area, the area that contains the greatest contrast of value, detail, intensity, and temperature.

The busy details of the tomato, the artichoke, and the asparagus are balanced by the plainer forms of the other vegetables. Your gaze is led up from the tomato, along the right edge (more detail, more highlight) of the artichoke, and into the asparagus. To keep your eye from wandering off around the artichoke, I heavily shaded its left side and used less crisp detail there. The red ribbon helps connect the tomato to the asparagus and pulls the eye along. But to keep your eye from climbing all the way to the top of the asparagus and then up through the top of the canvas, I lowered the intensity of the asparagus tips and curved some to direct your attention toward the carrots. There, the eye goes down the slope of the carrots to the busy radish leaves, where the light mushroom grabs the gaze and helps it travel to the white cloth. Notice that the line along the right edge of the cloth repeats the line of the carrots and the mushroom. On the cloth, you're confronted with all the detail of the radishes and the garlic. From there, you might further explore the artichoke and then continue across the tomato to the lesser players. The pepper and onion help bridge colors between the tomato and the carrots. Notice the purple, orange, brown, and reds reflected in the pepper. The purple of the eggplant is also repeated in the garlic, artichoke, and asparagus. The duller reds in the radishes and the ribbon repeat the tomato's red to keep the eye moving. The low intensity squash behind the carrots softens what could otherwise be a severe junction, thus bridging the color interval between the wall and the carrots. The shadow of the artichoke softens what would be a very distracting hard edge and strong value contrast of the tablecloth against the dark wall.

The angular, geometric nature of the unadorned wall and the sturdy slab of the table are balanced by the busy and organic lines of the vegetables. The light wall and tablecloth balance one another against the dark wall and table and the area beneath the table. These five strong sections almost lend an abstract touch to the composition.

After cycling through the vegetables, an easy exit from the painting is to follow the long fold in the cloth downward, past the smaller folds, and then out of the picture.

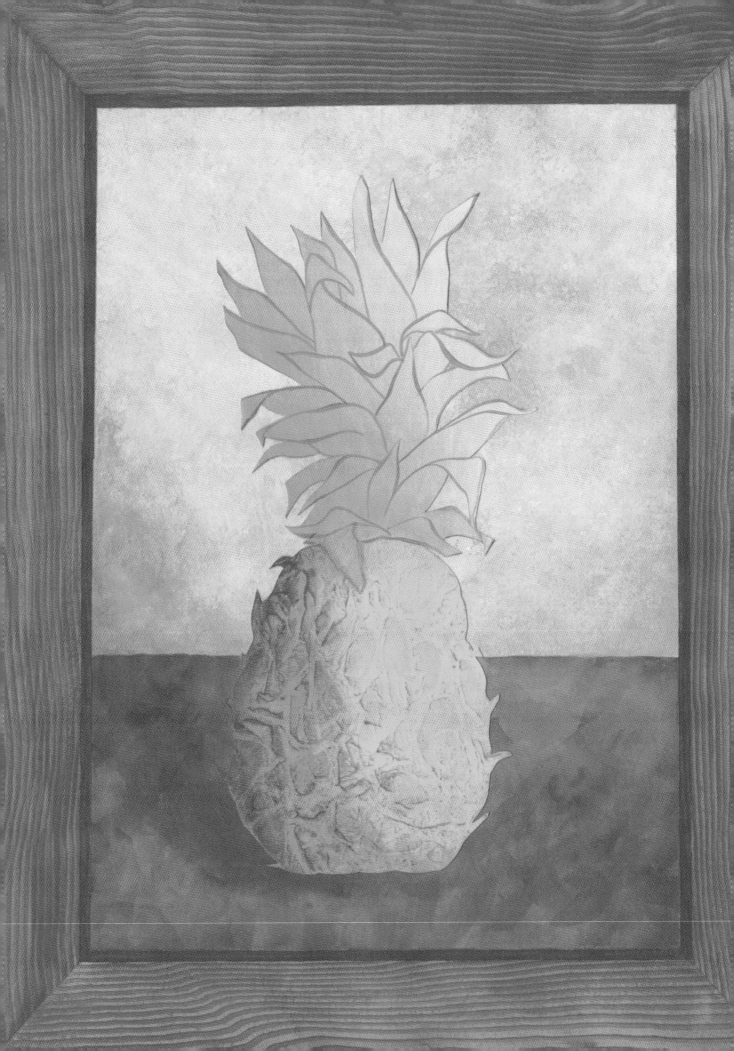

<p style="text-align:center">Chapter 6</p>

Backgrounds

<p style="text-align:center">"Art arises when the secret vision of the artist and the manifestation of nature
agree to find new shapes."</p>

<p style="text-align:center">KAHLIL GIBRAN</p>

Let's consider how background colors and textures can affect our paintings. They can draw attention to our subject matter, they can undermine it, or they can completely overwhelm it. I have painted the subjects in this book using a variety of background colors and techniques. In some lessons, I show how the subject looks on different backgrounds. In others, I refer you to other similarly colored subjects to give you additional color combination ideas, as well as an opportunity to determine which work and which do not, and which combinations you like and and don't like. We all respond differently to colors. I love clean, strong, happy colors and contrasting color schemes. You may prefer softer pastels, or muted colors. It's important that we each determine the color combinations that suit us best and that best interpret the mood we want to express in our paintings. Experience is the best teacher. Don't be afraid to try and even to fail. We learn much from our failures.

You may find this chapter especially helpful when you discover that several of the lessons are painted on white or off-white backgrounds. My goal is to encourage you to think how you might choose a background color for them, unhampered by seeing my choices. With each color decision you make, you'll be building a mental resource library from which to draw for future paintings.

OPPOSITE: *The special effects you see here include sponging, scumbling, marbleizing, graded wash, and woodgraining. Have fun with these techniques, but be careful not to overdo it. As you can see, it's possible to have too much of a good thing!*

RIGHT: *Before turning the page, decide what color, value, intensity, and type of background (smooth, textured, faux-finished, etc.) you would select for this sketch and why.*

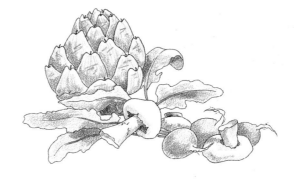

Background Colors

Consider what happens to the different subjects in these sketches with each change of background color. To make it easier for you to compare the effect backgrounds can have I have kept many of the subject colors fairly identical in each sketch. As such, most of the subjects are not well unified with the backgrounds. Compare what happens, however, when the background color is introduced into the subjects (see the artichokes on the red, dark green, and purple backgrounds). Try to determine what works, what does not, and what you'd do differently. Think of ways you might change the values and intensities of the subjects and/or the backgrounds to more prominently feature or subdue particular subjects—as was done with the radishes in the two otherwise identical sketches on the light green backgrounds.

Unifying Subject and Background

Our backgrounds are most effective when their colors work in conjunction with the subject matter they surround. After you have chosen the color, value, and intensity for the subject matter and background of your painting, you have to make sure that the two work together. There are a number of ways in which you can unify the subject matter of the painting with the background.

- Mix a little of the background color into the colors used for painting the subject. This will also lower the intensity of the subject colors.
- Use the background color to shade or highlight the subject, depending upon the color.
- Let the background color peek through the subject matter. You will notice when you work through the step-by-step lessons that this is a technique I use a lot. Depending upon the hue and value of my background, I may let it help suggest the shading, the highlighting, or the general color of my subject by applying the subject's local coloring thinly over the background.

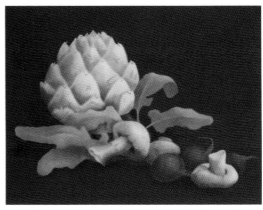

The low-intensity red of the background, because it is the complementary color of green, sets off the greens nicely. The contrast pulls our gaze to the artichoke and the leaves. Ah, but which will we focus on—artichoke or leaves? The size and busy detail of the artichoke help it take center stage. Those curved, pointed petals and all the detail in the scars scream, "Look at me!" OK. We did. So where does our gaze go next? The value contrast (light versus dark) pulls our eye from one mushroom to the next. Do we ever see the radishes? Hardly. They're melting right into the background. To keep them from disappearing entirely, we could darken the red behind them and/or brighten (change the intensity of) and lighten (change the value of) their hue slightly.

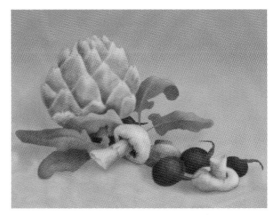

Just as we nearly lost the radishes on the red, we barely see—at first glance—the mushrooms on the tan. Without the dark contrast inside the caps, and the surrounding radishes, they would really be lost. To preserve the mushrooms, we could change their hue slightly, or change the value that surrounds them. What about the radishes and artichokes? Which grabs your attention first? Why? To focus more attention on the artichoke and less on the radishes, we could deepen the shading and details on the artichoke and soften the colors and contrasts of the radishes.

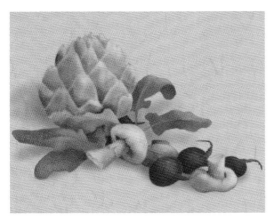

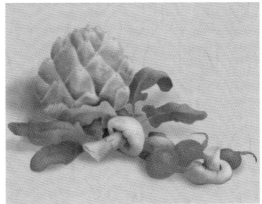

Exercise
After you have worked through the lessons on the subjects included in this sketch, try painting it on a woodgrained background. Such a background would add a rustic touch, reinforcing the organic nature of the produce. What would you want to focus attention on? How would you do it?

On the light green background, we lose a major part of our composition, but we certainly found the radishes! If we absolutely wanted a green background, would it help to darken its value? You bet! We would regain somewhat the "lost" portion of the composition—the artichoke and the leaves. The strong value contrast of a darker green background would also throw the spotlight on the very light mushrooms.

On this light green background, look what happens when we adjust the hue, value, and intensity of the radishes. They "fit" better with the rest of the subject matter, giving a soft, gentle effect. And, in spite of the fact that I've even added a fifth radish, the radishes don't command attention as they do on the light green background at left.

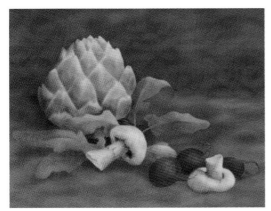

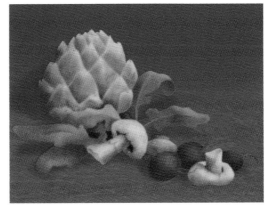

On the dark green background, the leaves are unobtrusive, focusing attention on the other subjects. The mushrooms first catch our eye, particularly the long-stemmed one, because of the strong value contrast and detail. From there, our eye is pulled upward to the artichoke, lured by the bright, light contrast, and by the upward thrust of the artichoke leaves. Now, perhaps, we notice the radish leaves and follow the downward curves to settle on the radishes. We might expect the red radishes to jump off the green background; but since the red is a lowered intensity, they do not react against the green the way the tomatoes do on page 215. Also, having touches of red scumbled throughout the background helps balance the red of the radishes, making them not so unique a color.

This violet background seems a little too sweet for these hearty veggies. And there's no unity between the subject and the background, even though I added violet tones in all the items. (Maybe we should have painted flowers on this background, instead!) Could we make a violet background work? Possibly. One way would be to lower both the intensity and the value of the background to create a more earthy tone. Then we'd need to adjust all the colors in the sketch, working more violet into the mixtures. That would help anchor the composition. If we wanted to showcase the mushrooms, we could tint them a warm gold (yellow being the complement of violet). Touches of golden highlights on the artichoke and leaves would help the eye travel through the composition.

Examples from the Lessons

Check out some of the step-by-step lessons to see how I unified the subject matter with the background.

- Apples (page 85) and bananas (page 89): In these sketches, background colors are blended or layered into the highlighting, local colors, or shading.
- Currants (page 109): The light value background shines through the currants to create highlights and a suggestion of transparency. Compare this gentle, calm effect with the "flashing-neon-sign" effect of the tomatoes (page 215) on their complementary green background. The tomato painting has a nervous, excited energy about it.
- Figs (page 113): The figs' thin paint lets the medium value background affect their local color. Yet, they're not lost on the background because of the strong value contrast.
- Pears (page 137): Here is another understated treatment. I've worked the deep burgundy of the background into both the pears and the leaves. The overall impression of this background and subject treatment is one of somberness with the patina of antiquity. Just the effect I was after for these drab (but delicious) Bosc pears. A brighter background could have competed with the pears. If the overall impression is too somber for you, liven the pears slightly with a wash of a brighter yellow over the highlight area.
- Persimmons (page 141): I painted the background color into the shading on the fruit to tie things together. The persimmons look quite vivid in their analogous color scheme on the deep burgundy background, but can you imagine how much more raucous they would look on an intense, deep blue background? The selection of a bright green background would be even more incongruous since persimmons are a fall fruit. If we want green (and want to unify the fruit with its season), the green should be one of lowered intensity. (Look at the color wheels on pages 32 to 33 and choose a green you think would work.)
- Plums (page 149): I chose a plum-colored background to illustrate the subtle effect possible when subject matter and background color are of similar hues. There is great unity in such a combination. The trick is to have sufficient contrast in values and intensities so the subject matter does not vanish. Imagine how different these plums would appear on a golden background.
- Eggplants (page 191): Notice how the streaky, crackled texture of the light tan background emphasizes the contrast with the smooth, dark eggplant. The eggplant's calyx and stem are unified in color and texture with the background, further heightening the contrast of the slick skin of the vegetable.
- Garlic (page 195): Notice the thick and thin areas of paint application in step 1. Where the dark background shows through the thin paint, it helps create depth and dimension. The garlic rests quite happily on the mauve background, sporting some of the mauve in its coloring. These garlics would not sit as comfortably on a green background without adjusting their coloring.
- Mushrooms (page 199): I used a textured brown background to evoke a more woodland, earthy atmosphere, and to tie the mushrooms and background together quite naturally. Can you imagine these mushrooms painted on a sweet, delicate pink background? It boggles the mind. But then again, it all depends on the effect we want to achieve.
- Daffodils (page 229), hollyhocks (page 257), lilies (page 265): See how effectively the background colors shine through these flowers to both unify the subject and background and to suggest shading and texture.

Remember

While you're busy trying to unify the subject matter and background, don't let the focal point of the painting get lost. How can you avoid this? Contrast, contrast, contrast! Build up the focal point with contrast: light versus dark, detailed versus plain, intense color versus subdued color, warm versus cool. If the item you wish to be the focal point is a light value, surround it with darker values. Give it interesting details (scars, dewdrops, veins, thorns—whatever is appropriate) and surround it with items of fewer details. Intensify its color and increase the contrasts of its highlights and shading. Subdue colors of items around it. Remember that warm colors advance and cool colors recede. Using the artichoke exercise as an example, if the artichoke is a cool green, we can warm it by adding yellow. And even though the radishes would tend to advance because the color red is warm, we can cool them down with the addition of a little green.

Surface Prep and Faux Finishes

You can re-create the backgrounds I used in the step-by-step lessons with a few additional supplies. Or you can use the tools and techniques discussed here to create your own backgrounds. The photos on the next three pages illustrate some special backgrounds and faux finishes I used in the lessons. (The next section includes a chart with detailed explanations of every background in the lessons.)

Brushes for Basecoating

For general basecoating, I use a Loew-Cornell Series 7550 1½- or 2-inch flat brush. Although the brushes are expensive, they are worth the investment over time. Well cared for, they will last for years, and will outperform dozens of foam brushes, facilitating the application of smooth basecoats and finishes and crisp, sharp edges for trimming. For special effects such as scumbling (stroking several colors in an overlapping crisscross fashion), I use the 1-inch brush of that series. To paint streaks, I like a Series 2053 1-inch chip brush.

Several of the backgrounds call for the application of thin washes of color. When applying washes for marbleizing or other texturizing techniques, you may find it helpful to work with extender or retarding mediums and water mixed in your paints. This will give you more working time before the paint starts to set up. And of course, the larger the brush you use, the more quickly you will be able to work. When you do add mediums to your paint, be sure to dry the wash thoroughly with a hair dryer before proceeding to the next step. Otherwise, the thinned layer may lift off when wetted with the next paint application.

Scumble strokes in a crisscross fashion to create a broken-color background (see lessons on lemons and limes, pears, watermelons, beans, and poinsettias).

Apply thinned paint with a stiff-bristled brush to create a streaky background (see lessons for blackberries, kiwis, chili peppers, and onions).

Create a crackled, aged appearance with Weathered Wood (see lessons on asparagus and eggplants).

Using a Mini Paint Roller

For painting some backgrounds on large surfaces, a 2-inch mini paint roller is convenient. To paint a gradated wash over a solid background color, first apply a thin layer of water plus Brush 'n Blend Extender or Easy Float with the roller. Then, with the water and medium remaining in the roller, pick up the desired color and roll it on the area you wish to be the darkest value. As you work away from the starting point, you will have less and less paint in the roller and the color will be fainter.

To achieve a more opaque coverage with gradated colors, begin with the lighter value color. Starting at one end of your painting surface, roll the color on, covering about one fourth to one third of the area. Then doubleload the roller with the light color on one edge and the next color on the other edge. Roll those two on, slightly overlapping the previous application with the light edge of the roller, and working to create a smooth blend. To add another color or value, roll as much of the light value off the roller onto paper towels as you can. Then, again, doubleload the roller, this time with the new color and the one just previously used. Be careful not to pick up the roller from one area of the painting and jump to another area—you'll get a sudden shift of colors or values. Instead, roll from one area to another, letting the colors blend as you go. Consider basecoating the surface first with a color that would enhance the effect you're hoping to create, a color that would help pull together any colors you're going to roll on top of it.

Special Effects

Household sponges, sea sponges, chamois cloth, and crumpled plastic wrap pressed into wet paint to lift it off, or filled with paint to press it onto a surface, result in some interesting effects. Sponges and chamois cloth leave a soft-edged effect, especially when working with thinned paint. Plastic wrap imparts crisper details. Use sponges, chamois cloth, and plastic wrap to create leather-, granite-, and marble-like effects. For additional faux finishes and texturizing techniques, and more step-by-step photographs for accomplishing them, see *The Big Book of Decorative Painting*.

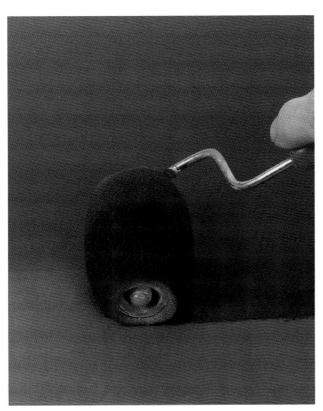

Use a 2-inch roller to easily merge colors into one another, for a gradated background (see lessons on persimmons and carrots).

Drybrush across raised streaks of dry paint to leave slight glints of color (see cherries lesson).

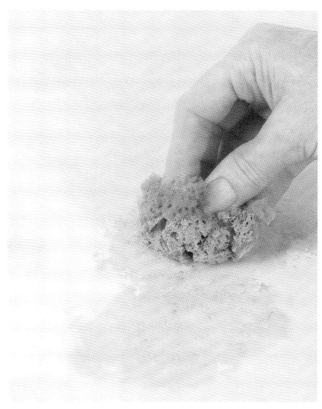

Press crumpled plastic wrap, chamois cloth, or a sponge into wet paint to create a leather-like texture (see lessons for hollyhocks and irises).

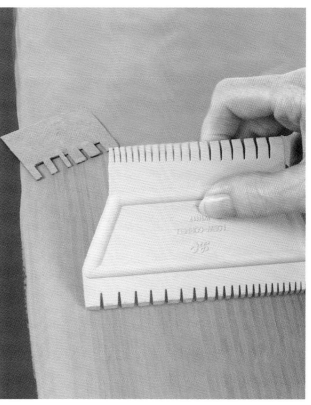

To create a background that resembles wood, streak the paint with a woodgraining comb or a piece of cardboard with "teeth" cut in it (see cherries lesson).

Create a marbleized background by spreading plastic wrap onto wet paint (see lessons for apples, mushrooms, hibiscuses, lilies, and pansies).

Roll paint across a plastic onion bag for a unique texture (see figs lesson).

Backgrounds Chart

In the following chart, I have listed the background colors and treatments used in each of the lessons. I combined them into one section—rather than including them with each lesson—to make it easier for you to interchange colors and background techniques.

Under the column titled "Background Treatment," the first time a color is mentioned it is in bold type. That color is shown in the column "Colors" in the order in which it is listed in the "Background Treatment" column. The column titled "Cast Shadow Colors" lists and illustrates the colors used for painting the cast shadows on the lesson worksheets. The suggested shadow colors are generally (and simply) darker values of the background color.

When the chart suggests darkening a shadow color with another color, thinly apply the first color listed to the entire shadow area. Let it dry. Then create a darker value by mixing a little of the second color with the first. Apply this mixture next to the object casting the shadow if the object is close to the surface on which the shadow is cast. Use a sideloaded brush, beginning up against the object and working away from it, letting the color fade as you progress. Remember that the darkest part of the shadow is closest to the object casting it, and shadow colors and edges are softer the farther away from the object they are. (For more details, see the discussion "Cast Shadows" in Chapter 4.)

Fruits

SUBJECT	BACKGROUND TREATMENT	COLORS	CAST SHADOW COLORS
APPLES	1. Basecoat with **Uniform Blue**. Dry 2. To marbleize, spread on **French Grey Blue** plus Brush 'n Blend Extender with a 2-inch flat brush. Work quickly, keeping all areas wet. Then . . . 3. Immediately cover with plastic wrap. Push wrinkles around in the plastic to create interesting texture. 4. Smooth over the plastic with flat hands to push paint gently up into the wrinkles. 5. Lift off the plastic wrap. Dry.		Uniform Blue
BANANAS	1. Basecoat with **Plum**. Dry. 2. Scumble with Plum, **Violet Haze**, **Dioxazine Purple**, and **Neutral Grey**. Keep all areas wet by working quickly and mixing water and Easy Float into your paints. 3. While the colors are wet, immediately dab with a crumpled wad of plastic wrap or chamois cloth.		Black Plum + Dioxazine Purple
BLACKBERRIES	1. Basecoat with **Flesh Tone**. Dry. 2. Use a very light touch to streak with thinned **Dried Basil Green** loaded into an old separated flat brush, or a 1-inch chip brush. Dry. Streak again with **Base Flesh**.		Olive Green + Blush Flesh + Base Flesh
BLUEBERRIES	Basecoat with **Light Buttermilk**.		Payne's Grey
CANTALOUPES	Basecoat with **Titanium White**.		Tangerine + Royal Purple

SUBJECT	BACKGROUND TREATMENT	COLORS	CAST SHADOW COLORS
CHERRIES	1. Basecoat with **Charcoal Grey.** Dry. 2. Apply thinned **Blue/Grey Mist** + Brush 'n Blend Extender or Easy Float. Then . . . 3. Immediately pull a woodgraining comb or hand-cut cardboard comb through it, leaving slight ridges. Dry. 4. Drybrush **Ice Blue** perpendicular to combed strokes with a stiff-bristled brush.		Charcoal Grey
CURRANTS AND GOOSEBERRIES	Basecoat with **Yellow Ochre.**		Mink Tan
FIGS	1. Basecoat with **Coral Rose.** Dry. 2. Stretch the plastic net of an onion bag over the painted surface. Tape snugly. 3. With a small roller, apply a mixture of **Shading Flesh** + water + Easy Float. Let dry briefly. 4. Remove the onion bag. Use a 1-inch foam or flat brush and water to loosen paint slightly with a gentle, scrubbing motion. 5. Cover with plastic wrap, pushing it around to create a wrinkly texture. Remove the plastic wrap. Dry.		Blush Flesh + Plum
GRAPES	Basecoat with **Light Buttermilk.**		Neutral Grey
KIWIS	1. Basecoat with **Prussian Blue.** Dry 2. Use a 1$\frac{1}{2}$-inch flat brush to apply thinned **Viridian Green** alternately with thinned **Mint Julep Green,** creating streaks. Dry. 3. Streak alternately with thin washes of Prussian Blue and Viridian Green.		Black Green
LEMONS AND LIMES	1. Use a 1- or 1$\frac{1}{2}$-inch flat brush to scumble strokes of **Orchid, Williamsburg Blue, Pansy Lavender, Slate Grey,** and **Salem Blue,** all mixed with Brush 'n Blend Extender. Then . . . 2. While the paint is still wet, blend the edges of the strokes so colors merge softly into one another.		Uniform Blue
ORANGES	Basecoat with **Titanium White.**		Blue Violet + Burnt Orange + Titanium White
PEACHES	Basecoat with **Buttermilk.**		Antique White
PEARS	1. Basecoat with **Antique Maroon.** Dry. 2. Doubleload a 1$\frac{1}{2}$-inch flat brush with **True Red** and Antique Maroon. Scumble the colors on, crisscrossing strokes to soften edges and to create random patches of light and dark.		Black Plum

SUBJECT	BACKGROUND TREATMENT	COLORS	CAST SHADOW COLORS
PERSIMMONS	1. Basecoat with **Primary Red.** Dry. 2. Working from the top downward, and merging one color into the next, use a 2-inch flat brush or 2-inch roller to paint the following colors: Top 1/4 of the area: **Georgia Clay** Next 1/4 of the area: **Brandy Wine** Third 1/4 of the area: **Cranberry Wine** Bottom 1/4 of the area: **Black Plum**		Black Plum + Black Green
PINEAPPLES	Basecoat with **Light Buttermilk.**		Neutral Grey
PLUMS	Basecoat with **Plum.**		Plum + Dioxazine Purple
POMEGRANATES	Basecoat with **Celery Green.**		Evergreen
STRAWBERRIES	Basecoat with **Light Buttermilk.**		Burnt Umber + Blush Flesh
WATERMELONS	1. Basecoat with **Hauser Light Green.** Dry. 2. Sideload a 1-inch flat brush with **Hauser Medium Green.** Apply crisscrossing brush strokes randomly, softening the edges by blending slightly. 3. Repeat step two using **Plantation Pine** to create darker areas.		Plantation Pine and/or Black Green

Vegetables

SUBJECT	BACKGROUND TREATMENT	COLORS	CAST SHADOW COLORS
ARTICHOKES	Basecoat with **Titanium White.**		Orchid + Sapphire + Charcoal Grey
ASPARAGUS	1. Basecoat with **Burnt Umber.** Dry. 2. Then brush on Weathered Wood. Dry. 3. Gently brush on **Antique White.** The crackles will appear quickly, so don't go back and overstroke. Dry. 4. Spray on a light coat of sealer or matte varnish to protect the crackled surface before painting on it.		Khaki Tan
BEANS	1. Basecoat with **Midnite Blue.** 2. Using a 1-inch flat brush, scumble on **Plantation Pine**, crisscrossing strokes to soften edges.		Black Green
CARROTS	1. Basecoat with **Violet Haze.** Dry. 2. Use a 2-inch roller to roll on thinned **Prussian Blue**, beginning at the bottom and working toward the top, letting the color fade as you go.		Prussian Blue
CHILI PEPPERS	1. Basecoat with **Coral Rose.** Dry. 2. Use a 1-inch chip brush to streak on thinned **Toffee.**		Mink Tan

SUBJECT	BACKGROUND TREATMENT	COLORS	CAST SHADOW COLORS
CORN	Basecoat with a mixture of **Honey Brown** + **Yellow Ochre**.		Raw Sienna
EGGPLANTS	1. Basecoat with **Raw Umber**. Dry. 2. Apply Weathered Wood. Dry. 3. Using a 1-inch chip brush, streak with thinned **Antique White**. Dry. 4. Spray lightly with matte varnish, then streak with very thin **Burnt Umber, Honey Brown,** and scant Raw Umber.		Burnt Umber
GARLIC	Basecoat with **Mauve**.		Raw Umber + Plum
MUSHROOMS	1. Basecoat with **Cashmere Beige**. Dry. 2. Marbleize with **Burnt Umber** thinned with water plus Easy Float. Quickly brush on the mixture using a 1- to 1½-inch flat brush, reworking your earliest strokes as you go to keep them from drying. Immediately cover the painted surface with plastic wrap, pushing wrinkles into it. Try to create an all-over pattern with no long, uninterrupted wrinkles. Peel off the plastic wrap. Dry. 3. Brush on two or three layers of thinned Burnt Umber, drying after each application.		Burnt Umber + Midnite Blue
ONIONS	1. Basecoat with **Soft Peach**. Dry. 2. Use a 1-inch flat brush and thinned **Peach Sherbert** to apply the paint in long streaks. Avoid overstroking your initial brush strokes lest you lose the subtle variation in tones.		Peach Sherbert deepened with Shading Flesh
RADISHES	1. Using a 2-inch minipaint roller, basecoat with **Neutral Grey** + **Titanium White** + very little **Black Forest Green**. Dry. 2. With very little paint still remaining in the roller, pick up thinned **Dove Grey** and roll the paint on in long, parallel strokes, pressing hard to work the color out of the roller.		Blue Haze
SWEET PEPPERS	1. Use a 2-inch paint roller to basecoat with **Crimson Tide**. 2. On the upper third, roll on **DeLane's Cheek Color**, thinned slightly with water plus Easy Float. Roll in a random pattern, crisscrossing diagonally. 3. On the center third, roll **Georgia Clay** the same as in step 2, slightly overlapping the previous area, and blending into the still-wet paint. 4. On the lower third, roll **Napa Red** as before. Then work gradually upward with horizontal strokes over the center and slightly onto the top area, letting the color fade as you progress upward.		Napa Red + Black Forest Green
TOMATOES	1. Basecoat with **Titanium White**. Dry. 2. Mix a tiny bit of **Prussian Blue** with **Black Forest Green** and dilute to a watercolor consistency. Use a 2-inch roller to apply the paint, rolling in a random, crosshatching motion. Allow some of the background white to show through slightly.		Black Green

Flowers

SUBJECT	BACKGROUND TREATMENT	COLORS	CAST SHADOW COLORS	
AMARYLLISES	Basecoat with **Toffee**.		Mink Tan + Sable Brown	
CROCUSES	Basecoat with **Light Buttermilk**.		Blue/Grey Mist	
DAFFODILS	Mix **French Grey Blue** + **Lilac** + **Titanium White**. Apply with 2-inch roller.		French Grey Blue	
DAISIES	Basecoat with **Blue Haze**.		Blue Haze + Lamp (Ebony) Black	
GARDENIAS	Basecoat with **Ice Blue**.		Blue/Grey Mist + Buttermilk	
GERANIUMS	Basecoat with **Light Buttermilk**.		Blue/Grey Mist	
GRAPE HYACINTHS	Basecoat with **Ice Blue**.		Blue/Grey Mist shaded darker with Neutral Grey	
HIBISCUSES	1. Basecoat with **Bright Green**. Dry. 2. Brush on very thinned **Mistletoe** and cover quickly with plastic wrap to marbleize. Push wrinkles in the wrap; then peel it off. Dry. 3. To create the darker border, measure and mark the straight edges. Then apply tape to the inside edge of the marked lines. Seal edges lightly by burnishing them with the round back of a spoon. 4. Use a large flat brush to quickly and randomly brush on thinned **Black Forest Green** and **Dark Pine.** Then immediately, while the paint is still wet, repeatedly dab a crumpled wad of plastic wrap into it until you achieve a texture that suits you.		On light background: Leaf Green On dark background: Black Forest Green shaded darker with Black Green	
HOLLY	Basecoat with **Buttermilk**.		Thinned Blue/ Grey Mist	
HOLLYHOCKS	1. Basecoat with **Desert Sand**. Dry. 2. Use a 2-inch roller or brush to apply thinned **Khaki Tan** randomly. Then . . . 3. Immediately dab the wet paint with a sponge or crumpled wad of plastic wrap or a chamois cloth.		Khaki Tan + Sable Brown	

SUBJECT	BACKGROUND TREATMENT	COLORS	CAST SHADOW COLORS
IRISES	1. Basecoat with **Sea Aqua**. 2. Apply a wash of **Bluegrass Green** thinned with water and Easy Float or Brush 'n Blend Extender. Then immediately . . . 3. Use a 1-inch flat brush to scumble **Antique Teal** and **Viridian Green** randomly in the upper left area, across the top and down the left side. 4. Quickly dab with crumpled plastic wrap, working from the light area into the dark.		Antique Teal + Lamp (Ebony) Black
LILIES	1. Basecoat with **Green Mist**. Dry. 2. Quickly scumble large strokes of both **Arbor Green** and **Jade Green**. Then immediately . . . 3. Marbleize with plastic wrap.		Arbor Green + Charcoal Grey
MAGNOLIAS	Basecoat with **Hauser Dark Green** or **Rookwood Red**.		Black Green or Rookwood Red + Black Green
MARIGOLDS	Basecoat with **Light Buttermilk**.		Ice Blue shaded darker with Charcoal Grey
MISTLETOE	Basecoat with **Light Buttermilk**.		Blue/Grey Mist
MORNING GLORIES	1. Basecoat with **Hauser Dark Green**. Dry. 2. Use a 2-inch roller to apply a thinned coat of **Green Mist**. 3. Under the design area, scumble Hauser Dark Green and **Leaf Green**.		Hauser Dark Green + Black Green
PANSIES	1. Basecoat with **Taupe**. 2. Brush on a coat of thinned **Sable Brown**. Then . . . 3. Immediately marbleize with plastic wrap.		Sable Brown + scant Burnt Umber
POINSETTIAS	1. Basecoat with **Holly Green**. 2. With a 1/2- to 1-inch flat brush, scumble (by criss-crossing brush strokes randomly) **Hauser Dark Green, Bright Green, Plantation Pine**, and **Antique Teal**, alternating colors, and blending brush stroke edges to soften slightly.		Black Green
TRUMPET VINES	Basecoat with **Lamp (Ebony) Black**.		None

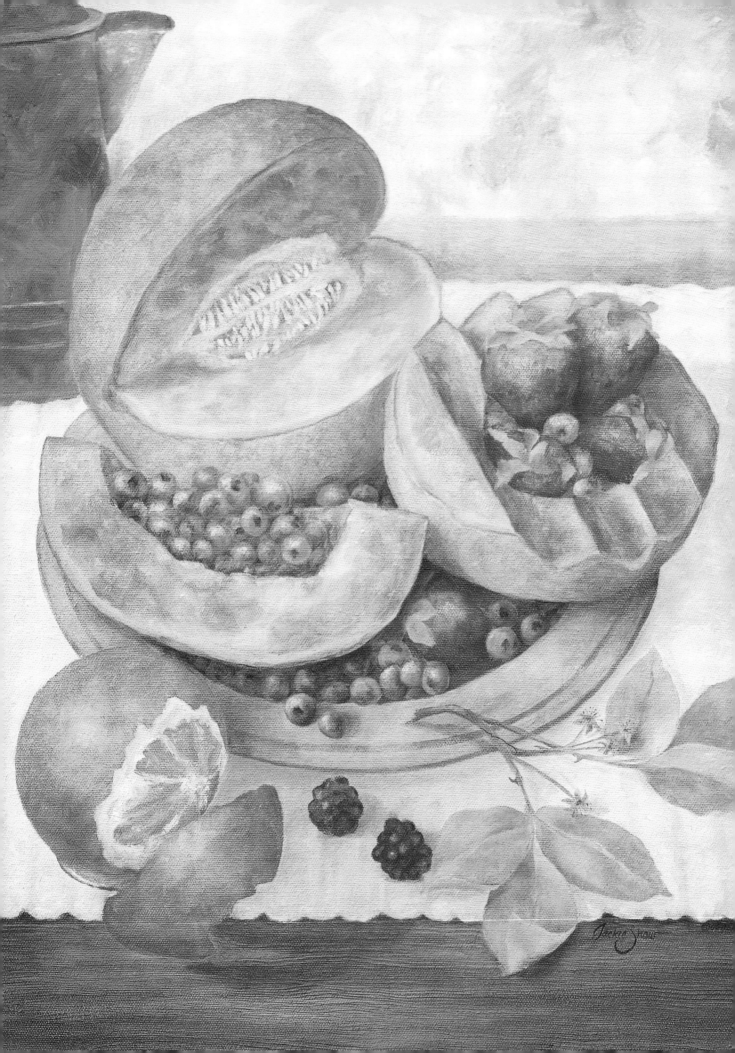

Step-by-Step Lessons:
Fruits

"The man who never made a mistake never made a discovery."
SAMUEL SMILES

This is it! We're ready to start discovering some of the wonderful things we can do with paint. The step-by-step lessons are in no particular sequence, so skip about as you like. Take a few minutes to scan the lessons in all three chapters to familiarize yourself with the various techniques and hints and where you might find them if you need a little extra elaboration for a particular lesson. Likewise, be bold and free enough to interchange techniques from one lesson to another. Then, abandon all fear of goofing up, with a carefree attitude jump right in!

Fear of making mistakes is one of the greatest obstacles to learning. Intimidation is another. I still recall anxiously the time I sat in a university classroom at an enormous drafting table, facing an equally formidable, expensive, and very white sheet of art board. I felt small and inadequate. Not wanting to ruin my pristine board with a single misplaced mark, I waited for divine intervention to strike. The professor, sensing my plight, approached. With his big, charcoal/pastels/paint-covered hands, he attacked my board, smearing and smudging it to ruin as I gasped in shock. Walking away he said, "There, now nothing you do to that board will ruin it." It was not the divine intervention I was anticipating! However, all those smudges and marks freed me to begin to work without fear of ruining my board. I'm sorry I can't be there to smudge away your intimidators. Just look on every painting attempt as an adventure and every mistake as a discovery, and have fun!

Blueberry Morning
16 × 20 inches, oil on canvas

This high key painting in complementary colors is rendered loosely. Notice the rhythm created by the repetition of the curves of the orange peel, the plate, and the cut edges of the melons. While the dominant line/shape is round, the zig-zag cut of the melon and the stiff, prickly stems of the blackberry leaves provide needed contrast.

Apples

Apples conjure up all kinds of rustic, down-home associations. After all, what is more American than "Mom's apple pie." An orchard is the perfect scene of tranquility, with the wonderful textures of the trees and leaves and the perfect springtime freshness of the blossoms. Apples, with their bold shape and color add strength to any picture. And, polished to a high gloss, they provide a perfect highlight.

Hints

1. Use the No. 10 flat brush to paint the apple, the Nos. 4 and 8 flat brushes to paint the leaves, and the No. 4 flat brush and the No. 1 liner brush to paint the stems. If you have an old, splayed bristle (hair) liner brush, use it to dab on the freckles in step 4.

2. Let's make these apples really glow. Beginning with a white undercoat followed by a bright yellow wash will do the trick. If you prefer a more subtle yellow, simply choose a more subdued undercoat, such as Moon Yellow (see a sample of that color on the bananas worksheet on page 89).

3. Notice how a dark, busy background, such as the one on the worksheet, calls for the more opaque coverage provided by a white undercoat. If you're working on a plain, light background you can skip the white undercoat.

4. In step 1, I show you two yellow options. I like the glow of the lighter yellow through the slightly more orange yellow. If you prefer a brighter apple, apply two coats of the bright yellow and omit the darker one.

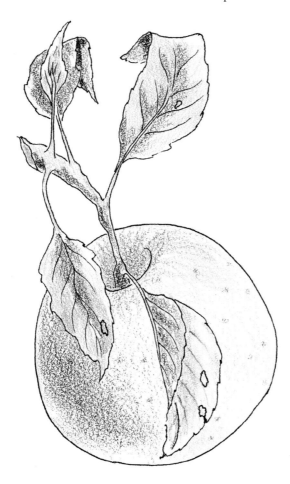

Contour Lines

To help you sense the three dimensionality of the apple (and other rounded subjects), draw contour lines on the pattern, starting at the center base of the apple and pulling upward into the stem depression. Then continue adding lines to each side, curving slightly outward. Notice how the tops and bottoms of the strokes curve toward the straight center line in the front, and away from it in the back. Also notice how that straight center line tilts with the axis of the apple. The apple in step 5 is more tilted than the one in step 4, so the color placement tilts accordingly.

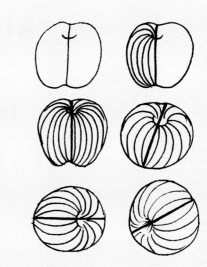

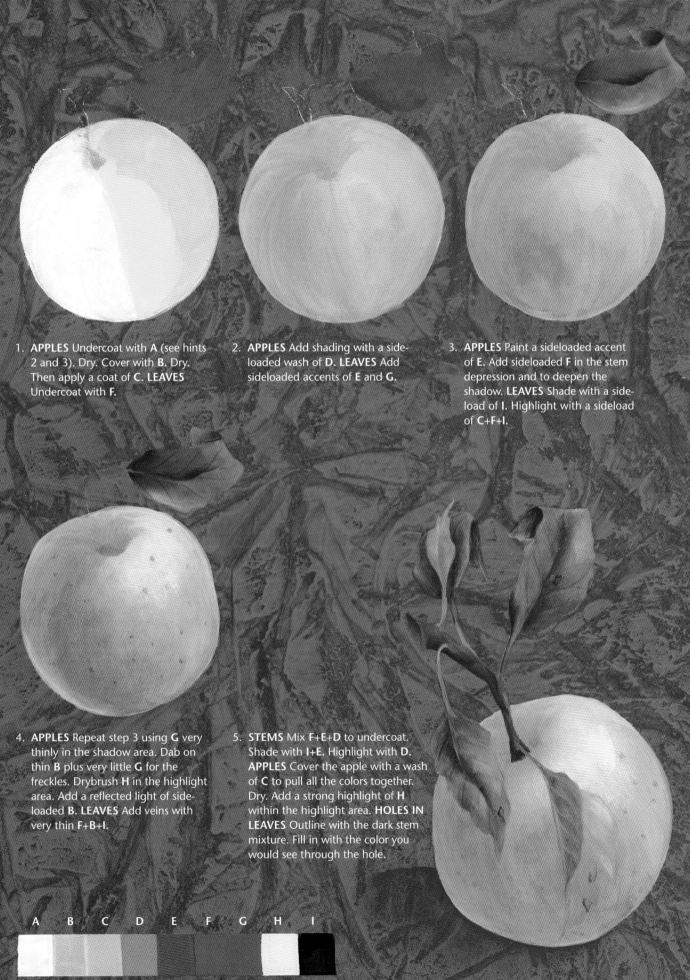

1. **APPLES** Undercoat with **A** (see hints 2 and 3). Dry. Cover with **B**. Dry. Then apply a coat of **C**. **LEAVES** Undercoat with **F**.

2. **APPLES** Add shading with a sideloaded wash of **D**. **LEAVES** Add sideloaded accents of **E** and **G**.

3. **APPLES** Paint a sideloaded accent of **E**. Add sideloaded **F** in the stem depression and to deepen the shadow. **LEAVES** Shade with a sideload of **I**. Highlight with a sideload of **C+F+I**.

4. **APPLES** Repeat step 3 using **G** very thinly in the shadow area. Dab on thin **B** plus very little **G** for the freckles. Drybrush **H** in the highlight area. Add a reflected light of sideloaded **B**. **LEAVES** Add veins with very thin **F+B+I**.

5. **STEMS** Mix **F+E+D** to undercoat. Shade with **I+E**. Highlight with **D**. **APPLES** Cover the apple with a wash of **C** to pull all the colors together. Dry. Add a strong highlight of **H** within the highlight area. **HOLES IN LEAVES** Outline with the dark stem mixture. Fill in with the color you would see through the hole.

A B C D E F G H I

Apples Reference Photos

Fortunately for us painters, there are thousands of varieties of apples, giving us a wide range of colors, sizes, and shapes from which to choose subjects for our paintings. Apples can be elongated, round, angular, streaked, freckled, and more. For creating paintings, we can also draw great inspiration from the variety of uses for apples: for eating; for making jelly, preserves, pies, desserts; for juice and cider; and for keeping the doctor away!

Bananas

PALETTE
A Moon Yellow
B Sand
C Antique White
D Raw Umber
E Forest Green
F Dioxazine Purple
G Pineapple
H French Grey Blue
I Sable Brown
J Marigold

BRUSHES
Flats: Nos. 6 and 8
Liner: No. 10/0

By including a partially peeled banana in a painting, we can create the illusion of interrupted activity—thus adding interest to the painting, and possibly creating anticipation or curiosity in the viewer. Plus, the soft texture of the inner skin provides a pleasing contrast, especially if there are other unpeeled bananas in the painting.

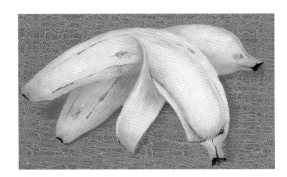

Hints

1. Use the largest flat brush you can handle for all work except the details in steps 2 and 5. Use the liner brush for the details.
2. Apply shading colors in very thin washes to build up the depth of shading gradually. It's easy to make shading darker with successive thin coats; it's much more difficult to lighten too heavy an application. Allow paint to dry thoroughly between applications.
3. If you're not fond of the bold, contrasting colors (blue and yellow) used on the worksheet, try some other combinations, such as the ones shown at right.

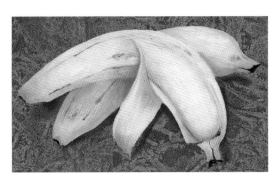

Notice how I've carried the background colors into the bananas. This makes a bridge from the subject to the background—or, in other cases, to the neighboring object—offering the eye some areas of smooth transition from one color to another.

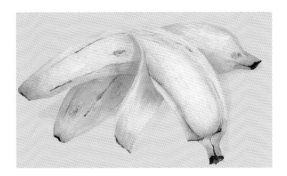

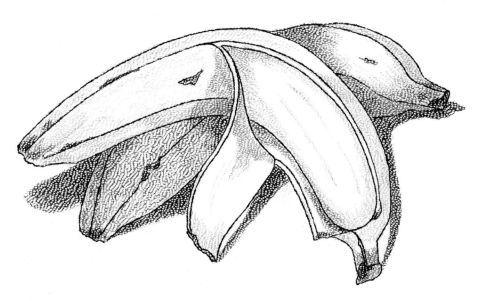

1. Undercoat the banana peels with **A.** Undercoat the fruit with **B** and the inside of the peel with **C+B.**

2. Shade the inside of the peel with **C+D.** Use the liner brush and **C+D** to paint thin lines on the fruit. Shade the peels with **A+F.** Tinge the tips of the banana peels with a side-loaded wash of **E.**

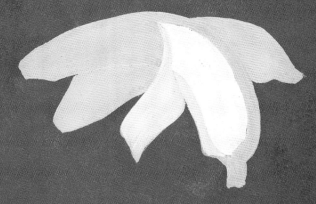

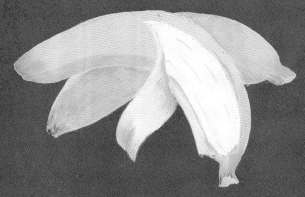

3. Scumble touches of **G** on the peel. Shade the peel with a sideloaded wash of **H.**

4. Shade the fruit first with **C,** then with **I.** Intensify the shading on the inside of the peel with **I.** Scumble a thin wash of **J** over the peels.

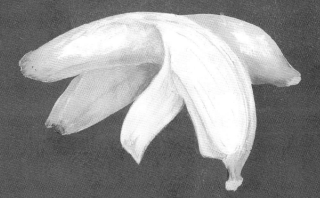

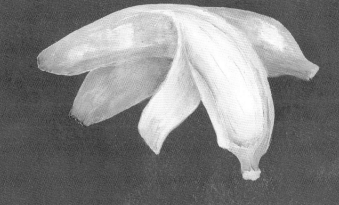

5. Use the liner brush to paint the edges of the open peel with **A+J.** Intensify the shading on the fruit and the inside of the peel, and add blemishes on the peels with scant amounts of **D.**

A B C D E F G H I J

Bananas Reference Photos

The bright, happy yellow color and long curving shapes of bananas can add a pleasing accent to our paintings. Their geometry also allows us to pose them in many ways to complement an arrangement. Study the effects light and shadow have on the various planes. A loosened banana peel adds an element of casualness. And painting the loosened peel can provide an exercise similar to the one suggested earlier in the book (see exercise 4 of "Reflected Lights" on page 57) for painting white eggs on a white cloth. Peel a banana and look closely for the subtle color variations between the fruit of the banana and the inside of the peel.

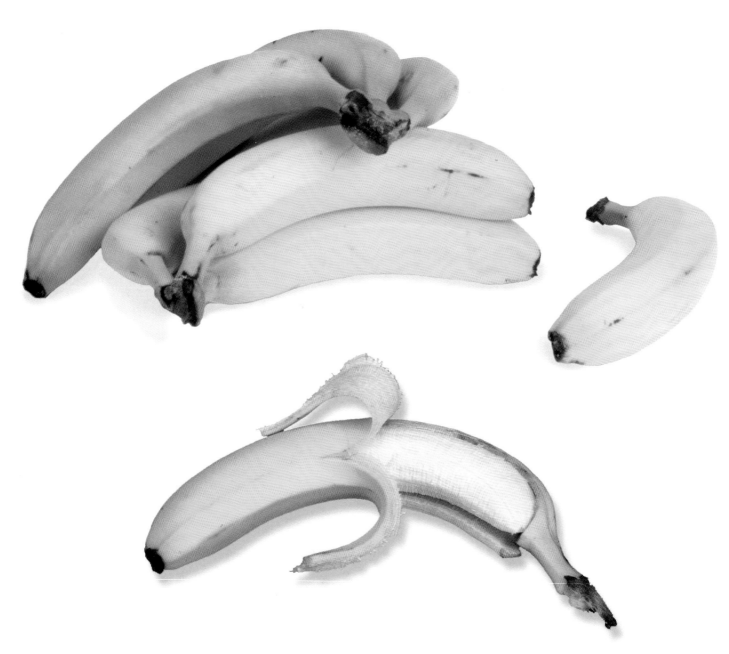

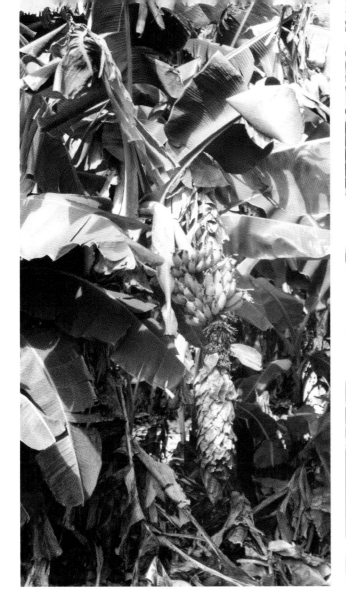
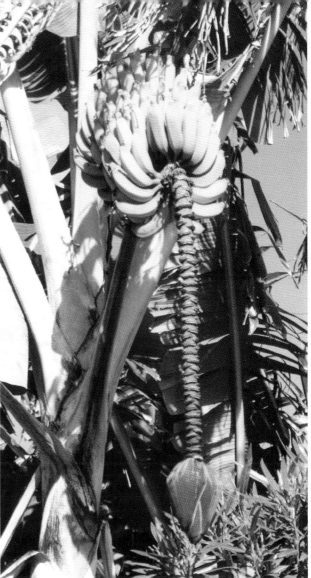
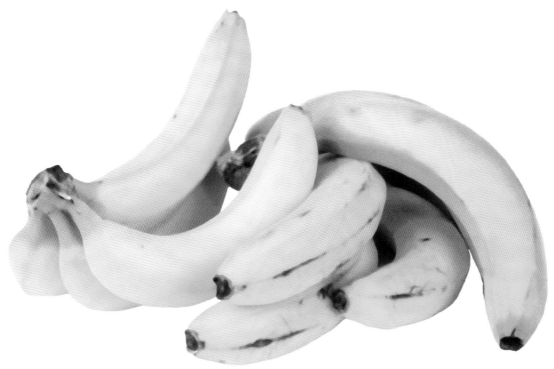

Blackberries

A late summer and early fall fruit, the purplish black color of the blackberries adds a strong contrast when painted in conjunction with yellow or gold pears. There are both thornless and thorny varieties. I find the latter more interesting because of the contrasting detail of the thorns. The calyx with its fuzzy stamens also adds visual interest.

Hints

1. Use the No. 6 flat brush to paint the leaves and berries. Use the No. 1 flat brush to add highlights and reflected lights to the berries and to paint the stem. Use the liner brush to paint fine details and leaf veins.

2. Paint the leaves first. Then, while painting the berries, brush some thinned berry colors at random on the leaves. This will help unify the colors in the composition. The darker berry colors, thinned, help accentuate shadow areas. Paint the stems using the leaf colors and techniques.

3. Don't worry if at first the leaf highlights, shadows, and color washes seem to appear too harsh. We'll tint them in step 4 with washes of greens to gently submerge the colors into the leaf.

4. Add the reflected lights in step 3 with a sideloaded No. 1 flat brush and very thin paint to enhance the juiciness of the drupelets.

5. Make berries appear more realistic by painting some drupelets in various stages of ripening. Do this in step 4— as illustrated on the green berry— by applying a thin wash of a different color to a few of the drupelets.

6. In step 4 of the blackberry directions, you will see colors listed with a slash ("/") between them. The letter to the left of the slash is the highlight color; letters to the right of the slash are the shading colors.

Quick and Easy Blackberries

After undercoating the blackberries, a quick and easy way to paint the drupelets (the little round balls that form each berry) is to use a well-worn, rounded pencil eraser.

1. Dip the eraser in a smear of wet paint on your palette. Dab the eraser once or twice on a fresh spot on the palette to remove excess paint.

2. Begin working on the outside of any berries that lie behind other berries. That way, drupelets from the underneath berries will not overlap the upper berries. Press the eraser first around the outer edge of the undercoated berry; then work inward in decreasing concentric circles.

3. If you used too much paint, and your first one or two imprints appear too heavily painted, just continue making imprints on the berry until your eraser is out of paint. Then quickly return to the overly painted drupelets and press the dry eraser in them to lift and smooth excess paint.

4. To make juicy, ripe berries, press hard on the eraser to broaden the imprint. To make unripe, green berries, barely press the eraser.

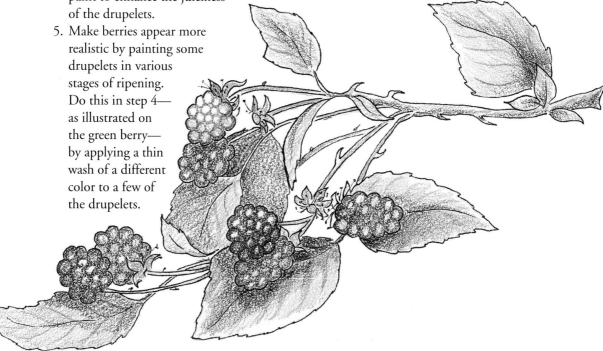

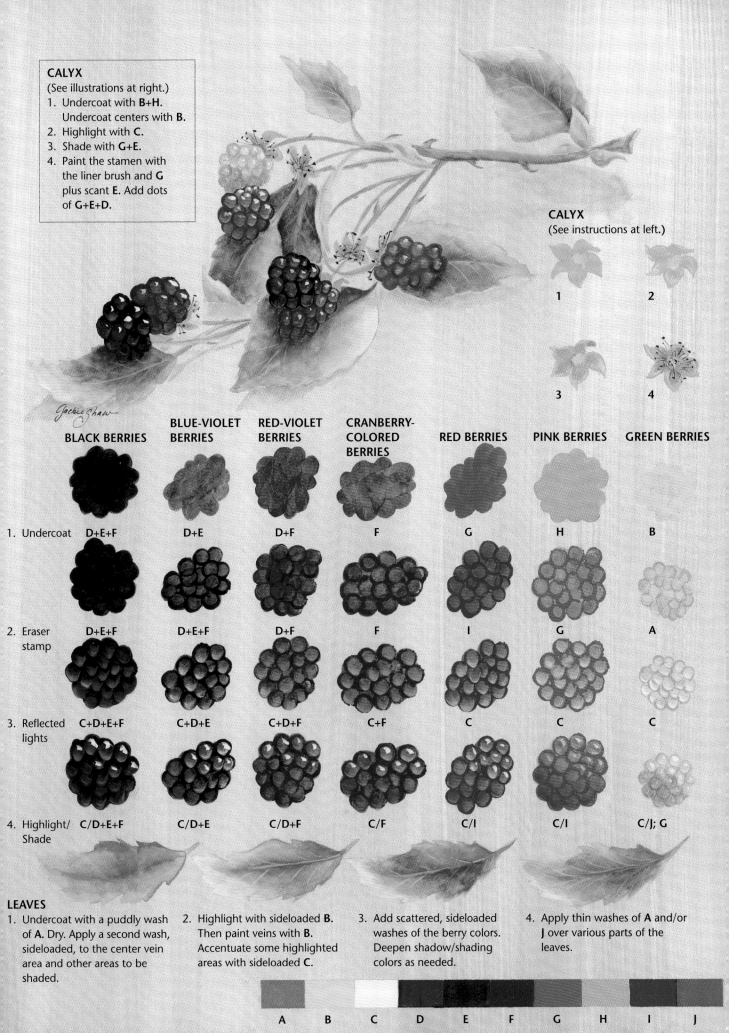

CALYX
(See illustrations at right.)
1. Undercoat with **B+H**. Undercoat centers with **B**.
2. Highlight with **C**.
3. Shade with **G+E**.
4. Paint the stamen with the liner brush and **G** plus scant **E**. Add dots of **G+E+D**.

CALYX
(See instructions at left.)

1

2

3

4

Jackie Shaw

	BLACK BERRIES	BLUE-VIOLET BERRIES	RED-VIOLET BERRIES	CRANBERRY-COLORED BERRIES	RED BERRIES	PINK BERRIES	GREEN BERRIES
1. Undercoat	D+E+F	D+E	D+F	F	G	H	B
2. Eraser stamp	D+E+F	D+E+F	D+F	F	I	G	A
3. Reflected lights	C+D+E+F	C+D+E	C+D+F	C+F	C	C	C
4. Highlight/ Shade	C/D+E+F	C/D+E	C/D+F	C/F	C/I	C/I	C/J; G

LEAVES

1. Undercoat with a puddly wash of **A**. Dry. Apply a second wash, sideloaded, to the center vein area and other areas to be shaded.

2. Highlight with sideloaded **B**. Then paint veins with **B**. Accentuate some highlighted areas with sideloaded **C**.

3. Add scattered, sideloaded washes of the berry colors. Deepen shadow/shading colors as needed.

4. Apply thin washes of **A** and/or **J** over various parts of the leaves.

A B C D E F G H I J

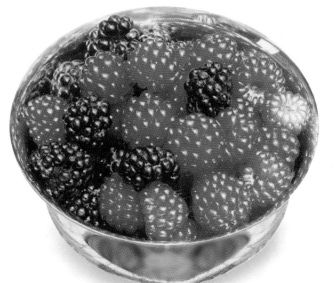

Blackberries Reference Photos

Blackberries exhibit a variety of colors—not just black. Study the sequence of development to see how the color changes as the berries mature. With their many glistening points of light, blackberries can remind us of black diamonds in a bowl. They also imply lushness as we imagine indulging in a mouthful. (Now there's a sensation to try to suggest through painting!) And we can't help but wince as we see them on their thorny branches and remember the difficulty of picking them.

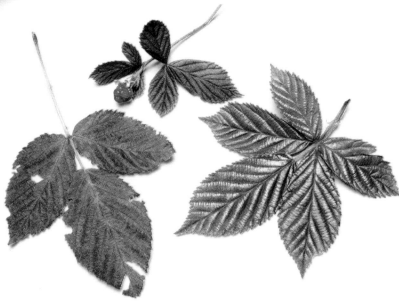

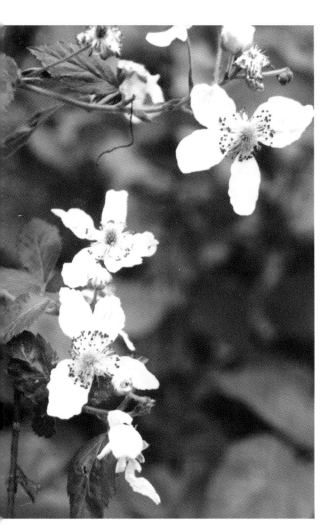

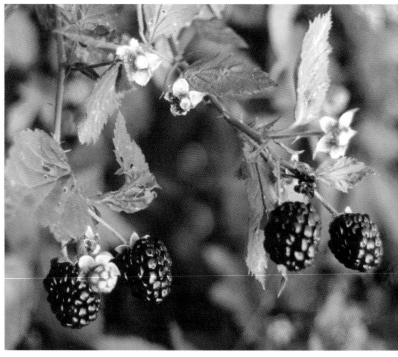

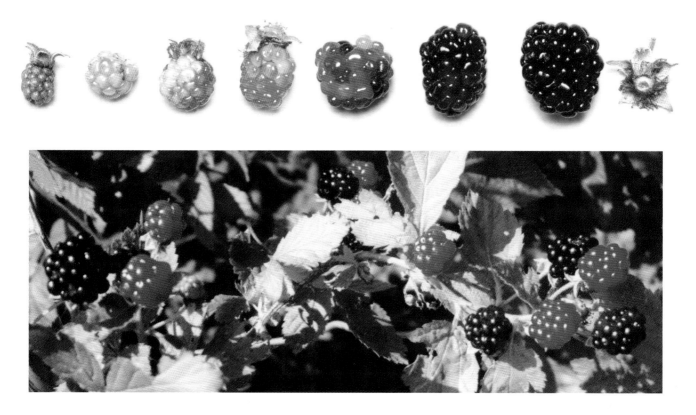

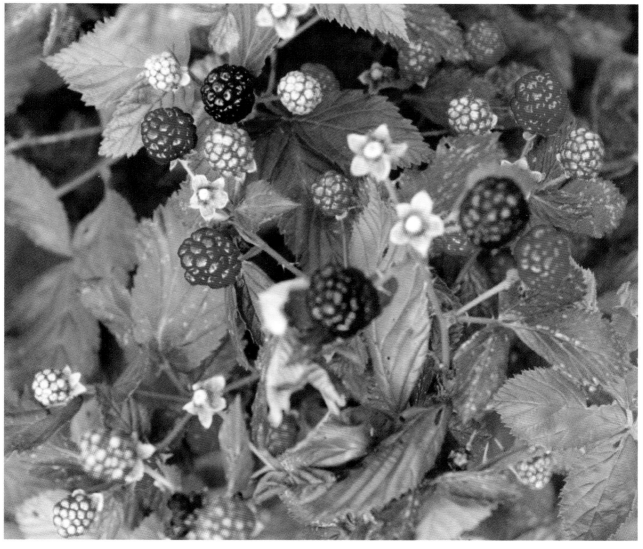

Blueberries

PALETTE
A Williamsburg Blue
B Dioxazine Purple
C Navy Blue
D Lamp (Ebony) Black
E Buttermilk
F Avocado
G Dove Grey
H Toffee
I Mink Tan
J Milk Chocolate

BRUSHES
Flats: Nos. 2, 4, and 8
Round: No. 0

MEDIUM
Brush 'n Blend Extender

I've included my recipe for making all sorts of pies below. But, since I prefer to paint rather than cook, I paint pies instead of cooking them. It's easily as much fun, and there are no calories. It just doesn't satisfy the sweet tooth.

Hints

1. Use the No. 2 and No. 4 flat brushes to paint the berries and leaves. Use the round brush to paint the blossom opening and the leaf veins. Use the No. 8 flat brush to paint the pie crust and juice.
2. Notice how effectively the splotchy application of color in step 2 adds variations, interest, and realism to the finished berries.

3. To drybrush the highlights in step 5, hold the brush parallel to the surface and barely skim across the berries.

You can easily create a border using the blueberries in this lesson. Design a simple arrangement of berries, then paint continuous repetitions. Add contrasting or harmonizing stripes to hold it all together.

Add Crust and Syrup to Make a Pie

You can also use this recipe to create other fruit pies, such as strawberry, blackberry, peach, and apple.

1. Use the No. 8 flat brush for the crust. Undercoat the crust with **H**. Then drybrush on highlights of **E**.
2. Dip the brush in water, then in **H**. Next, pick up a little **I** on one corner. Blend slightly on the palette, then dabble onto the crust. Darken shadows with a sideload of thinned **J**.
3. Paint berries as shown on the worksheet.
4. Paint syrup with **B**+**C** plus Brush 'n Blend Extender. Brush thinly over the berries letting color spill out of the crust.

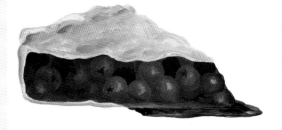

3 & 4

LEAVES

1. Undercoat the leaves with **F**.

2. Paint the veins with a mixture of **E+F**. Then highlight the leaf with sideloaded, thinned **E+F**.

3. Shade the leaves with a mixture of **C+D**. Then add accents with thinned **B**.

BERRIES

1. Undercoat some of the berries with **A** and some with a darker mixture of **B+C**.

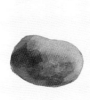

2. Brush a thinned mixture of **B+C** on the light berries and thinned **A** on the dark ones. Make the strokes choppy.

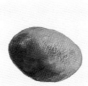

3. Loosely brush a thinned mixture of **G+A** on the light berries and **A+G** on the dark ones. While wet, use a damp flat brush to lift out patches of color.

4. Shade the lower left side of each berry with a mixture of **C+D**.

5. Drybrush a highlight along the upper right side of each berry with **E**.

6. Use the round brush to paint the blossom opening with a mixture of **C+B**. Add a strong highlight of **E** to each berry, then accent the opening with both light and dark blues (**A** and **C**).

7. Paint a reflected light along the lower left (opposite the highlight) of each berry with a mixture of **E+A+B**.

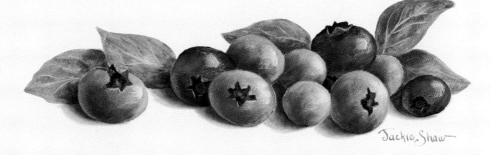

Jackie Shaw

A B C D E F G H I J

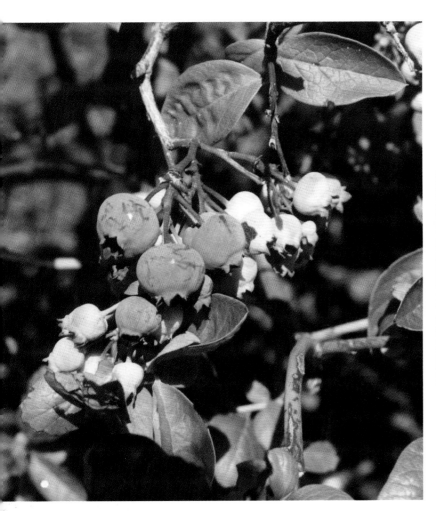

Blueberries Reference Photos

Blueberries look the picture of health in a bowl. They can be easily scattered around a composition, surreptitiously unifying the picture with their small, but strong bits of color. Notice some of the variations of color tinges, especially as the berries mature.

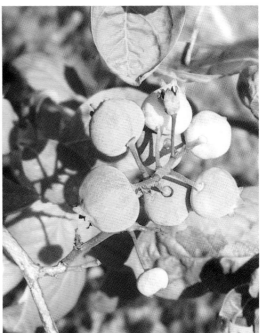

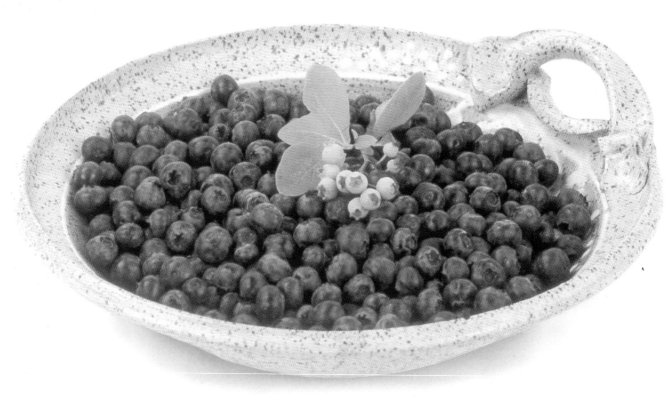

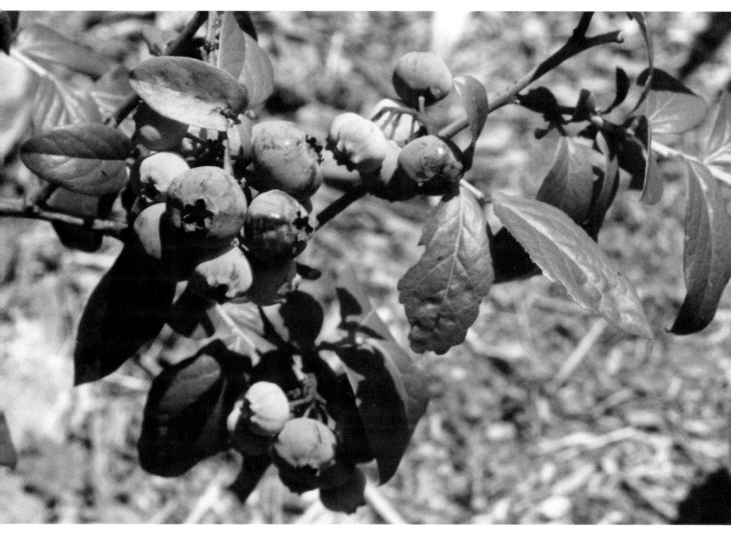

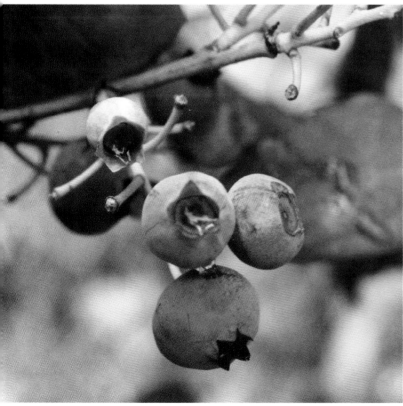

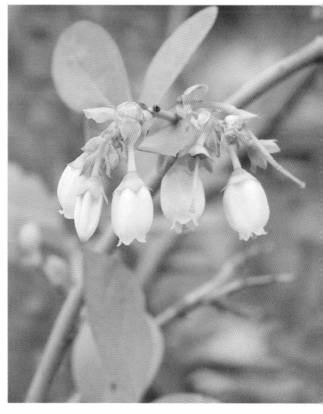

Cantaloupes

PALETTE

A Tangerine
B Cadmium Yellow
C Light Buttermilk
D Burnt Orange
E Leaf Green
F Antique Green
G Yellow Ochre
H Antique White
I Mississippi Mud
J French Grey Blue + Royal Purple

BRUSHES

Flat: No. 8
Round: No. 2
Liner: No. 2

Create a painting in a complementary color scheme by combining cut cantaloupes with blueberries. Or, try an analogous color scheme by combining the cantaloupes with cherries and bananas.

Hints

1. Use the flat brush to paint the flesh and the rind, the round brush to paint the seeds, and the liner to "doodle" on the rind.
2. By working with short, choppy, scumbling strokes and alternating colors in step 1, you will be able to paint fresh, juicy-looking fruit flesh. Avoid overworking the strokes lest you blend away the freshness.
3. In step 2, place the paint side of the sideloaded brush along the skin edge of the cantaloupe.
4. For best results, paint seeds and doodles on the skin freehand.

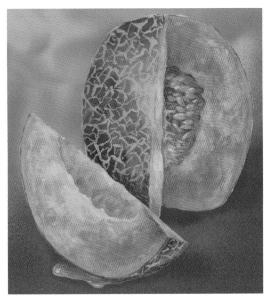

We normally think of a slice of chilled cantaloupe as refreshingly cool, but it seems almost hot here against this cold, watery background.

FLESH

1. Undercoat the flesh by scumbling short, choppy strokes randomly with **A**, a mixture of **A+B**, and a mixture of **A+B+C**. Add occasional thin touches of **D** for variety.

2. Sideload the flat brush with a mixture of **E+A+B**. Paint the green portion of the flesh closest to the rind. Using the liner brush, paint the edge of the rind with a thin line of **F**.

SEED MASS

1. Scumble a mixture of **A+D+F** in the seed cavity.
2. Load the round brush with a mixture of **C+A+F** and paint teardrop-shaped seeds.
3. Highlight the seeds and paint the seed stems with a mixture of **C+A+B**.
4. Apply a wash of **A** over the entire seed cavity.

RIND

1. Undercoat the rind with scumbled patches of **G**, **F**, and a mixture of **F+E**.

2. Load the liner brush with **H** and paint doodle lines of varying thicknesses on the rind.

3. Sideload the flat brush with thinned **I** to shade the rind. Apply additional shading and shadows with thinned **J**.

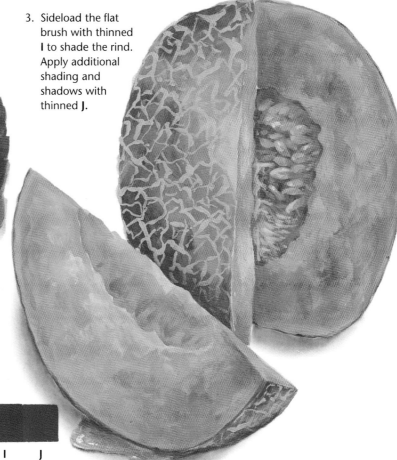

A B C D E F G H I J

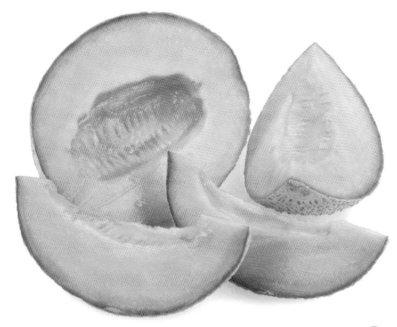

Cantaloupes Reference Photos

When a painting needs texture, consider the cantaloupe. Look at that busy, interlocking network of lines on the skin, and the fibrous mass holding all those seeds! Contrast all that with the smooth, succulent flesh. Some different ways of cutting the cantaloupe are illustrated here: Notice what clean, rather geometric lines the cut slices create.

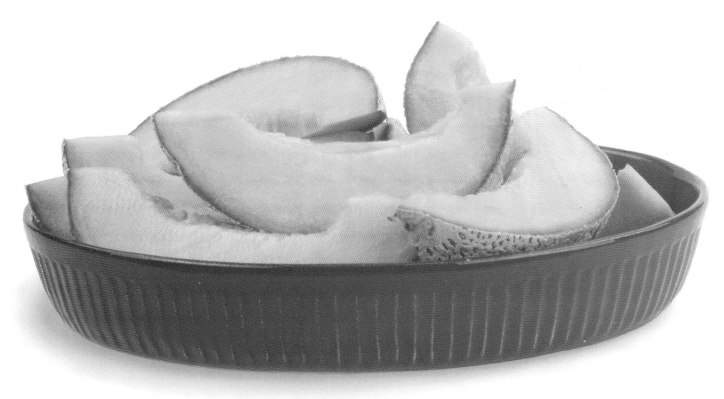

Cherries

PALETTE
A Gooseberry
 Pink
B Blush Flesh
C Napthol Red
D Napa Red
E Cranberry
 Wine
F Taffy Cream
G Desert
 Turquoise
H Celery
 Green
I Light
 Avocado
J Evergreen
K Yellow
 Green

BRUSHES
Flats: Nos. 4, 6,
 and 8
Liner: No. 1

Cherries are available in a great number of shapes and colors. As small fruits, they are handy to use for filling in areas in your painting, or to scatter as needed to help repeat colors in different areas. Clusters can be used for hanging or draping.

Hints

1. Use the No. 8 flat brush to paint the leaves, the No. 6 flat brush for the cherries, and the liner brush for the leaf veins and to basecoat the stems.

2. To paint lateral veins on both sides of the leaves, sideload the No. 8 flat brush (use the No. 4 on the smallest leaves) with very thin **J**. Begin at the base of the leaf with the color side of the brush facing toward the leaf tip. Paint a gentle, curving stroke, in the shape of a stretched out S, from the center vein toward the margin of the leaf. Immediately make the next stroke, allowing the water side of the brush to overlap slightly the previous stroke and soften it.

3. To paint the underside of the leaf, paint through step 3. Then delineate the veins with the liner and **K+F**. Next, sideload the No. 8 flat brush with **J**. Holding the paint side of the brush facing the center vein, paint an inverted V shape to tuck into the space between the lateral veins, thus shading between the veins. Dry. Then brush over the leaf with **K** or **J+K**. Dry. Drybrush the leaf with **F**.

4. For an idea how red cherries might look on a different-colored background, see page 56 and the lessons on currants and gooseberries (page 108), chili peppers (page 182), radishes (page 206), and tomatoes (page 214).

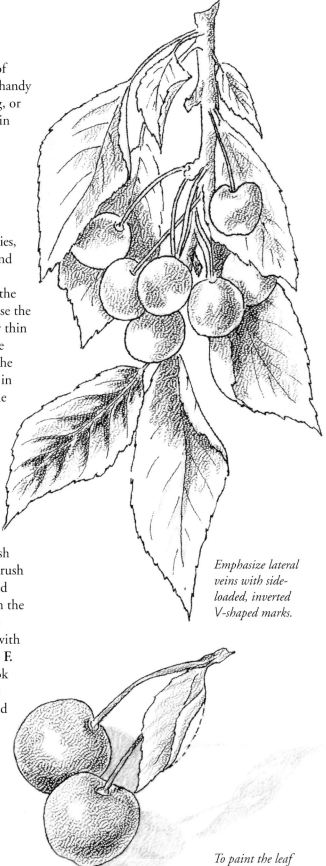

Emphasize lateral veins with sideloaded, inverted V-shaped marks.

To paint the leaf without a turned edge, use the dotted line on this pattern.

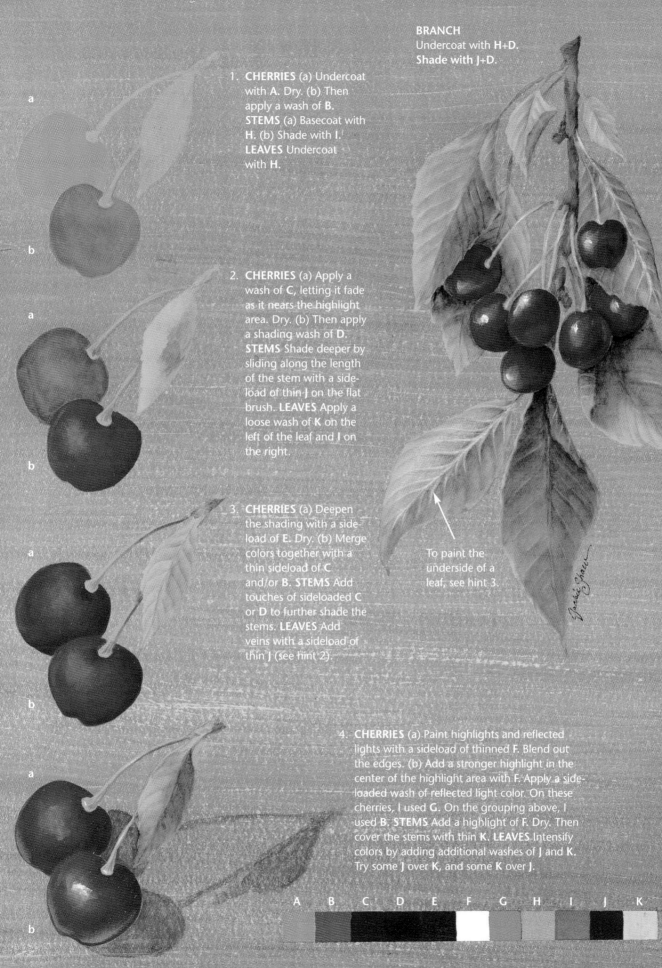

BRANCH
Undercoat with **H+D**.
Shade with **J+D**.

a

1. **CHERRIES** (a) Undercoat with **A**. Dry. (b) Then apply a wash of **B**. **STEMS** (a) Basecoat with **H**. (b) Shade with **I**. **LEAVES** Undercoat with **H**.

b

a

2. **CHERRIES** (a) Apply a wash of **C**, letting it fade as it nears the highlight area. Dry. (b) Then apply a shading wash of **D**. **STEMS** Shade deeper by sliding along the length of the stem with a side-load of thin **J** on the flat brush. **LEAVES** Apply a loose wash of **K** on the left of the leaf and **I** on the right.

b

a

3. **CHERRIES** (a) Deepen the shading with a side-load of **E**. Dry. (b) Merge colors together with a thin sideload of **C** and/or **B**. **STEMS** Add touches of sideloaded **C** or **D** to further shade the stems. **LEAVES** Add veins with a sideload of thin **J** (see hint 2).

To paint the underside of a leaf, see hint 3.

b

a

4. **CHERRIES** (a) Paint highlights and reflected lights with a sideload of thinned **F**. Blend out the edges. (b) Add a stronger highlight in the center of the highlight area with **F**. Apply a side-loaded wash of reflected light color. On these cherries, I used **G**. On the grouping above, I used **B**. **STEMS** Add a highlight of **F**. Dry. Then cover the stems with thin **K**. **LEAVES** Intensify colors by adding additional washes of **J** and **K**. Try some **J** over **K**, and some **K** over **J**.

b

A B C D E F G H I J K

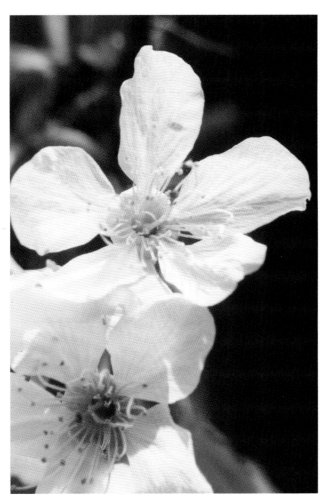

Cherries Reference Photos

How can you tell that I was photographing the cherry tree trunk and limb at an upward angle rather than at eye level? Answer: The horizontal lines in the bark are curving downward to meet my eye level or where I would see the horizon line by looking straight ahead. Draw horizontal lines around a paper towel tube. Note how the direction of the curvature of the lines seems to change as you stand the tube on end on top of the refrigerator, then on the counter, then on the floor. If you have trouble seeing this effect, stand farther away from the tube. Trust your eyes, and ignore your brain telling you the lines are all even and straight around the tube.

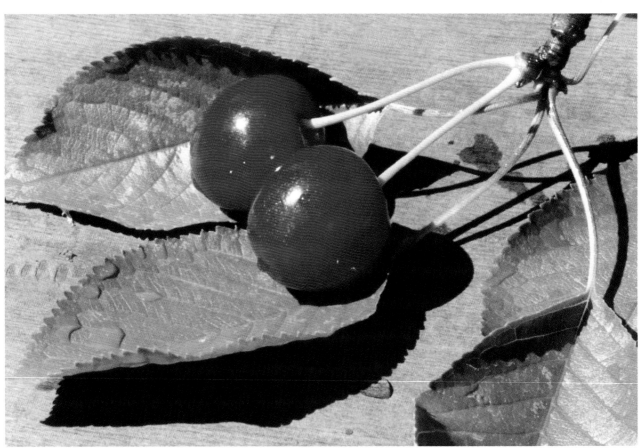

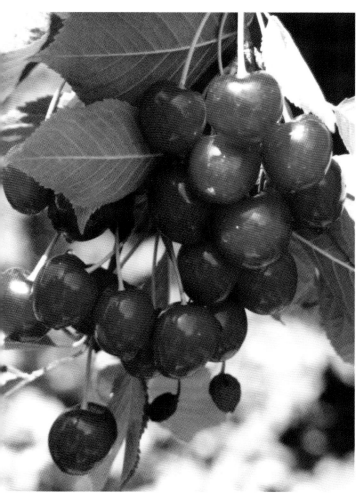
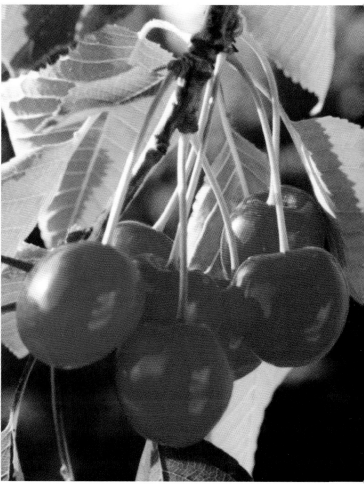
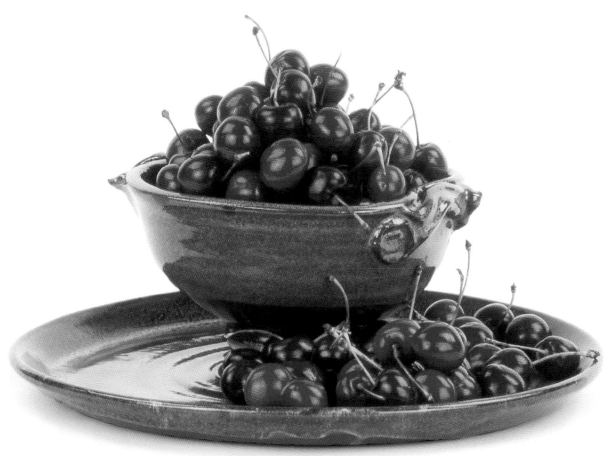

Currants and Gooseberries

CURRANTS PALETTE
A Coral Rose
B Yellow Ochre
C Cadmium Red
D Napthol Red
E Sand
F Plantation Pine
G Hauser Light Green

GOOSE-BERRIES PALETTE
A Moon Yellow
B Taffy Cream
C Light Avocado
D Avocado
E Buttermilk
F Plantation Pine
G Cadmium Red

BRUSHES
Flats: Nos. 4 and 6
Liner: No. 1

If you need some small berries to fill out a composition, currants or gooseberries may be just what you're looking for. There are over 100 species in the gooseberry/currant family, offering lots of color variety: red, white, and black currants; red, yellow, green, and white gooseberries. And if it's subtle texture you need, some gooseberries, depending on the cultivar, are hairy, and they have thorns!

Hints

1. Use the No. 4 flat brush to paint the berries and the branches and the No. 6 flat brush to paint the leaves. Paint the stems and berry veins with the liner brush.
2. To paint the leaves, apply a puddly undercoat. The resulting value changes will give your leaves interesting texture and variety.

GOOSEBERRIES
To paint gooseberries, follow the procedures for painting currants, substituting colors as follows:
1. Undercoat the berries with **A**. Paint the veins with a thick application of **B**.
2. Apply a thin wash of **C** over the berries, making sure the veins show through.
3. Shade the berries with **D**; highlight with **E**.
4. Paint the blossom ends with **F+G**. Paint the fine hairs with thinned **B**.

Contour Lines

When painting the veins in the berries, follow the contour lines (see "Contour Lines," page 84). Contour lines can also help you paint the zig and zag of the branches and to suggest their roundness. Notice how the outlines for both branches in the figure are the same. Yet, the different directions of the contour lines on each branch make the branches appear to be bending in different directions.

Currants

Gooseberries

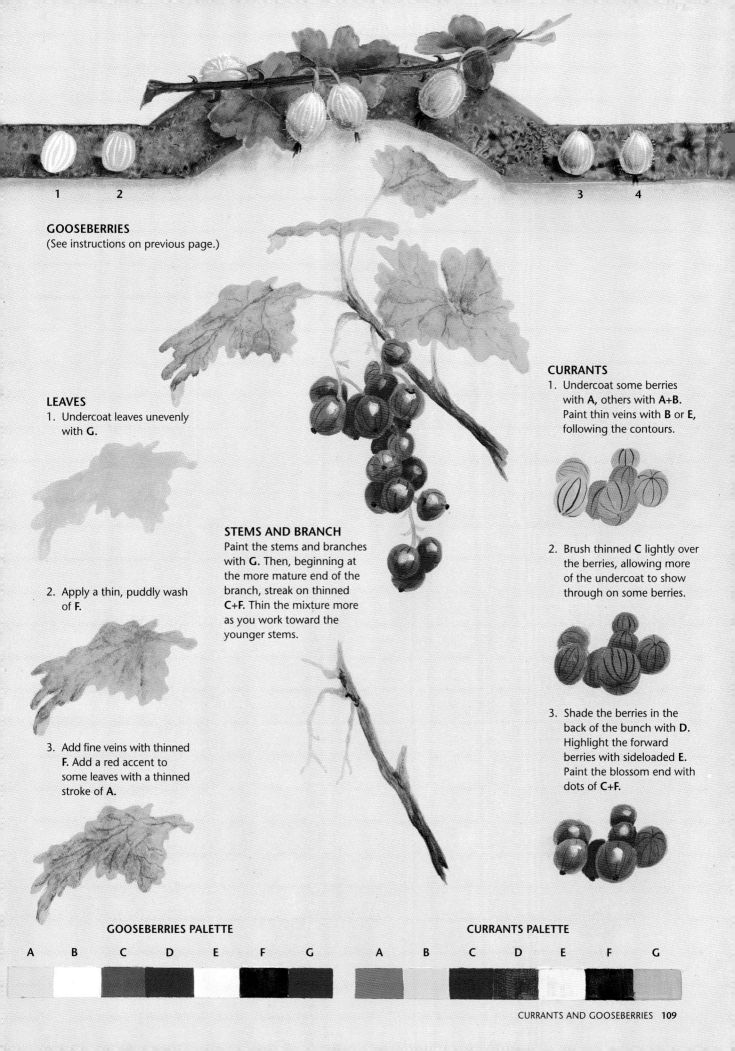

1 2 3 4

GOOSEBERRIES
(See instructions on previous page.)

LEAVES
1. Undercoat leaves unevenly with **G**.

2. Apply a thin, puddly wash of **F**.

3. Add fine veins with thinned **F**. Add a red accent to some leaves with a thinned stroke of **A**.

STEMS AND BRANCH
Paint the stems and branches with **G**. Then, beginning at the more mature end of the branch, streak on thinned **C+F**. Thin the mixture more as you work toward the younger stems.

CURRANTS
1. Undercoat some berries with **A**, others with **A+B**. Paint thin veins with **B** or **E**, following the contours.

2. Brush thinned **C** lightly over the berries, allowing more of the undercoat to show through on some berries.

3. Shade the berries in the back of the bunch with **D**. Highlight the forward berries with sideloaded **E**. Paint the blossom end with dots of **C+F**.

GOOSEBERRIES PALETTE

A B C D E F G

CURRANTS PALETTE

A B C D E F G

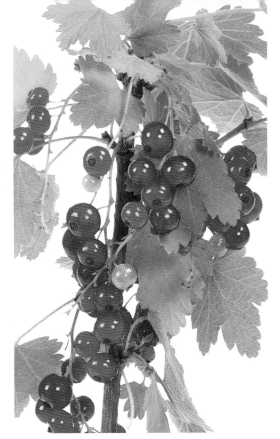

Currants and Gooseberries Reference Photos

Currants and gooseberries can provide quite a bit of detail in a painting, with their dark blossom ends, glittery highlights, radiating veins, and plentiful stems. Study the leaves in the photographs to see how the appearance of the veins on the top and undersides vary. Compare the different textures on the berries.

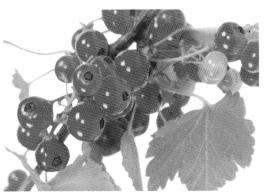

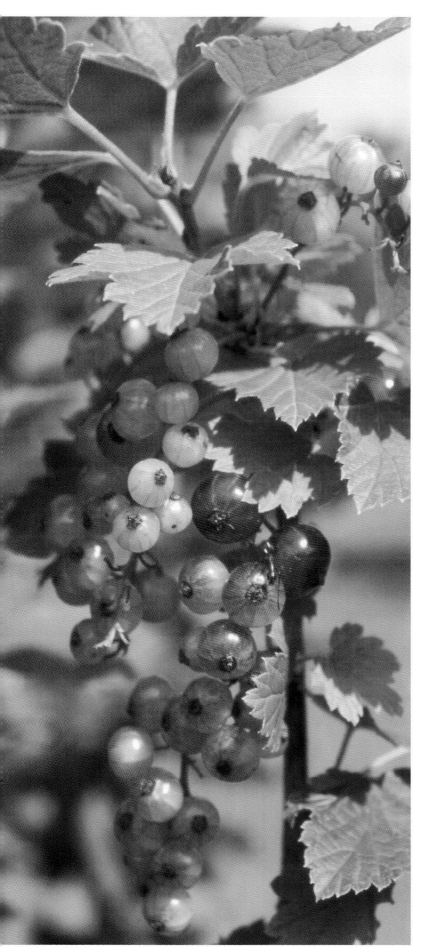

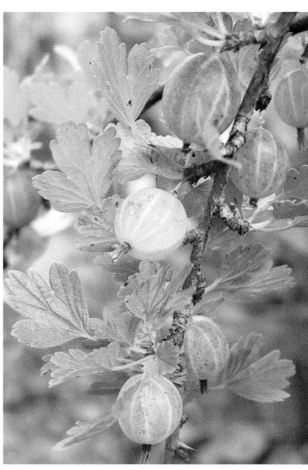

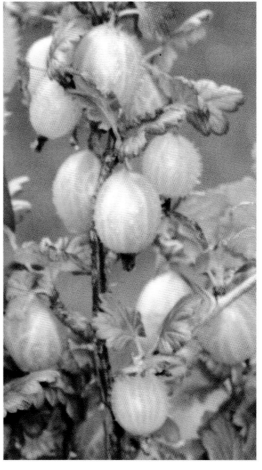

Figs

PALETTE
A Marigold
B Yellow Light
C Blush Flesh
D Plum
E Black Plum
F Yellow
 Green
G Hauser
 Medium
 Green
H Buttermilk

BRUSHES
Flats: Nos. 4
 and 10
Liner: No. 10/0

MEDIUM
Easy Float

The once "little fig tree" in my garden recently spurted to outrageous proportions in spite of our drought. Its whopping production of figs was enjoyed mostly by the chipmunks who savored them unaffected by my reproachful glare a mere two feet away. I guess if Adam and Eve thought the expansive fig leaves provided adequate coverage, those mischievous marauders probably felt quite invisible.

Hints

1. Use the No. 10 flat brush to paint the skin, the No. 4 flat brush to paint the flesh and stems, and the liner to paint the seeds and scars.

2. If you are working on a red, salmon, plum, or violet background, it is not necessary to undercoat your figs solidly. Notice how I've allowed some of the background color to peek through. This helps unify the subject with the background color.

3. Moisten the undercoated fig with an even, thin layer of water or water plus Easy Float to facilitate flowing the washes in steps 3 and 4. Blot the blossom end so that area is slightly drier and will accept more paint. Thin the paint with Easy Float and water. Brush on the color; then with a clean, damp brush, quickly wipe back from the stem end to lift out a bit of color, exposing the yellow underneath.

4. If any of your paints feel slippery and thus apply too transparently, let the first application dry, then apply additional thin coats until you obtain the depth of color desired.

5. To apply a highlight that seems to be a part of the fruit and not just a blob of paint slapped on, try this: Moisten the area to be highlighted with a little water plus Easy Float. Wipe away any excess with your finger. With a sideloaded brush, apply the highlight color. Then, using the clean side of the brush, gently work the edges of the highlight color into the underlying moisture.

6. As you apply succeeding layers of color, be careful not to totally obliterate the underlying colors; they are what make the fruit appear to glow color from within (see completed sketch in step 6).

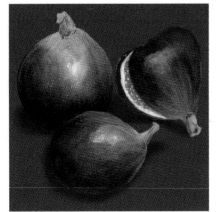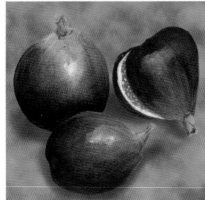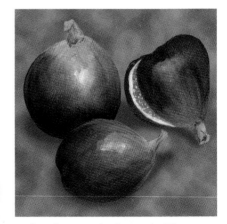

In all three backgrounds, even though I used colors from the figs themselves, the low intensity colors showcase the figs nicely. The strong, full range of value contrasts within the figs makes them effective on the light, the medium, and the dark value backgrounds.

1. Undercoat the stem and fruit with **A** (see hint 2). Lightly brush on **B** near the stem area, pulling strokes to follow the fig's contours.

6. Dab **D** plus scant **F** in the blossom end.

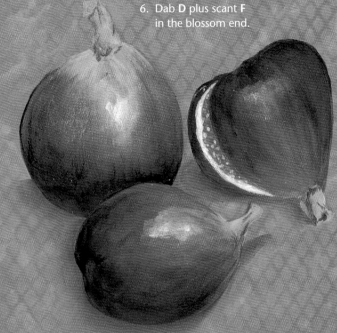

2. (a) Working from the base upward, brush on **C**, thinned slightly and sideloaded on the brush. (b) Then paint **F** from the stem downward. Also, paint **F** on the stem.

b

a

3. Repeat step 2(a) using **D** (see hint 4). Shade the stem with sideloaded **G**.

4. Repeat step 2(a) again, this time using **E**. Deepen the stem shading with **G** plus scant **D**. Dab **F** plus scant **D** in the cut end of the stem.

5. Add scars to the stem with **G+E**. Highlight the fig with a sideload of **H** (see hint 5). Add a slight reflected light with a sideload of **C**. (Step 6 above right.)

FLESH

1. (a) Paint the flesh of the fig with **H+A**. (b) Apply a wash of **C** to all but a thin edge.

a b

2. (a) Paint a few seeds with the liner brush and **H+A**. Dry. (b) Apply a thin wash of **C** over all seeds to submerge them. Then paint more seeds with **H+A**.

a b

A B C D E F G H

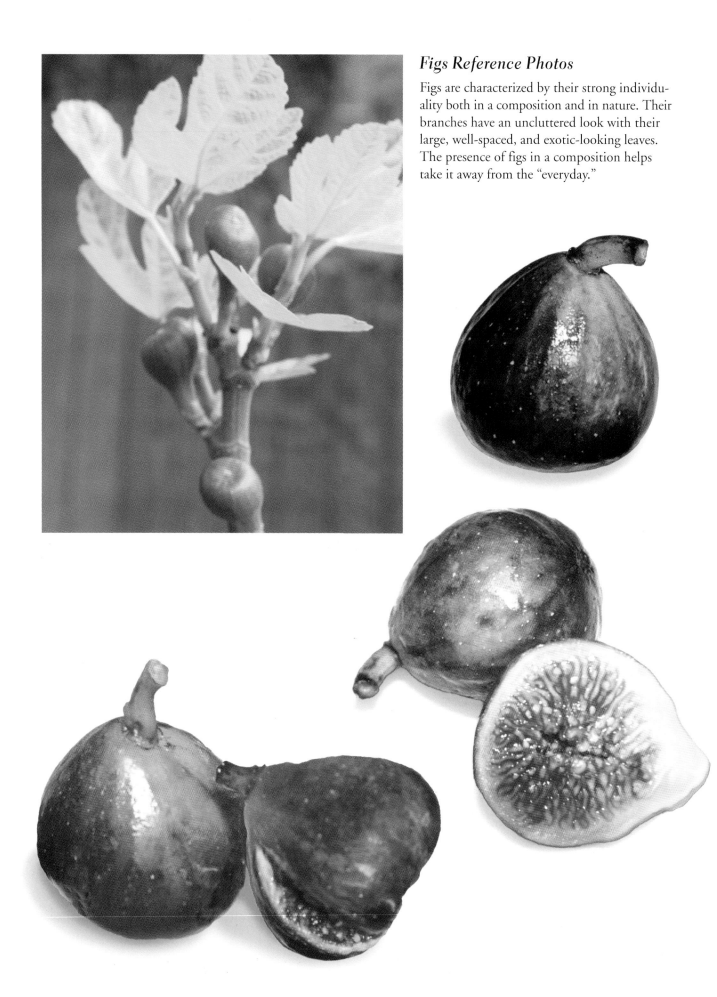

Figs Reference Photos

Figs are characterized by their strong individuality both in a composition and in nature. Their branches have an uncluttered look with their large, well-spaced, and exotic-looking leaves. The presence of figs in a composition helps take it away from the "everyday."

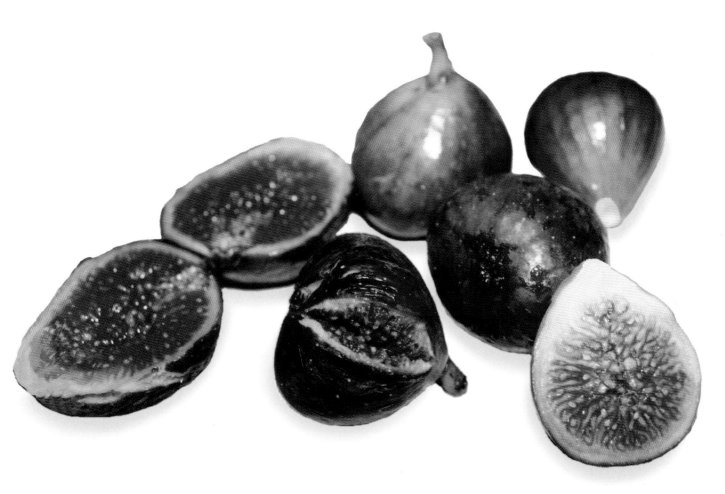

Grapes

RED GRAPES PALETTE

A Yellow Ochre
B Raspberry
C Dusty Rose
D Crimson Tide
E Red Violet
F True Blue
G Buttermilk
H Light Avocado

PURPLE GRAPES PALETTE

A Summer Lilac
B Violet Haze
C Wisteria
D Red Violet
E Royal Purple
F Payne's Grey
G Buttermilk

BRUSHES

Flat: No. 6
Liner: No. 10/0

I like to include grapes in paintings when appropriate because they lend themselves easily to different positionings: They can be hung, draped, or scattered. Their leaves, stems, and tendrils also add interest. And the numerous highlights they reflect can add sparkle to a painting. Use some restraint with highlights, however, leaving some grapes unhighlighted.

Hints

1. Paint grapes, leaves, and large stems with the flat brush. Use the liner brush to paint small stems and tendrils.

2. The process of painting opaque and translucent layers creates exciting effects and eliminates the monotony and dullness of overblending. Work with very little thinned paint (watercolor consistency), building layers until you are pleased with the result. Don't worry about matching these grapes exactly. Just strive for an overall pleasing effect.

*To paint the purple grapes shown here, follow steps 1 through 4 on the worksheet, substituting the colors listed above for purple grapes. Then, in step 5, highlight with **G+A**.*

If you'd like to paint green grapes, use the colors suggested for gooseberries (page 108). Add thin accents of Blush Flesh to suggest translucence.

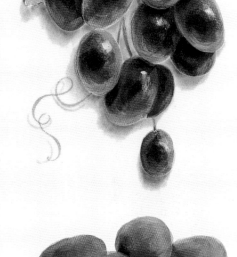

LEAVES, STEMS, AND TENDRILS

Mix any of the following colors individually with **H** to create a variety of dull greens: **A, B, C, D, E.** Make the leaves understated so they don't compete with the grapes for attention. See the step-by-step directions for leaves given for apples (page 84), blackberries (page 92), and currants and gooseberries (page 108).

 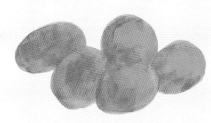

GRAPES

1. Undercoat grapes with **A.** Do not strive for smooth, even coverage. Blotchiness will enhance the final look of the grapes.

2. Apply a thin wash of **B** to all the grapes, allowing the coat to be uneven. Then dab full-strength **C** on some grapes (as shown on the three at right, above).

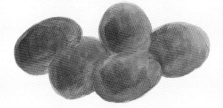 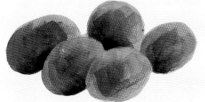 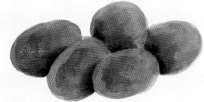

3. Apply a thin wash of **D** to all the grapes, still avoiding the temptation to blend everything smoothly.

4. Punch in some strong color accents with random strokes of **D+E.** Then add shading with a mixture of **D+E+F** sideloaded on the brush.

5. Add a purplish "frost" to the grapes with a mixture of **D+E+F+G.** Apply this color using either a dry brush or a sideloaded wash.

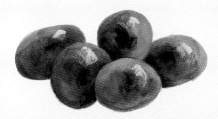

6. Repeat any of steps 2 through 5 in any sequence to strengthen the colors, tidy the edges, and merge the color layers together. Then add highlights of **G** mixed with a little **A.**

PURPLE GRAPES PALETTE

A	B	C	D	E	F	G

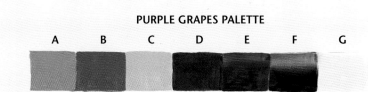

RED GRAPES PALETTE

A	B	C	D	E	F	G	H

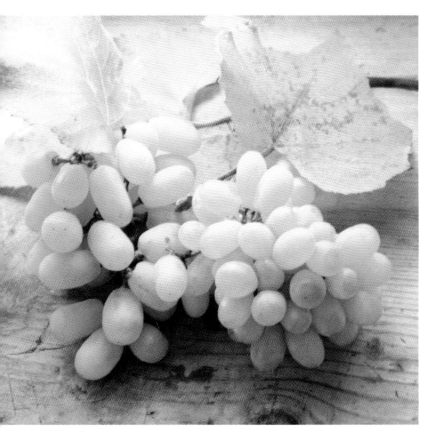

Grapes Reference Photos

Grapes are an artist's delight. They imply so much with their suggestion of abundance and the good life. The vast number of varieties include a wide range of colors, sure to enhance any color scheme. Notice how some grapes are quite round, others are more elongated. Notice too, that the elongated ones, when seen from the end appear round. Compare the different sizes, shapes, coloring, and bunching characteristics of the varieties shown here. Also, compare the fresh greens in the younger leaves against the more faded leaves at harvest time.

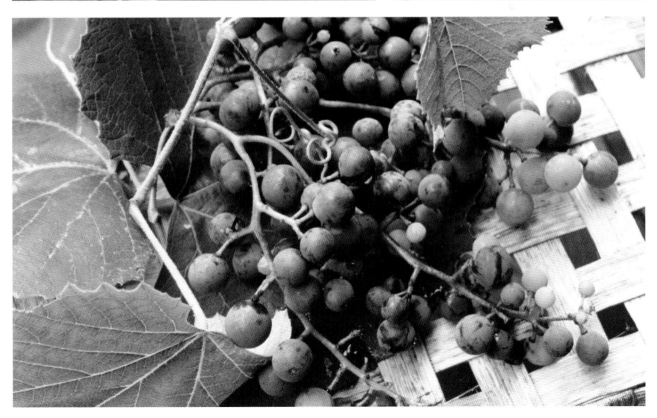

Kiwis

PALETTE
A Moon Yellow
B Light Avocado
C Taffy Cream
D Soft Black
E Plantation Pine
F Cadmium Red
G Hauser Light Green
H Raw Sienna
I Viridian Green
J Titanium White

BRUSHES
Flat: No. 6
Liner: No. 10/0
No. 2 flat "scruffy" brush

Since we don't have many brown fruits (well, fresh ones anyway), uncut kiwis give us a neutral-colored fruit if our composition needs one that will not scream for attention. However, cut one open, and its brilliant green flesh with radial lines and numerous black seeds can certainly attract the eye.

Hints

1. Use the flat brush to paint the skin and the flesh. Use the liner brush to paint "veins" and seeds. Use the scruffy brush to add fur to the skin.
2. In step 1:
 a. Apply undiluted paint heavily on the skin of the kiwi, tapping it with the corner of the brush as you work to create texture.
 b. Apply two coats of paint on the flesh by pulling strokes from the outside edge toward the center. To keep strokes from spiraling, think of the position of numerals on a clock and pull from those positions. Undercoating this way may take a bit longer, but it will provide not only some texture and color variations, but also a guide for applying the vein-like strokes in step 2. The second application will go much faster. I have left one of the cut sections without applying the second coat so you can more easily see the first layer of strokes.
 c. To apply paint for the center core, side-load the flat brush. Place the paint edge of the brush in the center and work out from there, letting the color fade as it overlaps the flesh at the edge of the core. Use the water-damp edge of the brush to facilitate the fade.
3. Before doing step 2, mark a small dot in the center of the core. Use the liner brush to paint the first four vein-like rays to divide the area into four pie shapes meeting at the center dot. That will help you place the remaining rays so they seem to radiate from the center, as in the right hand kiwi in step 2, rather than haphazardly as in the left hand kiwi. Fill in between the four rays with additional rays. Don't worry about having an equal number in each quadrant. (No one is going to count. And, if they do, they need something more interesting to do.)
4. To create furry texture on the skin, use scant, thick paint on a scruffy brush.
5. If you're going to paint a cast shadow, do it before adding light value "fur" to the skin. Otherwise, the shadow may obliterate the fuzz. If the fuzz is too obvious in the dark shadow area, let it dry, then apply a thin wash of shadow color over it.

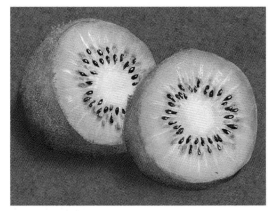

The multi-toned nature of the background echoes the rough texture of the skin. Warmed with touches of red, the background is so close in value, color, and intensity to the kiwi skin that, together, they emphasize the two circular splashes of green.

1. Undercoat the flesh with **A.** Apply a second coat. Undercoat the skin with thick **B.** Undercoat the center core with sideloaded **C,** placing the paint-filled edge of the brush to the center of the kiwi.

2. Paint veins on the flesh with **C.** Paint some seeds (not all of them, yet) with thinned **D.** Stipple the skin with **E+F.**

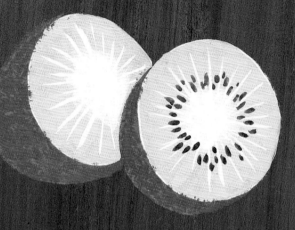

3. Apply a wash of **A** over the seeds to submerge them. Dry, then apply a wash of **G** to the flesh. Paint the cast shadows a darker value of your background color (see hint 5). Highlight the skin with **A** plus scant **E** plus scant **F.**

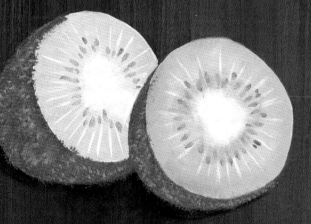

4. Use a scruffy brush to stipple the skin with **H.** Add more seeds with **D.** Dry. Surround the seeds with a crescent stroke of thinned **I.** Apply a wash of **I** over the flesh.

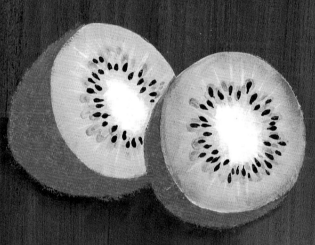

5. Highlight the raised seeds with **C.** Highlight the skin with drybrushed **A+H.** Shade the skin with sideloaded **E+F.** Use the corner of the flat brush with **J** to add very scant white sparkle to the flesh.

A B C D E F G H I J

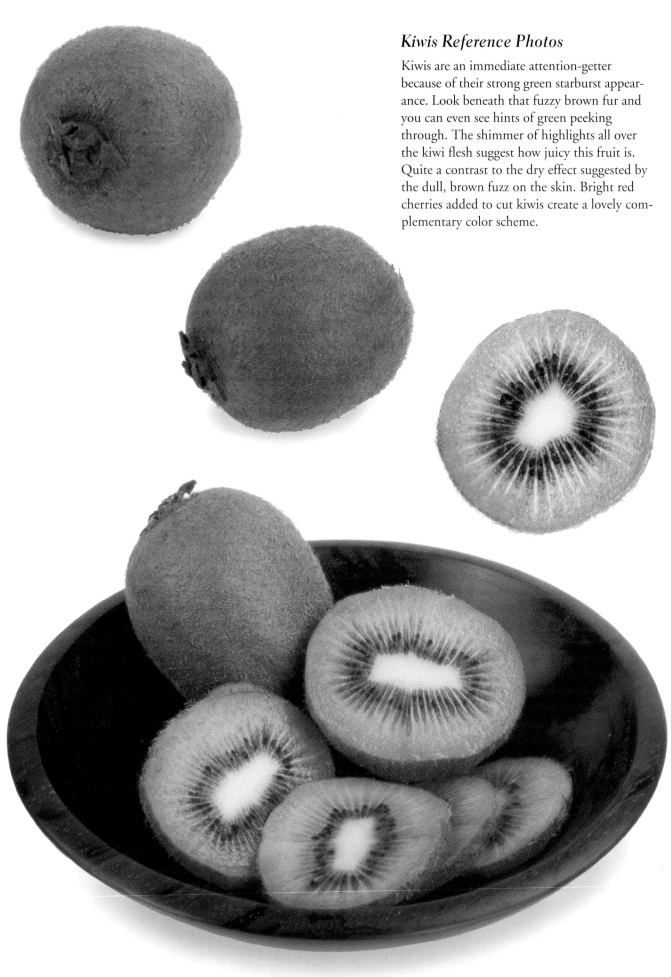

Kiwis Reference Photos

Kiwis are an immediate attention-getter because of their strong green starburst appearance. Look beneath that fuzzy brown fur and you can even see hints of green peeking through. The shimmer of highlights all over the kiwi flesh suggest how juicy this fruit is. Quite a contrast to the dry effect suggested by the dull, brown fuzz on the skin. Bright red cherries added to cut kiwis create a lovely complementary color scheme.

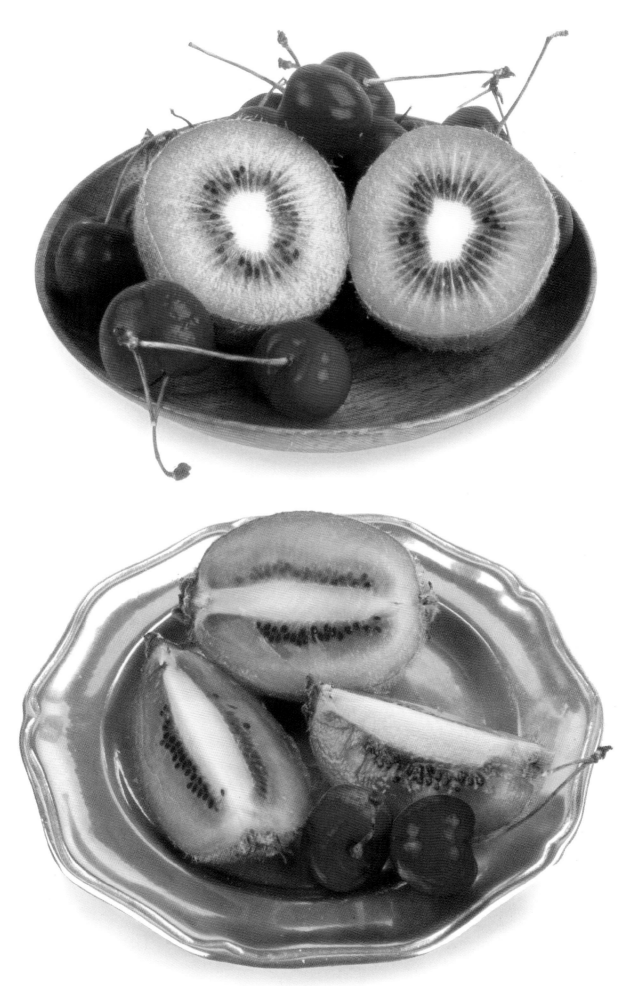

Lemons and Limes

While the worksheet is concerned primarily with painting lemons, it's easy to substitute colors to create the limes. The textured skins of citrus fruits, with their drybrushed highlights, add interesting contrast to a painting in which other fruits are all smooth skinned and shiny.

Hints

1. Use the flat brush to paint the skin, the flesh, and the leaves. Add details to the flesh with the liner brush. Paint the blossoms with the round brush.
2. To create an interesting texture for the skin, tap or dab on your undercoat paint for lemons and limes, rather than merely brush it on. Use thick, undiluted paint, drying well between coats.
3. The texture of the skin can be emphasized by drybrushing on highlights. Be sure to wipe most of the paint off the brush onto a paper

towel before attacking the fruit. The highlight color will "catch" on just the raised portions of the undercoat. You can continue adding layers until you achieve the effect you want, but it's hard to undo a too-heavy application (see "Drybrushing," page 24).

LIMES

To paint limes, follow the process for painting the lemons but substitute the colors from the lime palette as follows:

1. Undercoat the skins (including the edges of the cut slices) with **A**. Undercoat the rind with **B**.
2. Shade by dabbling **C** (heavier where shading is to be darkest), then **D**, letting some of the previous layers show through.
3. Highlight by drybrushing with **E**.
4. Sideload the brush with **A** and soften the edges where the yellow undercoat peeks through.
5. To paint the flesh of the limes, follow the first three steps for lemon flesh. Then in step 4, apply a wash of **D** over the flesh.

The warmth of these bright, sunny colors is intensified by the hard, dark red cast shadow, showing us that the light casting it is close and hot. Even the leaves are a warm green. Thank goodness for the cool relief of the blue-green lime. Care for a lemon-limeade?

LIME
(See instructions for painting limes on previous page.)

(See instructions for painting limes on previous page.)

BORDER
(See illustration below.)
Create a border by painting repeated sections. To paint the flowers, load the round brush with **B**, then dip the tip in **G**. Paint a pair of comma strokes for each petal. Use the liner to draw thin stamens of **A**. Add pollen dots of **C**.

LIMES PALETTE

A B C D E

LEMONS, LEAVES, AND FLOWERS PALETTE

A B C D E F G H I

1. Dab two or three heavy coats of **A** on the whole lemon. Undercoat the cut lemon rind with **B**. Use the round brush to stroke **C** on the flesh to form ridges. Undercoat the leaves with **D**.

2. Dab the lower third of the whole lemon lightly with **E**, leaving a thin edge of undercoat showing along the bottom. Dab thinned **A** on the flesh of the slice. Outline the lower edge of the slice with **A+E**. Brush a thin layer of water on the leaves, then add a center vein and splotches with **F**.

3. Dab or drybrush **G** on the upper part of the lemon. Use the liner to paint tiny comma strokes of **G** on the flesh of the slice. Brush a scant amount of water on the leaves, then add splotches of **D+C**. Enhance shading on the whole lemon with a sideload of **H**.

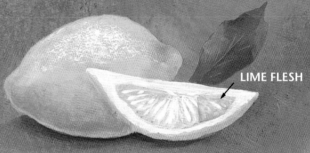

LIME FLESH

4. To merge the shading into the whole lemon, brush thinned **E** over it. Brush thinned **I** over the flesh and rind of the cut slice. Paint veins on the leaves with thinned **D+C**. Then brush a thinned layer of **D** over the leaves to blend colors softly. Add accent colors on the leaves, if desired, using any reds, purples, or deeper greens (see leaves in the border below).

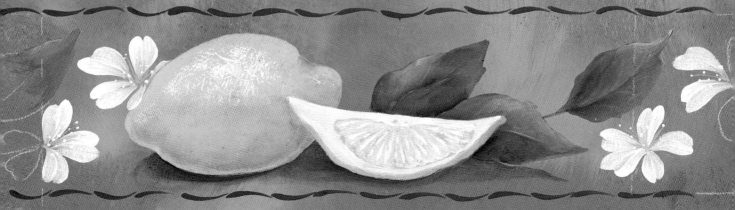

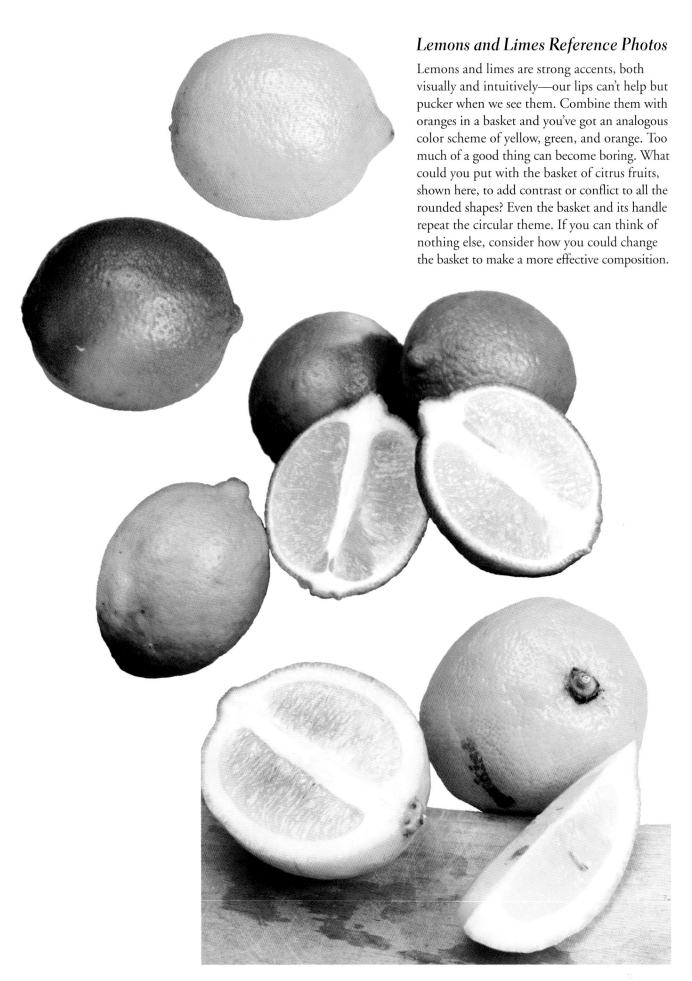

Lemons and Limes Reference Photos

Lemons and limes are strong accents, both visually and intuitively—our lips can't help but pucker when we see them. Combine them with oranges in a basket and you've got an analogous color scheme of yellow, green, and orange. Too much of a good thing can become boring. What could you put with the basket of citrus fruits, shown here, to add contrast or conflict to all the rounded shapes? Even the basket and its handle repeat the circular theme. If you can think of nothing else, consider how you could change the basket to make a more effective composition.

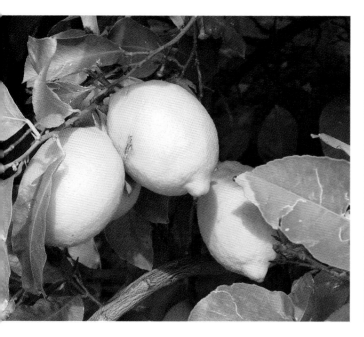

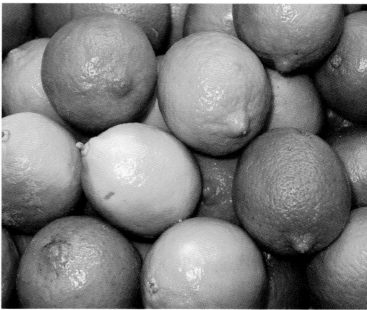

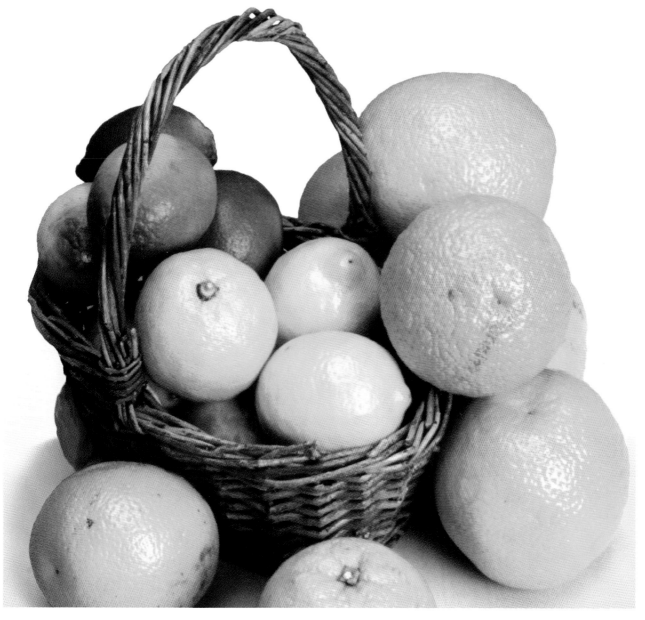

Oranges

Review the hints for painting lemons and limes in the previous lesson. Using thick enough paint to create a dimpled texture in the orange skin will help suggest realism.

Hints

1. Use the flat brush to paint the orange skin and flesh and the round brush to paint details on the flesh.
2. Make the orange slightly irregular in shape, not perfectly round.
3. Imagine painting this orange on a blue background. If you apply the orange color thinly on the part of the fruit in shadow, some of the blue background would show through. Our eyes would mix the orange and the blue visually, creating a lovely, appropriate shading color. When the background is a dark color, or particularly a dark complementary color, letting some of it shine through the undercoat of the object helps model the object or shade it.

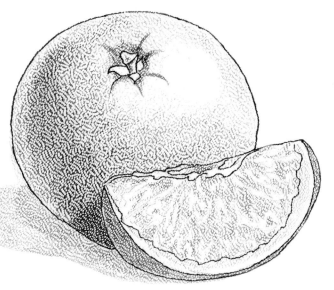

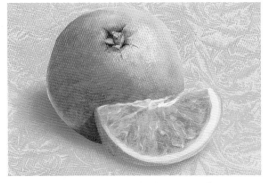

The marbelized texture of this background repeats somewhat the texture of the flesh of the orange in this monochromatic color scheme.

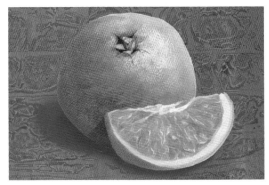

In this complementary scheme, the textured background tugs the gaze away from the orange—unlike the lack of competition from the solid red background.

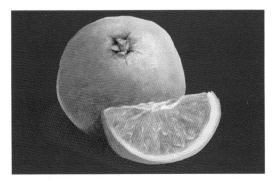

In this analogous scheme, the orange stands out as a bright beacon against the solid red background, which offers no textural competition.

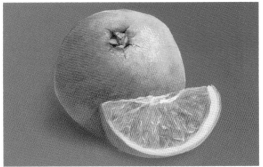

Here the combination of the orange with the blue-green and blue-violet background results in a split complementary color scheme. (See a fifth color scheme on page 54.)

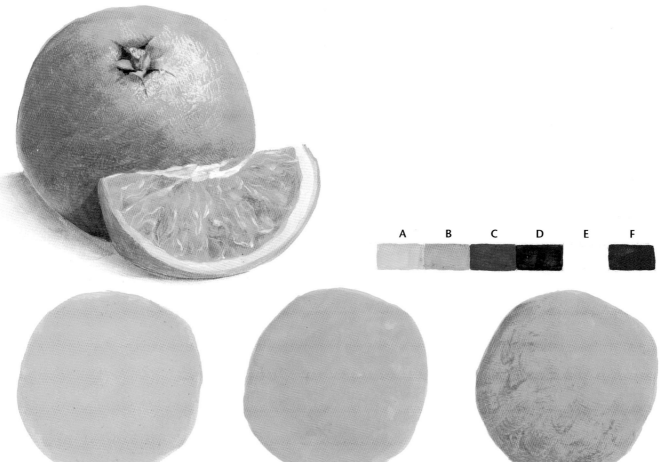

| A | B | C | D | E | F |

1. Undercoat the orange with **A**, tapping the paint on thickly to suggest texture.

2. Apply a thin, splotchy wash of **B**, letting more light value undercoat show in the upper right highlight areas.

3. Load the brush with extender, then sideload with a mixture of **B+C** plus very little **D** and shade the left side.

4. Load the flat brush with scant **A** plus a little **E**, and wipe nearly dry. Hold the brush parallel to the painting and lightly skim across the top third to highlight. Shade around the stem depression and paint the creases with **B+C+D**.

5. Accent the highlight, using more **E** and less **A**, applying the paint in the center of the highlight area. Paint the stem and calyx **F+A+E**.

6. Sideload the flat brush with **A+E** and paint a stroke of reflected light along the lower left edge of the orange. Highlight the stem with **A+E+F**; shade it with **F+C+D**. Paint a wash of **A** over the stem.

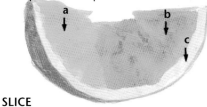

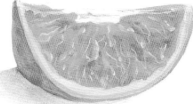

SLICE

1. (a) Dab on **A** thickly to create textured flesh. (b) Dab on a splotchy wash of **A+B+C** plus very little **D**. (c) Paint the membrane next to the rind using **E+A+B**. Paint the rind as described above.

2. Use the round brush to paint the white membrane at the center of the slice with **E+A+B**. Without rinsing the brush, dip it in extender and roll it on the flesh to create irregular lines.

3. Apply a wash of **A+C** over the flesh, membrane, and rind. Add a shadow in the membrane at the top of the slice and under the orange with **D+C+E**.

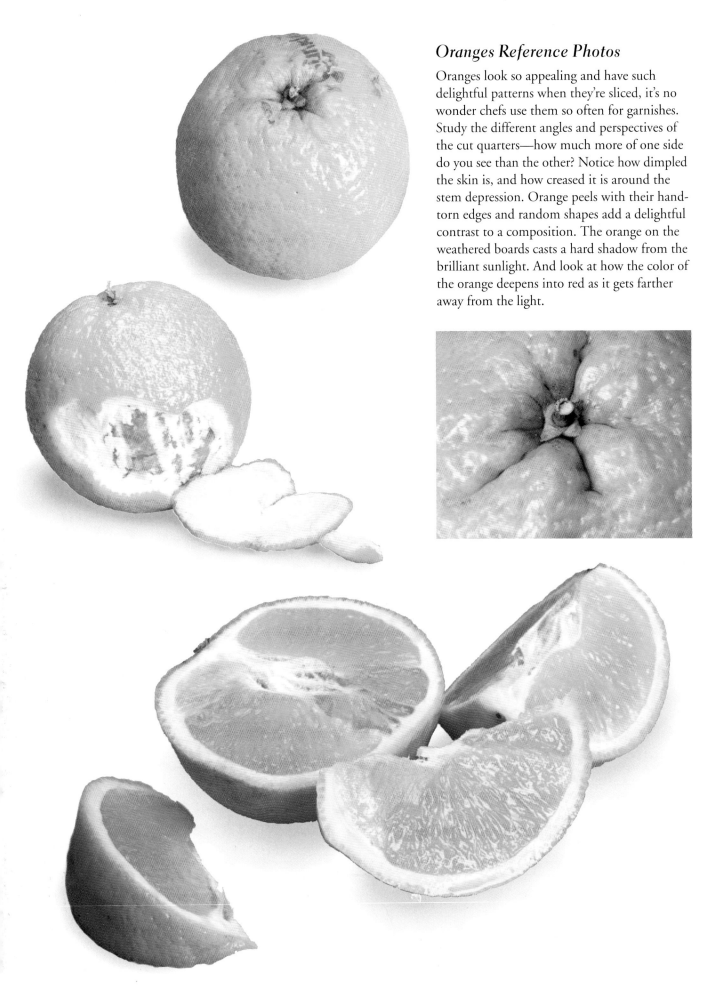

Oranges Reference Photos

Oranges look so appealing and have such delightful patterns when they're sliced, it's no wonder chefs use them so often for garnishes. Study the different angles and perspectives of the cut quarters—how much more of one side do you see than the other? Notice how dimpled the skin is, and how creased it is around the stem depression. Orange peels with their hand-torn edges and random shapes add a delightful contrast to a composition. The orange on the weathered boards casts a hard shadow from the brilliant sunlight. And look at how the color of the orange deepens into red as it gets farther away from the light.

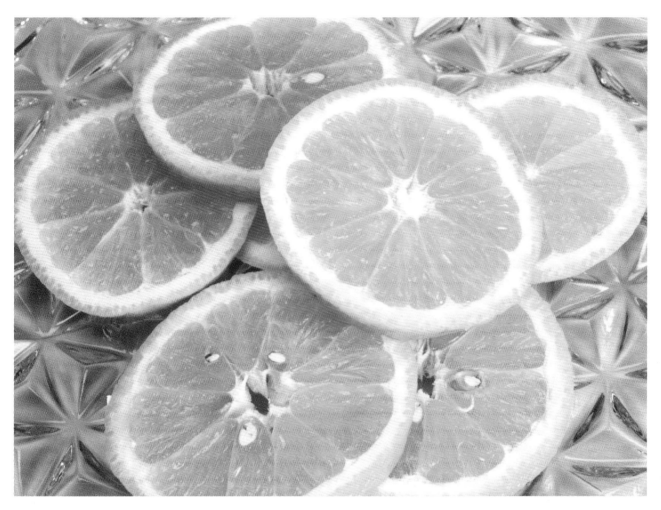

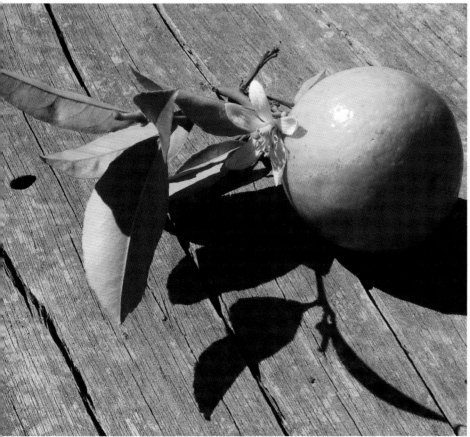

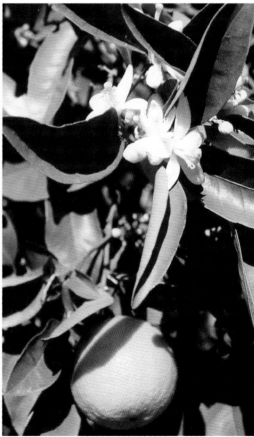

Peaches

PALETTE

A Moon
 Yellow
B Blush Flesh
C Crimson
 Tide
D Peaches 'n
 Cream
E Light
 Avocado
F Olive Green
G Midnite
 Green
H Antique Teal
I Shale Green

BRUSHES

Flats: Nos. 4
 and 8
Round: No. 2
Liner: No. 10/0
Round fabric
 (Series FAB):
 No. 8

MEDIUM

Brush 'n Blend
 Extender

The characteristic peach fuzz is accomplished by painting a thin overlay of light color on the nearly completed fruit. Be sure to let some of the fuzz extend slightly beyond the edges of the peach.

Hints

1. Use the No. 8 flat brush to paint the peach and leaves, the No. 4 flat brush to shade the stem depression, and the round brush to paint the stem. Use the liner brush to paint details on the leaves, and the fabric brush with its stiff bristles to add texture to the peach.

2. When you undercoat the peach, use thick paint and pat or stipple the last coat to create texture and to suggest velvety skin.

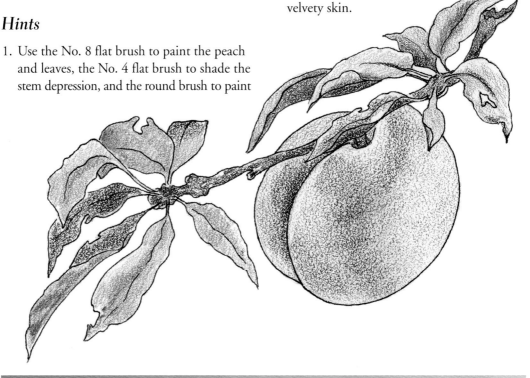

I used a soft pastel background here to echo the velvet softness of the peach skin. Notice how more interesting the gradated background is than if it had been a solid color.

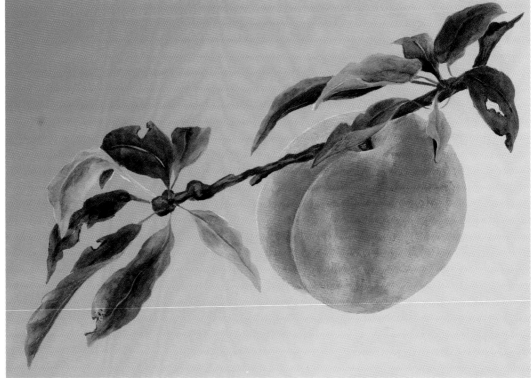

LEAVES

To paint the leaves (see the illustrations below), follow this process, substituting different greens for variety.

1. (a) Undercoat with **I**, then (b) apply a puddly wash of **E, F, G,** or **H.**
2. Sideload the No. 4 flat brush with **G.** Paint along the center vein and dab on shading sporadically.
3. Sideload the No. 4 flat brush with **B** to accent, then with **A** to highlight.
4. Use the liner brush to paint veins with **F** and to paint "bug-eaten" parts with the stem mixture, **B+E.**

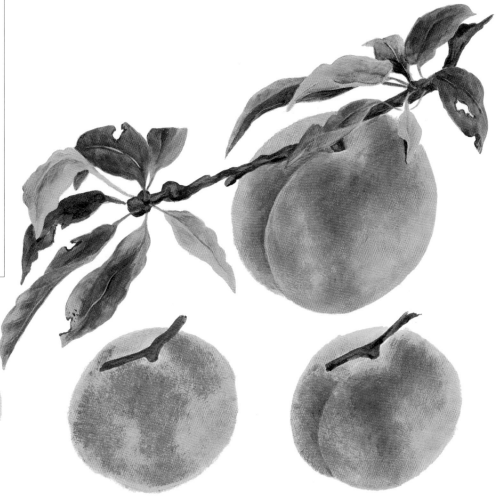

1. Undercoat the peach with two or three coats of **A** (see hint 2). Undercoat the stem using the round brush and **B+E.**

2. Brush a coat of extender on the peach. Use the fabric brush to pounce on **B,** heavily in some areas and lightly in others. Highlight the stem using the stem mixture plus **A.**

3. Sideload the flat brush with **C** to shade the cleft and deepen the peach's blush. Shade the stem with the stem mixture plus **G.**

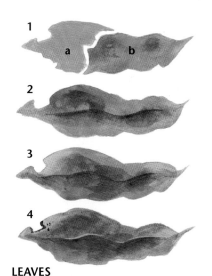

4. Sideload the flat brush with **D** and highlight the front edge of the cleft. Dry. Then lightly brush sideloaded **D** over the entire peach, using the clear side of the brush to "tickle" the color gently over areas where less is desired.

5. Sideload the flat brush with **E** and shade the stem depression.

LEAVES
(See instructions above.)

A	B	C	D	E	F	G	H	I

Peaches Reference Photos

It's easy to identify peach trees in the orchard (during non-fruiting periods that is) by their long, slender leaves. Using the photos, compare the bark with that of other fruit trees. Notice how closely the peach is attached to the branch. Its stem is but a stub. From what angle is the sun striking the peach on the weathered boards? Observe, observe!

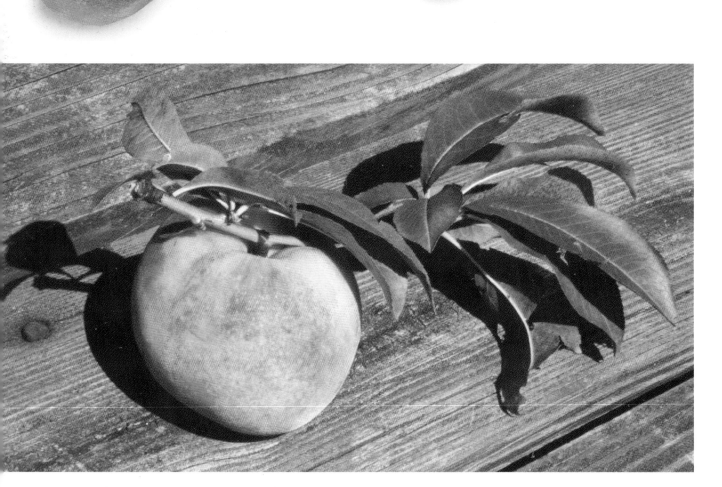

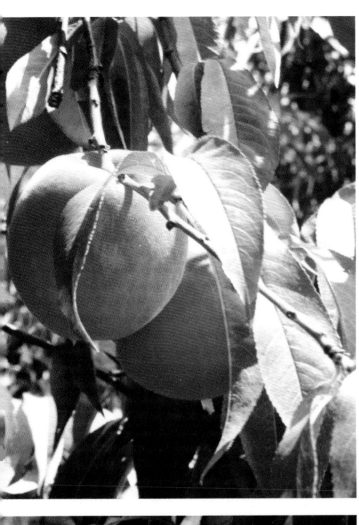

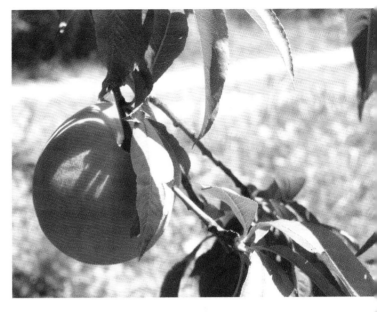

Pears

These instructions are for Bosc pears, which grow in an orchard near our home. I love their somber coloring. Wouldn't they look great in a melancholy, dark still life? If you prefer your pears to be a golden yellow, see the step-by-step directions for painting Douglas pears in my *Big Book of Decorative Painting*.

Hints

1. Use the No. 10 flat brush to paint the pears, the No. 6 flat brush for the leaves and the stem, and the liner brush for the leaf veins and to streak the stem.
2. As a puddly wash dries, it leaves variations in color values creating a mottled appearance. This is a great aid in preventing your work from appearing too meticulously overblended, stiff, and stylized.
3. For greater depth of colors, strengthen any highlights or shadows by repeating earlier steps and colors as needed after completing all of the steps the first time.
4. After completing all steps, apply a thin wash of **C** over the entire leaf if you'd like to mellow it a bit.

Contour Lines

Try drawing contour lines on irregularly shaped fruits or vegetables, such as these pears. To help you sense the full shape of the pear when you paint, let your brush strokes follow the contour lines. Keep this rounded feeling in mind as you add highlights and shading.

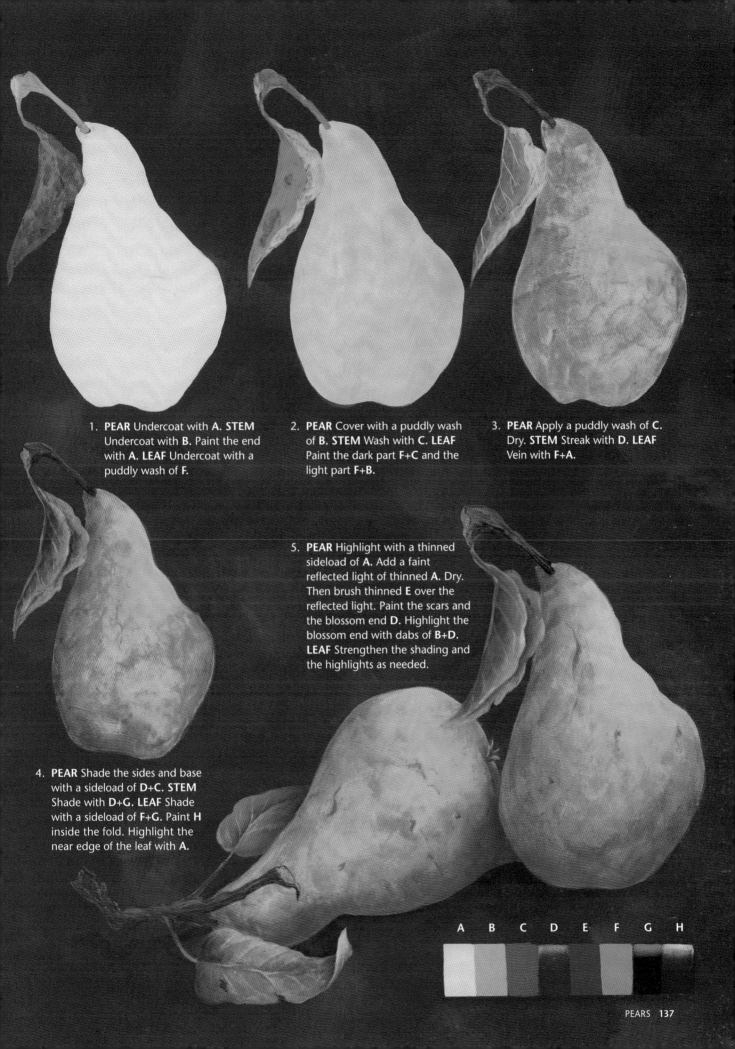

1. **PEAR** Undercoat with **A**. **STEM** Undercoat with **B**. Paint the end with **A**. **LEAF** Undercoat with a puddly wash of **F**.

2. **PEAR** Cover with a puddly wash of **B**. **STEM** Wash with **C**. **LEAF** Paint the dark part **F+C** and the light part **F+B**.

3. **PEAR** Apply a puddly wash of **C**. Dry. **STEM** Streak with **D**. **LEAF** Vein with **F+A**.

4. **PEAR** Shade the sides and base with a sideload of **D+C**. **STEM** Shade with **D+G**. **LEAF** Shade with a sideload of **F+G**. Paint **H** inside the fold. Highlight the near edge of the leaf with **A**.

5. **PEAR** Highlight with a thinned sideload of **A**. Add a faint reflected light of thinned **A**. Dry. Then brush thinned **E** over the reflected light. Paint the scars and the blossom end **D**. Highlight the blossom end with dabs of **B+D**. **LEAF** Strengthen the shading and the highlights as needed.

A B C D E F G H

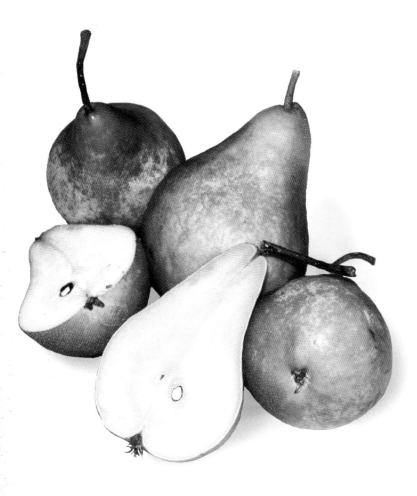

Pears Reference Photos

Pears have lots of visual appeal, and there are usually some blemishes, bruises, freckles, or lumps that are fun to paint. With several thousand varieties, you're sure to find a shape (elongated, rounded, short and squat, angular) and color (from greens to yellows, golds, browns, reds) to suit you. Study the pair of pears on the next page to see how the light has washed out all color where it strikes; how it causes the green of the leaf overlapping the pear to reflect onto the pear; how the shadow edge of the leaf is sharply defined on the pear; and how evident the reflected lights are.

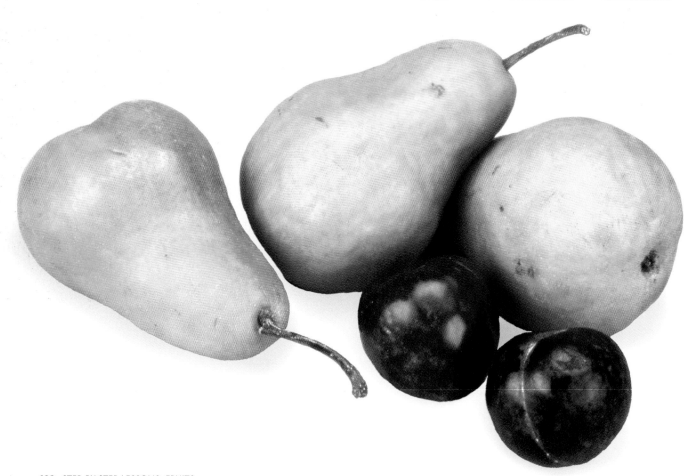

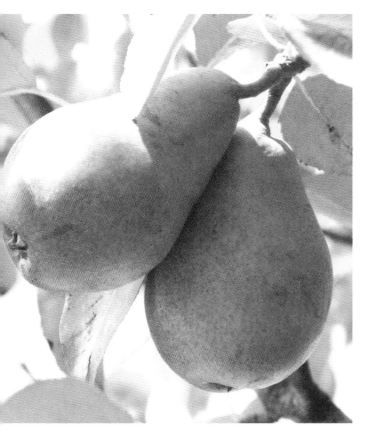

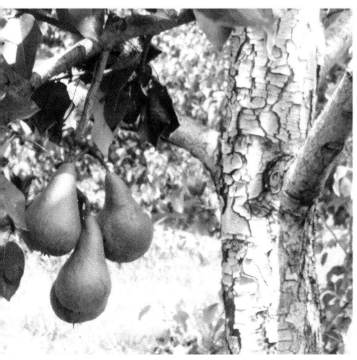

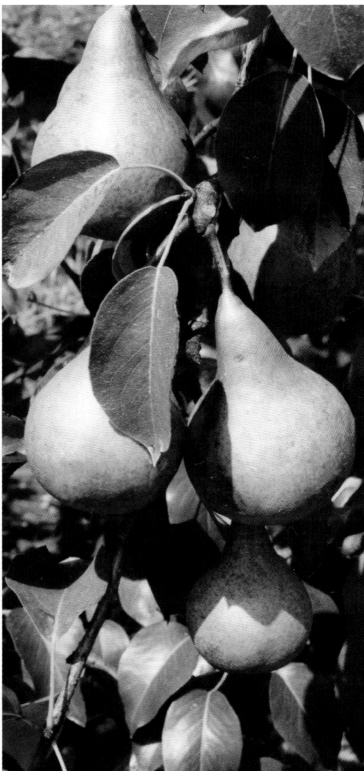

Persimmons

PALETTE
A Pumpkin
B Tangelo Orange
C Cadmium Orange
D Georgia Clay
E Brandy Wine
F Moon Yellow
G Tangerine
H Light Avocado
I Celery Green
J Charcoal Grey
K Burnt Orange
L Antique Green
M Dried Basil Green

BRUSHES
Flats: Nos. 2 (*or* 4), 6, and 10
Liner: No. 10/0

There are two types of persimmons: The common persimmon *(Diospyros virginiana)*, which grows 35 to 60 feet tall, and bears 1- to 1¹/₂-inch fruit; and the Japanese persimmon *(Diospyros khaki),* which grows 20 to 30 feet tall and bears 3- to 4-inch fruit. (The fruits in this lesson are Japanese persimmons.) If you have ever eaten a persimmon before it fully ripens in late fall, you know what an unforgettable puckering experience that can be.

Hints

1. Use the No. 10 flat brush to paint the persimmon, the No. 6 flat brush for the calyx, and the No. 2 or No. 4 flat brush for the center core of the fruit. Use the liner brush to paint the stem tip and the veins in the calyx.
2. These persimmons demonstrate how the gradual buildup of thin layers of progressively darker values over an opaque, light background creates a "glowing-from-within" luminescence. (You'll have to look hard to notice the subtle changes between the steps.) Review "Washes and Floated Colors" on page 25. Notice the far right fruit in step 5. The three darker wash layers were not applied over the highlight area, thus leaving the highlight to shine through the first layer.

3. Undercoat applications have a distinct effect on subsequent wash layers. For example, letting some of the background show through the undercoat in the calyx will create interesting variations of light and dark values. We can accentuate those variations by applying the undercoat more opaquely in those areas that we plan to highlight. For the light-colored fruit on this dark background, I undercoated the entire area solidly. (It may take two or three undercoats to completely cover the dark background.) On other occasions, I may decide to let some of the dark background show through the undercoat to suggest bruises, shading, or other color variations.
4. Suggested painting sequence: fruit (skin), flesh, calyx.
5. To create the fibrous texture of the flesh in step 3, sideload the flat brush with color, then skim back and forth on the brush's chisel edge to deposit narrow slashes of thinned paint.

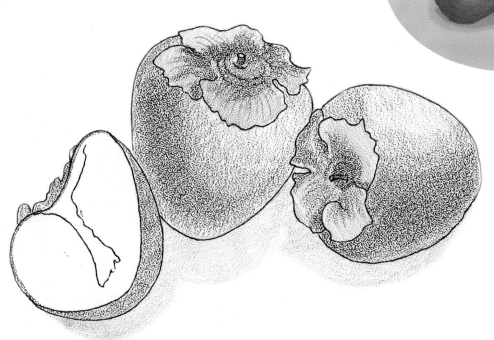

This light value, low intensity green background suggests the faded colors of fall and coordinates nicely with this fall-harvest fruit.

1. **FRUIT** Undercoat with **A. FLESH** Undercoat with **F. CALYX** Undercoat with a puddly sideload of **H.**

2. **FRUIT** Apply an even wash of **B. FLESH** Apply a puddly wash of **A. CALYX** Highlight with a sideload of **I.**

3. **FRUIT** Apply a wash of **C**, leaving areas to be highlighted uncoated. **FLESH** Streak on thinned **B** (see hint 4). **CALYX** Shade with a sideload of **J+H+K.**

4. **FRUIT** Apply dark shading with a sideload of **D. FLESH** Paint the center core sketchily with **F. CALYX** Apply puddly washes of **L** and **L+K.**

5. **FRUIT** Accent the darkest shading with **E. FLESH** Apply a wash of **G** over the center core, then shade the edges of the core with thinned **D+H. CALYX** Use the liner to paint the veins and stem tip with **M.**

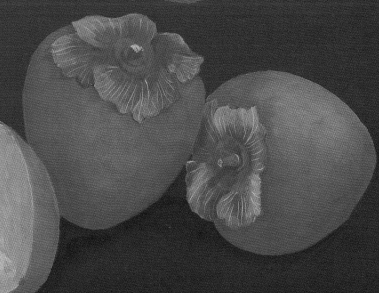

A B C D E F G H I J K L M

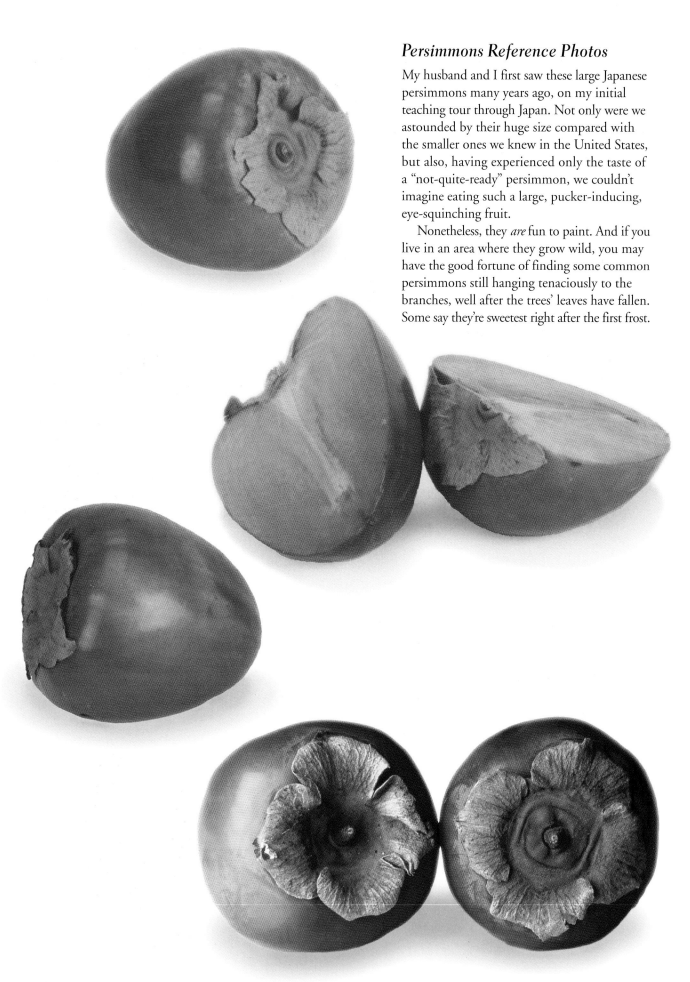

Persimmons Reference Photos

My husband and I first saw these large Japanese persimmons many years ago, on my initial teaching tour through Japan. Not only were we astounded by their huge size compared with the smaller ones we knew in the United States, but also, having experienced only the taste of a "not-quite-ready" persimmon, we couldn't imagine eating such a large, pucker-inducing, eye-squinching fruit.

Nonetheless, they *are* fun to paint. And if you live in an area where they grow wild, you may have the good fortune of finding some common persimmons still hanging tenaciously to the branches, well after the trees' leaves have fallen. Some say they're sweetest right after the first frost.

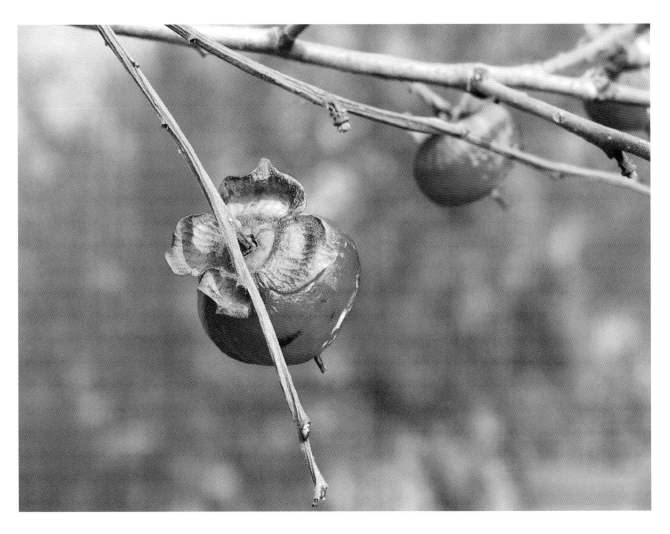

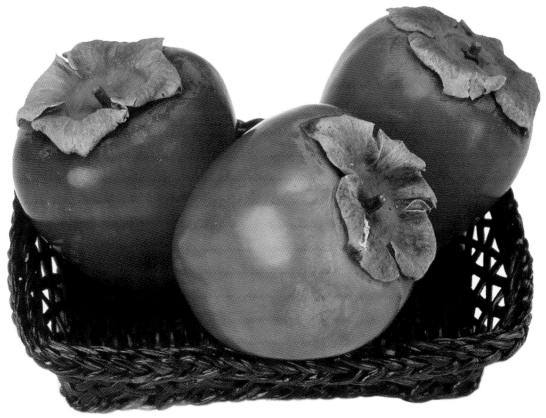

Pineapples

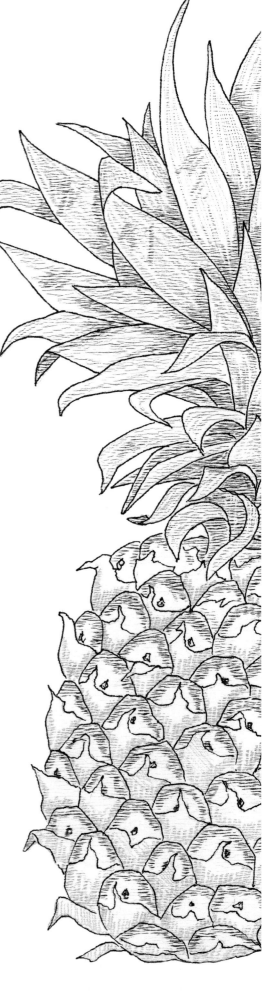

PALETTE
A Moon
 Yellow
B Hauser Light
 Green
C Plantation
 Pine
D Toffee
E Milk
 Chocolate
F Mint Julep
 Green
G Yellow
 Ochre

BRUSHES
Flats: Nos. 4
 and 6
Liner: No. 1

The sharp, spiky pineapple is a wonderful shape to add to a fruit painting that is too full of smooth, round objects. If possible, have a pineapple in front of you while painting. Use the worksheet to guide you, but use your pineapple to inspire you.

Hints

1. Use the flat brushes to paint the leaves and the pineapple, working with whichever size best suits the area. Use the liner brush to add details to the fruit skin.

2. The pineapple, a symbol of hospitality, is actually much easier to paint than it appears. One key to success is to avoid being too precise; uniform precision will make your pineapple look too stylized. Apply washes, sideloadings, and drybrushings loosely, almost carelessly.

3. In step 2 (pineapple) place the paint-filled edge of the brush along the outside edge of the pineapple segment to shade it. Allow this sideloaded stroke to be irregular— wider in some places, narrower in others.

4. To paint the leaf veins with the flat brush (leaves, step 2) load the brush with thinned paint, hold it perpendicular to the surface, and slide on the chisel edge.

5. The application of **F** (pineapple, step 5, and leaves, step 4) creates the waxy appearance on leaves and fruit for a touch of realism.

Space constraints prohibit showing the complete pineapple pattern at full-size. Use this reduced version to help you sketch the missing half. Or, photocopy this version and enlarge to the size you desire.

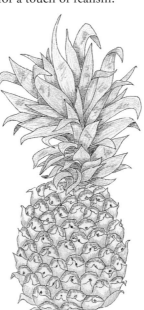

PINEAPPLE

1. Undercoat the pineapple with **A**. Then use the liner brush and thinned **D** to divide the sections.

2. Use the flat brush side-loaded with **C** to shade each section.

3. Use the flat brush and **D** to paint the pineapple's paper-like skin.

4. Apply a thin wash of **E** to the pineapple's skin. Deepen the color with loose washes of **C+E**. Dab dots of **C+E** in the centers of some sections.

5. Use the liner to accent the pineapple's skin with **E** and then with **G**. Drybrush **F** over each section.

LEAVES

1. Undercoat leaves with **B**.

2. Use the flat brush with **A** to tinge the leaf tips and to paint the veins.

3. Apply a wash of **D** on some tips.

4. Streak leaf tips with **E**. Apply a wash of **F** on the undersides of the leaves.

5. Loosely smear **B** over the wash of **F**.

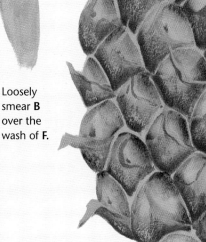

A B C D E F G

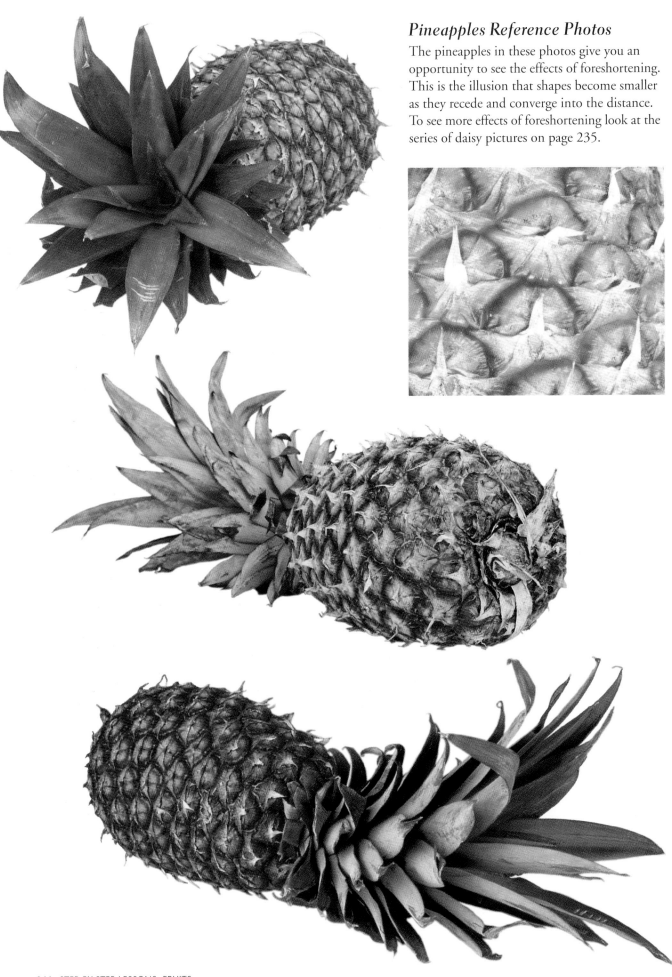

Pineapples Reference Photos

The pineapples in these photos give you an opportunity to see the effects of foreshortening. This is the illusion that shapes become smaller as they recede and converge into the distance. To see more effects of foreshortening look at the series of daisy pictures on page 235.

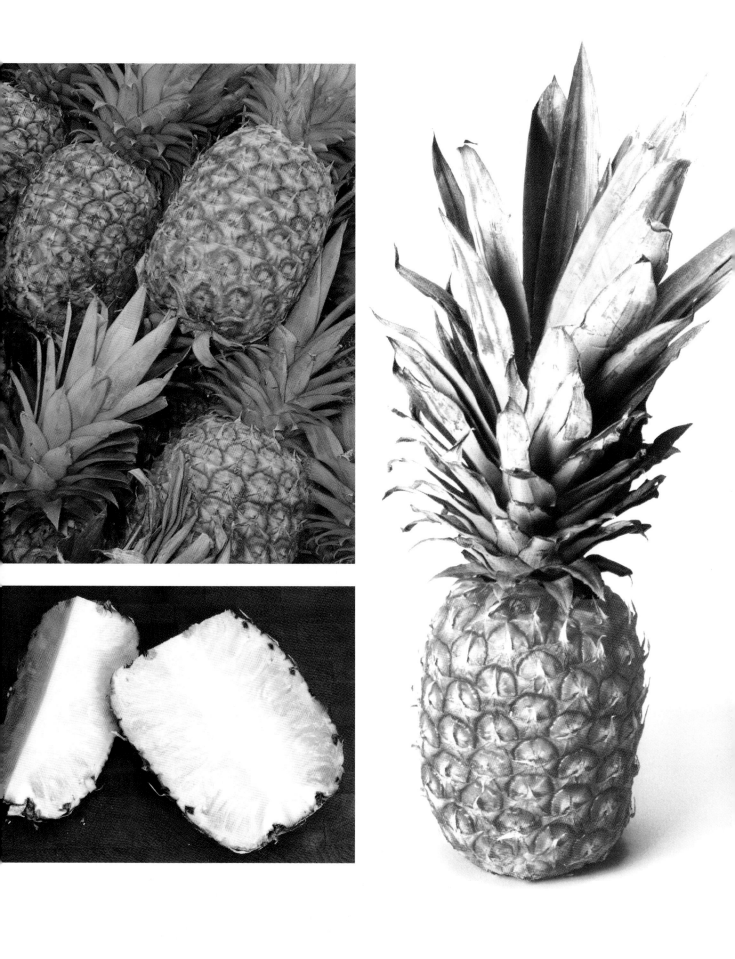

Plums

PALETTE
A Raspberry
B Cranberry
 Wine
C Dioxazine
 Purple
D Light French
 Blue
E Taffy Cream
F Avocado
G Plantation
 Pine
H Antique
 Green

BRUSHES
Flats: Nos. 8
 and 10
Liner: No. 10/0

MEDIUM
Easy Float

Plums are available in a variety of colors (reds, purples, blues, yellows) and with a variety of flesh colors. Plums also give you an opportunity to try painting a frost-like bloom on the fruit.

Hints

1. Use both flat brushes to paint both the leaves and the plums. Paint the leaf veins with the liner brush.

2. You may find the plums a bit of a challenge if you haven't mastered the application of thin washes. With the plums, we are not applying washes of only dark colors over light, but also light ones over dark—a little bit trickier.

3. These plums may test your resolve to "leave well enough alone." Because of the frosty-looking bloom applied in step 4 and the loose applications of color washes, it may be difficult to stop fiddling with the painting. Just remember, you can always, later, apply an adjusting wash of color. In the meantime, get up and walk away. The plums will, more than likely, look better when you return; whereas if you keep fussing with them, they're sure to spoil.

4. If, after getting away from your work and then coming back, you are still dissatisfied with the coloring on the plums, adjust it by trying a wash of **B**. Or, if areas are too dark, apply a sideload of **A** over them. Dry. Then gradually build up dark washes again.

5. If you were too heavy-handed with the light blue bloom, apply a wash of **B** over it. Then brush with **D** again if needed, but ever so thinly.

6. After applying the bloom, leave the plums alone and work on the leaves. Then add finishing details, highlights, and shading to both.

7. If your darker mixtures seem to fade and become dull, don't worry; a coat of varnish will bring them back to life. Meanwhile, you can dry the painting thoroughly, then brush a thin layer of water over it to see how the plums will appear when varnished.

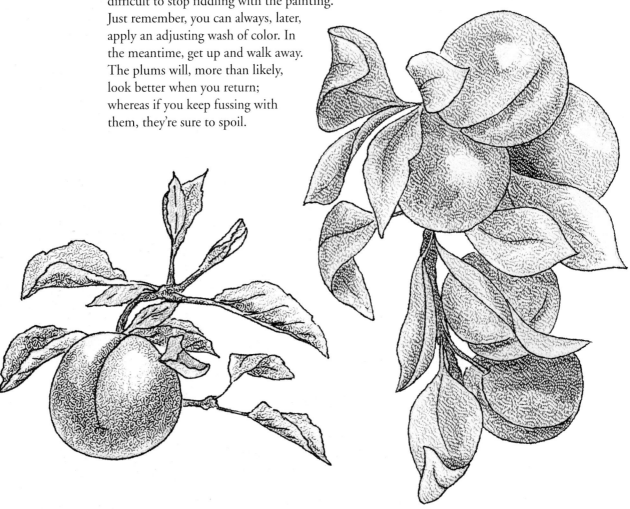

FRUIT

1. Undercoat the plums with **A**.

2. Apply a thin wash of **B**, letting a little more color settle in along one side of the crease and wherever else you'd like to emphasize dark colors.

3. Apply patches of **B+C** with a sideloaded brush. Blend edges of the application with the water side of the brush. Dry. Then brush a very thin layer of **B+C** over the entire plum.

4. Sideload the flat brush with scant **D** and Easy Float. Brush on the bluish bloom—more in some areas, less in others. Blend out the edges with the damp edge of the brush. While the bloom is wet, blot it with a damp paper towel. To remove unwanted areas of bloom, use a brush or cotton swab moistened with Easy Float and water.

5. Before doing this step, walk away. Return later with fresh eyes and apply sideloads of any colors you wish to strengthen. (Here, I've added more **C** to the base and right center.) Then highlight with a sideload of thinned **E**.

BRANCH
Paint the branch **F+B+C**.

LEAVES

1. Undercoat the leaves with **F**.

2. Shade with a sideload of **G**. Dry. Then shade again with a sideload of **G+C**.

3. Highlight with a sideload of thinned **E**. Use **E** also to paint the veins.

4. Add accents with a sideload of thinned **B** and/or **B+C**. Paint V shapes of **G+C** in the corners of the veins (see pansy leaves, page 285). Vary the highlights by applying a wash of **H**.

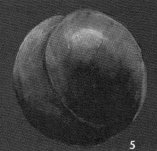

A B C D E F G H

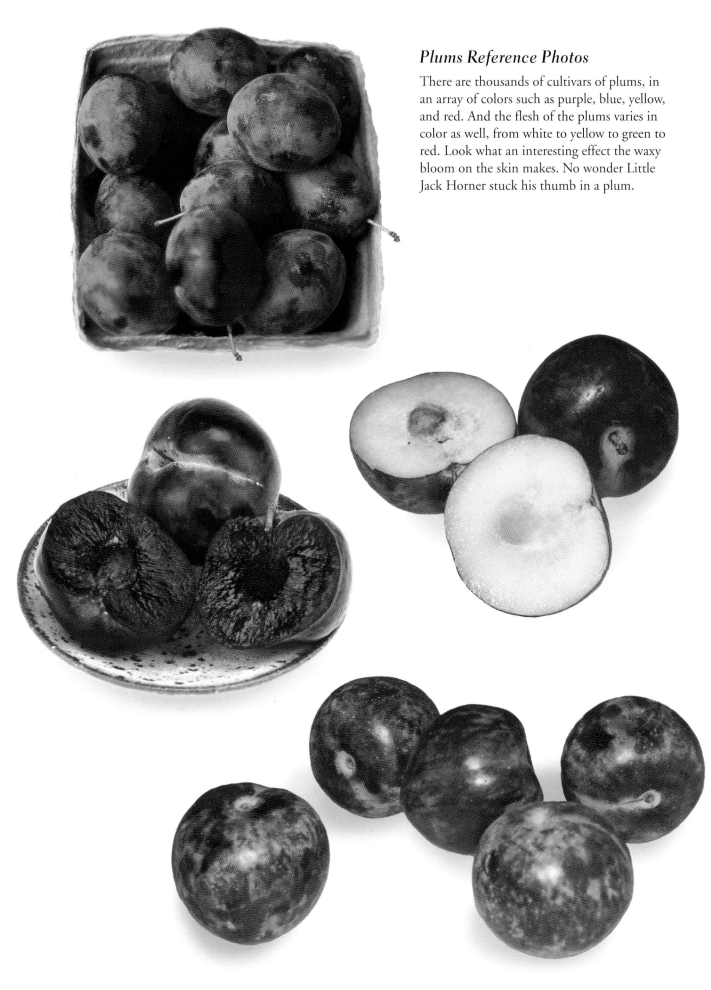

Plums Reference Photos

There are thousands of cultivars of plums, in an array of colors such as purple, blue, yellow, and red. And the flesh of the plums varies in color as well, from white to yellow to green to red. Look what an interesting effect the waxy bloom on the skin makes. No wonder Little Jack Horner stuck his thumb in a plum.

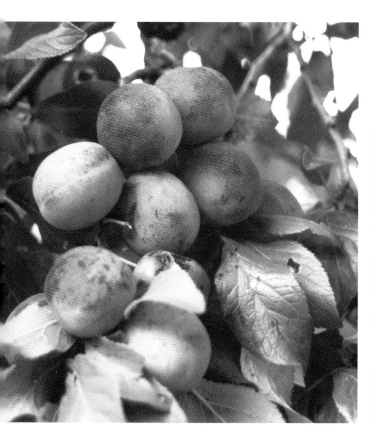

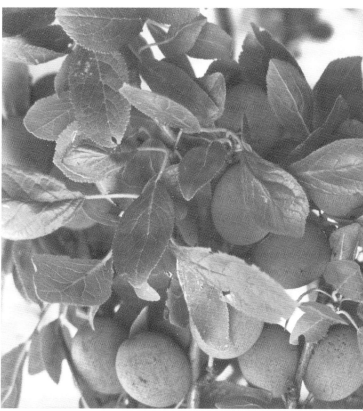

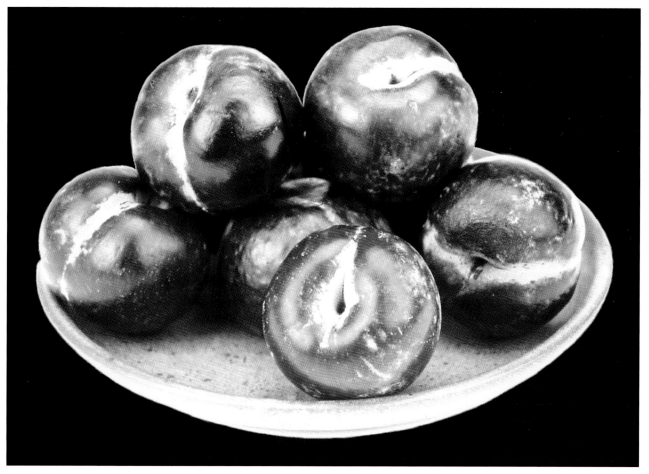

Pomegranates

PALETTE

A Medium
 Flesh
B Sand
C Crimson
 Tide
D Antique
 White
E Cranberry
 Wine
F Raw Umber
G Spice Pink
H Cadmium
 Red
I Tangerine

BRUSHES
Flats: Nos. 2, 6,
 and 10
Round: No. 2
Liner: No. 10/0

A fond childhood memory is my first encounter with this curious fruit and its juicy, pulp-covered seeds. Giving our own children a pomegranate became a fun, fall family tradition, continued even after they were grown. We've extended the tradition, now, to include our grandchildren. A cut pomegranate offers lots of interesting detail for a painting.

Hints

1. Use the No. 10 flat brush to apply undercoats and all washes. Use the No. 6 flat brush to detail the flesh in step 2, and the No. 2 flat brush to paint the seeds in step 3. Use the round brush to highlight the seeds, and the liner brush to fill in the blossom end and paint the pollen.

2. Don't bother tracing the seeds. It's much easier to paint them freehand. Use the No. 2 flat brush, forming two crescent strokes for each seed.

3. Notice on the worksheet how the spilled juice makes the area it covers appear darker.

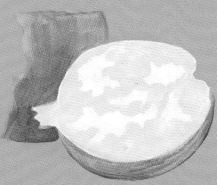

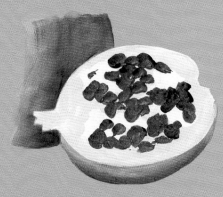

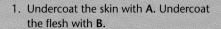

1. Undercoat the skin with **A.** Undercoat the flesh with **B.**

2. Apply a wash of **C** to the skin. Dab **D** on the flesh.

3. Apply a wash of **E** to the skin, heavier on the right and base. Paint the seeds with careless crescent-shaped strokes of sideloaded **E.**

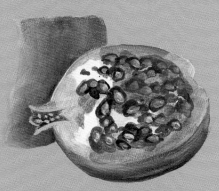

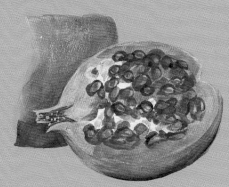

4. With the liner brush, fill in the blossom end with lines of **F.** Use the round brush to highlight seeds with **G**, then dot with **G+B.**

5. Apply a wash of **C** over most of the flesh. Dry. Apply a wash of **H** randomly over the flesh. Paint the pollen and highlight the blossom end with **A.**

6. Drybrush the skin with **A.** Apply a wash of **I** over the flesh area, keeping it thin on the whitish membrane.

7. Add a blemish or two with thinned **F,** outlined with **A.**

A B C D E F G H I

8. Paint the spilled juice with **H+C.** Highlight the juice with **B.**

153

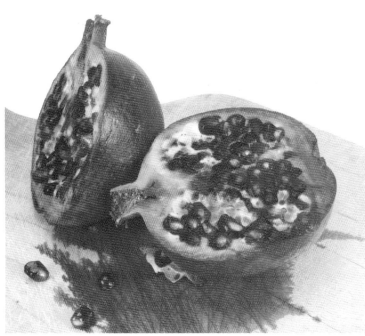

Pomegranates Reference Photos

Pomegranates look like they have already started to explode, even before they are cut open. That's why it is such fun to paint them opened up with juices dribbling all over. Their almost coarse-textured skin is interesting to paint, as well. Arrange a cut pomegranate (or any fruit or vegetable, for that matter) on a plate or board and study it from several viewpoints. Notice that the two photos of the cutting board show the same arrangement but at different angles. Learn to rearrange and to see things in other ways if your first attempt is not satisfying.

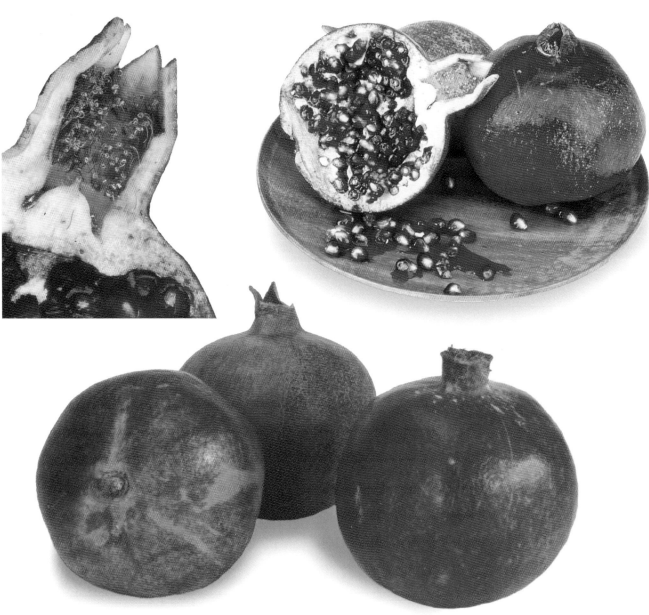

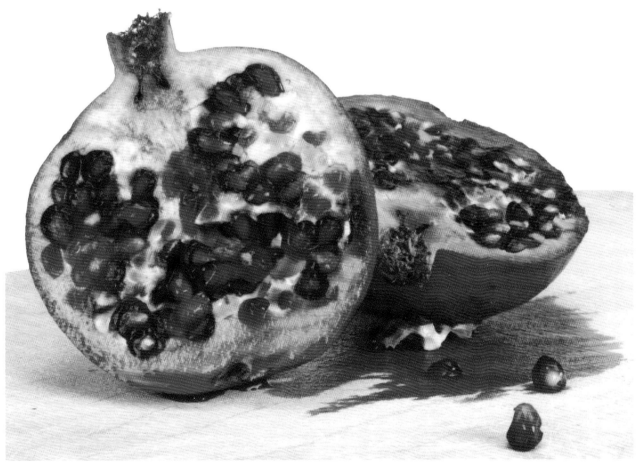

Strawberries

PALETTE
A Peaches 'n Cream
B Coral Rose
C Cadmium Red
D Cranberry Wine
E Moon Yellow
F Taffy Cream
G Light Avocado
H Colonial Green
I Black Forest Green
J Yellow Green

BRUSHES
Flats: Nos. 2 and 8
Round: No. 0
Liner: No. 10/0

We converted the front yard at our old mill home to an herb garden and strawberry patch. I have to race to the patch each morning to gather berries for our cereal before the chipmunks carry them off to sit on the rock wall fence and sample the free fare.

Hints

1. Use the No. 8 flat brush to paint the berries and leaves, the No. 2 flat brush to paint the calyxes, the round brush to paint the seed depressions and the seeds, and the liner to paint highlights around the seed depressions.
2. Suggested painting sequence: Paint the entire berry first, then the seeds, then the calyx.
3. Note in step 2 the heavier application of the wash color on the left (shadow) side of the berry.
4. To highlight the berry in step 4, use a sideloaded brush, keeping the paint edge of the brush toward the center of the highlight. Use the water edge of the brush to blend and soften the edges of the highlight.
5. Seed depressions: Stagger their placement so they don't line up like tin soldiers. Highlight all the way around a few in the center of the strong highlight area. Highlight on the left of those to the left of the highlight; on the right of those to the right of the highlight. (Remember how the light affected the depression in the ball of clay in exercise 2, page 54.)

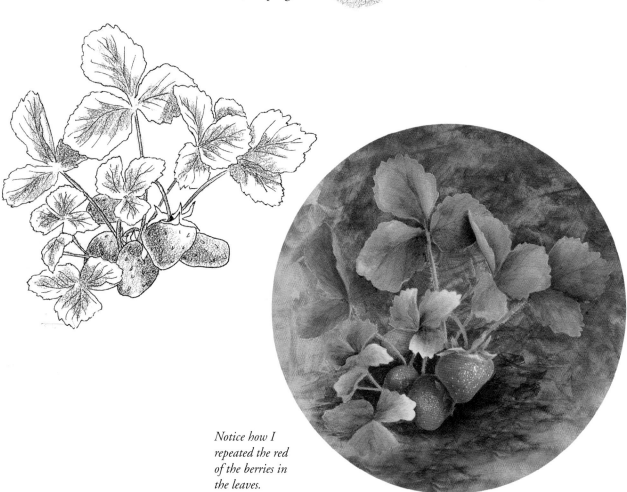

Notice how I repeated the red of the berries in the leaves.

1. **BERRY** Undercoat with **A. CALYX** Undercoat with **G**, heavier in some places.

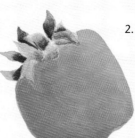

2. **BERRY** Float a wash of **B** over the entire berry. **CALYX** Shade with a mixture of **G+D**.

3. **BERRY** Shade the berry with **D. CALYX** Highlight with **F**.

4. **BERRY** Highlight with **F**.

5. **BERRY** Form the seed depressions on the berry with a thinned mixture of **C+D**. **CALYX** Tint with washes of **E**.

6. **BERRY** Highlight around the seed depressions on the berry with **F**, noting both the position and amount of highlight on the illustration. **SEEDS** Paint with **E**. **CALYX** Tint with washes of **B**.

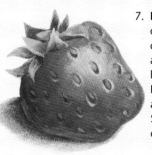

7. **BERRY** Cover with a wash of **C**. While it is damp, lift color off of the highlight area. Then, add a reflected light using a mixture of **H+F**. Add cast shadows with a mixture of **D+G**. **CALYX** Strengthen the light and dark values if needed.

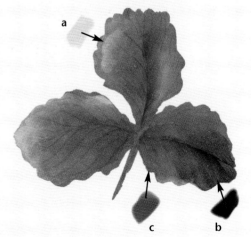

LEAVES

1. Undercoat with **G**.

2. Paint veins with **I**.

3. Cover with a puddly wash of **I**.

4. (a) Highlight with **J+E**. (b) Shade with **I**. (c) Add tints with **C** and with **I**.

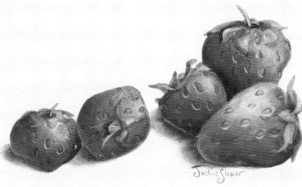

A	B	C	D	E	F		G	H	I	J

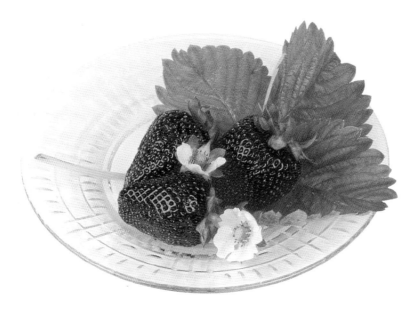

Strawberries Reference Photos

Look closely at the blossoms to see strawberries beginning to form within them. Note the shape and margins of the three-part leaves. Locate the strongest, broadest highlight area on the single strawberry. It's to the right of the center axis. Now look at the stem depressions to the right of that highlight. Where are the highlights on them? Then look at the depressions to the far left of that center axis. Where are the highlights on those depressions? If you did not do experiment 3 on page 54 of Chapter 4, that's what you missed!

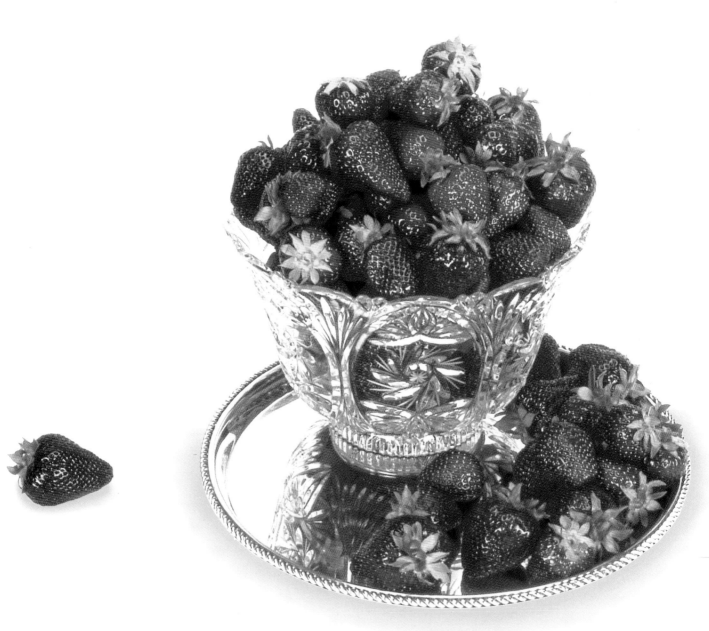

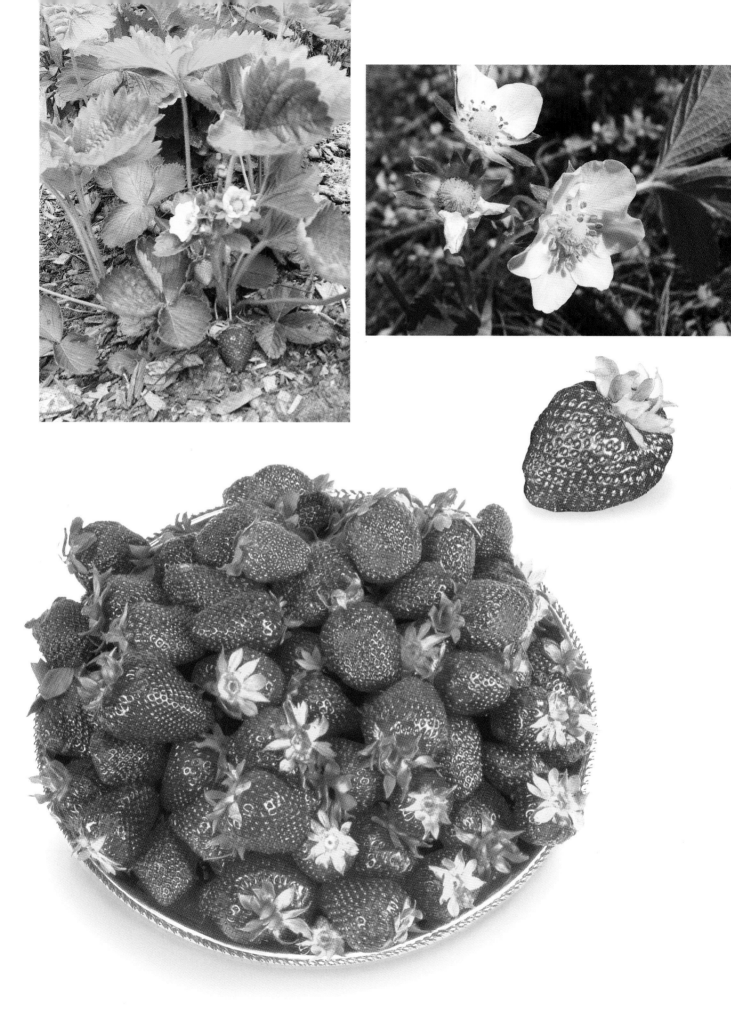

Watermelons

Although the seedless watermelons (if not as tasty) are handier to eat than the seeded variety, I think the ones with seeds are much more fun to paint. Besides, what fun is a watermelon if you can't have a seed-spitting contest?

Hints

1. Use the No. 10 flat brush to paint the flesh, rind, and skin; the round brush to paint the seeds; the No. 2 flat brush to highlight the seeds; and the liner to paint the cut edge of the skin.
2. Follow this sequence in painting the watermelon: flesh, rind, skin, seeds.
3. To create texture in the watermelon flesh, use a careless, slip-slap scumbling method and the No. 10 flat brush to apply the undercoat and subsequent sideloaded washes of color. Repeat any of the steps as needed, using a sideloaded brush and thin paint, to reintroduce any colors or highlights. For example, if your watermelon flesh becomes too red or dark, apply some very thin **A** loosely from a sideloaded brush. Let it dry.

Then if necessary, apply thin **B**, **C**, or **D** lightly over it.
4. After painting the flesh, paint the rind with a sideloaded brush. Place the paint side of the brush along the skin edge, letting the water side of the brush fade the rind color into the flesh.
5. Optional step: To add an interesting touch of color in your composition, try a thin wash of **M** in a deep shadow area.

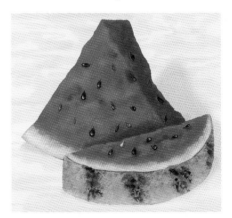

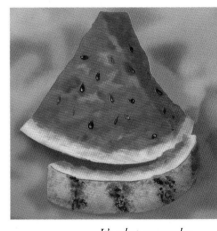

It's a hot, sunny day. Where would you rather eat your watermelon—in a warm, yellow room or a cool, blue one?

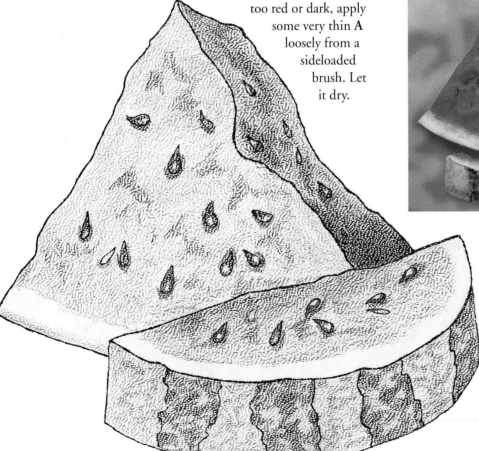

FLESH

1. Undercoat with **A**.

2. Scumble with thinned **B**, applying more **B** on the shadow side.

3. Scumble with thinned **C**, applying more on the shadow side.

4. Scumble with thinned **D**, applying more **D** on the shadow side. Then apply a wash to the shadow side with **E**. Deepen, if needed, with **E** plus a little **F** or **K**.

SEEDS

1. Undercoat most seeds **F**, some thinned **F**, and a few **G**.
2. Paint depressions around many seeds with sideloaded **E** plus a little **F**.
3. Apply a sideloaded highlight wash of **L**.
4. Add an accent highlight of **L**.
5. Submerge the tips or sides of some seeds into the flesh by tapping on a little **B**.

SKIN

1. Undercoat the skin with **I**.
2. Sponge on stripes of slightly thinned **J**. Dry.
3. Sponge on stripes of slightly thinned **K** over the stripes of **J**.
4. Sponge very thinned **J** over the entire skin.

RIND

1. Undercoat the rind with sideloaded **G** (see hint 4).
2. Paint the edge of the rind next to the skin with sideloaded **H**.
3. Paint the cut edge of the skin with a thin line of **K**.

A B C D E F G H I J K L M

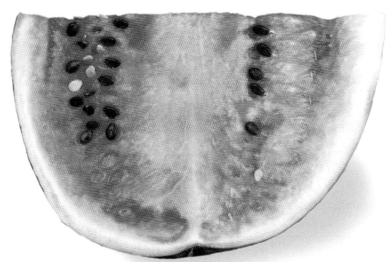

Watermelons Reference Photos

What tasty, perfect, complementary color schemes these fruit are! Watermelons range in size from around 6 pounds to approximately 40 pounds. They may be round or elongated. Their rind may be variegated or striped. Notice how the exposed pattern and placement of the seeds differs depending upon the cut; and how the seeds are often set down in little depressions. Look closely at the slice on the left to see the whitish, scroll-like curves in the flesh.

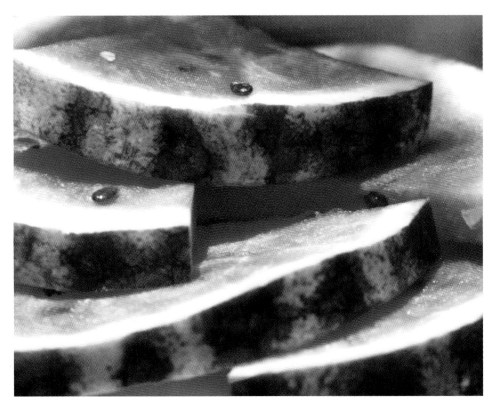

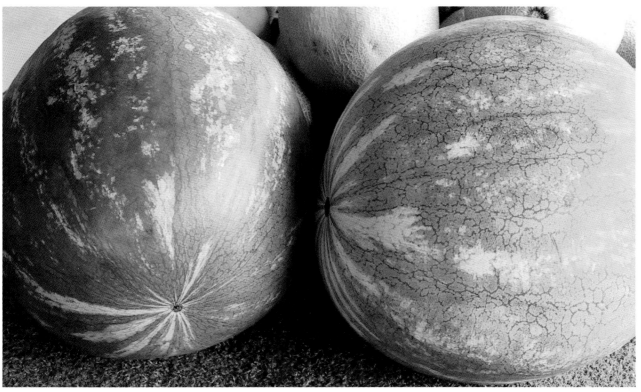

Chapter 8

Step-by-Step Lessons:
Vegetables

"Whoever wants to reach a distant goal must take many small steps."

HELMUT SCHMIDT

We all learn at different rates, in different ways, and in our own time. So you must resist the urge to compare your progress with your friends and your classmates. Just remember that commitment is the first step to success. Unless you're really committed to a task, it will be just that—a task. Another step to success is a positive attitude. Fight the urge to be critical of everything you do, comparing it unfavorably to standards you have not yet developed the skills to attain. Instead, look for the small accomplishments and tally them up. Another step to success is perseverance. No concert pianist ever made it to the stage without persevering through hours of practicing scales.

One of my favorite quotes to share with students, especially when they are struggling or dismayed, is a small tidbit from Danish scientist and poet Piet Hein that contains a huge nugget of advice: "Put up in a place where it's easy to see, the cryptic admonishment 'T.T.T.' When you realize how depressingly slowly you climb, it's well to remember that Things Take Time." So take your time; give yourself permission to be a learner. You, too, will reach your goal. Just make sure you enjoy the journey in the meantime. Oh, and eat your vegetables after you paint them. Mother knew what she was talking about.

Sweet Peppers and Gauguin
18 × 24 inches, acrylic on canvas

The brilliant yellow in this double complementary color scheme (red-green and yellow/orange-blue), though comparatively small in amount, becomes the dominating color by contrasting with so much dark, deep, and dull color. Notice how the framed Gauguin painting fills what would otherwise be too much empty space without distracting from the focal area.

Artichokes

PALETTE
A Olive Green
B Avocado
C Moon
 Yellow
D Dioxazine
 Purple
E Sapphire
F Orchid
G Red Iron
 Oxide

BRUSHES
Flat: No. 8
Liner: No. 1

Most of the commercially grown artichokes in the United States come from California. The plants pictured on pages 168 and 169, however, were grown and pampered in Clopper's Orchard on the side of South Mountain in Maryland, just a few yards away from our home. It was a treat to see them grow, to watch some burst into flower, to paint them, and most especially, to eat them! Artichokes are a great excuse for slurping up hot, melted butter!

Hints

1. Use the flat brush for all steps except painting the thorns in step 4, where you will use the liner brush. Working from the corner of the flat brush to add the streaks (step 3) and the thin bruise lines (step 4) will result in a softer, more natural effect than if you paint those features with the liner brush.

2. Before painting the artichoke, buy one and study it. Then use the step-by-step illustrations merely as a guide, substituting details (such as bruises, scars, shape of petals, thorns or no thorns) from your own artichoke. One of the benefits of painting fruits and vegetables from real life is that you get to eat the model when the painting is complete.

3. Review "Washes and Floated Colors" on page 25.

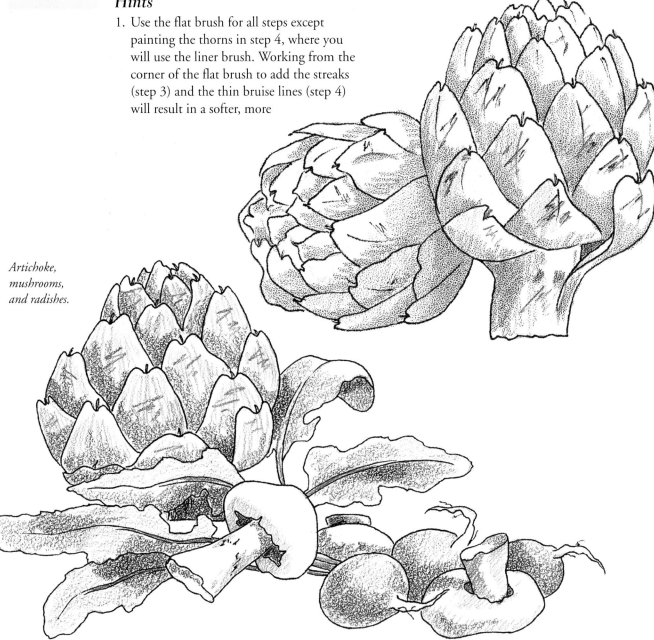

Artichoke, mushrooms, and radishes.

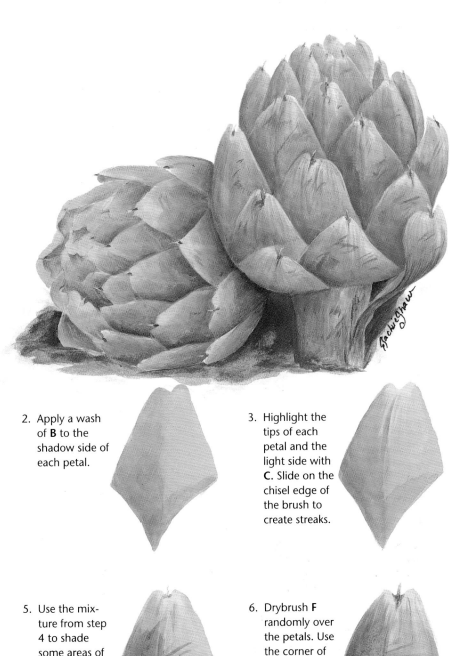

1. Undercoat the leaves with **A**.

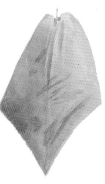

2. Apply a wash of **B** to the shadow side of each petal.

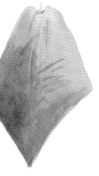

3. Highlight the tips of each petal and the light side with **C**. Slide on the chisel edge of the brush to create streaks.

4. Mix colors **D** and **B** to create a purplish-green. Use this color to suggest scars, bruises, and thorns.

5. Use the mixture from step 4 to shade some areas of each petal. Use a mixture of colors **E** and **B** to shade other areas.

6. Drybrush **F** randomly over the petals. Use the corner of the brush to add **C** to the thorns. Tinge the base of each thorn with **G+B**.

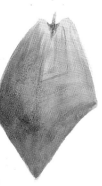

A B C D E F G

Artichokes Reference Photos

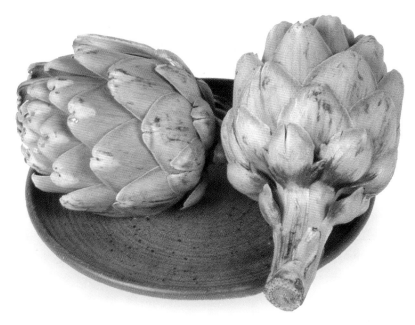

The artichoke, a native of the Mediterranean, grows 3 to 4 feet high and about 6 feet in diameter. Artichokes can add wonderful, textural quality to a painting. Cut in half, they're even more visually exciting. Artichokes can be arranged in a composition so that their petal or scale-like calyxes act as arrows, pointing the viewer's eye along the path we want it to travel. In the series of three photographs on the next page, you can follow the development of the vegetable from its edible state, through the opening of the prickly calyx, to the blossoming of the thistle-like flower.

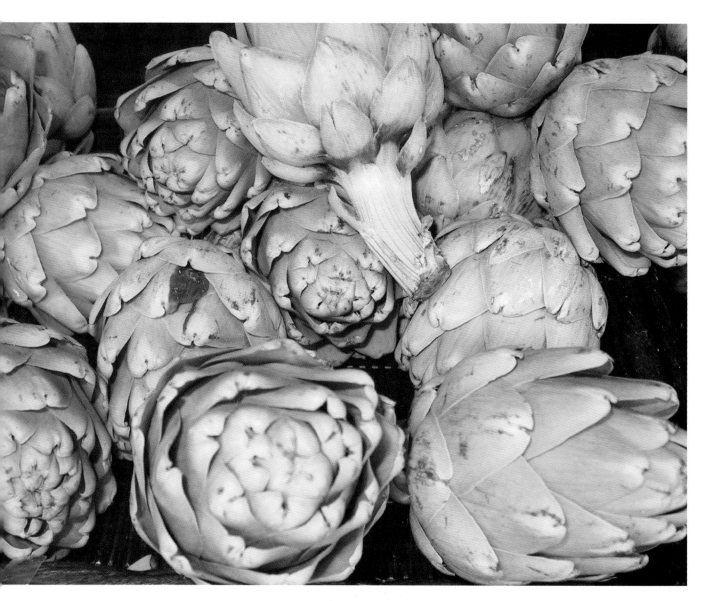

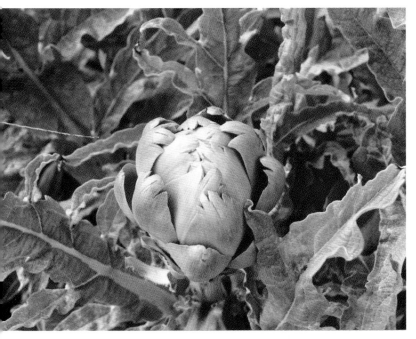

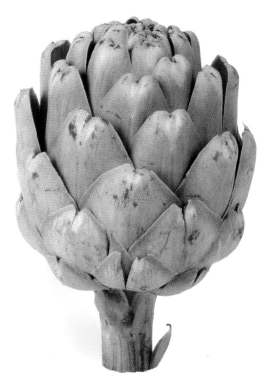

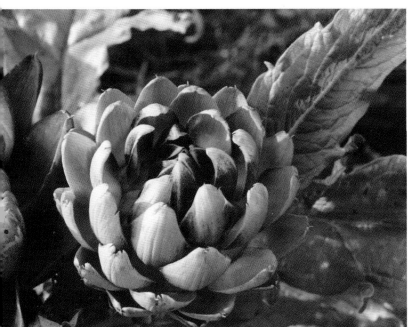

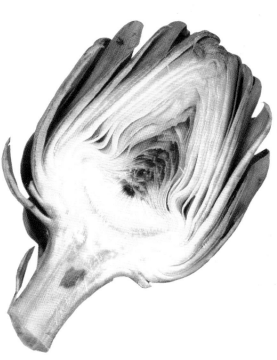

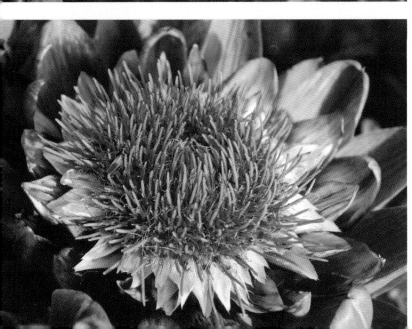

Asparagus

Asparagus provide extra versatility in a composition since they can be laid horizontally or made to stand vertically. They can be playfully splayed or carefully arranged with military precision. And an artist can skillfully use their long, slender shapes to lead the viewer's eye in a painting.

Hints

1. Use the No. 8 flat brush to paint the stalks, the No. 2 and the No. 6 flat brushes to paint the scales, and the No. 2 flat brush to paint the ribbon.
2. Paint the asparagus before painting the ribbon.

Note

I used a low intensity red for the ribbon on the worksheet page to prevent it from grabbing attention away from the asparagus. Compare its understated effect with the ribbon in the photo below left. The brilliant red ribbon screams for attention, especially since it is a warm color surrounded by so much of its cool, complementary color—green. Now notice, in the photo below right, how we can make the red ribbon almost disappear, even though it is still a warm color. By painting both it and the background a low intensity red, we're actually showcasing the asparagus and causing the ribbon to melt into the background.

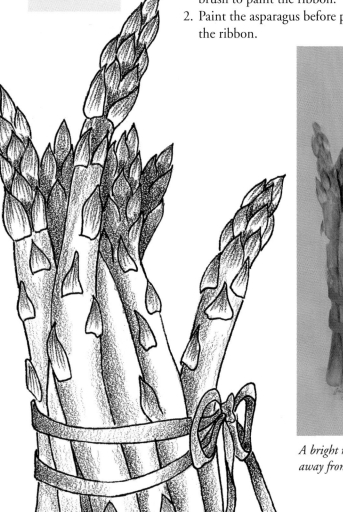

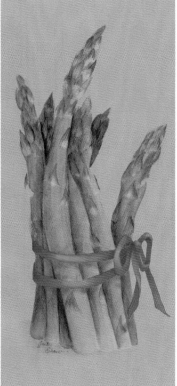

A bright red ribbon draws the eye away from the asparagus.

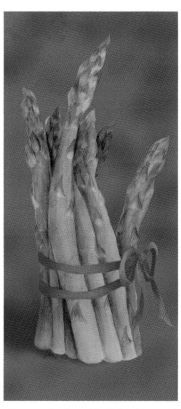

Features (such as this ribbon) painted in colors similar to the background color tend to disappear.

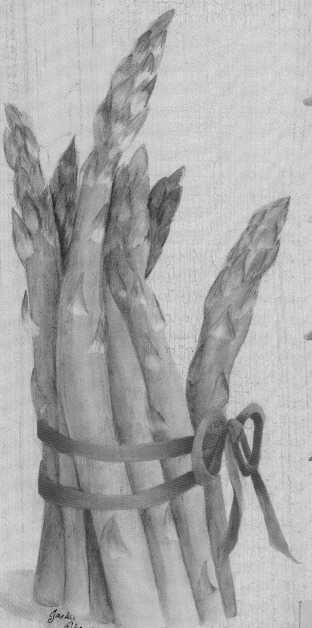

1. Use a flat brush to undercoat the asparagus with **A**.

2. Apply a thin, streaky, sideloaded wash of **B** by holding the flat
 brush at a 45-degree angle to the surface and sliding it back and
 forth along the length of the asparagus. Paint sideloaded thinned
 B on the tips of the asparagus to shade under the scales.

3. Use a small flat brush to paint the scales **C**.

4. Tinge the upper parts of the scales with thinned **D** sideloaded on
 the flat brush. Apply paint from the corner of the brush to create
 the streaks.

5. Shade the edges of the asparagus, and also those areas that are
 behind or under others, with a thin wash of **B+D**. Highlight with
 a wash of **E**.

A	B	C	D	E	F	G	H

RIBBON
(See instructions above.)

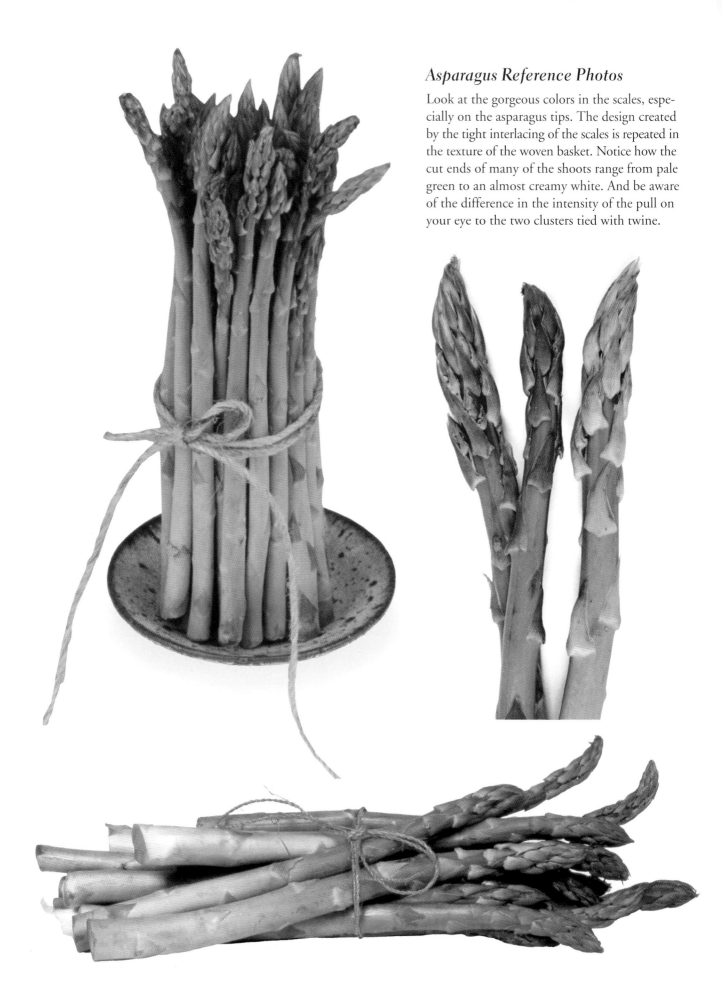

Asparagus Reference Photos

Look at the gorgeous colors in the scales, especially on the asparagus tips. The design created by the tight interlacing of the scales is repeated in the texture of the woven basket. Notice how the cut ends of many of the shoots range from pale green to an almost creamy white. And be aware of the difference in the intensity of the pull on your eye to the two clusters tied with twine.

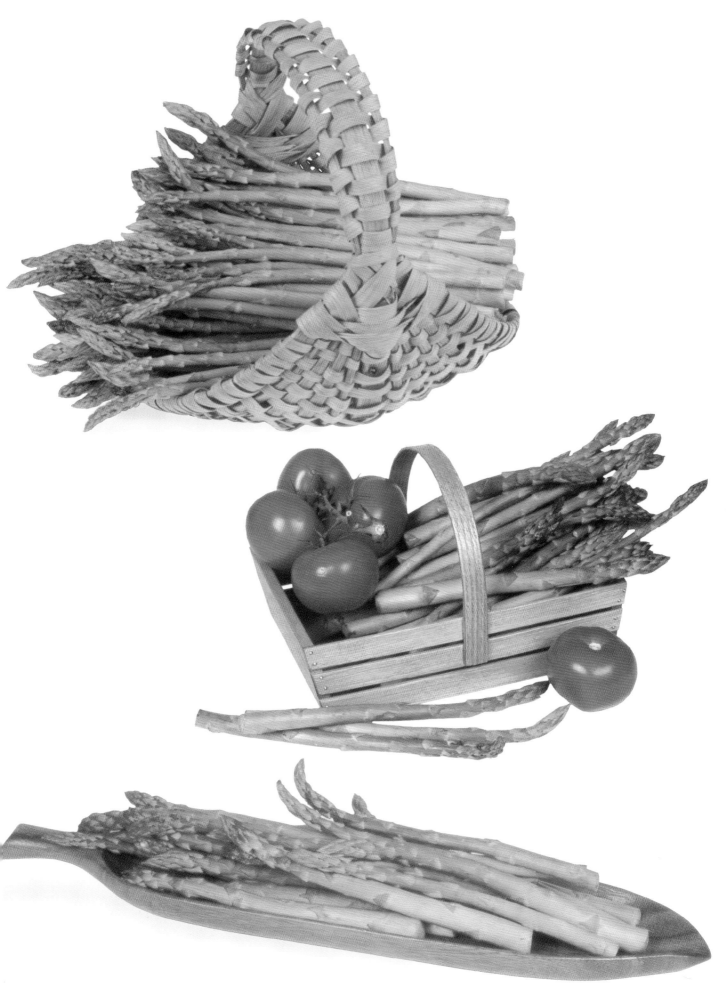

Beans

PALETTE
A Taffy Cream
B Pineapple
C Avocado
D Burnt Sienna
E Buttermilk
F Midnite
 Green

BRUSHES
Flats: Nos. 1
 and 8
Liner: No. 10/0

Beans, like berries and smaller fruits, can be massed to create a large impact; smaller clusters can be scattered to balance color or shape through repetition. The long, slender form of the beans also makes them good at directing attention by pointing the way.

Hints

1. Use the No. 8 flat brush to paint the beans and leaves, the No. 1 flat brush to paint the flowers, and the liner to paint the veins, stems, and tendrils.
2. Notice in steps 1 and 2 that the beans inside the pods are built up with first more opaque color, then more brilliant color. This process helps give shape to the bean pod before adding the local color wash. This build-up process is also used to form the calyx on the blossom.
3. If you paint the design with small flowers, just a suggestion of the colors and shading will be sufficient. If your design—and

hence flower—is larger, refer to the step-by-step illustrations for the flowers. Use the round brush to paint the flowers and the smaller leaves.

4. To paint the "string" in the bean, sideload the flat brush with **C.** With the color side of the brush facing you, and holding the brush perpendicular, pull the brush along the bean toward you. The water side of the brush will soften the line slightly as you stroke, creating a natural shadow.
5. Notice how the dark leaves fade into the background, thus focusing attention on the beans and flowers. If we wanted to focus attention on only the beans, we could subdue the tiny flowers using washes of the grayed shading mixtures (see step 2 of the flowers).
6. To imagine how the beans would look on a different colored background, turn to the artichokes (page 166) and asparagus (pages 170) lessons to see how the greens in those two vegetables relate to the background colors shown.

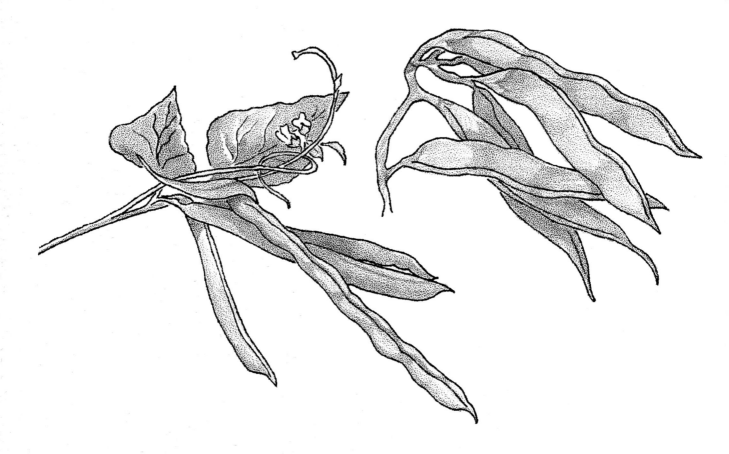

BLOSSOMS

1. (a) Undercoat the flower with **E**. (b) Undercoat with **A**. (c) Undercoat the calyx with **A**. Accent the bulge in the calyx with **B**.

2. Shade the light petals with sideloaded **E** plus very little **F+D**. Shade the yellow petals with sideloaded **B** plus very little **D+F**. Apply a thin wash of **C** on the calyx. Highlight the yellow petals with **E**.

BEANS

1. Undercoat the beans with **A**. On the developed beans, apply a second coat only on the "bumps." On the undeveloped beans, apply a second coat to the entire bean.

2. Paint the "bumps" **B**.

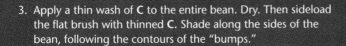

3. Apply a thin wash of **C** to the entire bean. Dry. Then sideload the flat brush with thinned **C**. Shade along the sides of the bean, following the contours of the "bumps."

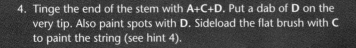

4. Tinge the end of the stem with **A+C+D**. Put a dab of **D** on the very tip. Also paint spots with **D**. Sideload the flat brush with **C** to paint the string (see hint 4).

LEAVES

1. Undercoat the leaves and leaf stems with **C**. Using **B**, undercoat the main stems and tendrils, and highlight the leaf stems.

2. Apply a puddly wash of **F** over the entire leaf. Apply a wash of **C** over the stems and tendrils.

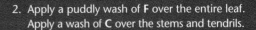

3. Paint the veins with the liner brush and thinned **C**. Shade the stems with **F+C**.

A B C D E F

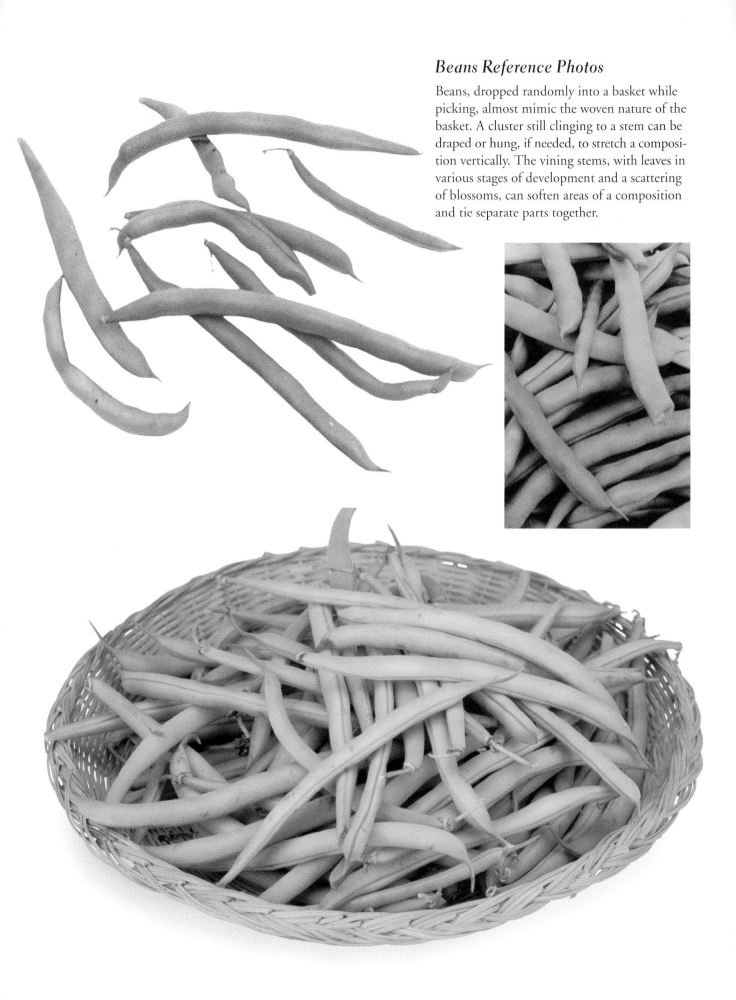

Beans Reference Photos

Beans, dropped randomly into a basket while picking, almost mimic the woven nature of the basket. A cluster still clinging to a stem can be draped or hung, if needed, to stretch a composition vertically. The vining stems, with leaves in various stages of development and a scattering of blossoms, can soften areas of a composition and tie separate parts together.

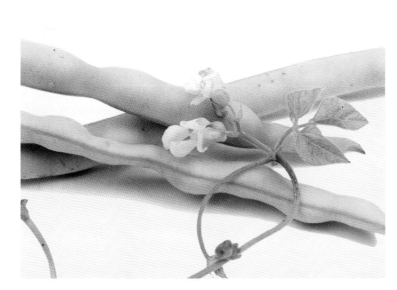

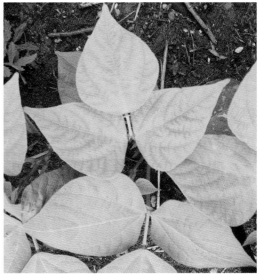

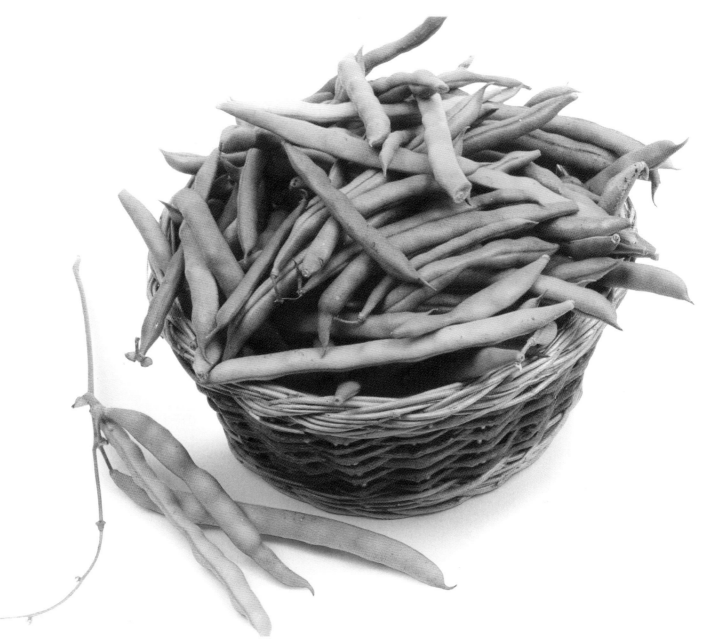

Carrots

PALETTE
A Pumpkin
B Tangerine
C Burnt
 Orange
D Burgundy
 Wine
E Prussian
 Blue
F Taffy Cream
G Avocado
H Mistletoe

BRUSHES
Flat: No. 8
Liner: No. 10/0
Dagger striper
 (Series
 7800): 1/4"
 (optional)

If you've ever plucked a carrot from the earth, rinsed it under a hose, and tasted its just-picked freshness, you can appreciate how a painting of carrots with their fresh, green tops could evoke memories of that crunchy, sweet, wholesome taste.

Hints

1. Use the flat brush to paint the carrots, fronds, and stems. Use the liner brush to paint the fine hair roots.
2. For best results in painting the carrots' delicate fern-like fronds, use the chisel edge of the flat brush (or, preferably, the dagger striper). Load a thinned mixture of **G+E+D** into the brush and paint clusters with tapping/dabbing strokes. Repeat at least a second and a third time, each time using a lighter value and slightly thicker paint.
3. To paint the stems, use the same color mixtures as for the fronds. Holding the flat brush perpendicular to the surface, slide on the chisel edge, laying down thin streaks of color. By using the flat brush, rather than a liner brush, the delineation between your values will be softer and more natural looking.

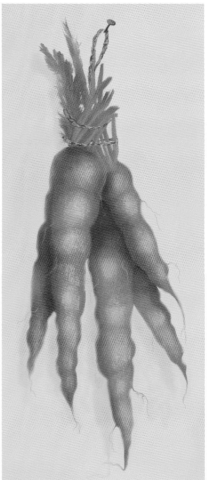

If the complementary color scheme of the worksheet sketch is too bold for your tastes, try a more harmonious combination with this analogous scheme.

TOPS AND STEMS

1. Dab thinned **G+E+D**.

2. Dab thinned **G**.

3. Dab thinned **G** and **H+F**.

A
B
C
D
E
F
G
H

CARROTS

1. Undercoat carrots with **A**.

2. Highlight with **B**, leaving spaces to suggest indentations.

3. Apply a wash of **C** over the whole carrot. Dry. Then shade edges and indentations with **C** sideloaded on the brush.

4. Intensify shading with a sideloaded wash of **C+D+E**.

5. Accent highlights by drybrushing a mixture of **A+F**. Use the liner brush to paint hair-like roots with **A**.

6. Deepen shading and add shadows with a sideloaded wash of **E**.

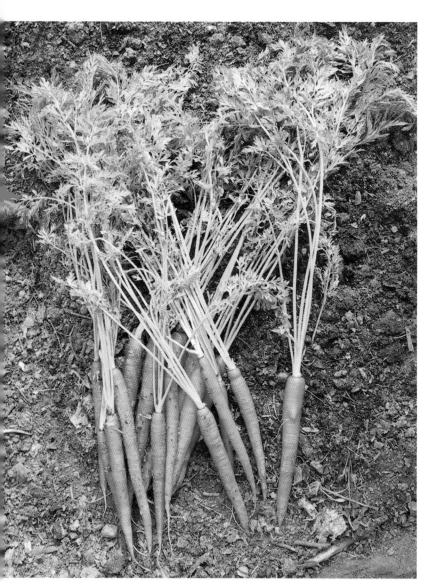

Carrots Reference Photos

Carrots' strong, readily identifiable color and shape lend a comfortable sense of familiarity to a painting. Their long, flowing, fern-like tops add a softness to hard edges and a sense of freshness. Notice the fine hair-like roots on the carrot and the creases girdling its circumference. Remember the experiment with the paper towel tube on page 106 of the cherries lesson, and how the lines seemed to curve differently, depending upon your eye level? Creases around the carrots do the same thing.

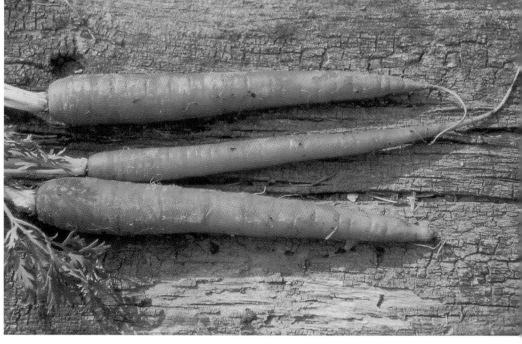

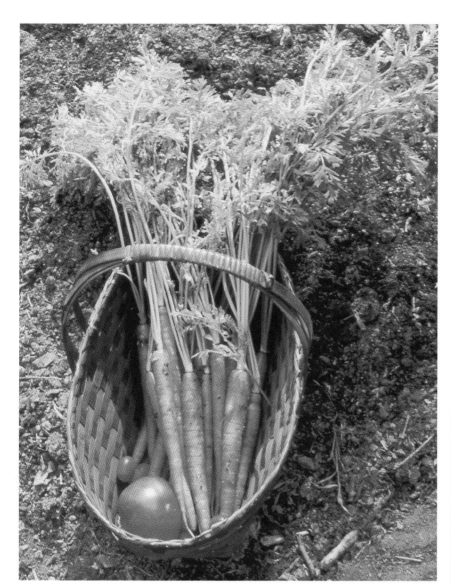

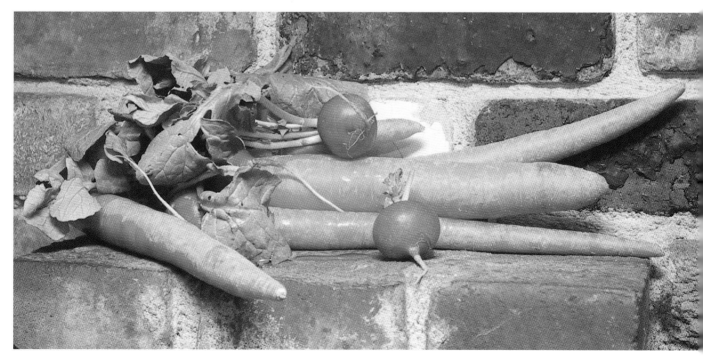

Chili Peppers

PALETTE:
A Coral Rose
B Peach Sherbert
C Antique Green
D Honey Brown
E Cherry Red
F Hauser Dark Green
G Burnt Sienna
H Napa Red
I Yellow Ochre
J Cadmium Red

BRUSHES
Flat: No. 6
Round: No. 2
Liner: No. 1

Chili peppers, because they can be shown hanging, draped, or arranged on a surface, allow versatility in arranging a composition. They can also add a distinct regional flavor. Dried and wrinkled chilies add charming contrast to a too-slick, shiny, or smooth composition.

Hints

1. Use the flat brush to paint the peppers, the round brush to paint the calyx and stems, and the liner brush to paint the raffia.
2. To imagine how the red chilies might look on another color background, see the subject-to-background color relationship of the cherries on pages 105, the pomegranate on page 153, and the red tomatoes on pages 214 and 215.

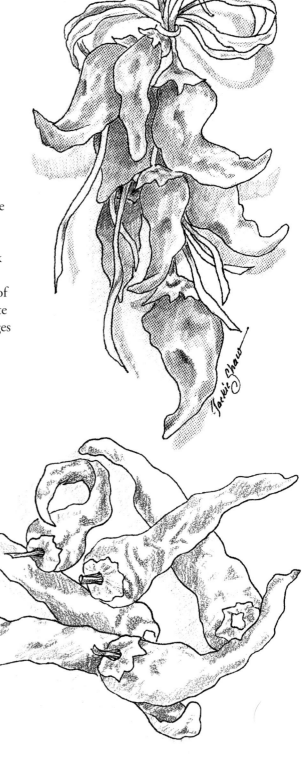

Red chilies painted on a light orange background with a dash of turquoise take on a Southwestern flavor.

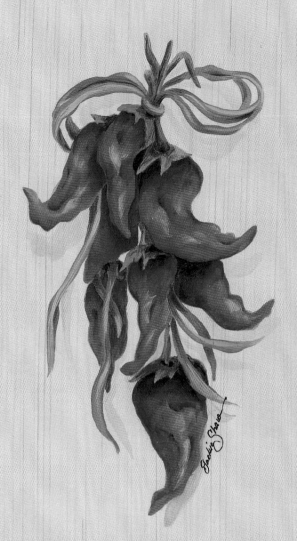

1. Undercoat the peppers with **A**, then highlight them with **B** sideloaded on the flat brush. Undercoat the calyx and the stems with **C**, and the raffia with **D**.

2. Apply a wash of **E** over the peppers. Shade the calyx and the stems with **F+G**. Shade the raffia with **G**.

3. Sideload the flat brush with **G** to shade the peppers, then deepen some areas with **H+F**. Highlight the calyx and the stems with **C+I**. Deepen the raffia shading with **G+H**.

5. Add highlight accents with **I**.

4. Apply a wash of **J** on the peppers. Highlight the raffia with **D+I**. Using a thin wash, paint cast shadows in a color slightly darker than your background color.

A B C D E

F G H I J

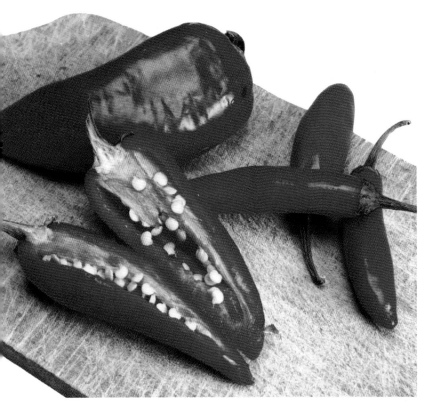

Chili Peppers Reference Photos

Look at the chili peppers in and beside the pottery bowl. They are in different stages of drying. Notice how the red color deepens, and how many more little highlights are on the more crinkled skin. Compare the skins of these chilies to the hanging, well-dried ones, and then to the just-picked ones on the cutting board. A sliced-open chili offers eye-catching contrast and detail with its bright, almost white seeds and subtle orange-tinged ribs.

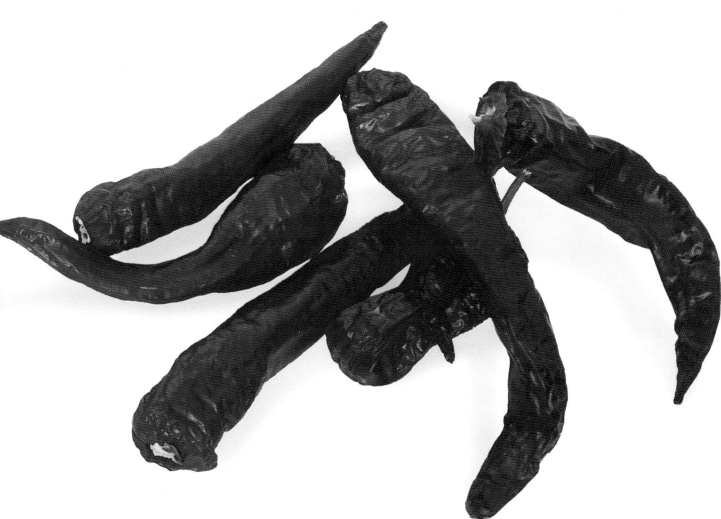

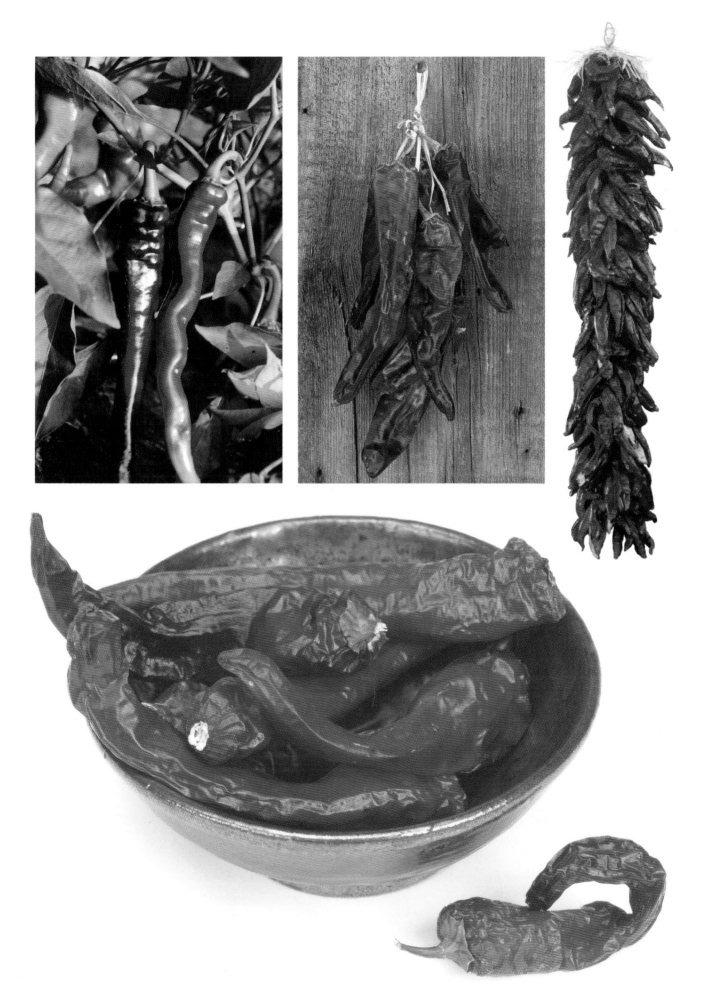

Corn

PALETTE

A Sand
B Light Buttermilk
C Yellow Ochre
D Raw Sienna
E Raw Umber
F Red Iron Oxide
G Black Plum
H Plum
I Cranberry Wine
J Cadmium Yellow
K Honey Brown
L Russet
M Antique Mauve
N Khaki Tan
O Taffy Cream

BRUSHES

Flats: Nos. 2 and 6
Liner: No. 10/0
Old toothbrush

I focused this lesson on painting dried Indian corn as it provides an opportunity to play with a large variety of color washes. To paint fresh sweet corn, two sideloaded crescent strokes of deep yellow per kernel will do the trick.

Hints

1. Use the No. 6 flat brush to paint the corn and husks, the No. 2 flat brush to color the kernels and paint the nail and twine, and the liner to paint the silks.

2. The trick to painting Indian corn is to apply the sideloaded, thinned colors for the individual kernels—over a solid undercoat—with a small flat brush.

 a. For each kernel, paint two crescent strokes around the outside edges, leaving the inner section as a highlight area.

 b. In step 11, to intensify the highlights, dab them on with the corner of the No. 2 flat brush. The flat brush will create a soft, realistic, random effect.

 c. An optional wash of color after step 11 will totally change the appearance. Step 12 illustrates a wash of **I**; however, other colors would also work.

3. To undercoat the husks, hold the flat brush upright and slide on the chisel edge, laying the paint down in ridges (to create texture and variety) as it is forced out of the brush hairs.

 a. Follow the contours of the husk. Add a few lighter veins with the liner brush and thick paint. The wash color, applied in step 3, will settle among the ridges, creating variety in color and value.

 b. To apply shading (steps 4, 5, 6), sideload the flat brush with thinned paint. Hold the brush perpendicular to the surface and slide lightly on the chisel edge, pushing the paint back and forth following the contours to suggest veins. For broader, deeper shaded areas, work with the brush held at a 45-degree angle and paint from the flat side.

4. To paint fresh, green husks, substitute greens (see colors for radish leaves, page 207) for the colors used in painting the dried husks in steps 3 to 6. Keep the inner husks lighter in value.

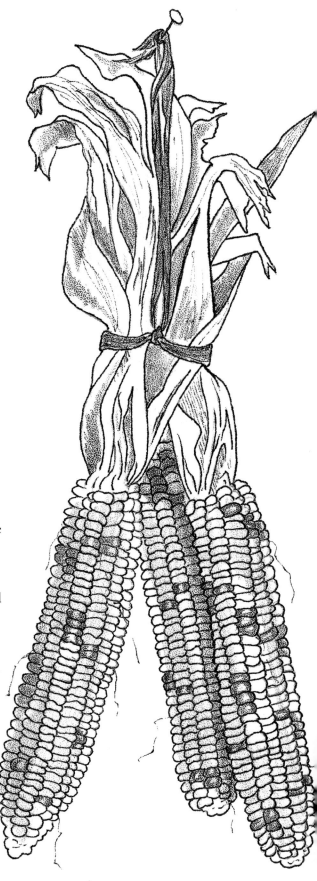

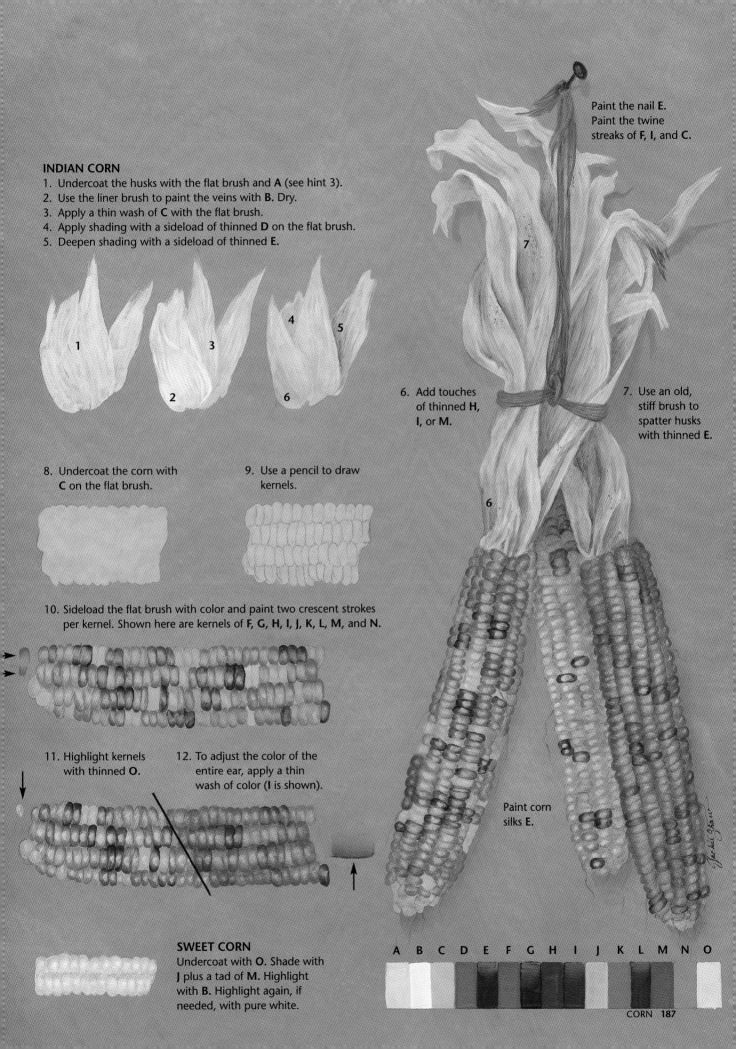

INDIAN CORN

1. Undercoat the husks with the flat brush and **A** (see hint 3).
2. Use the liner brush to paint the veins with **B**. Dry.
3. Apply a thin wash of **C** with the flat brush.
4. Apply shading with a sideload of thinned **D** on the flat brush.
5. Deepen shading with a sideload of thinned **E**.

Paint the nail **E**.
Paint the twine
streaks of **F**, **I**, and **C**.

6. Add touches
 of thinned **H**,
 I, or **M**.

7. Use an old,
 stiff brush to
 spatter husks
 with thinned **E**.

8. Undercoat the corn with
 C on the flat brush.

9. Use a pencil to draw
 kernels.

10. Sideload the flat brush with color and paint two crescent strokes
 per kernel. Shown here are kernels of **F**, **G**, **H**, **I**, **J**, **K**, **L**, **M**, and **N**.

11. Highlight kernels
 with thinned **O**.

12. To adjust the color of the
 entire ear, apply a thin
 wash of color (**I** is shown).

Paint corn
silks **E**.

SWEET CORN

Undercoat with **O**. Shade with
J plus a tad of **M**. Highlight
with **B**. Highlight again, if
needed, with pure white.

A B C D E F G H I J K L M N O

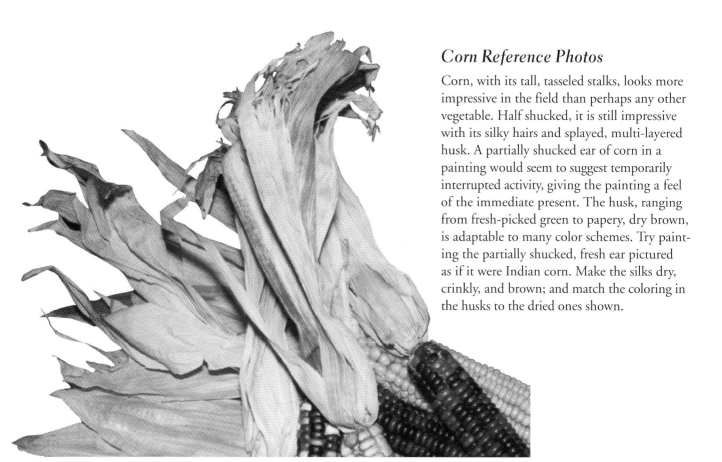

Corn Reference Photos

Corn, with its tall, tasseled stalks, looks more impressive in the field than perhaps any other vegetable. Half shucked, it is still impressive with its silky hairs and splayed, multi-layered husk. A partially shucked ear of corn in a painting would seem to suggest temporarily interrupted activity, giving the painting a feel of the immediate present. The husk, ranging from fresh-picked green to papery, dry brown, is adaptable to many color schemes. Try painting the partially shucked, fresh ear pictured as if it were Indian corn. Make the silks dry, crinkly, and brown; and match the coloring in the husks to the dried ones shown.

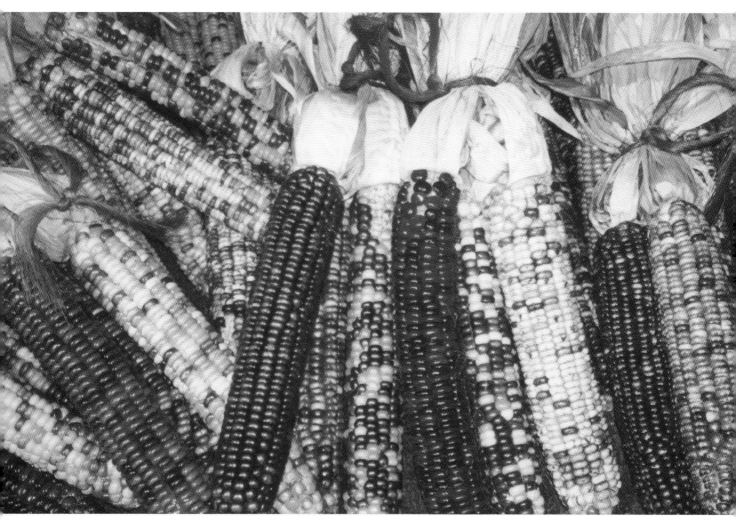

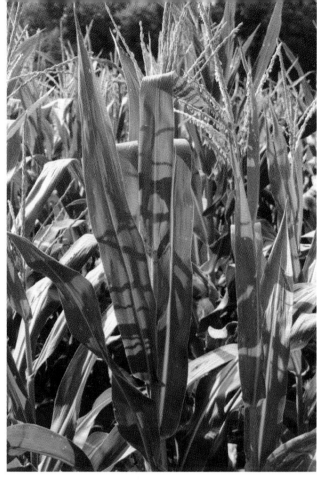

Eggplants

PALETTE
A Cool Neutral
B Warm Neutral
C Olive Green
D Plum
E Black Plum
F Paynes Grey
G Yellow Ochre
H Light Buttermilk

BRUSHES
Flats: Nos. 4, 6, and 10

Eggplant, with its smooth, even contours and color can easily hide in the background of a painting as a gentle shape. Or, it can command center stage when its expansive surface area reflects a broad, brilliant highlight contrasted against its dark purple skin.

Hints

1. The eggplant has a large, smooth surface area, so use the largest flat brush you can comfortably handle. Use the smaller flat brushes to paint the calyx and the blossom end.
2. The technique and colors used here for painting the eggplants could also be used to paint purple peppers and plums. A bunch of grapes and grape leaves would also be lovely painted in these colors.

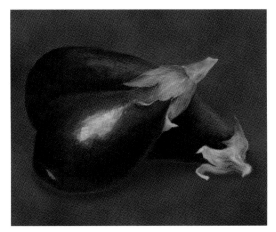

Notice how much more obvious the calyxes are on this dark background than on the lighter worksheet. Even though this background absorbs the eggplants, it creates a dramatic effect.

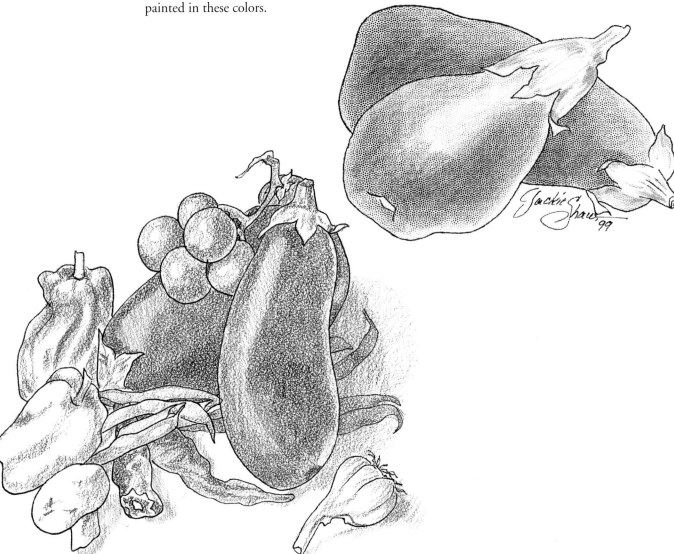

1. Undercoat the calyx and stem with **A**. Undercoat the eggplant with **B**.

2. Apply a puddly wash of **C** on the calyx and stem. As the puddles dry, some areas will contain more pigment than others, creating a mottled appearance. Beginning at the base of the eggplant, stroke on a thin wash of **D**, allowing the wash to fade as you approach the calyx.

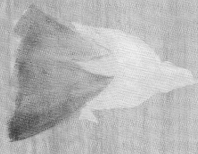

3. Add bruises and shading to the calyx and stem with **E** sideloaded on the flat brush. Shade the eggplant with a wash of **E**. Repeat as needed to create depth.

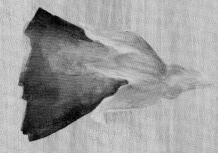

4. Deepen the shading on the calyx and stem with a mixture of sideloaded **C+F**. Deepen the shading on the eggplant with a wash of **F**.

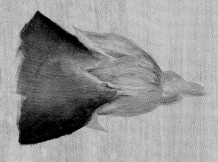

5. Paint the blossom end with a mixture of **G+E+F**. Then, moisten the eggplant and brush thinned **G** into the center to create the highlight area. Let the color disperse into the moisture. Dry. Add a stronger shine within that area by drybrushing on **H**. Sideload the flat brush with **D+B** and paint the reflected light along the bottom edges of the eggplant. Highlight scattered areas on the calyx with **G+C**.

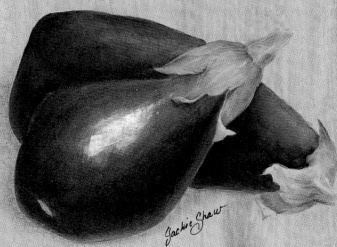

A B C D E F G H

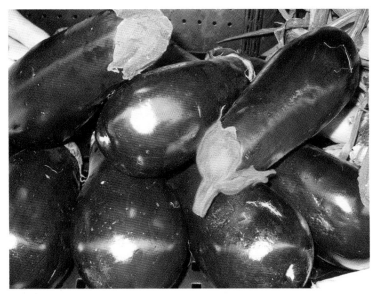

Eggplants Reference Photos

In addition to the familiar large, dark, purple eggplant, there are many other varieties: long slender ones; little globe-shaped ones; white ones; light purple ones; pink or red-violet ones with irregular, white stripes; small, yellow Thai ones; and tiny, pea-shaped green ones. Look hard at the woven tray and you'll see five different varieties, plus two other members of the nightshade family—peppers and tomatoes. If you were to paint that tray of vegetables, you might consider toning down the brilliant white of the eggplant and garlic. Their strong contrast against the dark eggplants is jarring. The light value mushrooms and yellow squash offer a more pleasing contrast.

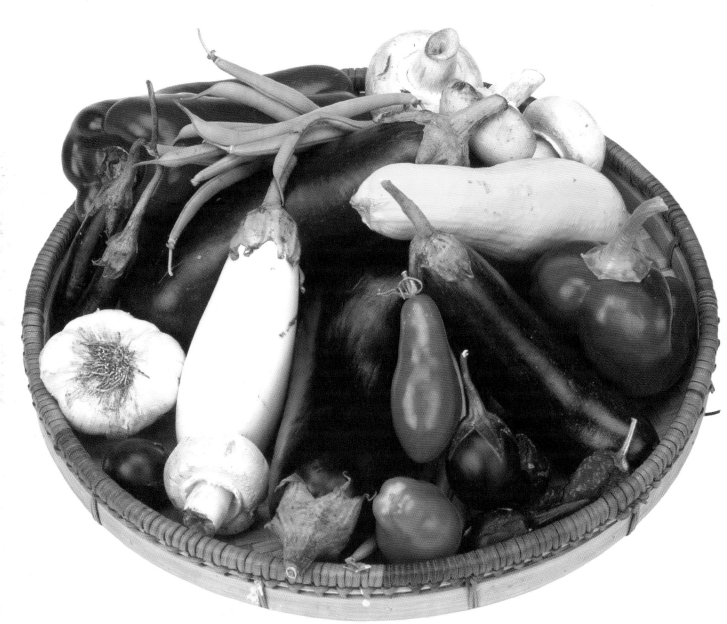

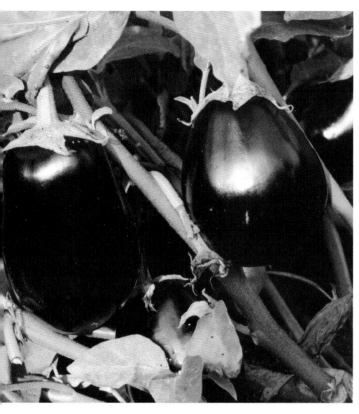

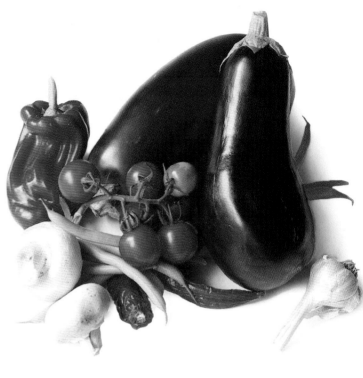

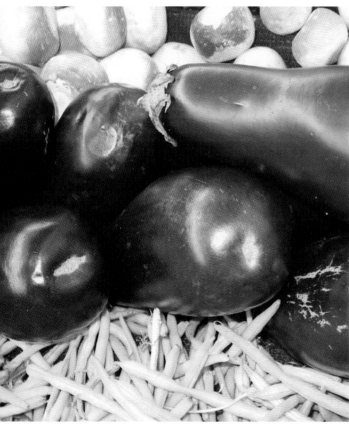

Garlic

PALETTE
A Buttermilk
B Sand
C Khaki Tan
D Light
 Buttermilk
E Raw Umber
F Plum
G Mauve

BRUSHES
Flats: Nos. 6
 and 8
Liner: No. 10/0

Garlic bulbs have lots of character, making them fun to paint. Line up a half dozen and they'll all be quite different. The torn bits of crinkly outer skin, the center stalk, the mass of curly roots, and the knobby lumps of the individual cloves all make garlic an interesting candidate for a painting.

Hints

1. Use the No. 8 flat brush to paint the whole garlics, the No. 6 flat brush to paint the cloves, and the liner brush to paint the veins, broken skin details, and the roots.
2. Garlic can spice up a vegetable design as delightfully as it spices up a meal. Place some fresh garlic nearby to study as you paint.

You might be surprised at the variety of subtle color changes and textures you'll see.

3. If you'd like to have garlic always on hand for a painting subject, set a few bulbs aside and let them dehydrate. They'll retain their shape and can be arranged and rearranged so they appear different in each painting.
4. When working on a medium to dark value background, let some of the background color show through the undercoat. This will help define the contours of the cloves, suggest texture, and unify the subject with the background. Apply the undercoat streakily, working from the base of the garlic to the tip.
5. Building up the opacity of the individual cloves at their fullest part (within the whole garlic) helps create dimension (see step 2).

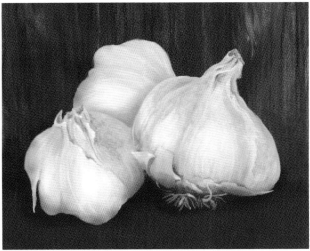

To create a faux woodgrained background, use a woodgraining comb or create a comb by cutting comb-like strips in a piece of heavy chipboard. Drag the comb through wet paint thinned with Brush 'n Blend Extender (see page 75).

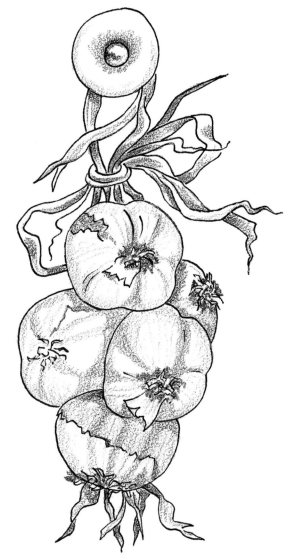

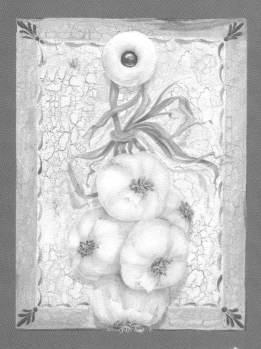

Try painting this bunch of hanging garlic using the pattern on the previous page.

1. Use the flat brush to undercoat the garlic with thinned **A**.

2. Build up "bulges" with more **A**, unthinned.

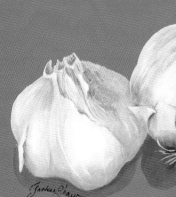

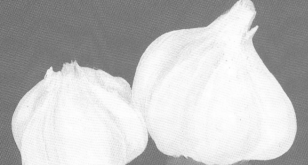

3. Apply a thin wash of **A** over the entire garlic bulb.

4. Paint a streaky wash of **B**. Then undercoat the root area with **C**.

5. Sideload the flat brush with **C** to add shading.

6. Highlight the bulges with **D**. Shade the roots and base with sideloaded **E**.

GARLIC CLOVES

1. Undercoat individual cloves with **B**.

2. Paint a "streaky" wash of **C**, then accent with thinned **G**. Fill in the base end with **C**.

3. Sideload a flat brush with **F+E** to add shading. Use the liner brush and **E+F** to accent details.

7. Use the liner brush and thinned **D** to paint the veins and broken skin details. Shade the details with thinned **E**. Dab on **F** to accent.

8. Use the liner brush to paint the roots **B+C**. Highlight with **B+A**. Add shadows in a thinned, darker value (**E+F**) of background color (**G**).

A	B	C	D	E	F	G

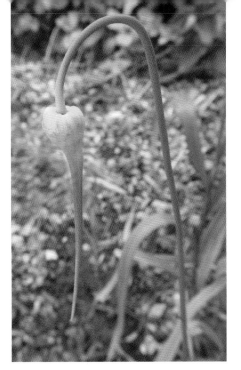

Garlic Reference Photos

Growing your own garlic for painting subjects is really quite easy. In the fall, four to six weeks before the ground freezes, break open a garlic bulb, and plant the individual cloves about five inches apart and two inches deep in fertile soil and full sun. In the summer, when the leaves die back, pull the bulbs and dry them. Let a few of the more interesting shapes totally dry out. They'll make perfect painting models for years if handled gently. The flower head, shown in the picture at left, will begin to straighten a bit, causing the plants to look like a bunch of long-necked geese bobbing in the breeze. These heads should be cut off to encourage bulb growth, but I enjoy the look of them, so I let some of them grow anyway.

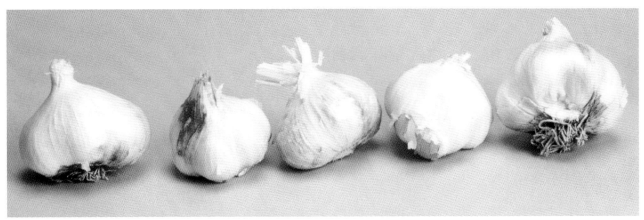

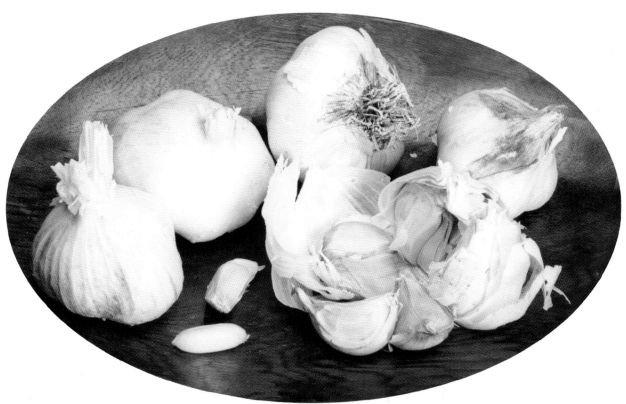

Mushrooms

PALETTE
A Antique White
B Raw Sienna
C Dark Chocolate
D Midnite Blue
E Taffy Cream

BRUSHES
Flat: No. 8
Liner: No. 10/0

Even though mushrooms are not vegetables (they're fungi), I've included them in this section because they've been appreciated for their flavor since the early Greeks and Romans. However, since their food value is negligible, I, personally, prefer just to paint them.

Hints

1. Use the flat brush to paint the mushroom stems and caps, and the liner brush to paint the gills and tears.

2. Don't frustrate yourself by trying to copy these mushrooms exactly. You'll have more fun and greater success by just using the suggested steps and colors, and letting your random brush strokes guide where smudges, tears, dents, and wrinkles fall.

3. Buy a package of fresh mushrooms and dump them on a shelf near your painting area. Pick a few interesting ones to serve as models. You can even use the outline of the patterns provided and simply plug in details from your models.

4. When you finish painting, sauté your models and have a feast (provided you didn't contaminate them with paint).

Mushrooms, chili peppers, garlic, cherry tomatoes, and herbs. See a photograph of these delectables on page 201.

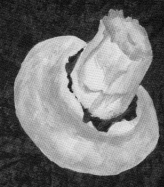
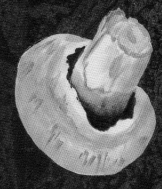

1. Undercoat with **A.**

2. Brush on a thin layer of water or water plus medium. Then immediately brush on thinned **B,** allowing it to appear splotchy.

3. Sideload the flat brush with **C+D.** Fill in the gill area, placing the loaded side of the brush deep inside the cap and letting the color fade as it works up the base of the stem. Add dark smudges and creases by painting with the corner of the brush.

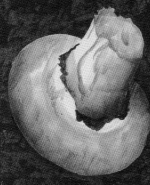
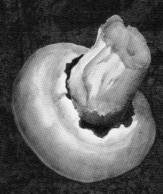

4. With the brush still sideloaded with **C+D,** add shading to the cap and the stem. Add some color variations by shading in spots with just sideloaded **C.**

5. Highlight with sideloaded **E.** Then add a reflected light with very little **E+B.**

6. Repeat any of the previous steps to adjust and/or strengthen hues and values. Add gills where appropriate with the liner and **B.** Paint cast shadows a darker value of the background color (in this case **C+D**).

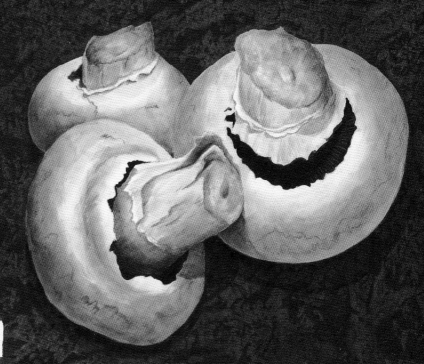

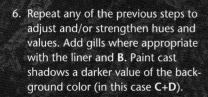

A B C D E

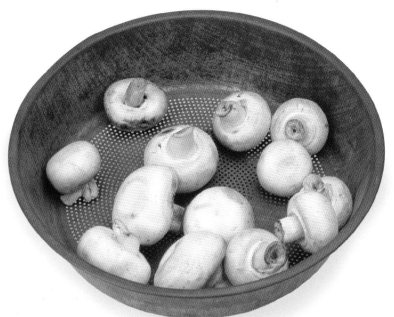

Mushrooms Reference Photos

Just look at all the wonderful smudges, scars, and irregularities on these mushrooms. They're not perfect. So relax when you paint them; don't blend their subtle colors to oblivion! After trying the mushrooms in the lesson, have some fun painting uniquely shaped and colored wild mushrooms. You might even create your own fanciful fungi.

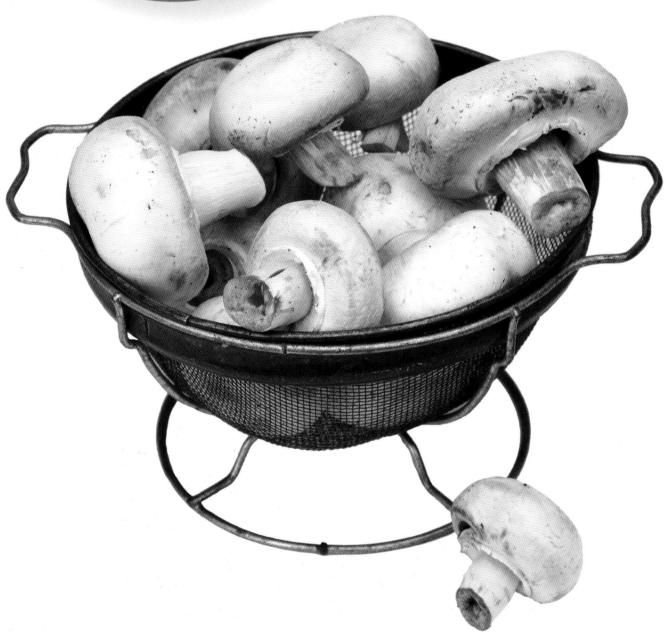

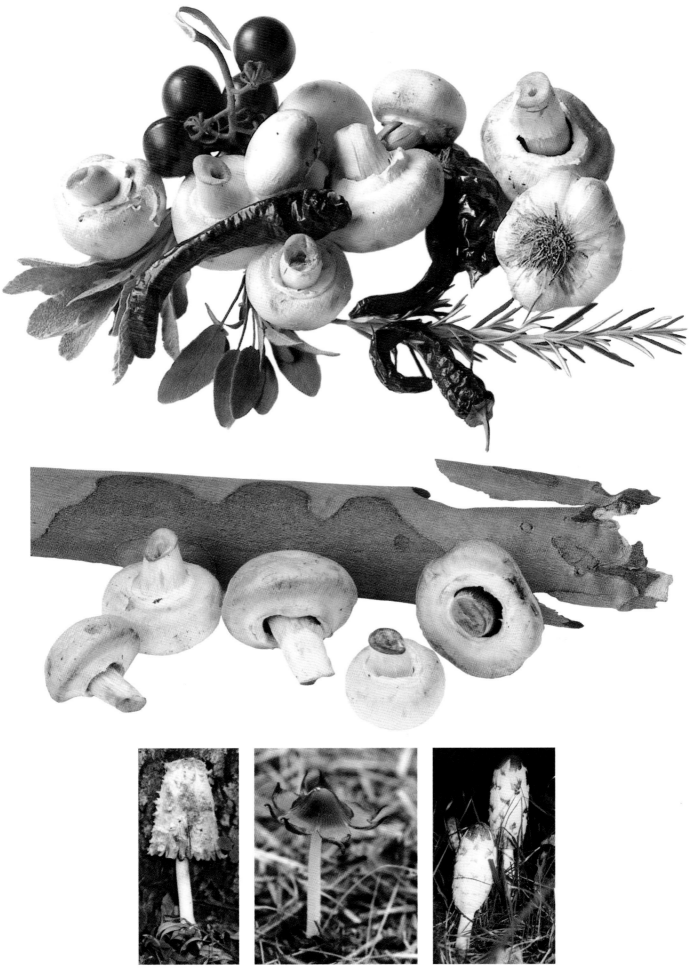

Onions

RED ONIONS PALETTE

A Napa Red
B Moon Yellow
C Brandy Wine
D Burnt Umber

WHITE ONIONS PALETTE

A Eggshell
B Buttermilk
C Light Buttermilk
D Reindeer Moss Green
E Neutral Grey
F Titanium White

YELLOW ONIONS PALETTE

A Moon Yellow
B Buttermilk
C Terra Cotta
D Burnt Orange
E Cadmium Yellow
F Burnt Umber
G Raw Umber

BRUSHES

Flats: Nos. 2 and 8
Liner: No. 10/0

The word "onion" comes from the Latin *unio,* which means large pearl. In this lesson, we'll paint three large pearls, each a different color.

Hints

1. Use the No. 8 flat brush to paint the onion, the No. 2 flat brush to paint detailed areas of broken skin, and the liner brush to paint the roots.

2. If you're working on a dark background, you can omit step 1 and let the dark background show through step 2 to suggest the vein lines in the onion skin. (If you have my *Big Book of Decorative Painting,* you can see how this technique works on page 199.) Pay attention to the contour lines (see the box at the right).

3. If the highlight seems too strong when you first apply it in step 2, don't worry. Subsequent layers of thinned washes will be applied over it to submerge it "into" the onion. Try to keep the wash layers thin, though, so you don't lose the light/dark variations which suggest the vein-like texture in the onion skin. If you should lose the veins, paint them back in with the liner, using very thinned paint to keep them from appearing too overworked.

4. The instructions on the following page are for red onions. Change the colors as described below to paint the white and yellow onions.

 a. White onions: Use **A** to undercoat, **B** to contour and highlight, **C** to apply the first wash, **D** and **E** to paint the flesh under the broken skin and to shade and create additional wash color variations, and **F** to add final wash adjustments and highlights.

 b. Yellow onions: Use **A** to undercoat, **B** to contour and highlight, **C** to paint outer layers of skin, **D** to wash a reddish glow onto the skin, **C** to apply shading to the exposed flesh, **E** as a wash for creating color variations, **F** for shading, and **G** then **A** for the roots.

Contour Lines

Notice how the contour lines radiate out from the bold center line. Letting your brush strokes follow these lines will help establish the roundness of the subject.

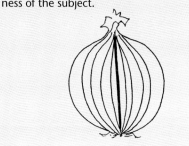

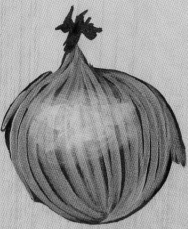

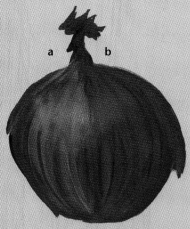

1. Undercoat with **A**, working from base to tip and following the contours of the onion.

2. Streak from base to tip with **B** sideloaded on the flat brush. Then highlight with **B**.

3. (a) Cover the onion with a wash of **A**. Dry. (b) Apply a slightly heavier wash of **C**.

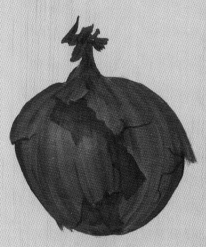

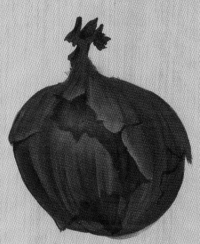

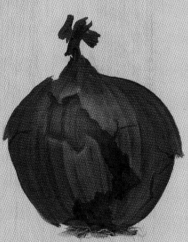

4. Sideload the brush with **A** and paint the broken skin area. Use thinner paint in the highlight area and heavier paint near the base and along the edges of the broken skin.

5. Brush very thin **B** across the inside skin area to reestablish the highlight and on some edges of the broken skin.

6. Add roots by painting a side-loaded smudge of **D** at the base. Then use the liner to paint fine roots **D+B**.

RED ONIONS PALETTE

A B C D

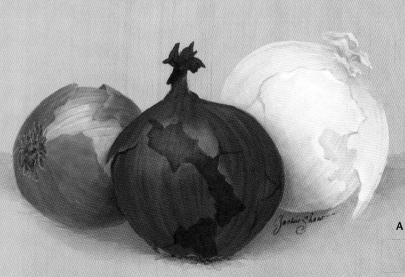

WHITE ONIONS PALETTE

A B C D E F

YELLOW ONIONS PALETTE

A B C D E F G

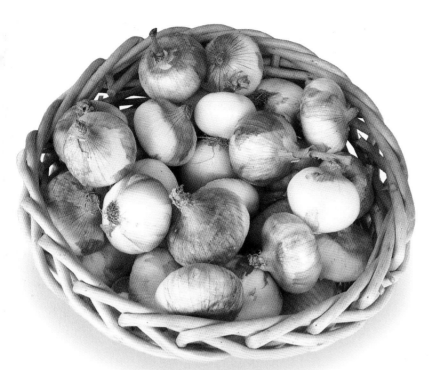

Onions Reference Photos

The onions photographed on the red background show an excellent example of reflected light. We know immediately that they are white onions, but just look at the amount of red reflected onto their skins! Use a paper punch to make a hole in white paper. Hold it at arm's length and, closing one eye, look at the onion through the hole with the other eye. By isolating the colors like this, you'll be able to see more clearly how much red is actually reflected. Notice, also, how the vein lines mark the contours of the onions. Did you know that the warmer the climate, the sweeter grows the onion?

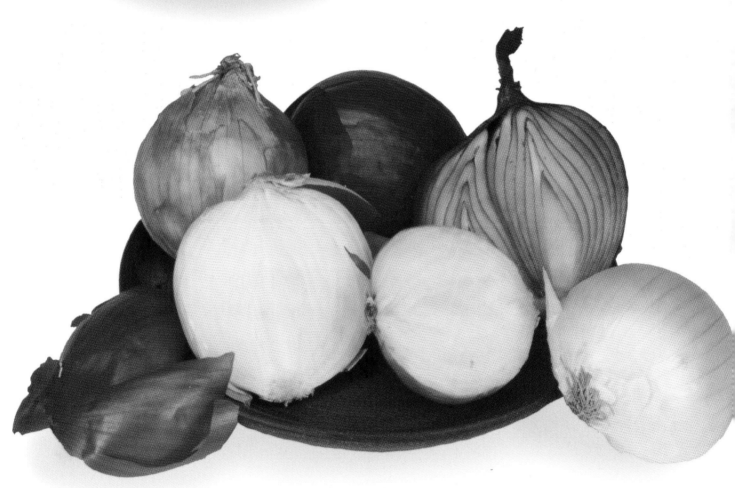

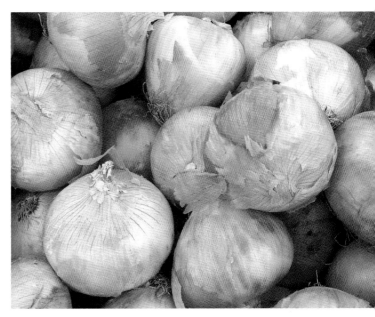

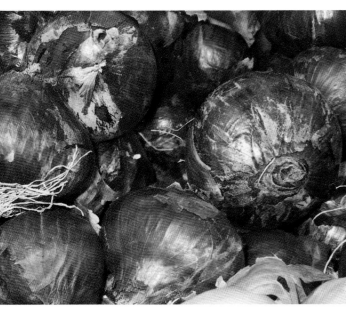

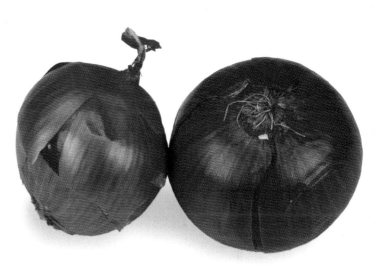

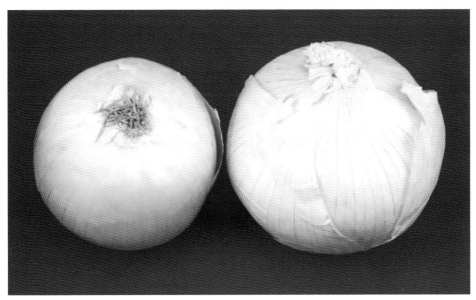

Radishes

Radishes are perfect for providing a little touch of red in just the right place. Their interestingly shaped leaves also add a nice bit of contrast. Radish leaves are good ones to practice on since their floppiness makes them appear more casual and less in need of precise painting than more rigid leaves.

Hints

1. Use the flat brush for all steps except for painting the leaf veins and the fine roots. Use the liner brushes for these.
2. You will find that radish leaves are easier to paint and much more interesting to look at in a painting if you do not work too hard at blending the colors together. Overblending creates a stiff, thick, unnatural appearance. Instead, apply your water-based paint in a splotchy, puddly fashion. When the puddles dry, color will be more concentrated in some areas, less so in others. The result will be leaves with variations of values; leaves that appear pliable and thin.
3. For even more variety, add to the leaves thinned touches of highlights, deeper shadings, and accent colors (reds, oranges, blues, violets, other greens . . .) with a sideloaded flat brush.
4. See page 10 for an alternate color scheme.

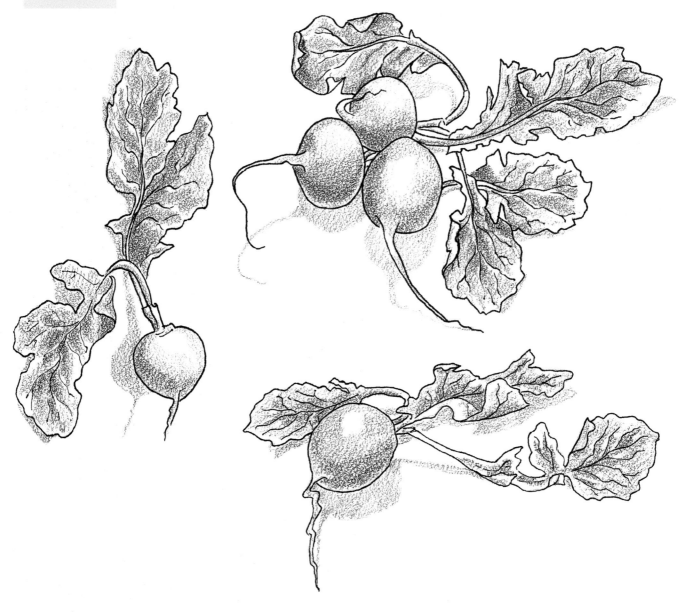

LEAVES

1. Undercoat leaves with a puddly wash of **G**. (Note: Veins showing are from the drawing.)

2. Add shading with random dabs of thinned **C**, placing more along the center vein line and under turned-up edges. Slide on the chisel edge of the flat brush to shade the stems.

3. Highlight the leaves with sideloaded **H**. Slide on the chisel edge to paint center veins with thinned **H**.

4. Paint small veins with the liner and thinned **C**. Sideload the flat brush with thinned **B** and apply random patches of color to the leaf.

RADISHES

1. Use the flat brush to undercoat the radish with **A**. Use the No. 1 liner brush to paint the "tail."

2. Apply a wash of **B** over the entire radish, shading the edges more heavily.

3. Add deeper shading with a mixture of **B+C+D**.

4. Using the flat brush to dry-brush on the highlights, apply **A**, then **E**. Use the smaller liner brush and **A** or **E** to paint hair-like roots. Sideload **F** on the flat brush and paint a reflected light on the side opposite the highlight.

Paint cast shadows a deeper value (**I**) of the background color.

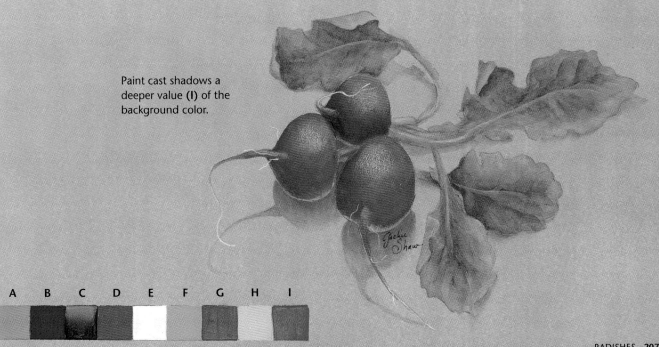

A B C D E F G H I

Radishes Reference Photos

The little pewter plate lets you easily see the reflection of the radish and leaves. But there's something even more interesting going on in that plate. Look at all the reflected lights and shadows. Look again. See if you can distinguish the reds, blues, and greens in addition to the reflected radish. Notice how those lights and shadows are what give the plate's contours definition. Look at the little Japanese goblet and tray. How does the top of the goblet suggest that the photographer's viewpoint was above it? Compare the oval-shaped top of the goblet to the changing daisy shapes on page 235. How would you have to hold the goblet to see the top as a straight line? Grab a cup or glass and experiment.

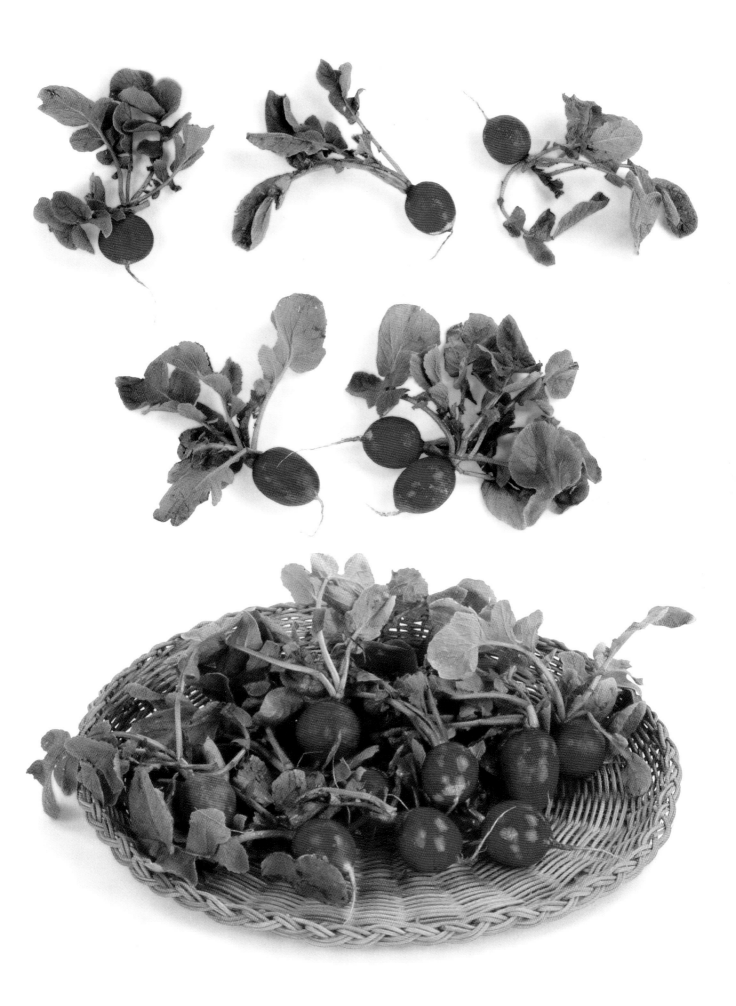

Sweet Peppers

YELLOW PEPPERS PALETTE
A Moon Yellow
B Cadmium Yellow
C Pineapple
D Summer Lilac
E Blush Flesh

GREEN PEPPERS PALETTE
A Olive Green
B Forest Green
C Mistletoe
D Pineapple
E Blush Flesh

RED PEPPERS PALETTE
A Cadmium Red
B Napa Red
C Blush Flesh
D Pineapple

BRUSHES
Flats: Nos. 2 and 8
Liner: No. 10/0

Sweet peppers are available in a variety of colors. After you paint the yellow, green, and red ones in this lesson, try painting orange and purple ones. Work with the actual produce in front of you to help determine the colors you'll need for each step. Otherwise, use the colors proposed for oranges (page 128) and eggplants (page 190).

Hints

1. Use the No. 8 flat brush to paint the peppers, the No. 2 flat brush to paint the stems, and the liner brush to add details to the stems.
2. You'll note that I've rearranged the step-by-step procedure a bit for each color variety. This is just to show you that the hues and values are more important than the sequence of steps in most cases. You might find that it's easier for you to visualize shapes within the pepper (or any subject) by first establishing the dark areas as shown in the first part of step 2 of the red peppers. Or if you relate better by identifying the lightest areas (as in the first part of step 2 of the green peppers), then put them in first. Or, maybe it's more helpful to you to apply the overall wash color first (as in the first part of step 2 of the yellow peppers) so you have it to compare lights and darks against.
3. Take a moment to study steps 3 and 4 for the yellow peppers. Notice that I chose to shade the pepper with violet (the complementary color of yellow). This is a more colorful way to create shading colors than mixing a dark brown or black with the local color to darken it. And rather than mixing the complementary color with the local color, I like to paint with it directly, then submerge it with a thin wash layer of the local color.
4. Notice also in step 4, the reddish glow of the reflected light. You can see it most readily in the yellow peppers (review "Reflected Lights" on page 56).

PAINTING THE STEMS
Use the color palette for green peppers.
1. Use the flat brush to undercoat the stem with **A**. Dab a mixture of **C+E+D** on the cut end.
2. Cover the stem with a thin wash of **C**.
3. Use the liner brush to streak the stem with **B**.
4. Shade the stem with a sideload of **B**.

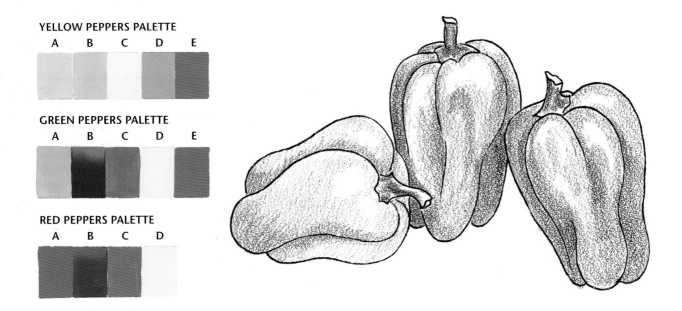

YELLOW PEPPERS PALETTE
A B C D E

GREEN PEPPERS PALETTE
A B C D E

RED PEPPERS PALETTE
A B C D

YELLOW PEPPERS

1. Undercoat with **A**.

2. Apply a thin wash of **B**. Then highlight with a sideload of **C**.

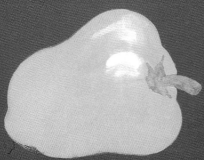

3. Shade with a sideload of **D**.

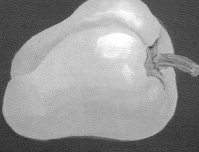

4. Apply a thin wash of **B** over the shading to submerge it into the pepper. Dry. Then add a reflected light with thinned **E** sideloaded on the brush.

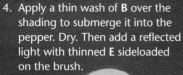
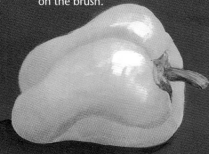

GREEN PEPPERS

1. Undercoat with **A**.

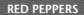

2. Highlight with a sideload of **D**. Shade with a sideload of **B**.

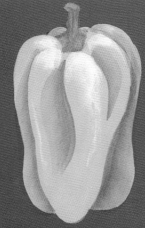

3. Apply a thin wash of **C** over the entire pepper. Strengthen the highlight with **D**.

4. Strengthen the shading with **E+B**. Add additional touches of **E**.

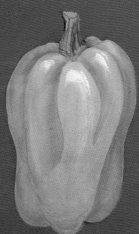

RED PEPPERS

1. Undercoat with **A**.

2. Shade with a sideload of **B**. Dry. Then apply a wash of thinned **B** over the entire pepper. While the wash is wet, wipe out highlight areas with a clean, damp brush.

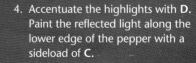

3. Highlight with a sideload of **C**.

4. Accentuate the highlights with **D**. Paint the reflected light along the lower edge of the pepper with a sideload of **C**.

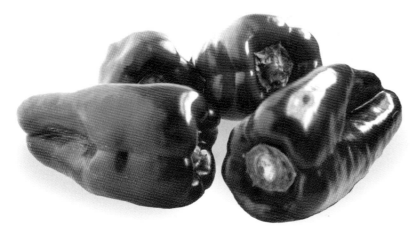

Sweet Peppers Reference Photos

Look closely at the lineup of multicolored peppers on the bottom of the next page. Can you see color in their cast shadows, and reflected colors from their neighboring peppers? Notice how many highlights appear on a single pepper—one for every lump and bump facing the light source. A cut pepper, showing its seed mass and ribs, adds a fascinating, busy bit of detail, and a welcome contrast from all the slickness of the almost plastic-looking peppers.

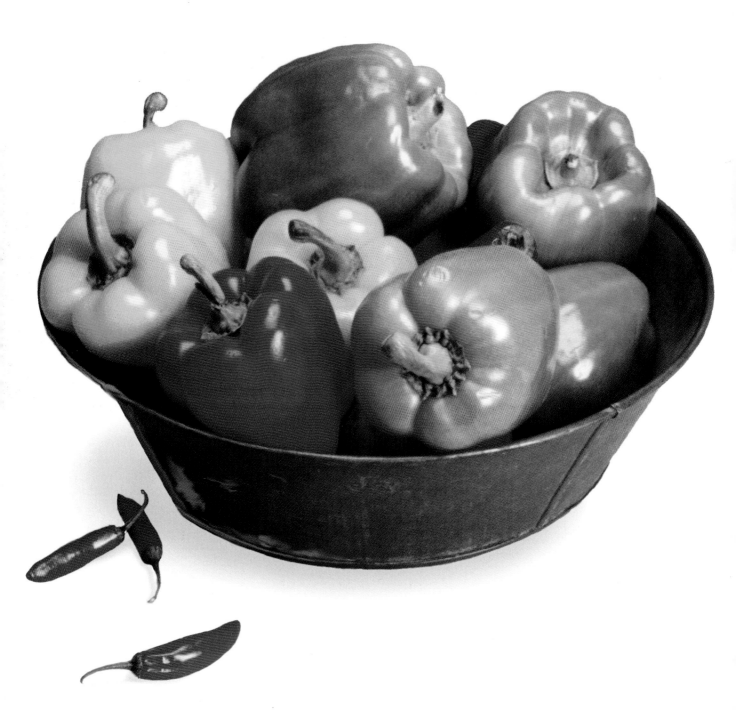

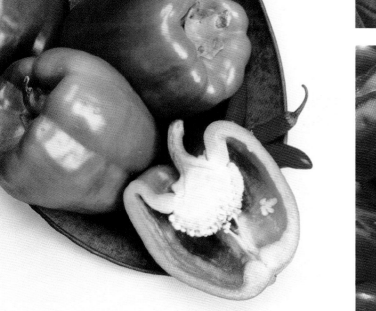
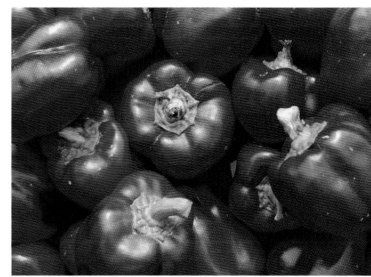
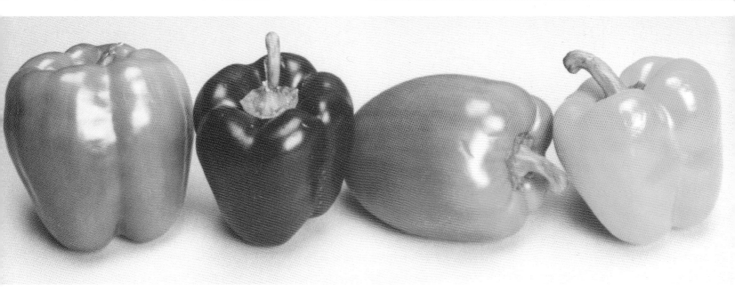

Tomatoes

PALETTE
A Yellow Ochre
B Cadmium Red
C Tomato Red
D Deep Burgundy
E Deep Teal
F Avocado
G Black Green
H Antique Gold

BRUSHES
Flat: No. 12
Round: No. 4

MEDIUM
Easy Float

The tomato is really a fruit because the edible portion contains the seeds; vegetables consist of edible stems, roots, and leaves. Since we more often think of tomatoes as vegetables, I have included them in this section of the book.

Hints

1. Use the flat brush to paint the tomato and the round brush to paint the calyx.
2. In painting this tomato we will let the highlight area shine from within, rather than applying light value paint on top of our paint layers. To do this, first apply a thin, even layer of water plus Easy Float. Remove any excess water so the surface is just barely, but evenly, damp. Then, beginning at the edge of the tomato, and working with a large, sideloaded brush, apply a red wash up to and just over the edge of the highlight area. The red paint will disperse gradually into the damp area, leaving a softened edge. Avoid the tendency to overwork this step. The paint will soon start to "grab." Let it dry. Then repeat the step as needed to get the depth of color desired. If the wash covers too much of the highlight area, blot immediately with a damp brush to lift out excess color.
3. Some tomatoes have creases at the stem end. If you would like to add them, sideload the flat brush with a red that is slightly darker than the area on which you will be painting the crease. Apply the paint along one side of the crease line then immediately flip the brush to apply the sideloaded paint to the other side of the crease. Blend to remove any hard-edged paint lines in the crease (see "Edge-to-Edge Blending," on page 26).
4. In painting the calyx, add shading and highlighting by applying thinned paint in fine streaks, following the growth direction from base to tip.

Compare this warm/cool color scheme with the warm/cool one on the worksheet.

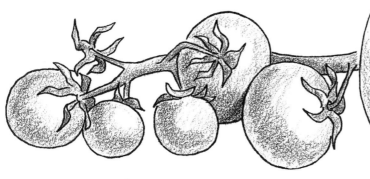

CALYX

1. Undercoat with **F**.

2. Shade with **F+G**. Highlight with **A+F**.

3. Apply a wash of **H+F**.

6. Add a reflected light by sideloading the flat brush with **E** plus very little **A**. Shade indentations with a sideload of **B+C**, or on darker tomatoes with **D**.

TOMATO

1
2

1. Undercoat the tomato with **A**.

2. Apply a thin wash of **B**. Dry.

3. Apply a thin layer of water plus Easy Float to the highlight area. While it is wet, apply another wash of **B**, working it gently onto the edges of the damp area. Dry. Repeat the step until you're satisfied with the depth of color achieved.

4. Apply a wash of **C** as in step 3.

5. Shade with a wash of **D**, again leaving the highlight area light.

A B C D E F G H

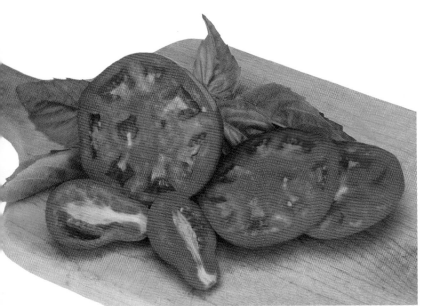

Tomatoes Reference Photos

Learning to adapt and change reference material to suit your needs multiplies your opportunities to explore, learn, and make effective substitutions. Try painting a cherry tomato in the small Japanese tray on page 208 of the radishes lessons. Or substitute a sweet pepper in place of one of the tomatoes in the cluster at the bottom of this page. Or replace the beans in the basket on page 177 with a pile of cherry tomatoes. The possibilities are endless!

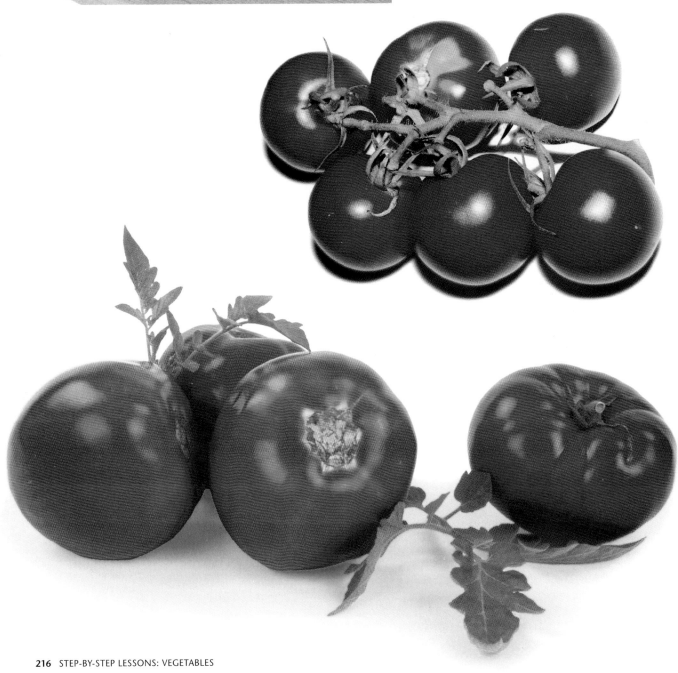

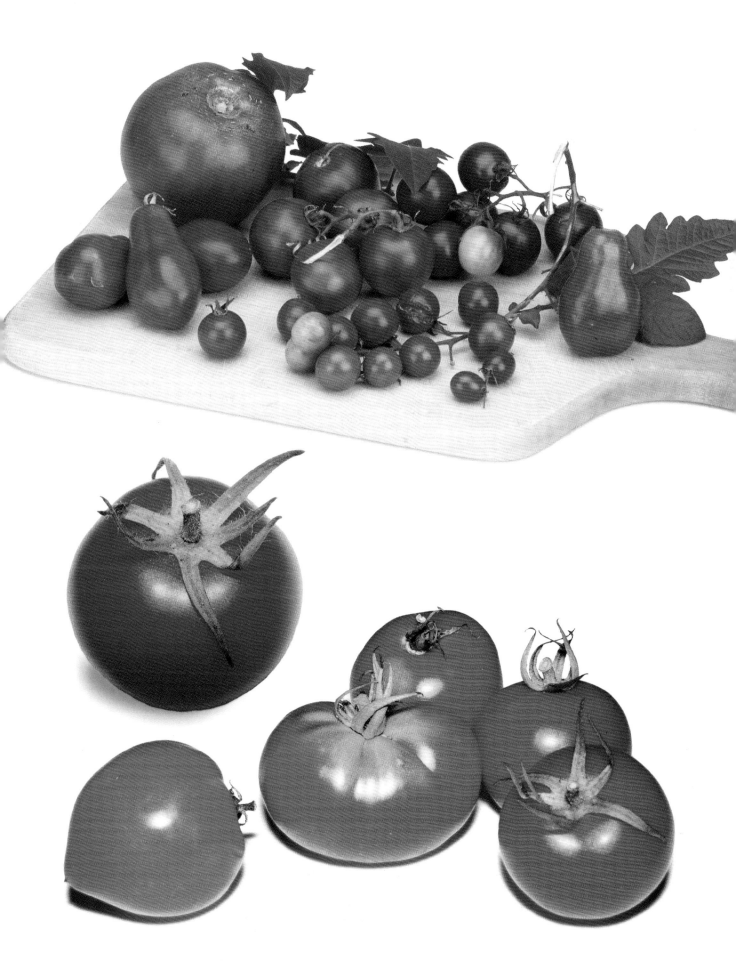

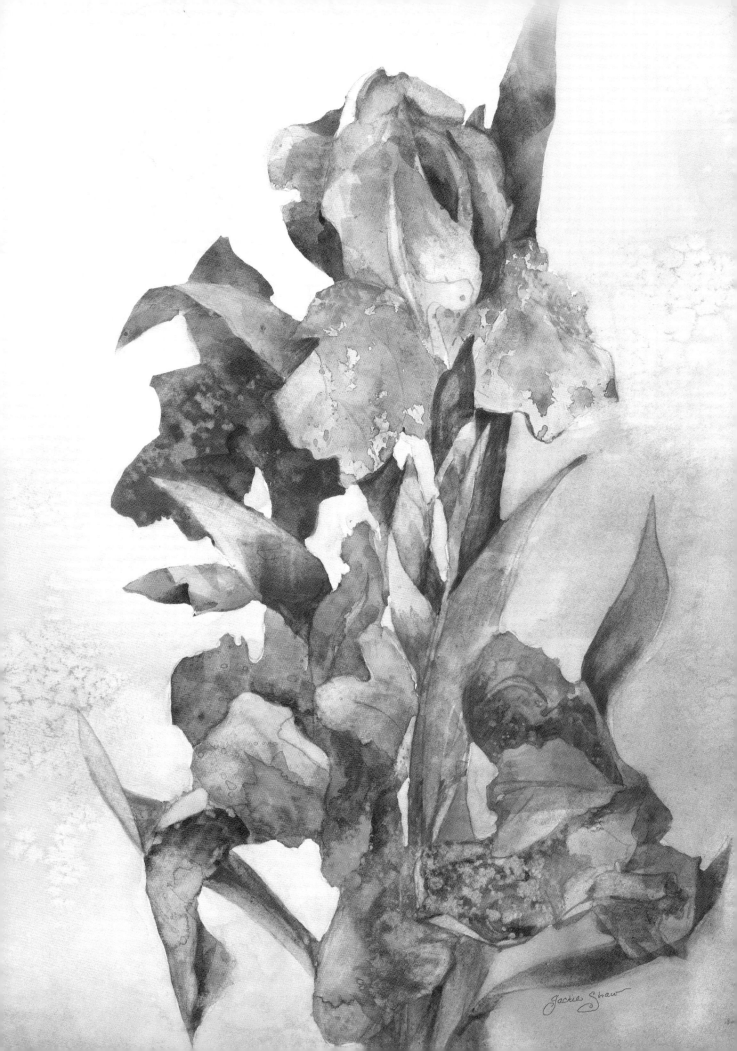

Chapter 9

Step-by-Step Lessons:
Flowers

*"So live that only the most beautiful wildflowers
will spring up where you have trod."*

HENRY DAVID THOREAU

If you have worked your way through many of the lessons without being intimidated by a blank surface—as I was early in my learning days—congratulations! On the other hand, if you have found yourself craving divine intervention, here is a "loosening up" technique you can try that gets rid of that intimidating pristine white surface. It also makes a lovely background effect for painting flowers. (See the background of the iris watercolor at left.)

Take two or three colors of paint at random, the largest paintbrush you have, and lots of water. Spread the colors juicily around on your painting surface, letting them intermingle as they will. While the paints dry, reflect on the elements and principles of design (review Chapter 5 if you need a reminder). Let the elements and principles guide you in painting the subject matter you have chosen on the background that resulted from your random paint splashing. Choosing background colors at random can have a liberating effect, getting you out of a comfortable, but perhaps over-used, color rut. Such random choices can also make you stretch a little further and think a little harder when trying to reconcile the resulting background color mixture with the colors of the subject matter you plan to work with. In both cases, you are bound to grow and improve. So slosh those paints about and have fun! (I even did quite a bit of sloshing on the irises, and that was fun, too.)

Dappled Irises
9 × 12 inches, watercolor on paper

Flowers lend themselves nicely to loose, delicate painting techniques. I painted these irises with watercolors in very thin, puddly washes. You can get the same effect by thinning your acrylics and using multiple layers of a variety of colors. For best results work on watercolor paper.

Amaryllises

My collection of amaryllis bulbs, saved from many Christmases past, bloom now each summer in an array of rich, hot colors. This striking, tall flower, with its upward shooting leaves, lends bold strength to a composition.

Hints

1. Use the liner brush to paint the veins in step 2 and the pistil and stamen in step 5. Use the flat brushes for all other steps.
2. Since this subject is painted on a light background, some of the background sparkles through the undercoat for highlights. Work with watery-thin acrylic paints, building up the dark values slowly in thin layers.

The deep red-orange amaryllis blossoms seem especially brilliant in this split-complementary color scheme.

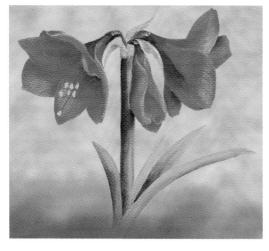

The combination of colors in this sketch was inspired by the photo of quince blossoms on page 48. This is a more harmonious color scheme (analogous) than the one above, which is strongly contrasting.

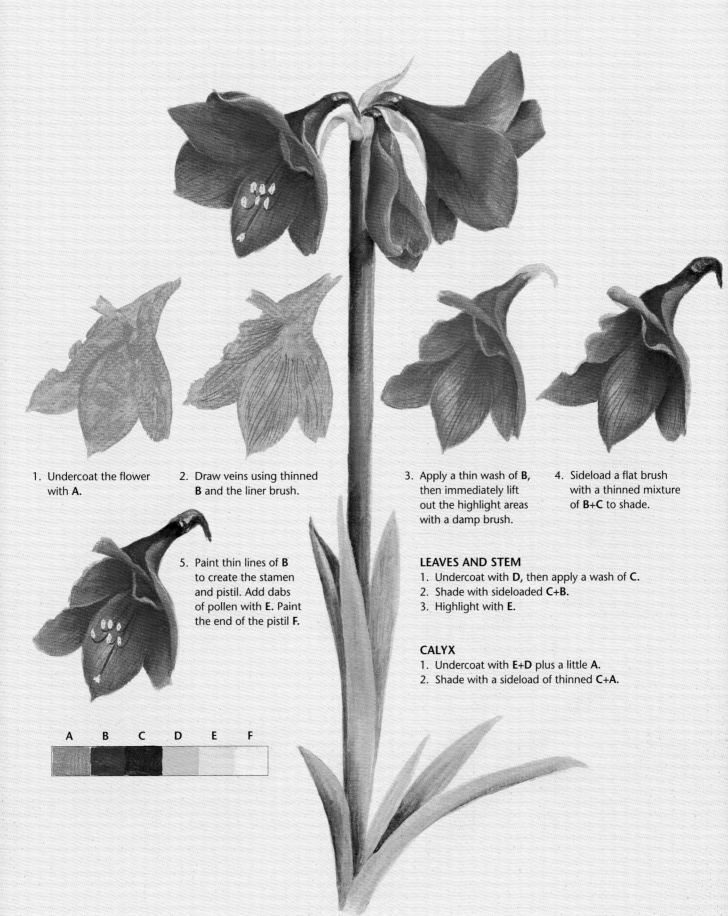

1. Undercoat the flower with **A.**

2. Draw veins using thinned **B** and the liner brush.

3. Apply a thin wash of **B**, then immediately lift out the highlight areas with a damp brush.

4. Sideload a flat brush with a thinned mixture of **B+C** to shade.

5. Paint thin lines of **B** to create the stamen and pistil. Add dabs of pollen with **E.** Paint the end of the pistil **F.**

LEAVES AND STEM
1. Undercoat with **D**, then apply a wash of **C.**
2. Shade with sideloaded **C+B.**
3. Highlight with **E.**

CALYX
1. Undercoat with **E+D** plus a little **A.**
2. Shade with a sideload of thinned **C+A.**

A B C D E F

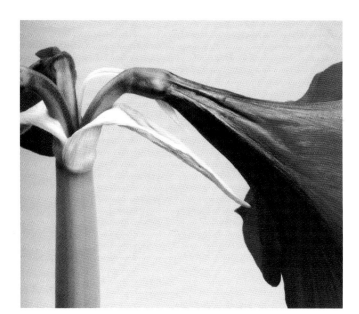

Amaryllises Reference Photos

The close-up detail photo of the dry, papery calyx also shows how three or four of these large flowers emerge from the top of the sturdy flower stalk. Notice, in the pink-streaked white amaryllis, how the flow of the vein lines suggests the curvature of the petals.

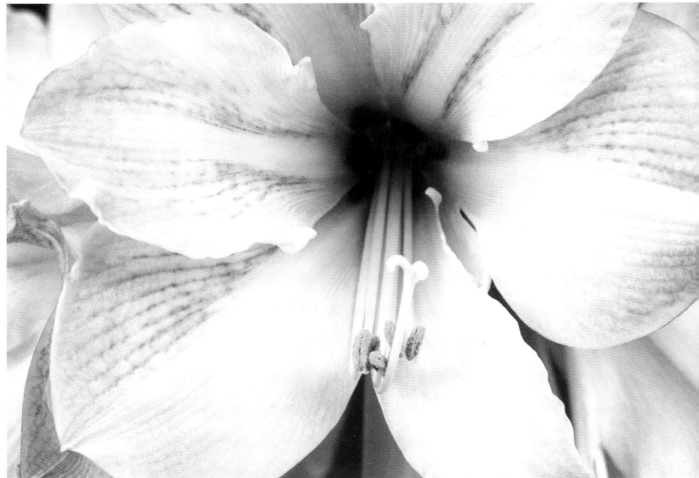

Crocuses

PALETTE
A Indian Turquoise
B Cadmium Yellow
C Dioxazine Purple
D Georgia Clay
E Red Violet
F Ultra Blue
G Leaf Green
H Black Forest Green
I Titanium White

BRUSHES
Flats: Nos. 4 and 6
Round: No. 0

Crocuses are scattered throughout nearly all my gardens, and I'm convinced it's their job, as early spring bloomers, to signal the weeds that it's time to take over. The fall blooming variety lets the weeds know they can slack off, for this gardener is about to call a truce for a few months.

Hints

1. Use the No. 6 flat brush to paint the flowers, the No. 4 flat brush to paint the leaves, and the round brush to paint the leaf veins and the stamen.

2. To paint red-violet crocuses, use the colors suggested for the irises on page 260; for white crocuses, use the white lily colors on page 264.

3. By using the chisel edge or a corner of the flat brush to paint streaks on the flower petals (in step 2) and the white veins in the leaves, you will get a softer, less obtrusive, more natural look than if you use the round brush or a liner brush. If you find the flat brush too difficult to use and thus insist on using a liner brush, work with very thin paint. Do, however, use the fine-pointed round brush or a liner brush with less watery paint to paint the highlight details in step 5.

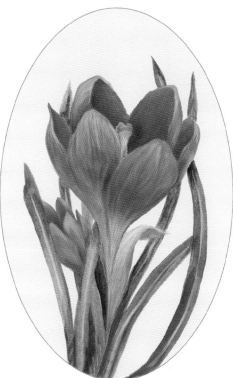

Use the red grapes palette (page 116) to paint crocuses this color.

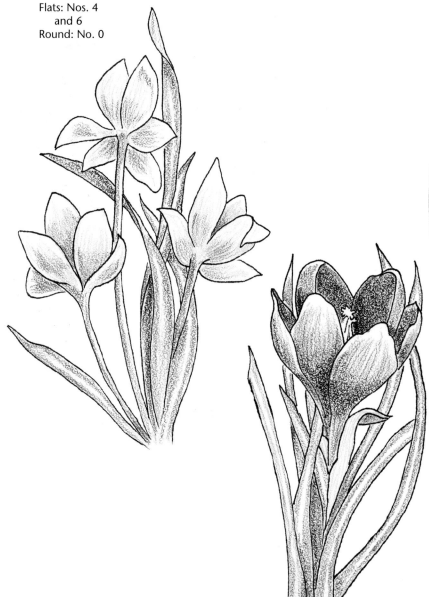

LEAVES

1. Undercoat the leaves with **G**.
2. Sideload the flat brush with **G** to shade the leaves.
3. Use the round brush and thinned **I** to paint the center vein.

1 2 3

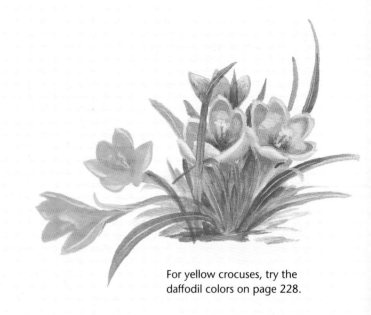

For yellow crocuses, try the daffodil colors on page 228.

FLOWERS

1. Undercoat the petals with **A** and the stamen with **B**.

2. (a) Cover the petals with a thin wash of **C**. (b) While the wash is still wet, streak it with the paint remaining in the corner of the brush. Add a wash of **D** on the stamen.

3. Shade the petals with a thinned sideload of **E**. Add more **D** to the stamen.

4. Deepen the shading on the petals with a mixture of **E+F**. Shade the stamen with a mixture of **C+D**.

A	B	C	D	E	F	G	H	I

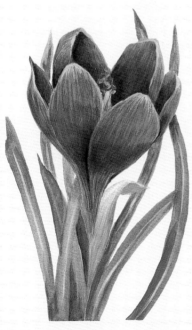

5. Highlight the top edges of the petals with the round brush and a mixture of **A+I**. Add pollen dots of **D** to the stamen.

CALYX

Paint the papery calyx with a light value mixture of **I+G+B+C**. Vary this mixture to create a darker value for the shading.

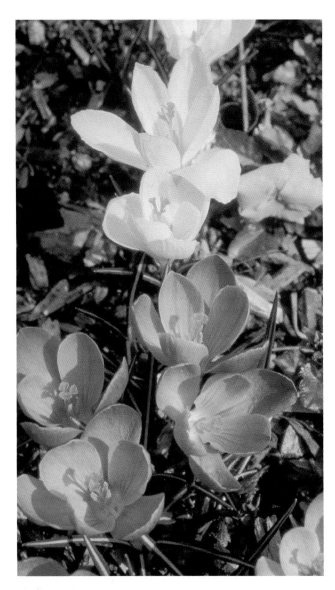

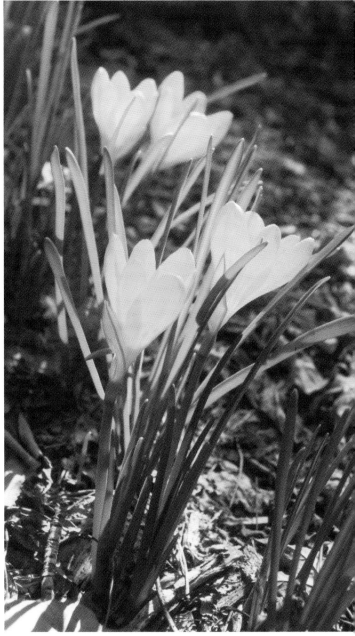

Crocuses Reference Photos

Study the shadows cast by the petals and stamen in the photo at left. Try to determine why each shadow is shaped the way it is, and how the shadow shape helps us know the shape of the petal on which it is cast. What happens when a shadow falls across one petal, then continues down onto a lower petal?

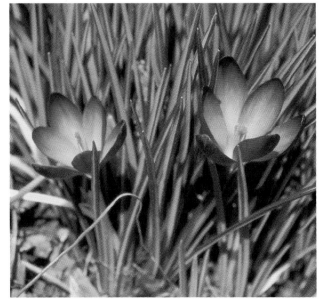

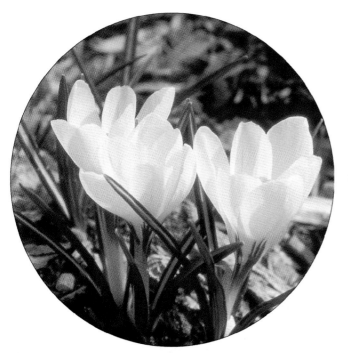

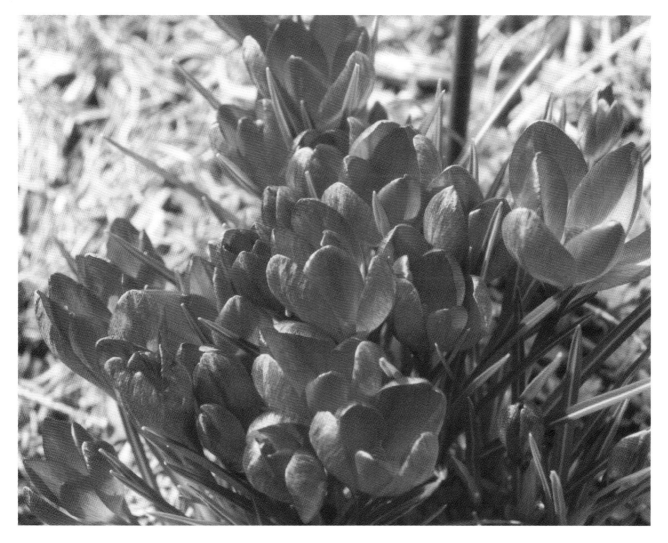

Daffodils

PALETTE

- **A** Titanium White
- **B** Yellow Light
- **C** Light Avocado
- **D** French Grey Blue
- **E** Cadmium Yellow
- **F** True Ochre
- **G** Evergreen

BRUSHES

Flats: Nos. 6 and 10
Liner: No. 2

Daffodils run rampant in our yard. From the dozen bulbs I planted 20 years ago, now, no matter where I sink a spade to plant or transplant something, I encounter a half bushel of bulbs. Giving them away by the hundreds seems only to multiply my treasures.

Hints

1. Use the No. 6 flat brush for all petal and leaf steps except for the wash in step 2. Use the No. 10 flat brush for that. Use the liner brush to paint the pistil, stamen, and pollen.

2. Notice how the blue background peeks through the undercoat and ultimately through even the final steps. This provides interesting modulation in the hues and values, keeping the flower from appearing too overworked and stiff. It also unifies the subject with the background. On areas that you wish to appear lighter, apply heavier undercoat paint.

3. To paint the "trumpet" in step 1, hold the sideloaded brush so the paint side touches the edge of the trumpet. Slide lightly on the brush's chisel edge into the throat of the trumpet to deposit heavy ridges of paint separated by strips of thin paint. Be sure to follow the contours of the flower.

4. If after completing the daffodils any shading or accent colors are too strong, "merge" them into the daffodil with additional washes of E or **B**.

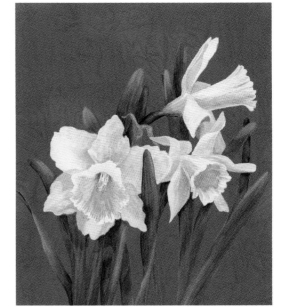

To see how daffodils will look on other background colors, see the lessons on apples, bananas, lemons, and sweet peppers.

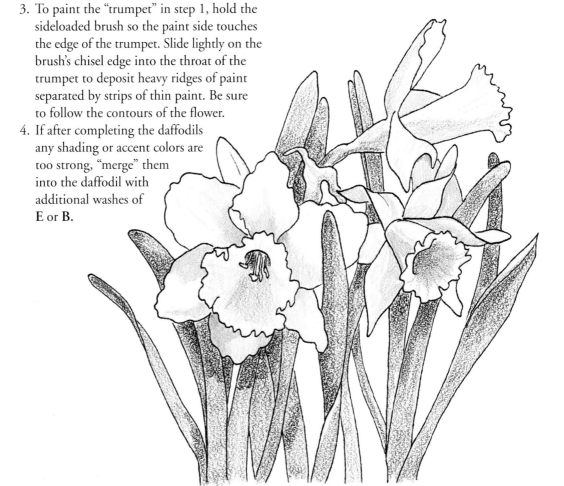

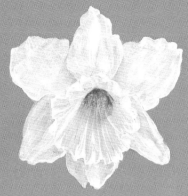

1. Undercoat the daffodil with **A** to create texture. See hint 3.

2. Apply a thin wash of **B** with the flat brush.

3. Shade the inside of the trumpet with the flat brush sideloaded with **C+B**. Deepen the shading with **D**. Then, shade the petals with **D+A**.

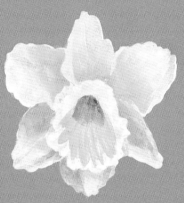

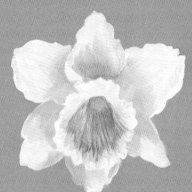

5. Sideload the flat brush with **F** and slide it back and forth on its chisel edge inside the trumpet to shade with streaks. Add random touches of **F** to the petals where needed for definition.

4. "Merge" the shading colors into the blossom with a wash of **E**. Add touches of **E** on the petals and inside the trumpet. Let dry, then apply an overall wash of **B**.

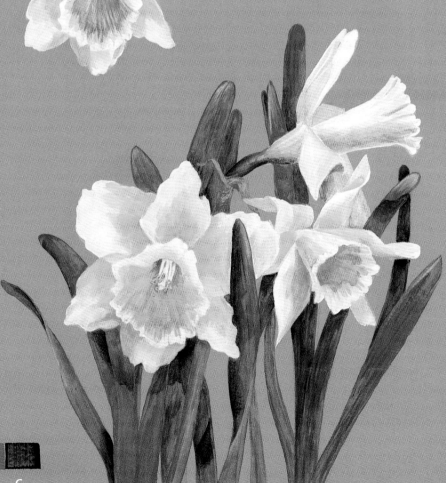

LEAVES
Undercoat the leaves with **C**. Shade them with streaks of **G**, then add some highlights with streaks of thinned **A+C**.

PISTILS AND STAMENS
Use the liner brush and **A+B** to paint narrow lines in the flower's center as in the finished flower at right. Let dry, then apply a thin wash of **E** over the base of the lines. Stipple on pollen dots with **F**.

A B C D E F G

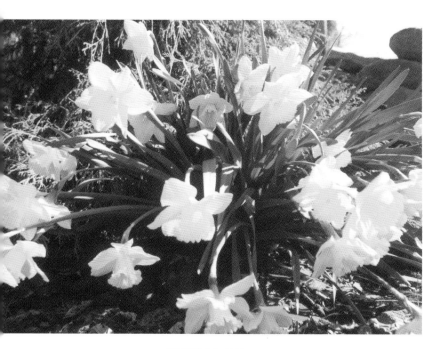

Daffodils Reference Photos

Use some of the photos showing different perspectives (opposite page) to help you design an arrangement of daffodils. Observe what a difference the location of the light source makes by comparing the flowers lit from above with those lit from behind.

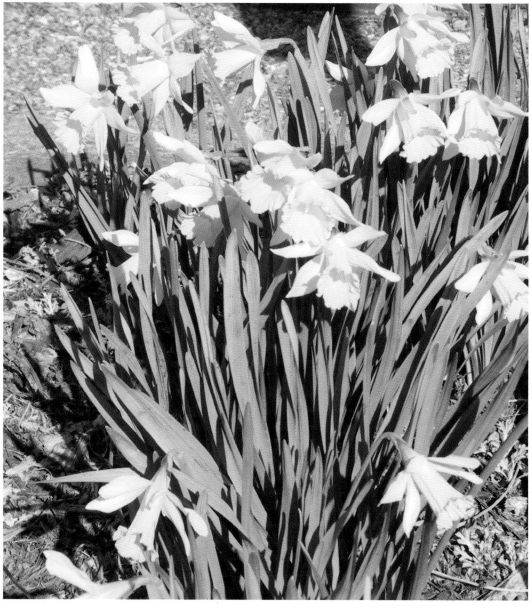

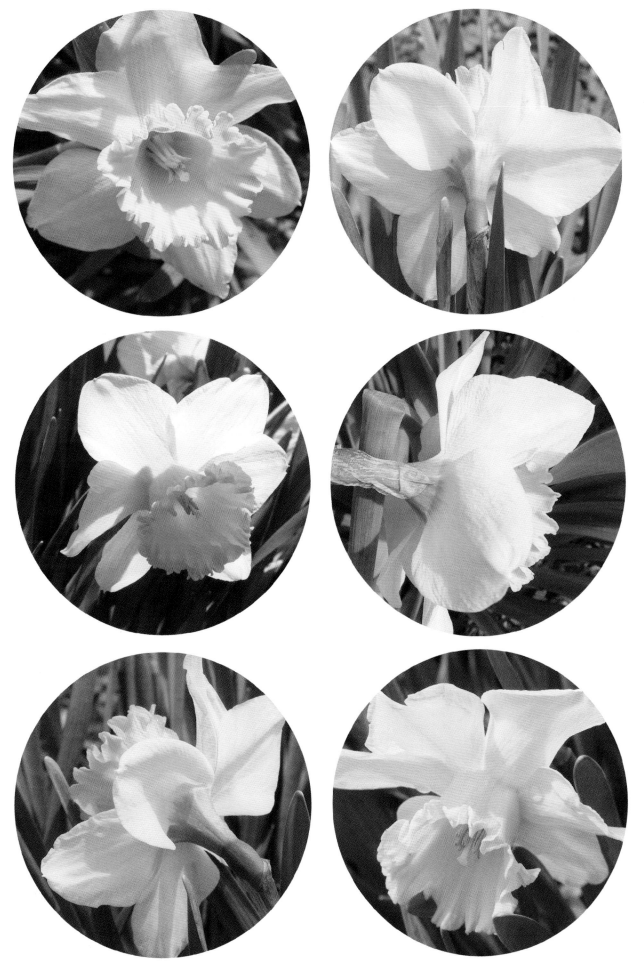

Daisies (and Daisy-like Flowers)

PALETTE
A Blue/Grey Mist
B Dove Grey
C Titanium White
D Dioxazine Purple
E Blue Haze
F Antique Gold
G Cadmium Yellow
H Black Forest Green

BRUSHES
Flat: No. 6
Round: No. 4
Scruffy brush (for stippling centers)

Paint other daisy-like flowers such as sunflowers, rudbeckia (black-eyed Susans), and echinacea by applying a wash of yellow or pink over the white daisy petals. Add darker values to shade. (See daffodils and hollyhocks for possible colors.) Stipple centers with brownish yellow to brownish orange. The leaves may vary from lobed, to toothed, to smooth.

Hints

1. Use the round brush for the flower petals, the flat brush for the leaves, and a scruffy brush for stippling the flower centers.
2. The flower centers will require repeated steps to build up color on a dark background. If you choose a lighter value background for the daisies, basecoat the flower centers with a brownish mixture of **G+D** to help suggest depth.
3. In step 3, use a separate brush (a flat or round will do) and clean water to moisten the base and tip of three or four petals at a time. Immediately apply the paint strokes as illustrated, beginning and ending a little within the strokes applied in steps 1 and 2. Let these shorter strokes bleed into the moisture to soften their beginnings and endings.
4. Keep the leaves understated to direct the focus to the flowers. Brush on the green mixtures loosely and thinly, applying the darkest values near the flowers. If you are not comfortable brushing colors on loosely and randomly for the leaves, follow the step-by-step directions for painting radish leaves, page 207.

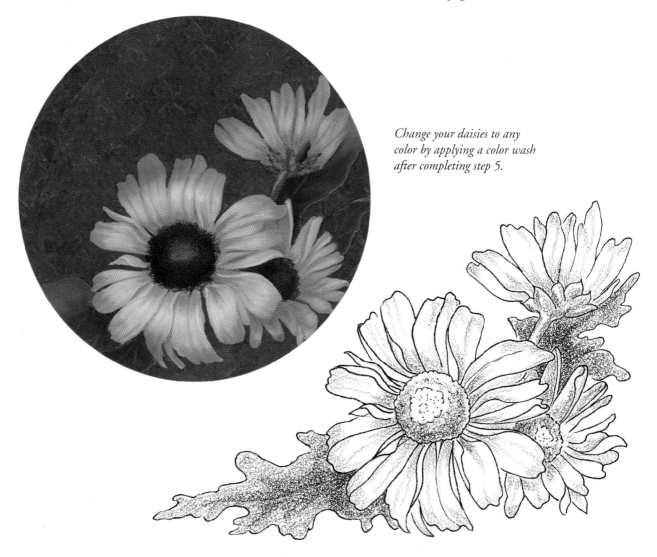

Change your daisies to any color by applying a color wash after completing step 5.

1. Undercoat the petals with thinned **A**. Paint the centers (as below) after completing the petals. For the leaves, use **D, E, F, G,** and **H** to create a variety of greens.

2. Brush mix **A** with a little **B** and water. Paint thin strokes on top of the undercoat. Allow some areas of the undercoat to show through.

3. Apply highlight strokes of thinned **B**, a little shorter than the strokes in step 2.

4. Repeat step 3 using **C**. Build up the highlight area with many thin lines blurred together. Accent some of the petal edges with full-strength **C**.

5. Shade the base of the petals with a thinned mixture of **A+D**. For deeper shading use **D+E**.

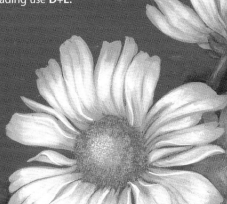

 1 2 3 4

CENTERS
(See instructions below.)

A B C D E F G H

CENTERS
(See illustrations above.)
1. Stipple the flower center with **F+E.** Stipple **E+G** in the middle.
2. Stipple **F** over the entire center.
3. Stipple **G** in the middle.
4. Stipple **C+G** to highlight.

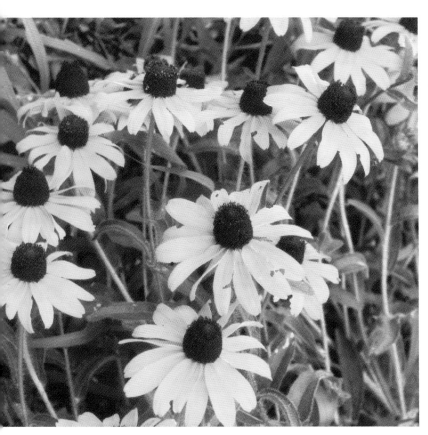

Daisies Reference Photos

Notice in the photos on the next page that all the circles are the same width, but as the perspective changes, the circles (likewise the daisies and the daisy centers) become flatter, more oval shaped. Practice making such mental comparisons whenever you study photographs or actual subject matter.

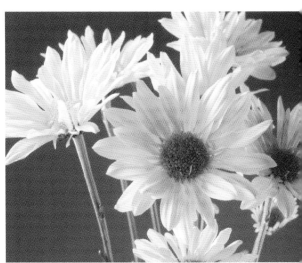

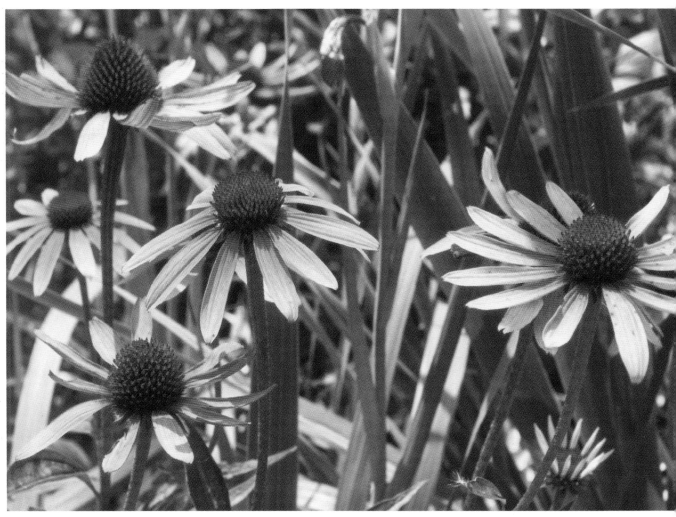

Gardenias

PALETTE

A Olive Green
B Green Mist
C Light Buttermilk
D Antique White
E Yellow Ochre
F Violet Haze
G Plantation Pine
H Hauser Dark Green
I Hauser Light Green
J Raw Sienna
K Buttermilk
L Titanium White

BRUSHES

Flats: Nos. 2, 4, and 6
Liner: No. 1

When I was young, a gardenia bush grew outside my bedroom window. I loved its intoxicating fragrances. Then, when my husband-to-be, Lynn, and I were married, I carried a single gardenia blossom. It is still my favorite flower; and now, forty years later, he is still my best beau.

Hints

1. Use the largest flat brush you can comfortably handle for each step. Use the liner brush to paint the "bug bites."
2. To work with the accompanying pattern, transfer only the outlines of the leaves and the overall outline of the gardenia shape. Then after undercoating, transfer or draw in the individual petals.
3. For more hints on painting lateral veins in the leaves with sideloaded V shapes, see cherries, hint 2 (underside of leaves), page 104, and pansies worksheet, page 285.
4. When you first place the shadings in the flower petals, they may appear a little strong. Don't worry. A final unifying color wash will make them a natural part of the flower. Repeat thin wash layers as needed to pull the colors together, making sure the previous layer is completely dry.

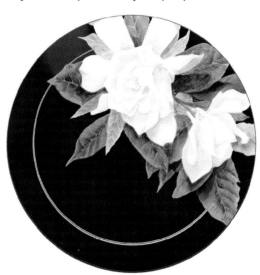

If the combination of white flowers on a white background on the worksheet doesn't excite you, here are two other possibilities.

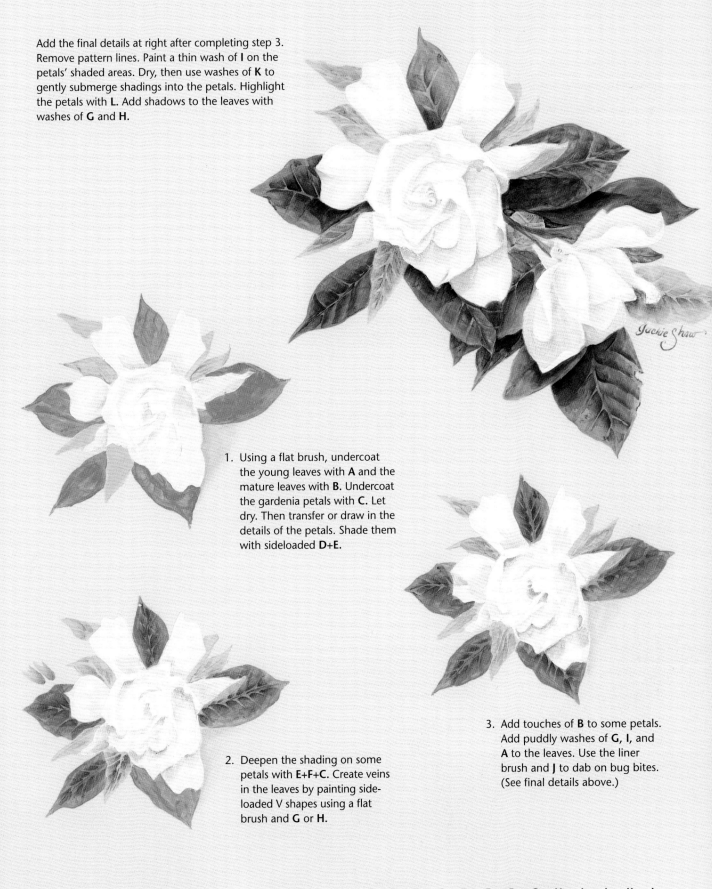

Add the final details at right after completing step 3. Remove pattern lines. Paint a thin wash of **I** on the petals' shaded areas. Dry, then use washes of **K** to gently submerge shadings into the petals. Highlight the petals with **L**. Add shadows to the leaves with washes of **G** and **H**.

Yuckie Shaw

1. Using a flat brush, undercoat the young leaves with **A** and the mature leaves with **B**. Undercoat the gardenia petals with **C**. Let dry. Then transfer or draw in the details of the petals. Shade them with sideloaded **D+E**.

2. Deepen the shading on some petals with **E+F+C**. Create veins in the leaves by painting side-loaded V shapes using a flat brush and **G** or **H**.

3. Add touches of **B** to some petals. Add puddly washes of **G, I,** and **A** to the leaves. Use the liner brush and **J** to dab on bug bites. (See final details above.)

A B C D E F G H I J K L

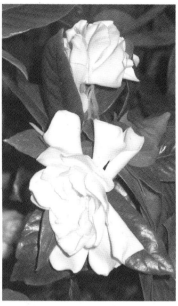

Gardenias Reference Photos

Compare the strong, shiny, multiple highlights on the crisp gardenia leaves with the subtle, diffused highlights on more limp leaves such as radish leaves. Being aware of, and painting such differences helps add variety to your paintings. If you tried the earlier exercise of painting white eggs on a white napkin on page 57, the experience should help you in seeing and painting the subtle variations of white petals against other white petals.

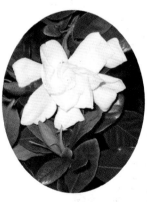

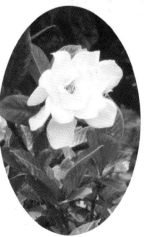

Geraniums

PALETTE

A Coral Rose
B Blush Flesh
C Light Buttermilk
D Napthol Red
E Cadmium Yellow
F Olive Green
G Hauser Medium Green
H Hauser Light Green

BRUSHES

Flats: Nos. 2, 6, and 8
Liner: No. 10/0

My oldest geranium (at 15 years) now stands four feet tall, in spite of consistent pruning. After near total neglect all winter, it seems only too happy to bloom vigorously all summer, much to our delight.

Hints

1. Use the No. 6 flat brush to undercoat, shade, and highlight all flower petals, except the tiny, turned petals. For these use the No. 2 flat brush. Use the No. 8 flat brush to undercoat the leaves and to apply the wash in step 7. Use the No. 2 flat brush to paint the spaces between the veins in step 6.
2. To paint pink geraniums, use the colors suggested for hollyhocks, hibiscuses, or morning glories. To make them a hot pink, use the hollyhock colors and apply a second wash of Red Violet after step 2 of the hollyhock color sequence. To paint red geraniums, use the colors suggested for poinsettias, or you can easily make the worksheet geranium a more brilliant red by applying a wash of **B** over the entire blossom before step 1(b). Then use **D** in step 1(b) to shade the petals. In step 2, use **E** to highlight and streak the petals. For steps 3 and 4, replace color **D** with a mixture of **D+G**.

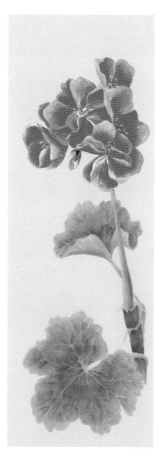
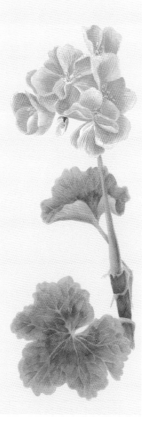

Experiment by substituting background and flower colors for the ones suggested on the worksheet.

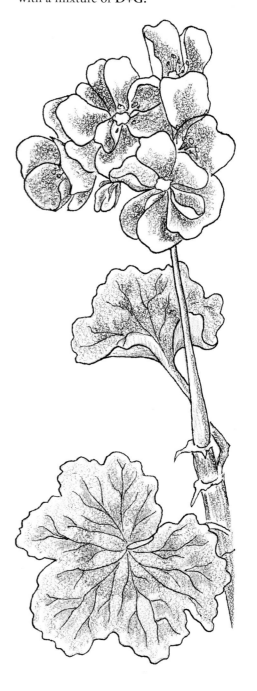

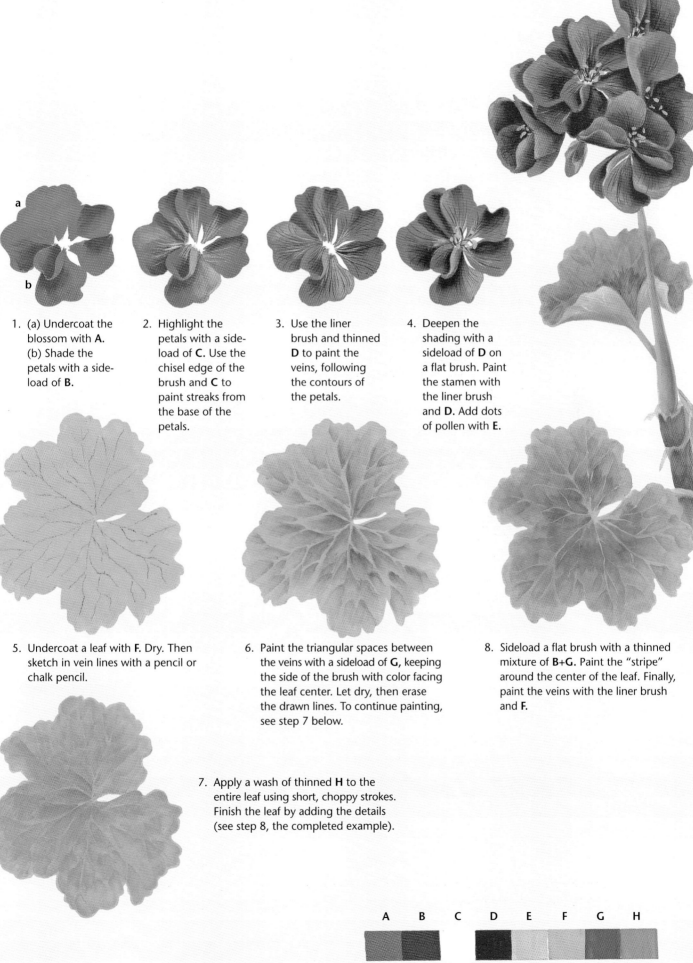

1. (a) Undercoat the blossom with **A**. (b) Shade the petals with a side-load of **B**.

2. Highlight the petals with a side-load of **C**. Use the chisel edge of the brush and **C** to paint streaks from the base of the petals.

3. Use the liner brush and thinned **D** to paint the veins, following the contours of the petals.

4. Deepen the shading with a sideload of **D** on a flat brush. Paint the stamen with the liner brush and **D**. Add dots of pollen with **E**.

5. Undercoat a leaf with **F**. Dry. Then sketch in vein lines with a pencil or chalk pencil.

6. Paint the triangular spaces between the veins with a sideload of **G**, keeping the side of the brush with color facing the leaf center. Let dry, then erase the drawn lines. To continue painting, see step 7 below.

8. Sideload a flat brush with a thinned mixture of **B+G**. Paint the "stripe" around the center of the leaf. Finally, paint the veins with the liner brush and **F**.

7. Apply a wash of thinned **H** to the entire leaf using short, choppy strokes. Finish the leaf by adding the details (see step 8, the completed example).

A B C D E F G H

Geraniums Reference Photos

Watching the many little geranium buds burst open from their cluster at the end of outward reaching stems is like watching a fireworks display in very slow motion.

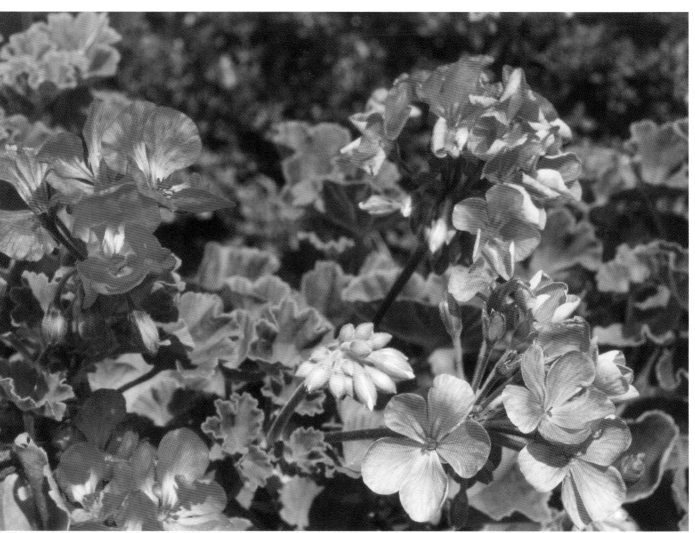

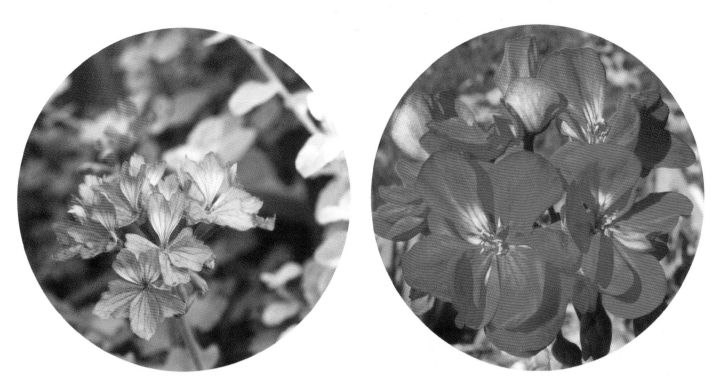

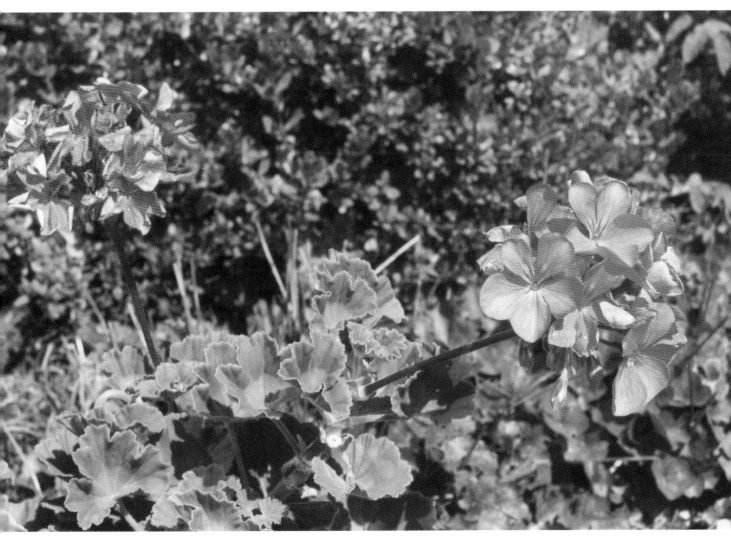

Grape Hyacinths

PALETTE
A Titanium White
B Pansy Lavender
C Dioxazine Purple
D Blue Violet
E Country Blue
F Plum
G Arbor Green
H Moon Yellow
I Leaf Green

BRUSHES
Flat: No. 2
Round: No. 2
Liner: No. 2

Like daffodils, grape hyacinths are easy to naturalize in the yard. I use them to embellish the stone borders around my thirty-some gardens. So I seem to be forever digging up little new ones, which have escaped the boundaries, and nestling them back where they belong.

Hints

1. Use the round brush to undercoat the flowers and to paint the leaves. Use the flat brush to apply washes, shading, and drybrushing. Paint details with the liner brush.
2. Undercoat the grape hyacinths with a well-loaded round brush to create textured ridges in their petals. The ridges will stand out above the succeeding layers of wash.
3. Grape hyacinth flowers open from the bottom of the cluster upward. When the very lowest blossoms have started to shrivel closed, the ones just above them will have the white fringed opening. Farther up the cluster the blossoms will still be closed and egg-shaped. And if you look closely, you may see a star-like shape on the tip where the six petals will pull slightly apart to open, creating the white fringe. Refer to the separate illustrated step for painting these unopened blossoms.
4. Notice that the higher the blossoms are on the stalk, the lighter in value they are. For the lightest blossoms, omit steps 3 and 4.

Create a gradated background by using a 2-inch foam roller brush to blend one background color into another. Basecoat entirely with the main color. Dry. Then doubleload the roller to add the deeper color.

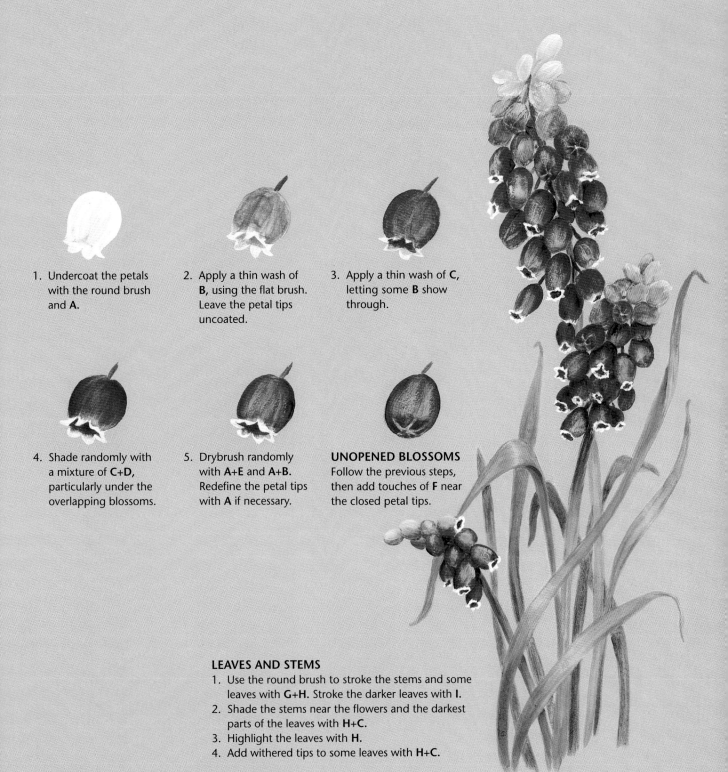

1. Undercoat the petals with the round brush and **A**.

2. Apply a thin wash of **B**, using the flat brush. Leave the petal tips uncoated.

3. Apply a thin wash of **C**, letting some **B** show through.

4. Shade randomly with a mixture of **C+D**, particularly under the overlapping blossoms.

5. Drybrush randomly with **A+E** and **A+B**. Redefine the petal tips with **A** if necessary.

UNOPENED BLOSSOMS
Follow the previous steps, then add touches of **F** near the closed petal tips.

LEAVES AND STEMS
1. Use the round brush to stroke the stems and some leaves with **G+H**. Stroke the darker leaves with **I**.
2. Shade the stems near the flowers and the darkest parts of the leaves with **H+C**.
3. Highlight the leaves with **H**.
4. Add withered tips to some leaves with **H+C**.

A	B	C	D	E	F	G	H	I

Grape Hyacinths Reference Photos

Grape hyacinths awake in spring along with the crocus, and seem quite undeterred by a bit of snow. In the photographs, compare the different sensations created by other colors in amongst the grape hyacinths. The bright red adds quite a jolt. The complementary yellow, too, is a lively contrast. The soft gray exudes a quieter, more soothing effect.

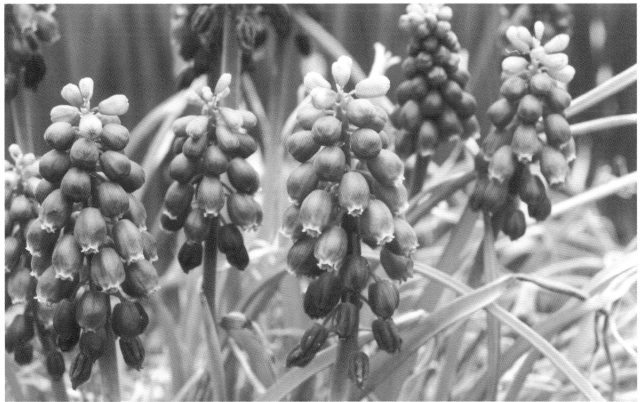

Hibiscuses

PALETTE
A Leaf Green
B Hauser Light
 Green
C Pink Chiffon
D Dark Pine
E Boysenberry
 Pink
F Gooseberry
 Pink
G Golden
 Straw
H French
 Mauve

BRUSHES
Flats: Nos. 6, 8,
 and 12
Liner: No. 10/0
Scruffy brush
 (optional)

These large flowers can add colorful impact to a painted arrangement without the effort of painting many petals (such as would be required for painting roses or peonies, for example). Painting many ruffles in the petal edges and folds will make the flowers appear soft and delicate.

Hints

1. Use the flat brushes to undercoat, apply washes, sideload, and drybrush highlights. Use the liner brush to paint veins in the leaves and the flower petals.
2. Leaves painted on a mottled green background offer a pleasing way to unify the painting and focus attention on the flowers, provided there is sufficient value contrast between at least some edges of the leaves and the background. In this case, I have texturized the background using a wad of plastic wrap. Sometimes, I let the shapes of the plastic wrap wrinkles suggest the

shape of a leaf, and then refine it with darker or lighter values as needed—just enough to make the leaf barely discernable. That creates a leaf that seems to be in the shadows, fleshes out the design when needed, and further connects the subject to the background.

3. Notice in Petals, step 1, how some of the background green peeks faintly through the undercoat. The number of layers of paint you use in step 1 will vary depending upon your background color, your petal color, and how heavily or thickly you apply the paint. Just be sure to leave scattered areas of the background showing through to add subtle hue shifts to your flowers.
4. When adding drybrushed highlights to the flower petals in step 5, hold the brush parallel to the painting and float it lightly across the petals, moving in the direction opposite the vein lines. The underlying ridges of paint will catch glitterings of your highlight color. (Review "Drybrushing" on page 24.)

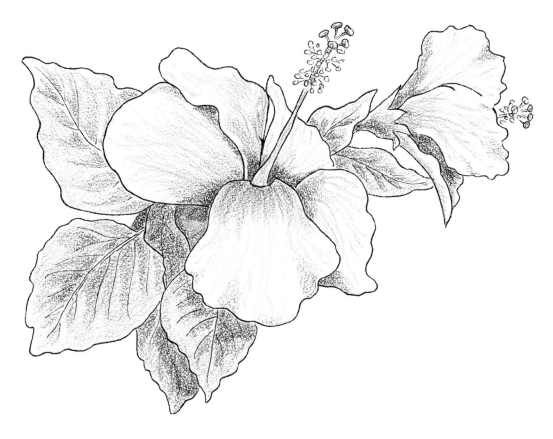

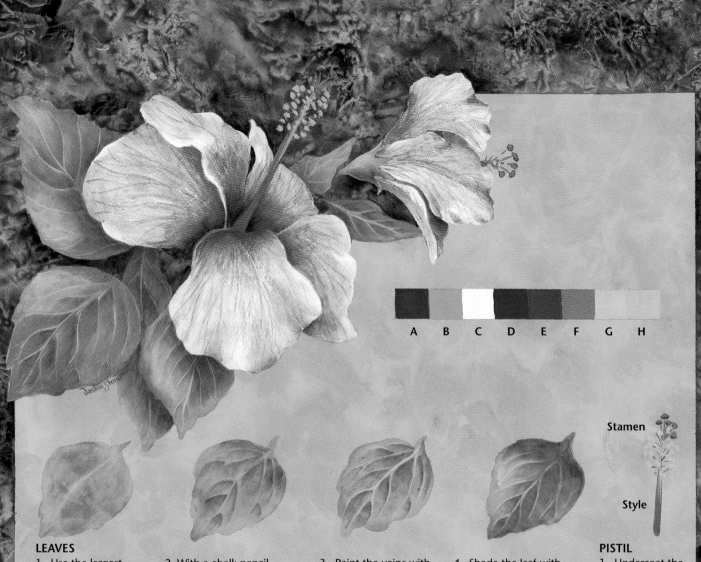

Stamen

Style

LEAVES

1. Use the largest flat brush you can handle to apply a thin, splotchy wash of **A**. While wet, lift out the central vein with a damp brush. Dry.

2. With a chalk pencil, draw vein lines. Then sideload a flat brush with **A**. With the paint side of the brush toward the chalk line, paint inverted V shapes to create shading between the veins.

3. Paint the veins with the liner brush and **B+C**.

4. Shade the leaf with **A+D** sideloaded on a flat brush. Then highlight with **C+B**.
5. (See completed design.) Apply a wash of **B** over the highlight areas.

PISTIL

1. Undercoat the style with **E+F**.
2. Highlight with **C+F**.
3. Paint the stamen with **E** topped with **F**.
4. Paint the pollen **G**.

PETALS

1. Using a flat brush, undercoat with three thin layers of **C**, building up a streaked texture following the contours of the petals. Dry between each layer.

2. Apply a thin wash of **E**.

3. Paint the veins with the liner brush and thinned **E**. Keep the veins thin and light. If any appear too heavy, quickly blot them to soften.

4. Add random touches of color (**H**, **F**, and deeper **E** shading) to suggest ruffles.

5. Drybrush **C** across the petals. Then sideload with **C** to highlight the petal edges.
6. (See completed design.) Paint the darkest shading accents on the petals with a sideload of **E+D**.

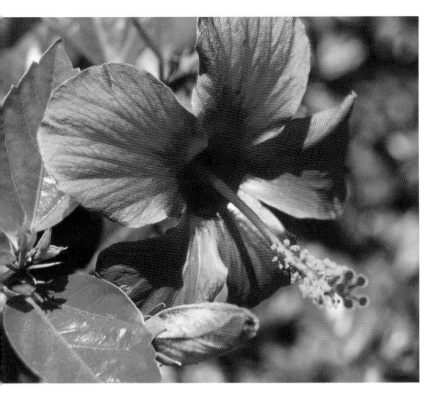

Hibiscuses Reference Photos

To paint the different hibiscuses shown in the photos, use the directions for the pink hibiscus in this lesson, substituting color palettes from other lessons, such as peaches, geraniums, hollyhocks, and trumpet vines.

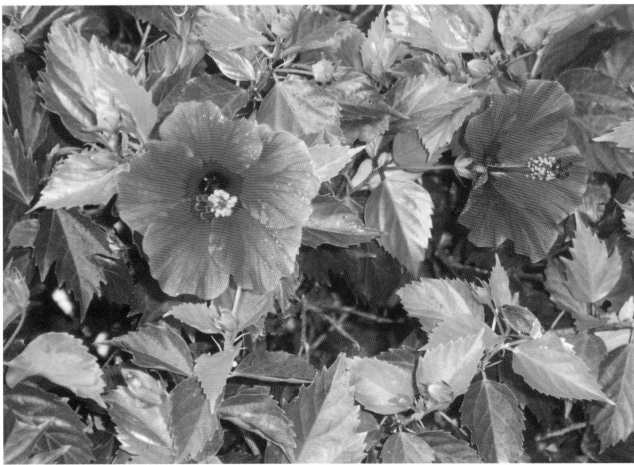

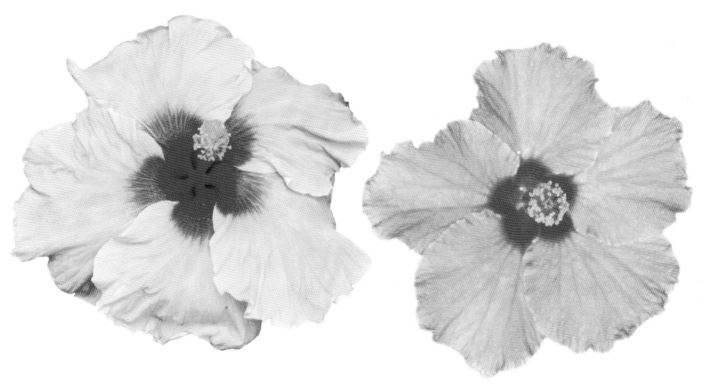

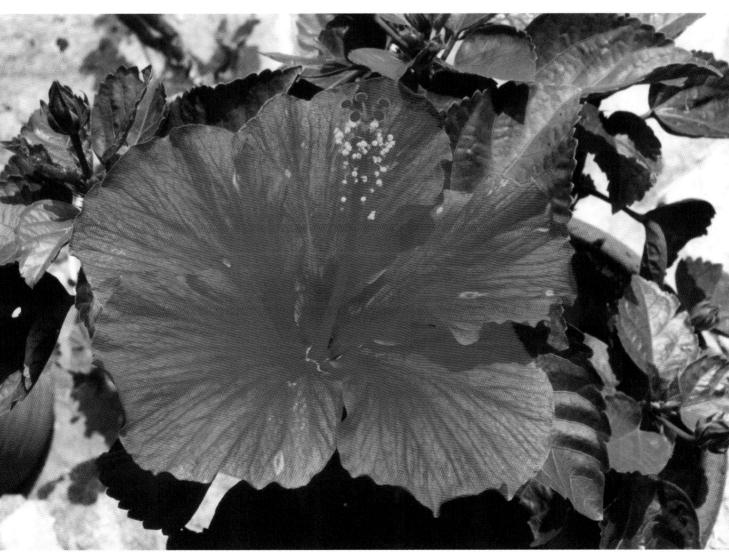

Holly

While the holly flowers are insignificant, holly leaves can provide striking contrast in a composition of soft textures, soft edges, smooth surfaces, or delicate petals. With their red berries, they can form the foundation of a dramatic, complementary color scheme.

Hints

1. Use the No. 2 flat brush to paint the berries and branch and the No. 6 flat brush to paint the leaves. Use the liner brush to paint veins and add details to the blossom end of the berry.

2. To make more obvious the difference between the top and underneath surfaces of the leaves, exaggerate the predominate light or dark value of each. (See photos of both sides of the leaves on pages 254 and 255.)

3. Build up the drybrushed highlights on the leaves gradually. Don't try to accomplish the effect in a single effort. Let each application dry; then add another. Remember: The less paint remaining on your brush after you wipe it dry the more control you'll have. (See "Drybrushing" on page 24.)

4. When shading the berries, leave a narrow rim of the basecoat color exposed on the edge opposite where the highlight will be. This will serve as the reflected light.

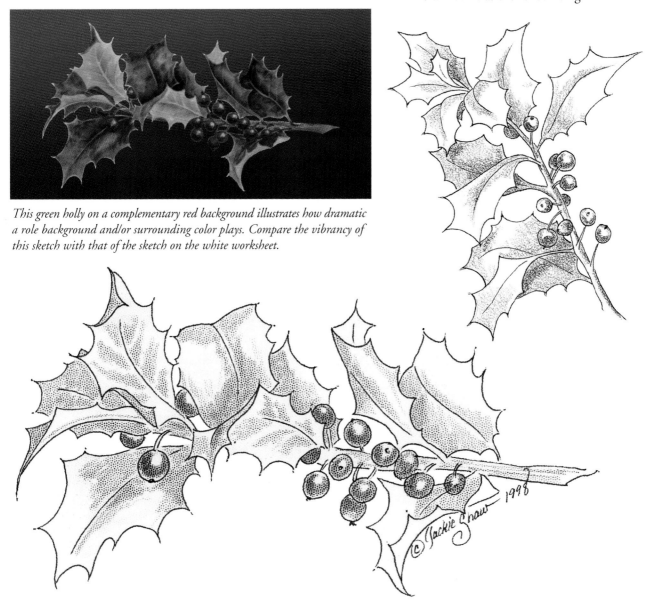

This green holly on a complementary red background illustrates how dramatic a role background and/or surrounding color plays. Compare the vibrancy of this sketch with that of the sketch on the white worksheet.

1. Use the flat brush and **A** to under-coat the tops and undersides of the leaves. Paint the thorny tips using the liner brush and **B**.

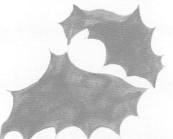

2. Paint a puddly wash of **C** on the tops of the leaves.

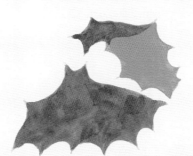

3. Add veins on the tops of the leaves using the liner brush and **A**. Paint veins on the undersides of the leaves using **A+B**.

4. Sideload the flat brush with **C**. On the top of the leaf, shade along one side of the central vein, between some of the lateral veins, and wherever you want the leaf to appear turned or in shadow. Shade underneath the leaf using sideloaded **A+C**.

1 2 3 4

BERRIES

1. Use the flat brush to basecoat berries with **D**.
2. Apply a thin wash of **E**.
3. Shade with a sideload of **E+C**.
4. Highlight with a dab of **B**. Add a dab of **C+E** to the blossom end.

5. Use the liner brush to add a tinge of **D** to the tips of the thorns. Drybrush highlights on the leaves using **B**.

6. Paint the branch using the flat brush and the stems using the liner brush with a mixture of **B+C+D+E**. Add more **C** and **E** to the mixture for darker detailing on the branch.

A B C D E F

Cast shadow is **F**.

Holly Reference Photos

Compare the coloring of the top and underneath sides of the holly leaves. Note the way the berries are attached individually to the branch. Create your own holly branch by studying closely the leaves on these pages. Then sketch several leaves on tracing paper, cut them out, and arrange them along a branch.

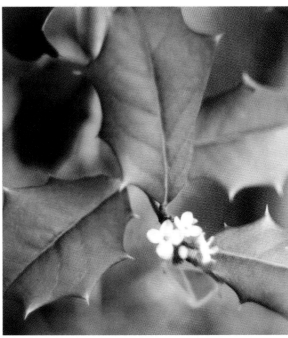

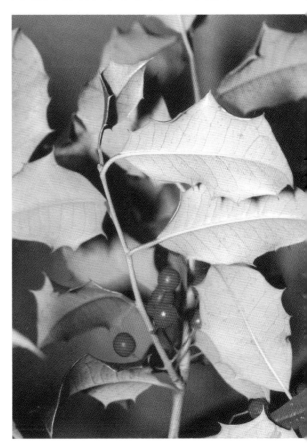

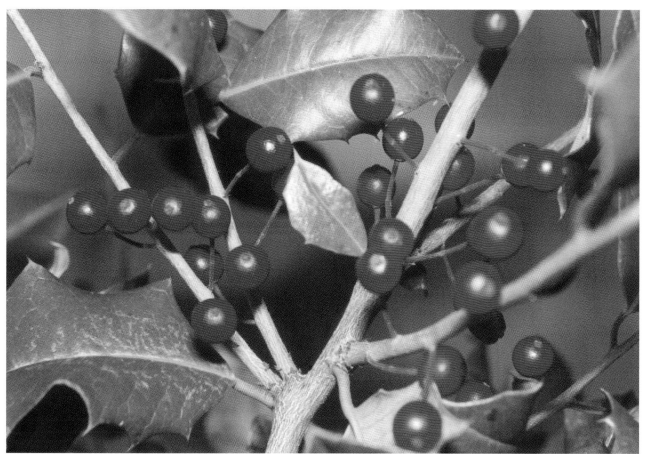

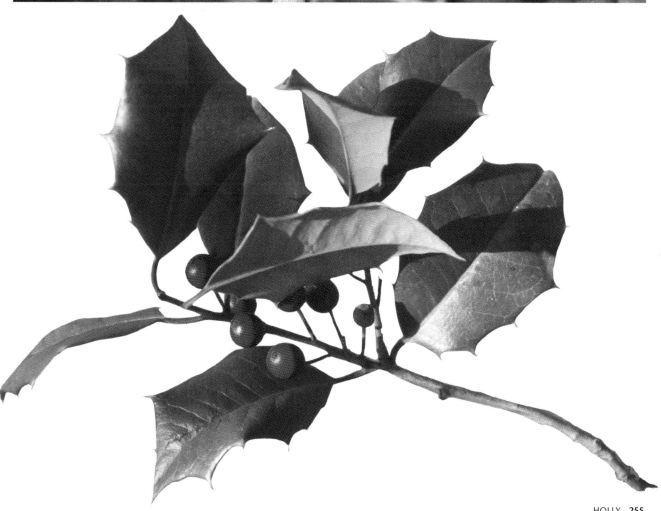

Hollyhocks

PALETTE
A Pink Chiffon
B Burgundy Wine
C Antique Teal
D Summer Lilac
E Yellow Ochre
F Light Avocado
G Pineapple

BRUSHES
Flats: Nos. 6 and 8
Liner: No. 1
Scruffy brush (optional)

Hollyhocks remind me of summers on a farm; of making flower chains, garlands, and ballerina flower dolls; of fences by the roadside; and of old homesteads that used to be. Resolutely, the flowers reappear each summer to confirm that life goes on, and to help recall memories for the older generations and create them for the younger ones.

Hints

1. Use the largest flat brush you can handle for all applications except the flower veins in step 2 and the leaf veins. Use the liner brush for these.

2. Building up textured strokes, as suggested in step 1(b), creates little ridges that will catch the drybrushed highlights in step 4. The glittery highlights help to suggest fine veins in the petals. For another way of creating this texture (working into thin wet paint), see lilies worksheet, page 265, step 1.

3. Notice how the soft pink washes on the leaves unify the leaves with the flowers and how the random, puddly washes of the various green mixtures keep the leaves' colors fresh and interesting. This is an easy and effective technique for painting leaves. It prevents stiff-looking, "blended to death" leaves.

4. Study the hollyhocks on the photo reference pages to see how distinctly the veining in the petals stands out. Try to capture that effect in step 4 with drybrushing.

Contour Lines

Use contour lines to help you paint the curves and flow of a flower petal. Notice how different contour lines on two identical flower petals create two different effects.

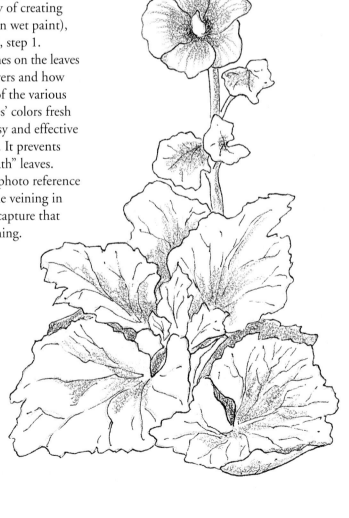

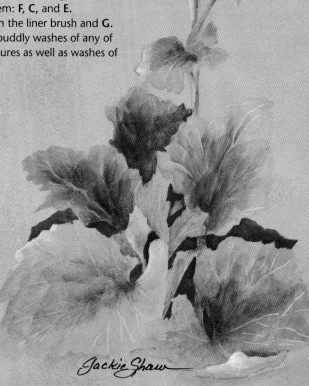

1. (a) Basecoat the petals with a thin coat of **A**. (b) Then, load the flat brush with thick paint and stroke from the tip of the petal to the base on the chisel edge of the brush to add textured, vein-like strokes. Dry.

2. Apply a wash of **B** with a flat brush. Dry. Use a sideloaded flat brush to apply a second wash to deepen the center area. Place the paint edge of the brush toward the center of the flower, letting the color fade outward and be softened by the water edge. Paint a few, very faint vein lines with thinned **B**.

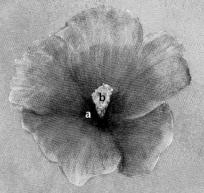

LEAVES AND BUDS

1. Undercoat leaves and buds with a puddly wash of any of the following colors and mixtures of them: **F**, **C**, and **E**.
2. Paint veins with the liner brush and **G**.
3. Add tinges of puddly washes of any of the green mixtures as well as washes of **A**, **B**, and **E**.

3. (a) Shade the petals and the deepest part of the center with **B+C**. (b) Stipple the center with **D**, then **E**.

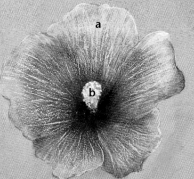

4. (a) Pick up a little **A** on a flat or a "scruffy" brush. Work it into the brush hairs, then wipe the brush quite dry. Drybrush across the petals, moving perpendicular to the vein lines. (b) Highlight the pollen with **G**.

Jackie Shaw

| A | B | C | D | E | F | G |

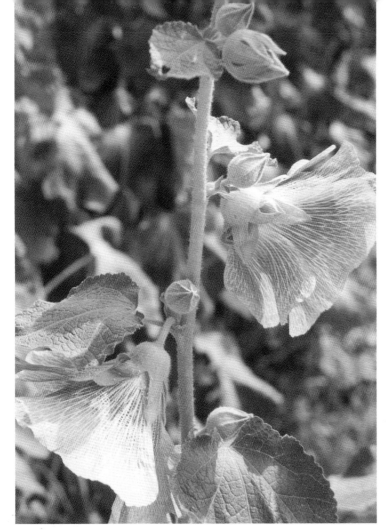

Hollyhocks Reference Photos

Lay a piece of tracing paper over some of the photos on these pages and trace the circular or oval-shaped outlines of each flower. Notice how even though the flowers make a circle when looked at straight on, that circle assumes a different shape when viewed from different directions. (Refer to the series of daisy photos on page 234.) When painting hollyhocks, try to capture the ruffled, fragile appearance of the petals.

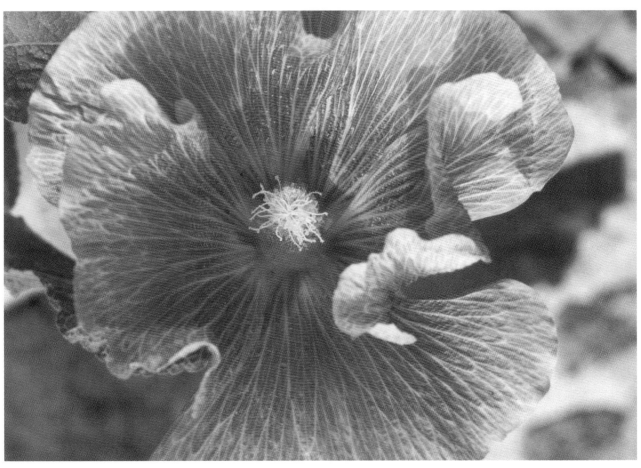

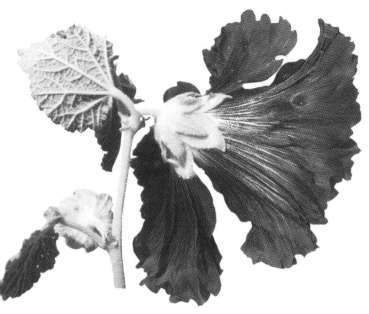

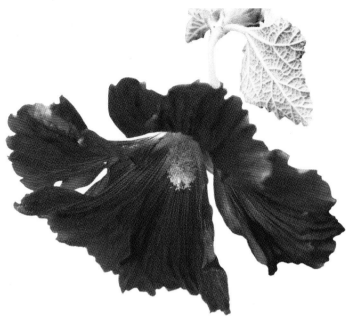

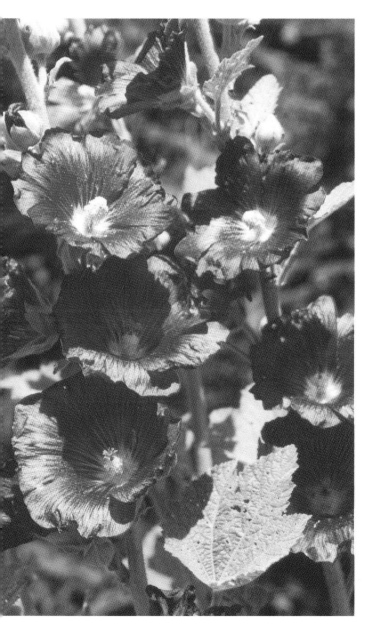

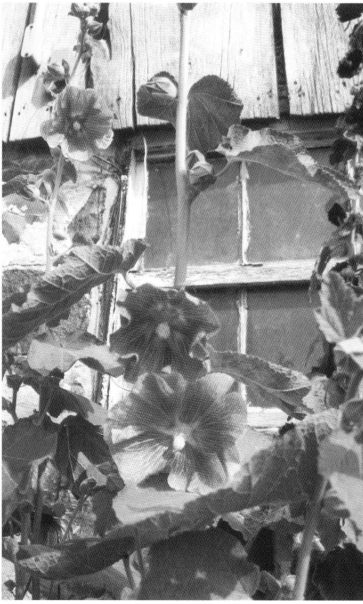

Irises

PALETTE

A Buttermilk
B Black Plum
C Plum
D Primary
 Yellow
E Royal Purple
F Cranberry
 Wine
G Sea Aqua
H Dark Pine
I Black Forest
 Green

BRUSHES

Flats: Nos. 6
 and 8
Liner: No. 10/0

The iris, cultivated between 3,000 and 4,000 years ago, was named for the Greek goddess of the rainbow, Iris. A dear neighbor, now deceased, started me collecting irises, which truly run the gamut of colors in the rainbow (and then some!). I have to restrain myself from stopping and begging to exchange rhizomes when driving past a planting of irises in colors I don't have.

Hints

1. Use the largest flat brush you can handle for all steps except to paint the veins in the flowers. Use the liner brush for these.
2. When applying washes, make them puddly so they dry with a mottled appearance. This will give the flower petals a more varied, ruffly, and delicate look.

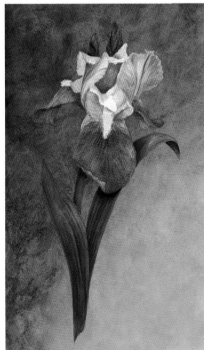

Violet, blue, and green make an analogous color scheme—in this case, a rather lively one.

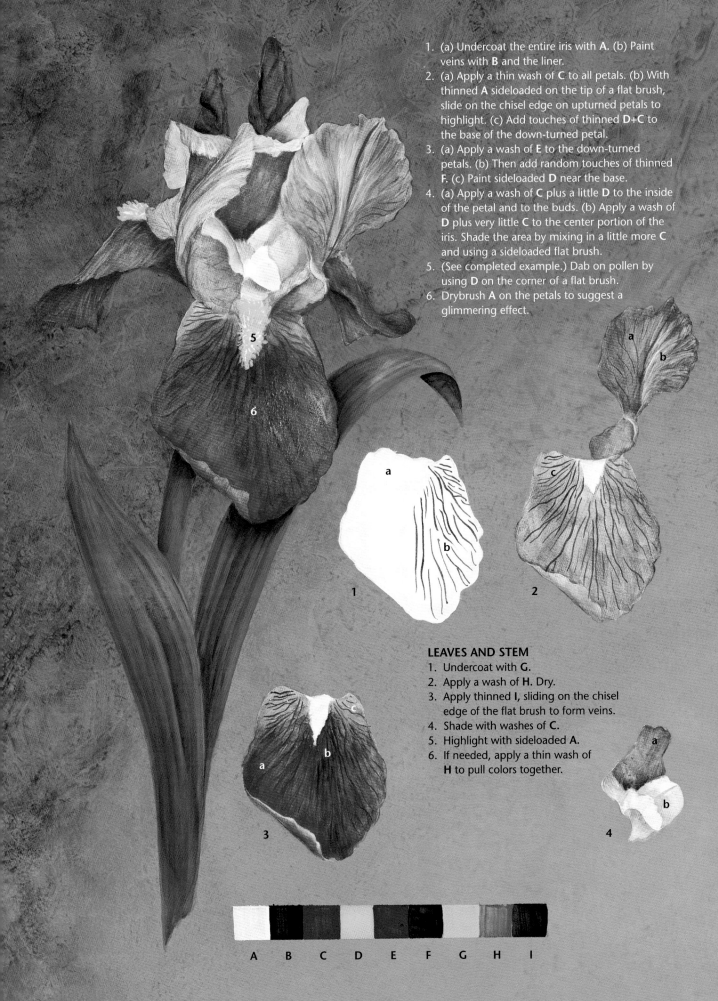

1. (a) Undercoat the entire iris with **A**. (b) Paint veins with **B** and the liner.
2. (a) Apply a thin wash of **C** to all petals. (b) With thinned **A** sideloaded on the tip of a flat brush, slide on the chisel edge on upturned petals to highlight. (c) Add touches of thinned **D+C** to the base of the down-turned petal.
3. (a) Apply a wash of **E** to the down-turned petals. (b) Then add random touches of thinned **F**. (c) Paint sideloaded **D** near the base.
4. (a) Apply a wash of **C** plus a little **D** to the inside of the petal and to the buds. (b) Apply a wash of **D** plus very little **C** to the center portion of the iris. Shade the area by mixing in a little more **C** and using a sideloaded flat brush.
5. (See completed example.) Dab on pollen by using **D** on the corner of a flat brush.
6. Drybrush **A** on the petals to suggest a glimmering effect.

LEAVES AND STEM

1. Undercoat with **G**.
2. Apply a wash of **H**. Dry.
3. Apply thinned **I**, sliding on the chisel edge of the flat brush to form veins.
4. Shade with washes of **C**.
5. Highlight with sideloaded **A**.
6. If needed, apply a thin wash of **H** to pull colors together.

A B C D E F G H I

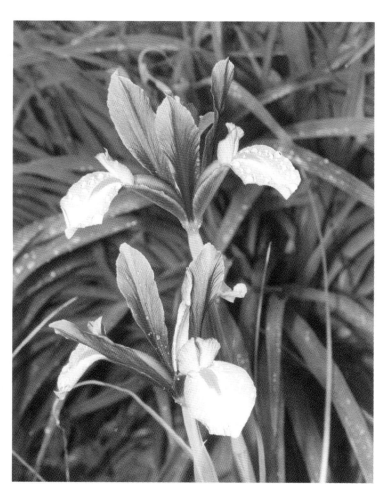

Irises Reference Photos

Space limitations permit only a small sampling of the wide range of colors of irises. But chances are, if you need a particular color flower to complete a composition, you'll find there exists an iris in—or near—that color.

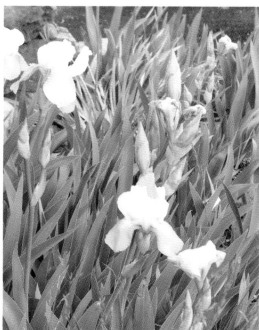

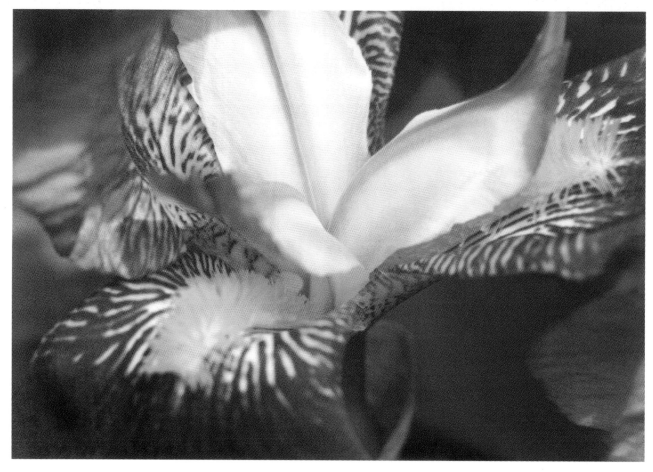

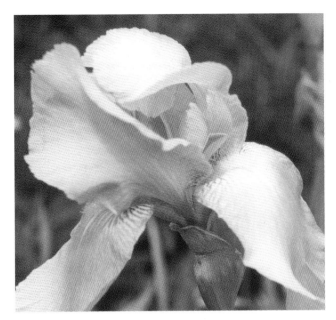

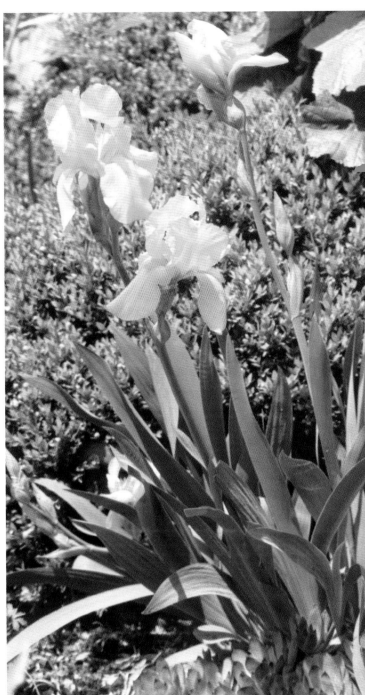

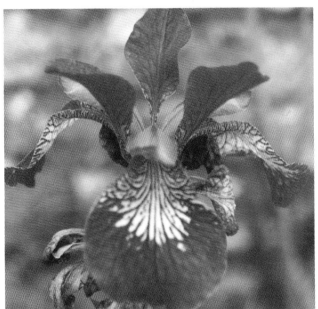

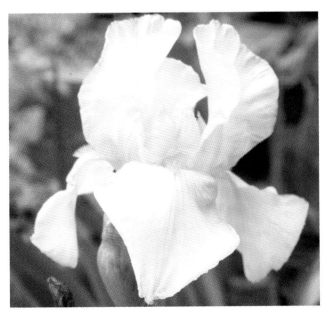

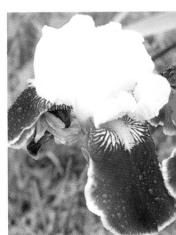

Lilies

PALETTE
A Buttermilk
B Light
 Buttermilk
C Charcoal
 Gray
D Blue/Grey
 Mist
E Olive Green
F Midnite
 Green
G Black Forest
 Green
H Titanium
 White
I Tangerine
J Burnt Sienna

BRUSHES
Flats: Nos. 4
 and 10
Liner: No. 1

There are approximately 100 species and count-less hybrids of lilies. I decided to use a white lily for the worksheet because once you paint its light and dark values, you can apply a colored wash to create whatever color lily you like. They come in just about every color but blue. The flowers may face upward, horizontally, or down-ward; and their petals may be trumpet-shaped (as shown here), bowl-shaped, funnel-shaped, or may curve tightly backward to touch the stem.

Hints

1. Use the largest flat brush you can handle for all steps except where the liner brush is specifically mentioned.
2. Notice how effective and unobtrusive the veins in the flower petals look when they're created with thin, wet color, moved about on the chisel edge of the No. 10 flat brush. Using the flat brush rather than a liner helps to create subtle shading as well as texture. With the flat brush, we're also less apt to try as hard as we might with the liner to make "just perfect," evenly spaced veins. These flow gently and are then merged slightly into the petals with the wash layer of color.
3. For ideas on background colors for the other lilies, check some of the other lessons (including those for fruits and vegetables) to see how the reds, yellows, pinks, and oranges look on various colored backgrounds.

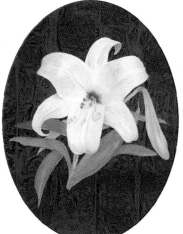

Try not only different back-ground colors but also different lily colors. Use some of the palettes suggested in other lessons. Notice the different leaves and stamens on the various lilies shown in the photos on pages 266 and 267.

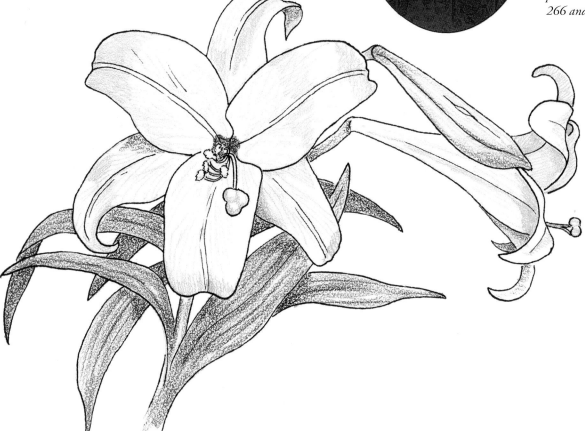

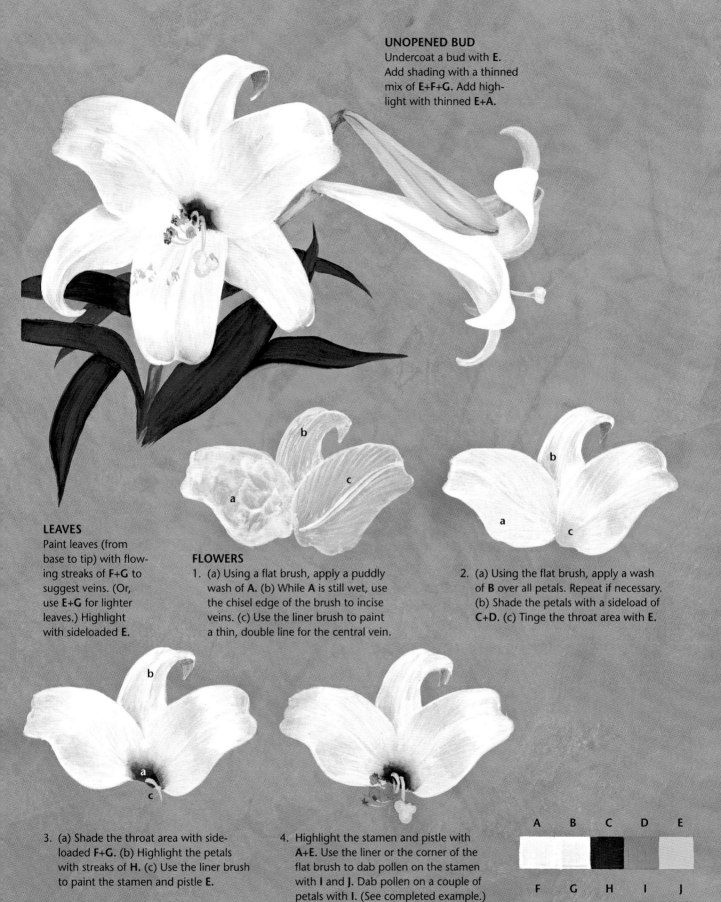

UNOPENED BUD
Undercoat a bud with **E.** Add shading with a thinned mix of **E+F+G.** Add highlight with thinned **E+A.**

LEAVES
Paint leaves (from base to tip) with flowing streaks of **F+G** to suggest veins. (Or, use **E+G** for lighter leaves.) Highlight with sideloaded **E.**

FLOWERS
1. (a) Using a flat brush, apply a puddly wash of **A.** (b) While **A** is still wet, use the chisel edge of the brush to incise veins. (c) Use the liner brush to paint a thin, double line for the central vein.

2. (a) Using the flat brush, apply a wash of **B** over all petals. Repeat if necessary. (b) Shade the petals with a sideload of **C+D.** (c) Tinge the throat area with **E.**

3. (a) Shade the throat area with sideloaded **F+G.** (b) Highlight the petals with streaks of **H.** (c) Use the liner brush to paint the stamen and pistle **E.**

4. Highlight the stamen and pistle with **A+E.** Use the liner or the corner of the flat brush to dab pollen on the stamen with **I** and **J.** Dab pollen on a couple of petals with **I.** (See completed example.)

A	B	C	D	E

F	G	H	I	J

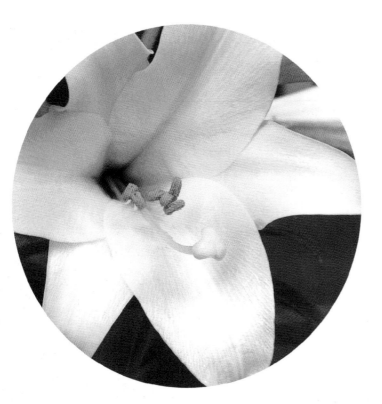

Lilies Reference Photos

Here are a few varieties of lilies from my garden. To paint them, use the techniques from the worksheet, altering colors as needed. To paint the yellow, soft pink, and light orange lilies, follow the directions through step 2(b). Then apply a wash of your choice of pink, yellow, or light orange. To paint red and deeper orange lilies, use color **I** for the undercoat and wash steps through 2(a). Then, for the red lilies, apply a wash of red, letting it fade into the orange in the throat. Mix a darker value red for the shading in 2(b). For steps 2(c) through step 4, use the photographs to help you select the detailing colors for the throat, stamen, spots, and other markings. Use the hibiscus palette to paint the hot pink lily.

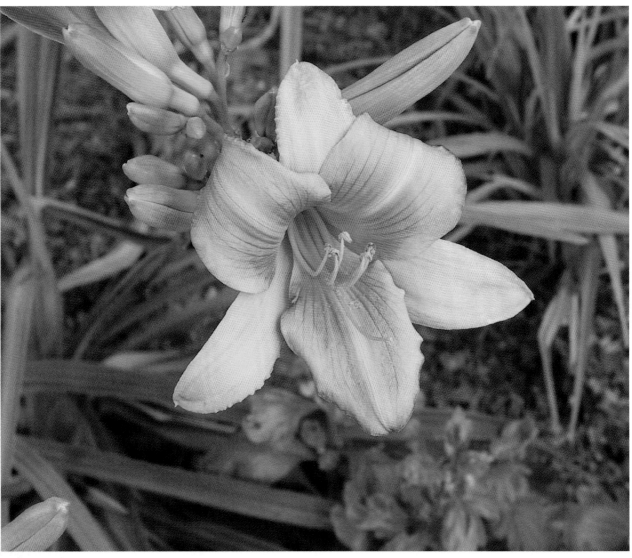

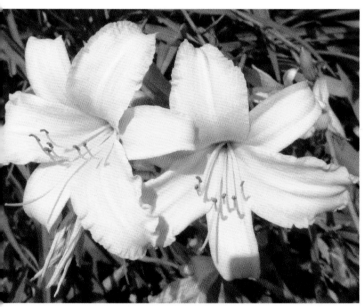

Magnolias

I absolutely love painting these stately flowers. A family friend gave me two tiny seedlings so I could someday enjoy painting ones I grew. The surviving one of the pair, now five years later, stands only a foot tall. It's going to have to grow a lot faster than that for me to be around to paint it!

Hints

1. Use the largest flat brush you can for all steps except for leaf veins and cracks, and flower stamens. Use the liner brush for these.

2. Transfer the pattern for the leaves and edges of the outside flower petals. Undercoat smoothly. Then transfer details for the inner petals and center.

3. Prepare yourself for seeing lots of wonderful colors in something white by studying a group of white shelled eggs. See "Cast Shadows," exercise 3, on page 55.

4. In some cases, thin layers of three colors of washes (blue, yellow, and pink) are stacked one upon the other on the creamy white background of the magnolia. The layering results in some lovely, gentle, almost elusive colors. For best results, work with very little paint, repeating the steps if necessary, to build up the colors slowly.

See my explanation of how to paint waterdrops on page 298.

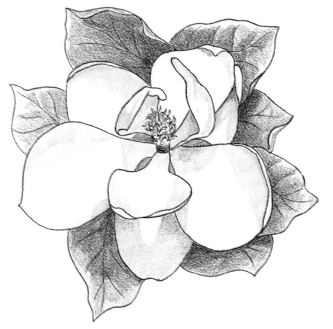

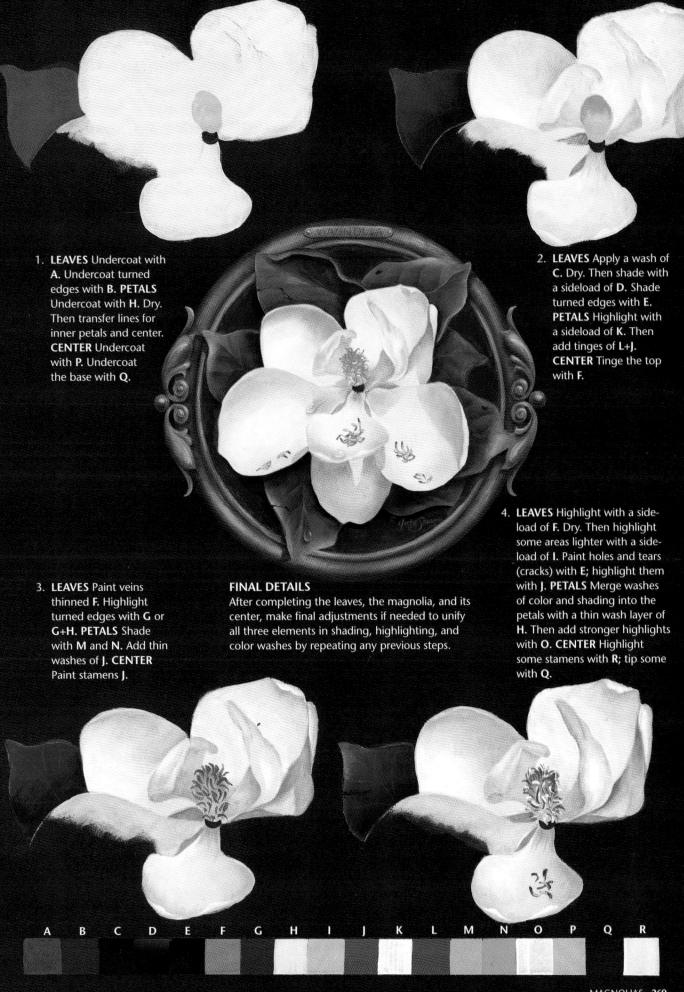

1. **LEAVES** Undercoat with
A. Undercoat turned
edges with **B. PETALS**
Undercoat with **H.** Dry.
Then transfer lines for
inner petals and center.
CENTER Undercoat
with **P.** Undercoat
the base with **Q.**

2. **LEAVES** Apply a wash of
C. Dry. Then shade with
a sideload of **D.** Shade
turned edges with **E.**
PETALS Highlight with
a sideload of **K.** Then
add tinges of **L+J.**
CENTER Tinge the top
with **F.**

4. **LEAVES** Highlight with a side-
load of **F.** Dry. Then highlight
some areas lighter with a side-
load of **I.** Paint holes and tears
(cracks) with **E;** highlight them
with **J. PETALS** Merge washes
of color and shading into the
petals with a thin wash layer of
H. Then add stronger highlights
with **O. CENTER** Highlight
some stamens with **R;** tip some
with **Q.**

3. **LEAVES** Paint veins
thinned **F.** Highlight
turned edges with **G** or
G+H. PETALS Shade
with **M** and **N.** Add thin
washes of **J. CENTER**
Paint stamens **J.**

FINAL DETAILS
After completing the leaves, the magnolia, and its
center, make final adjustments if needed to unify
all three elements in shading, highlighting, and
color washes by repeating any previous steps.

A B C D E F G H I J K L M N O P Q R

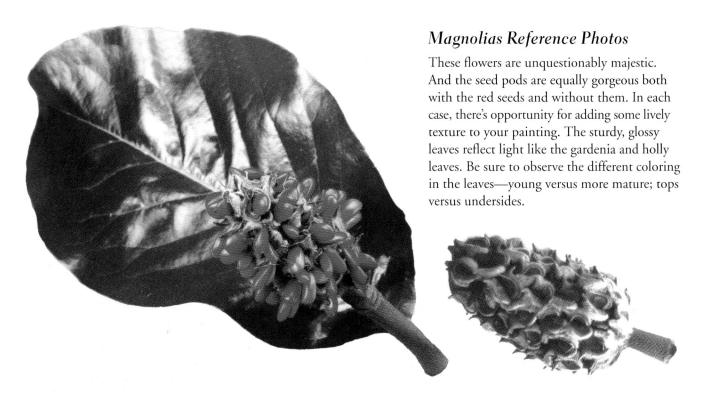

Magnolias Reference Photos

These flowers are unquestionably majestic. And the seed pods are equally gorgeous both with the red seeds and without them. In each case, there's opportunity for adding some lively texture to your painting. The sturdy, glossy leaves reflect light like the gardenia and holly leaves. Be sure to observe the different coloring in the leaves—young versus more mature; tops versus undersides.

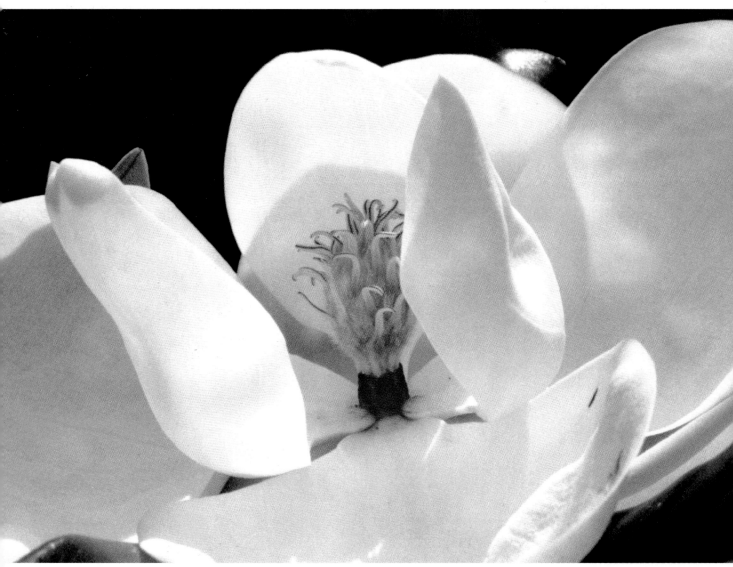

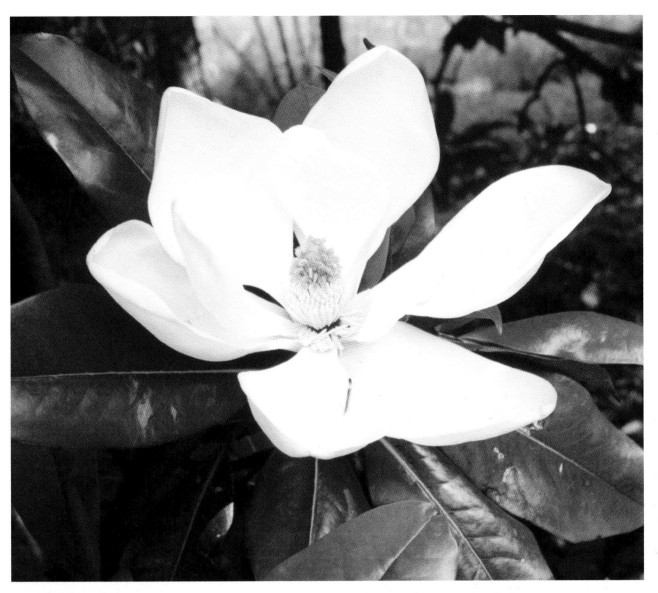

Marigolds

PALETTE
A Marigold
B Georgia Clay
C Napa Red
D Lemon Yellow
E Cadmium Orange
F Primary Yellow
G Celery Green
H Arbor Green
I Reindeer Moss Green
J Charcoal Gray

BRUSHES
Flats: Nos. 2, 4, 6, 8, and 10 (or 12)
Liners: No. 1

A Welsh weather omen proclaims that marigolds failing to open early in the morning indicates an ensuing storm. I've never tested that omen, but I do know that my tomato plants are happily free of nematodes when marigolds grow around them.

Hints

1. Marigolds are quick and easy to paint. Use a selection of flat brushes, always working with the largest brush you can handle for a given area. Use the liner brush to outline the flower petals.
2. Paint the bottom layer of petals first. After that, you may find it easier to paint the remaining layers freehand. See the directions below for painting freehand stroked marigolds. Try both techniques, and perhaps use a combination of the two.

Quick and Easy Marigolds

1. To paint quick, easy brushstroke marigolds, you need master just one stroke—a dipped crescent stroke. To make the stroke, doubleload the No. 6 flat brush with **A** on one side, **B** on the other. Then:
 a. Imagine a clock face. Place the dark corner of your brush in the center of the clock, with the light corner facing 10 o'clock.
 b. Slide briefly toward 10 o'clock; then, gradually leaning the brush handle back a little toward you, press down on the dark-paint corner causing the light-paint corner to flare upward. Now, slightly rotate the brush toward 12 o'clock. Then slightly release the pressure and press again as you continue rotating the brush to point toward 2 o'clock.
 c. At 2 o'clock, begin releasing the pressure on the brush, letting the hairs return to the chisel edge. Pull the brush back toward the clock center starting point, and lift off.
2. To paint the freehand marigold, draw a dime-sized circle around which you will paint the outer layer of petals. Let them dry, then move inward and paint another slightly overlapping row, leaving the dark part of the previous layer showing. Continue making rows, using smaller brushes as needed, until you have no room left. Finish with a few pollen dabs of **A**.
3. To paint quick leaves, doubleload the No. 4 flat brush with a light and a dark green. Stand the brush on the chisel edge with the light side of the brush facing the outside edge of the leaf. The dark side will shade the center vein area. Zig-zag from the base of the leaf to the tip on one side of the leaf, rotating slightly as you paint, leading with the light green, to form a point at the leaf tip. Repeat on the other side.

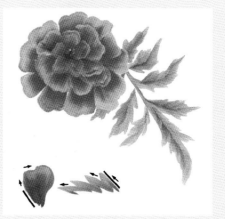

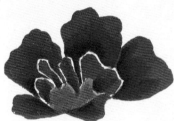

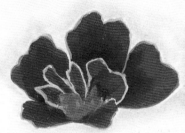

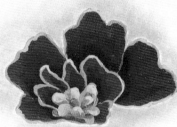

1. Undercoat the petals with **A.**

2. Doubleload a flat brush with **A** and **B.** Place the darker value at the base of each petal.

3. Shade each petal with **C.**

4. Highlight the edges of some petals with **D.**

1. Brush mix **E+B.** Undercoat the petals, leaving the edges unpainted. (Note: Apply basecoat thinly in the flower center.)

2. Shade the petals with **C.**

3. Use the liner brush to outline the petals with **F.**

4. Form the small center petals by painting tight crescent-shaped strokes with a small flat brush sideloaded with **F.** Highlight edges with **D.**

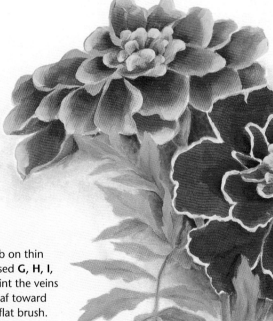

LEAVES

To paint the leaves, randomly dab on thin washes of a variety of greens. I used **G, H, I,** and **J+H** for the darkest value. Paint the veins by sliding from the base of the leaf toward the tip on the chisel edge of the flat brush. Keep the leaves understated so they do not compete with the very detailed blossoms.

A B C D E F G H I J

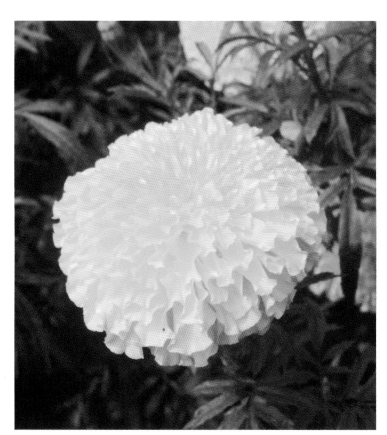

Marigolds Reference Photos

The directions in the lesson are for painting two-toned red and orange marigolds. To paint the yellow marigold, use the palette suggested for painting daffodils. (P.S. You get extra points for painting the grasshopper and the ant!)

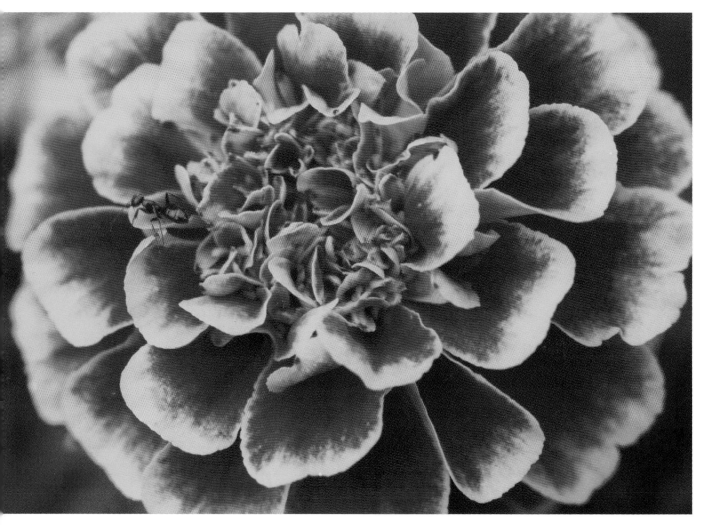

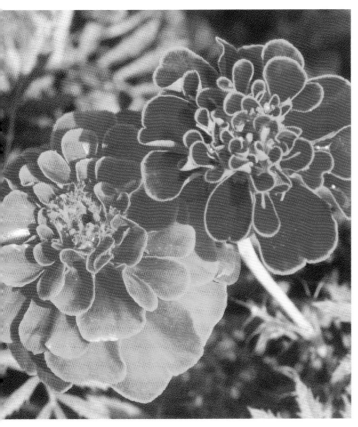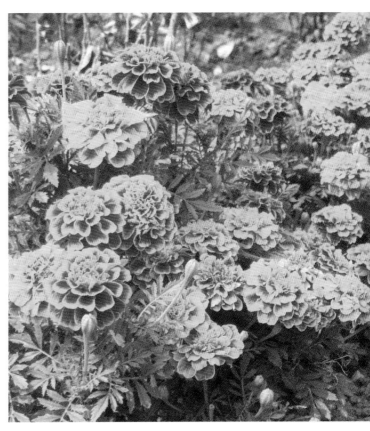

Mistletoe

PALETTE

A Cherry Red
B Napa Red
C Blush Flesh
D Coral Rose
E Avocado
F Light Avocado
G Hauser Dark Green
H Buttermilk
I Cool Neutral
J Khaki Tan
K Sable Brown
L Moon Yellow
M Titanium White

BRUSHES

Flats: Nos. 2, 6, and 8
Liner: No. 10/0

Mistletoe, a parasitic plant found growing in oak and other trees, figured in Druid rituals and continues to this day to hold a cherished place in Christmas customs. It has yellowish flowers, thick, succulent-looking leaves, and waxy white berries.

Hints

1. Use the largest of the recommended flat brushes you can handle for each step involving painting the undercoats, the shading, the veining, and the highlighting. Use the liner brush to add reflected lights and blossom ends to the berries.
2. Paint the ribbon in its entirety first, then the leaves, and finally the berries.
3. To make the ribbon shiny like satin, use a sideloaded brush to highlight it. See page 22 for hints on making smooth, blended transitions. To make the ribbon look like velvet, drybrush on the highlights and paint highlights along the ribbon edges to make them appear thicker.

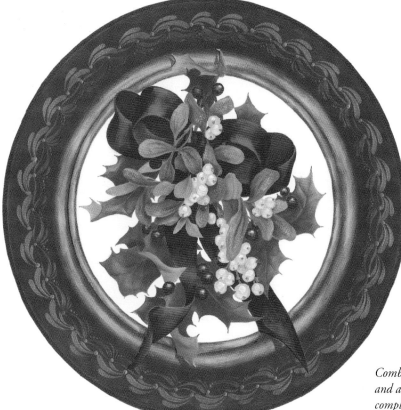

Combine mistletoe with holly and a red ribbon for a striking complementary color scheme.

1. **RIBBON** Undercoat with **A**. **LEAVES AND STEMS** Undercoat some with **E**, others with **F**. **BERRIES** Undercoat with **H**.

2. **RIBBON** Shade the underneath portions with sideloaded **B**. **LEAVES** Paint veins in the lighter green leaves with **E**. Use **G** to vein the darker green leaves. **BERRIES** Apply a wash of **I**.

3. **RIBBON** Highlight with a sideload of **C**. **LEAVES AND STEMS** Shade with a sideload of **G**. **BERRIES** Shade with a sideload of **J**.

4. **RIBBON** Accent with highlights of sideloaded **D**. **LEAVES** Add the pebbly texture with a drybrush of **L**. **BERRIES** Highlight with a dab of **M**. Add a reflected light along the lower edges with **H**. Paint the blossom ends with **K**. (See finished example.)

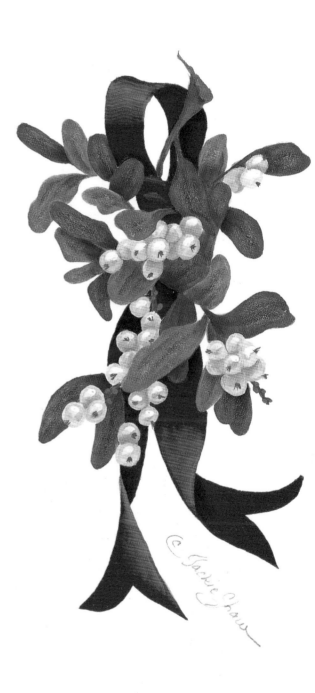

A	B	C	D	E	F	G	H	I	J	K	L	M

Mistletoe Reference Photos

You'll probably find mistletoe leaves to be the easiest ones in the book to paint. Notice how a highlight or a shadow along an edge of a leaf defines its thickness. The slightly coarse texture of the leaf reflects lots of tiny bits of light. Drybrushing accomplishes this feature easily. On the ribbon, compare the way the slick, satin side reflects the light while the nappy, velvet side absorbs it.

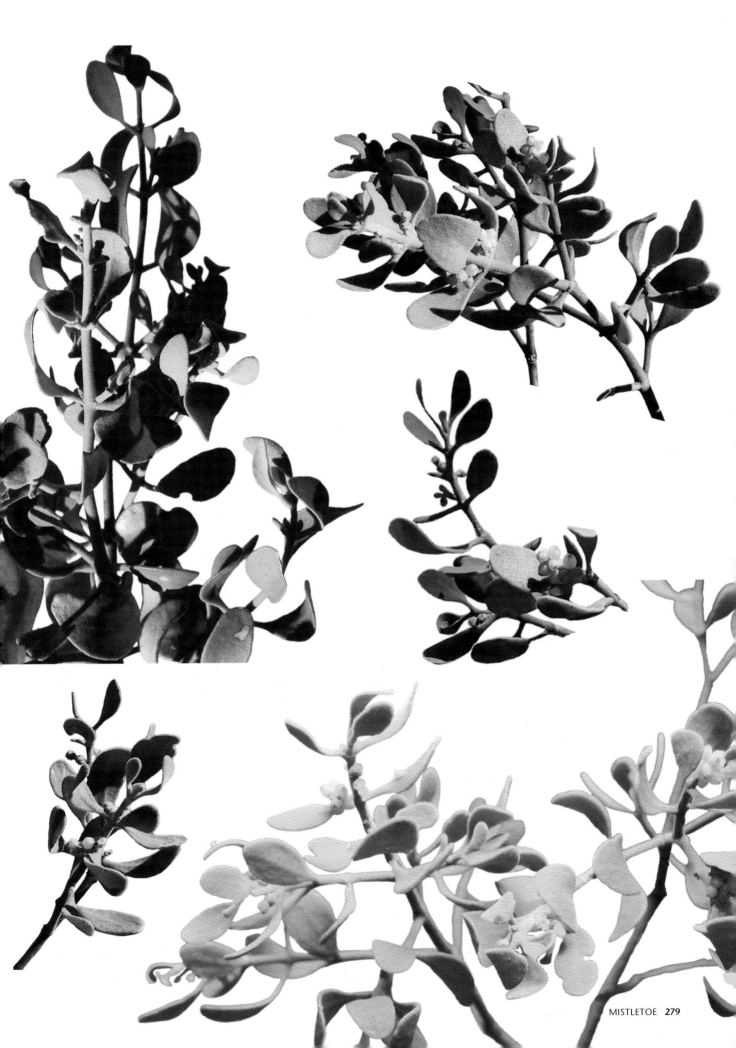

Morning Glories

PALETTE
A Light
 Buttermilk
B Green Mist
C Primary
 Yellow
D Marigold
E Plum
F Evergreen
G Olive Green
H Teal Green
I Titanium
 White

BRUSHES
Flats: Nos. 6
 and 8
Liner: No. 10/0

To paint blue morning glories, substitute one or two blues for the plum (color E), then follow the worksheet directions.

The first seeds I planted as a child were morning glories. And what an abundance of beautiful, blue flowers those few seeds produced. I was in awe. It's a little more work to paint them than to plant them, but the results are as much fun.

Hints

1. When painting these cheerful blossoms, use the No. 8 flat brush for large leaves and petals and the No. 6 flat brush for smaller areas. For the veins, tendrils, and flower markings, use the liner brush, thinning the paint with water as needed.

2. To paint the flower petals, begin at the outside edge and pull toward the center or down into the throat. This will help you think about the curve and flow of the petal. It will also help establish both the form of the petals and the placement of the veins.

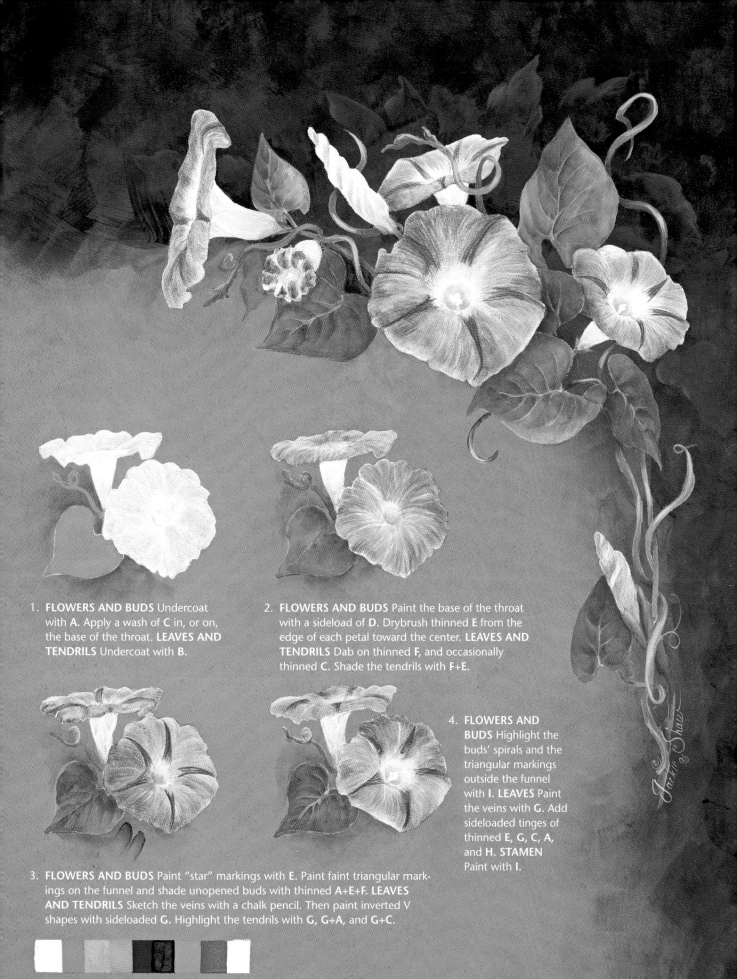

1. **FLOWERS AND BUDS** Undercoat with **A.** Apply a wash of **C** in, or on, the base of the throat. **LEAVES AND TENDRILS** Undercoat with **B.**

2. **FLOWERS AND BUDS** Paint the base of the throat with a sideload of **D.** Drybrush thinned **E** from the edge of each petal toward the center. **LEAVES AND TENDRILS** Dab on thinned **F,** and occasionally thinned **C.** Shade the tendrils with **F+E.**

4. **FLOWERS AND BUDS** Highlight the buds' spirals and the triangular markings outside the funnel with **I. LEAVES** Paint the veins with **G.** Add sideloaded tinges of thinned **E, G, C, A,** and **H. STAMEN** Paint with **I.**

3. **FLOWERS AND BUDS** Paint "star" markings with **E.** Paint faint triangular markings on the funnel and shade unopened buds with thinned **A+E+F. LEAVES AND TENDRILS** Sketch the veins with a chalk pencil. Then paint inverted V shapes with sideloaded **G.** Highlight the tendrils with **G, G+A,** and **G+C.**

A B C D E F G H I

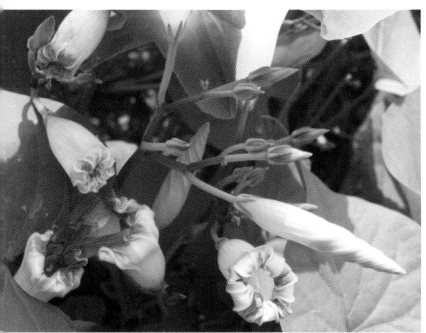

Morning Glories Reference Photos

Look closely at the photos on this page and you'll see some spiraling unopened buds as well as some spent blossoms turning inward on themselves. Often, the density of heart-shaped leaves obscures the abundance of meandering vines, but you can see them clearly on the next page in the photo at top left. Some varieties have very obvious star-shaped rays on the open blossoms.

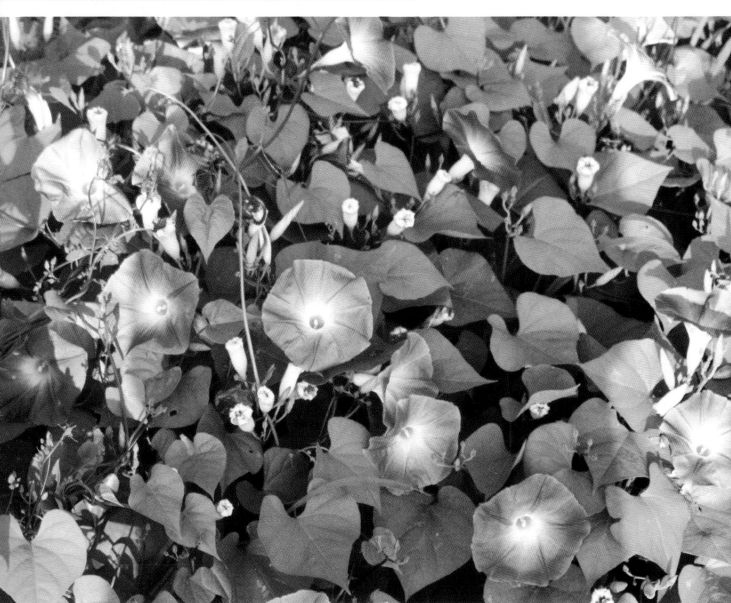

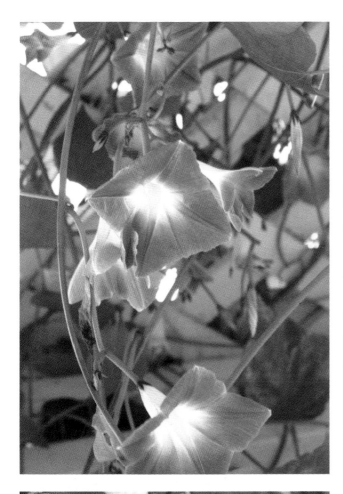

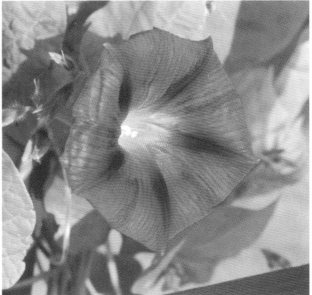

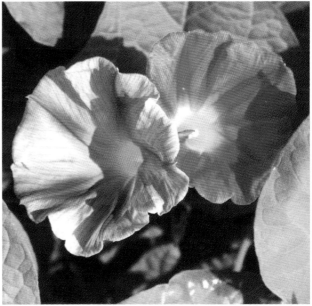

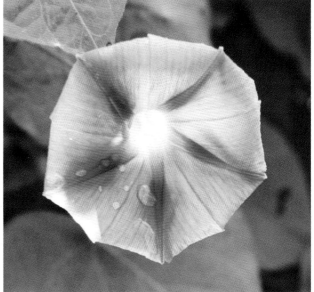

Pansies

PALETTE
A Spice Pink
B Burgundy
 Wine
C Cranberry
 Wine
D Napthol Red
E Cadmium
 Yellow
F Buttermilk
G Boysenberry
 Pink
H Black Plum
I Olive Green
J Deep Teal
K Antique Teal

BRUSHES
Flats: Nos. 4
 and 6
Liners: Nos. 2
 and 10/0

For over 25 years of professional painting, I avoided painting pansies. I even avoided planting them. All because they once grew in the front yard of my beloved grandmother's neighbor. When I was an adoring three-year-old, I picked every pansy my tiny hands could hold and carried them lovingly to my grandmother. To my astonishment and dismay, she sent me back to apologize to the neighbor. I'm sure both of them got over the incident quickly, but it took me 52 years. Now my gardens sport many varieties of pansies, but they always remind me of a hard lesson learned.

Hints

1. Use the flat brushes to apply undercoats, washes, sideloads, and drybrushed highlights. Use the liner brushes to paint veins and fine details.

2. In the lily and morning glory lessons, vein lines in the petals were created by stroking along the contour lines with a flat brush on a watery undercoat. Let's try a different approach with the pansy. This time we'll use a very fine No. 10/0 liner brush and very thin paint, slightly darker than the undercoat. In the lily and the morning glory lessons we painted the vein lines under the overall color. For the pansies, we will place them on top. In both cases, though, it's important that the veins follow the contours (see Contour Lines on page 256). When using the darker color to paint the veins on, rather than under, we must keep them delicate and subtle.

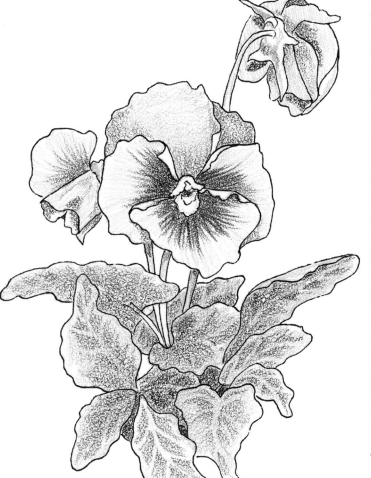

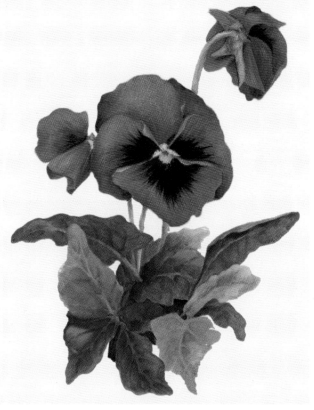

You can use the worksheet directions to paint any single-colored pansy, such as a purple one. Just select related values of the same color—such as a light, medium, dark, and very dark purple, a slightly different purple, and black. Label the colors A, B, C, D, G, and H, respectively. Colors E and F can remain the same.

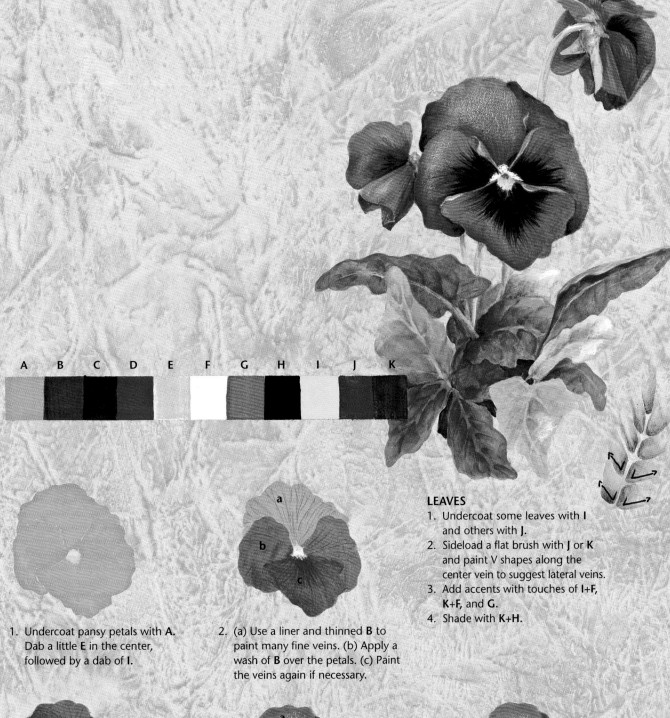

A B C D E F G H I J K

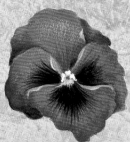

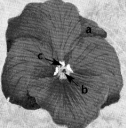

1. Undercoat pansy petals with **A**. Dab a little **E** in the center, followed by a dab of **I**.

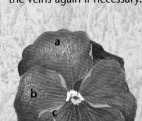

2. (a) Use a liner and thinned **B** to paint many fine veins. (b) Apply a wash of **B** over the petals. (c) Paint the veins again if necessary.

LEAVES
1. Undercoat some leaves with **I** and others with **J**.
2. Sideload a flat brush with **J** or **K** and paint V shapes along the center vein to suggest lateral veins.
3. Add accents with touches of **I+F**, **K+F**, and **G**.
4. Shade with **K+H**.

3. (a) Sideload a flat brush with **B** and shade the petals. (b) Add a dab of **D** in the center. (c) Dab **F** in the center at the bases of the side and back petals.

4. (a) Apply scattered tinges of **D** and **G** on some petals. (b) Then drybrush on highlights of **F**. (c) Paint areas where the petals have flipped over with **A**.

5. Paint the dark shading at the bases of the lower three petals with **H+C**. Paint a wash of **G** lightly over the drybrushed areas. Highlight the petals' turned edges with **A+F**.

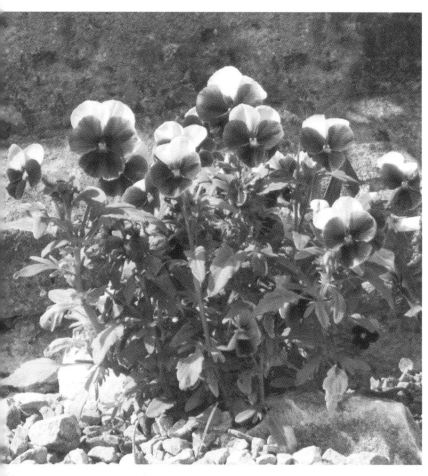

Pansies Reference Photos

Pansies are cultivated in a wide range of colors and combinations. Use the photographs here as color inspirations. If you need help in determining basecoat, wash, shading, and highlighting colors, use the color palettes, which suit you, from any of the other lessons.

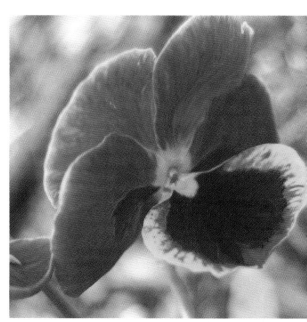

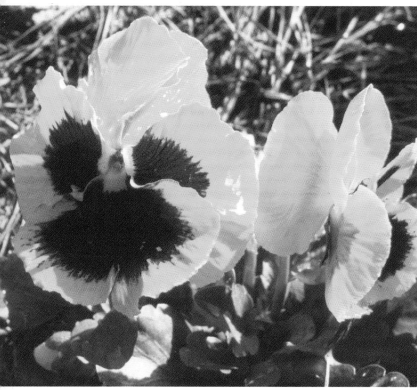

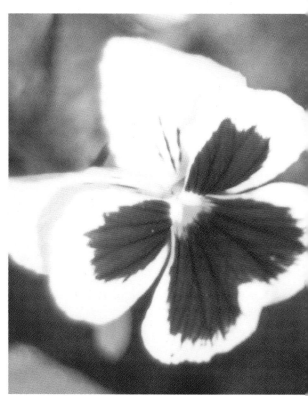

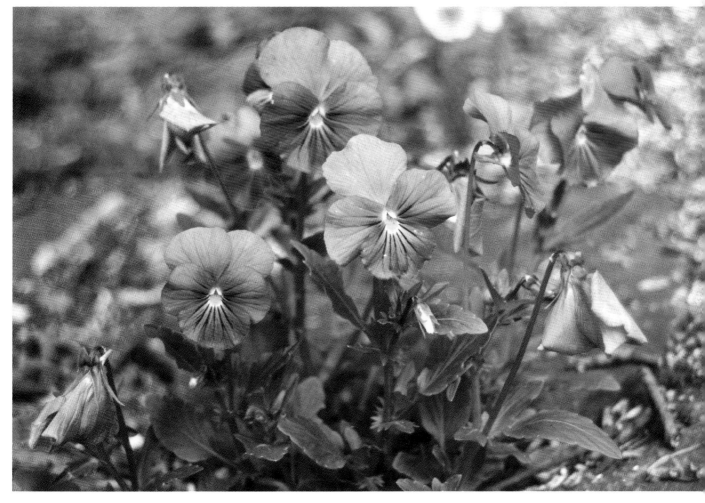

Poinsettias

PALETTE

A Peaches 'n Cream
B Antique Rose
C True Red
D Alizarin Crimson
E Red Violet
F Leaf Green
G Antique Teal
H Black Forest Green
I Hauser Light Green
J Lemon Yellow

BRUSHES
Flats: Nos. 1, 6, and 8
Liner: No. 1

I have a hard time throwing away plants, so the number of poinsettias I had growing (as just green foliage, mind you) was staggering, that is until—through neglect while I was working on this book—most of them died. Only once did I try to get a dozen of them to bloom, carefully monitoring their fourteen hours of darkness each day. I did get four red leaves out of the bunch. Hardly worth the effort!

Hints

1. Use the No. 8 flat brush for the larger leaves (both red and green), the No. 6 for the smaller ones, and the No. 1 for the tiny center blossoms. Use the liner brush to stipple color on the blossoms.
2. For more information on shading between the lateral veins in the leaves (step 3), see hint 2 of the cherries lesson (page 104) and the pansies worksheet (page 285).

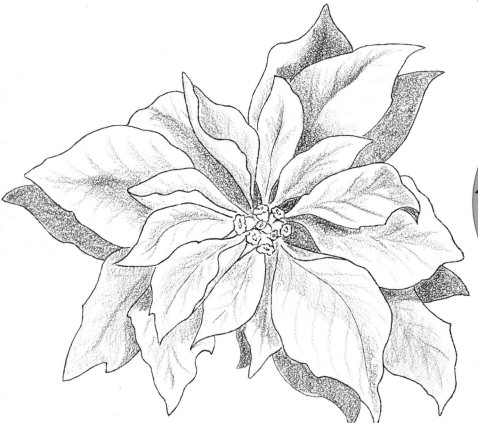

The cream and the red background colors were "safe" choices—sure to work. The blue-green background is an unexpected color choice—sort of makes one perk up and pay attention.

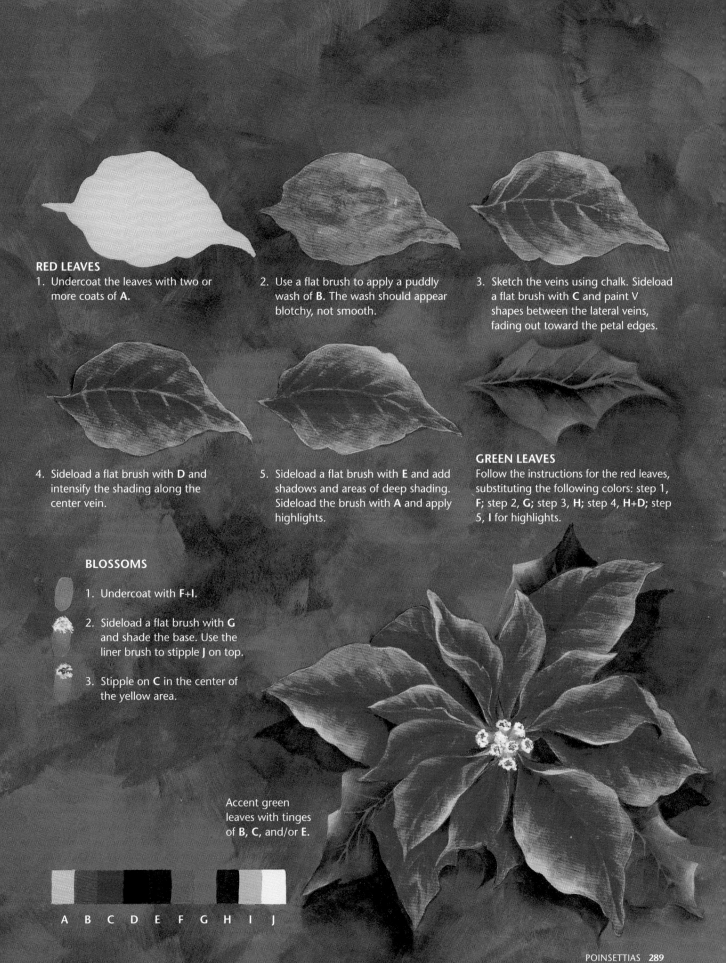

RED LEAVES

1. Undercoat the leaves with two or more coats of **A**.

2. Use a flat brush to apply a puddly wash of **B**. The wash should appear blotchy, not smooth.

3. Sketch the veins using chalk. Sideload a flat brush with **C** and paint V shapes between the lateral veins, fading out toward the petal edges.

4. Sideload a flat brush with **D** and intensify the shading along the center vein.

5. Sideload a flat brush with **E** and add shadows and areas of deep shading. Sideload the brush with **A** and apply highlights.

GREEN LEAVES

Follow the instructions for the red leaves, substituting the following colors: step 1, **F**; step 2, **G**; step 3, **H**; step 4, **H+D**; step 5, **I** for highlights.

BLOSSOMS

1. Undercoat with **F+I**.

2. Sideload a flat brush with **G** and shade the base. Use the liner brush to stipple **J** on top.

3. Stipple on **C** in the center of the yellow area.

Accent green leaves with tinges of **B**, **C**, and/or **E**.

A B C D E F G H I J

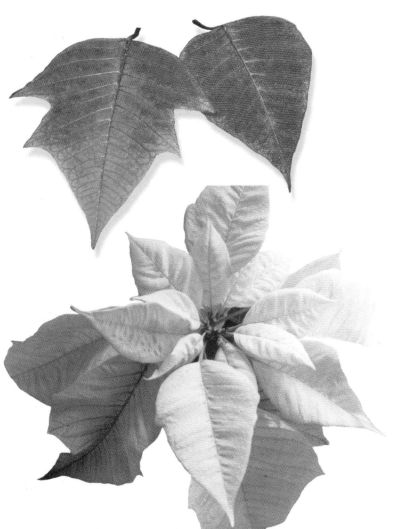

Poinsettias Reference Photos

Paint white poinsettias using colors from the gardenias palette (page 236). Paint pink ones using the hollyhocks palette (page 256). To paint the speckled poinsettias shown on the next page, use a "scruffy" brush to apply red "freckles" over a cream-colored basecoat. (P.S. The actual blossoms of the poinsettia are in the center of all those gorgeous red, white, or speckled leaves.)

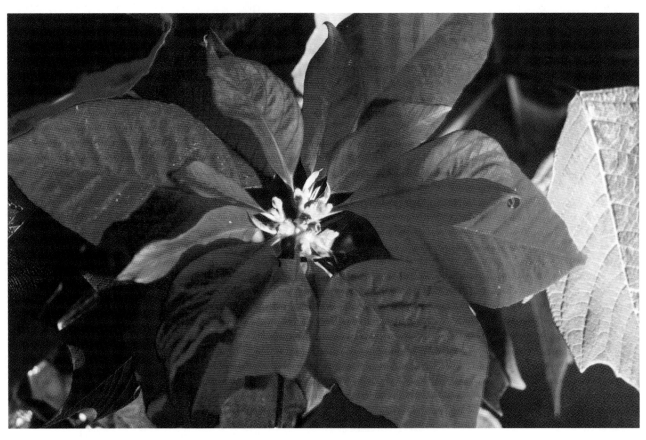

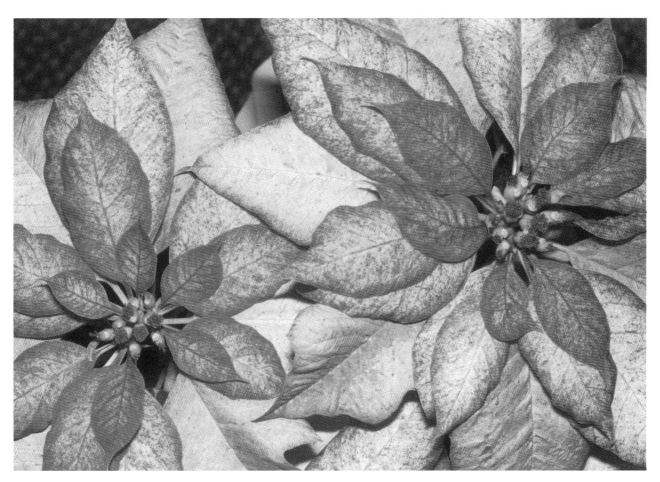

Trumpet Vines

PALETTE
A Coral Rose
B Spice Pink
C Peaches 'n
 Cream
D Camel
E Forest Green
F Tangerine
G Tomato Red
H Buttermilk
I Arbor Green
J Blush Flesh

BRUSHES
Flats: Nos. 2, 4,
 6, and 8
Liner: No. 10/0

A vigorous trumpet vine, growing on an arbor beside our home, attracts dozens of humming-birds to our office window from summer into fall. Its flowers are easily painted with a light touch and thin washes of color.

Hints

1. Use the largest flat brush you can handle for all steps except for painting the stamen, pollen, and center leaf veins. Use the liner brush for these.
2. Before painting the petals, review "Contour Lines," page 256.
3. If you prefer to paint the trumpet vine flowers on a lighter value background, consider painting the leaves lighter colors. Look at the leaves for apples, page 85, and blackberries, page 93, for example. Add traces of trumpet flower colors to the leaves to coordinate them with the flowers.

The circular band serves three purposes: to repeat the flower's circular shape and orange color; to carry an element of design onto the plain side of the plate; and to integrate the two sides of the plate by containing the blue-green background.

© Jackie Shaw 1999

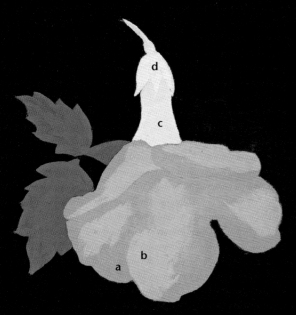

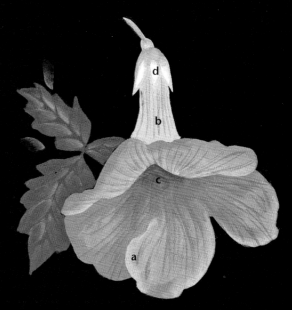

1. **FLOWER** Use a flat brush to undercoat the petals: (a) with **A** and (b) with scattered accents of **B**. (c) Undercoat the tube of the flower **C**. (d) Undercoat the calyx **D. LEAVES** Use a flat brush to undercoat the leaves **E**.

2. **FLOWER** (a) Sideload a flat brush with **C** to highlight the petals. (b) Then apply a wash of **F** on the tube. (c) Shade inside the throat with **G**. Then using the chisel edge of the brush, drag thin vein lines of **G** from inside the throat to the edges of the petals, following the contours of the petals. Also paint vein lines of **G** on the exterior of the tube. (d) Highlight the calyx with **H**. Dry. Then apply a wash of **E**, leaving the tips of the calyx uncoated. **LEAVES** Sketch in veins with a chalk pencil. Then, using a flat brush sideloaded with **I**, start at the base of the leaf with the color side of the brush facing toward the center of the leaf and paint V-shaped strokes between the veins.

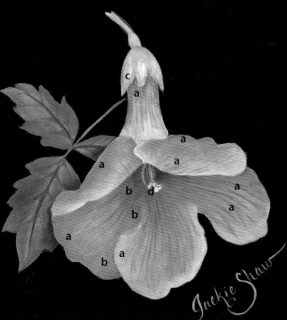

3. **FLOWER** (a) Tinge the petals and the base of the tube with scattered washes of both **J** and **F**. Deepen the shading in the throat with sideloaded **G** plus a little **E**. (b) Shade under overlapping petals with a thinned sideload of **G**. (c) Apply a wash of **F** on the calyx. Then while the paint is still wet, add a tinge of **G** to the tips. (d) Use the liner brush and a mixture of **H+F+A** to paint the stamen. Dabble on pollen with **H+F**. **LEAVES** Use the liner brush to paint the center veins on the leaves with **E** plus a little **G**. Add traces of color sporadically to the leaves using various sideloads of **F, J,** and **E**. Paint shadows on the leaves with **E+G**. Paint stems with the liner brush and **E+F**.

A	B	C	D	E	F	G	H	I	J

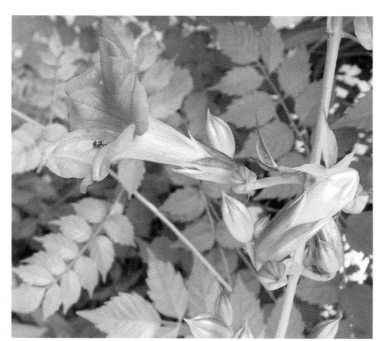

Trumpet Vines Reference Photos

Notice how sturdy the trumpet flower vines are in comparison to the morning glory vines. These vines are able to support the weight of a profuse cluster of buds and flowers, even when growing almost horizontally. The number of buds keeps the plant blooming constantly with flowers approximately three inches long by two inches wide. The compound leaves march along the stems in perfect formation like squads of nine or more soldiers.

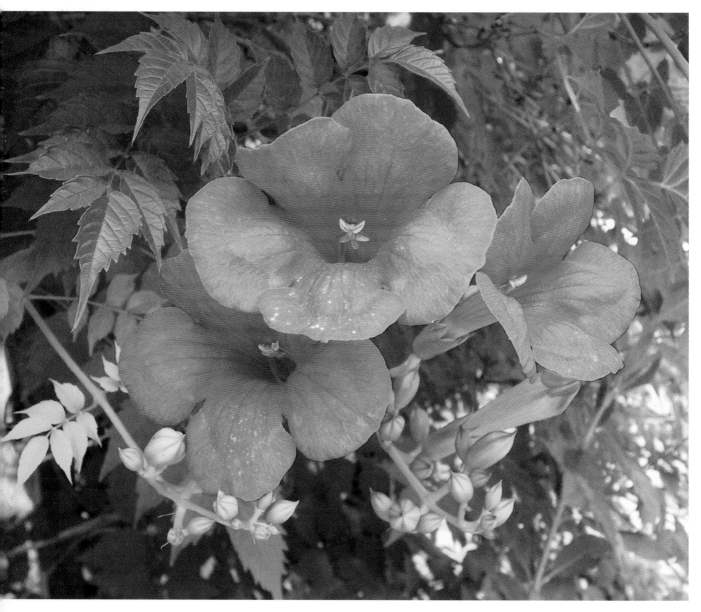

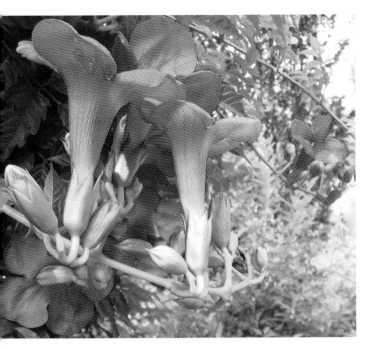

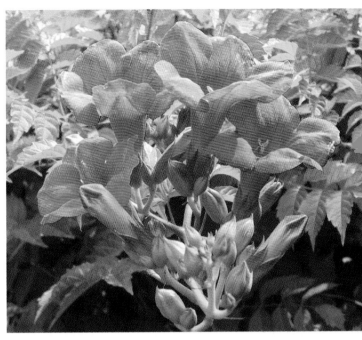

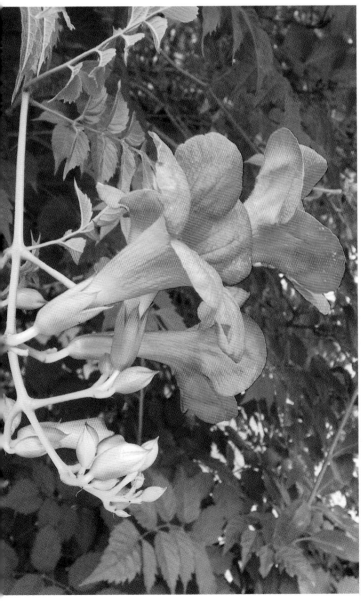

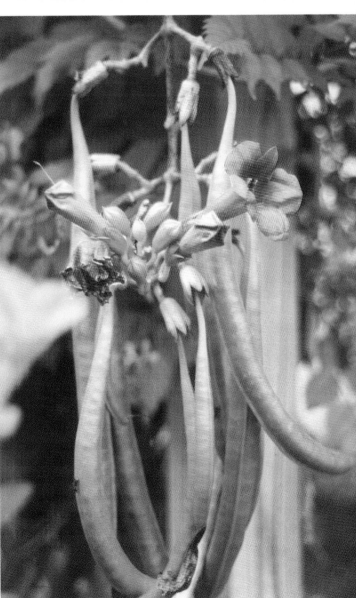

Now What?

"An artist is a special kind of person; and each person is a special kind of artist."

UNKNOWN

You've worked your way through the step-by-step painting lessons; now what? The individual lessons were but the first, faint glimmers of light at the dawn of a bright new day. There are so many more rays of light to see as the day broadens. So many more exercises, lessons, teachers, and books. And so many more things you can do to expand upon this beginning, and ultimately develop a brilliant style of your own.

Combining the Lessons

You may wish to combine several of the lesson subjects in a composition. Try to do so without strictly adhering to the step-by-step lessons. If you have painted several of the lessons, you should have a good understanding of the process of undercoat, shading, highlighting, and adjusting color washes.

HOLDING IT ALL TOGETHER

Remember, the lessons were painted as individual instructional units on different-colored backgrounds. Thus each subject's color relates to its background color. In your composition, you must strive for unity by relating all items both to one another and to their common background color. Suppose you decide to paint a pile of fruit, including bananas, on a yellow background. If you fail to adjust the yellows from the banana lesson to keep them from getting lost on your yellow background, you'll be singing, "Yes, I have no bananas." For they could easily disappear in all that yellow.

Likewise, if you were to paint a composition following each individual lesson exactly, the various parts of the composition would look like a bunch of individual parts stuck together; like an undressed, tossed salad. Lots of different bits and pieces, shapes and textures, colors and tastes, but no dressing to unify the whole. That's one of the problems inherent in breaking down techniques for individual subjects into step-by-step instructions that are easy to follow. So just remember, when you're mixing a composition out of the ingredients in these lessons, you need the "dressing" that will bind it all together. The dressing is full of wonderful ingredients: value, intensity, hue, unity, dominance, balance, rhythm, line, and so on.

ADJUSTING COLORS

You'll need to adjust your colors to unify the subjects with one another. That may mean using a red different from the one I suggested in, for example, the cherry lesson. You may need either a less intense red or you may need to subdue the red suggested in the lesson. You may need to make some colors richer, others lighter. An easy way to harmonize all the colors in a painting is to include a gray or some other color in every color mixture. Or, as a college professor advised us when painting outdoors, "Put a little blue in everything you do." So our red barns, rooftops, clouds, grass, and even yellow sunflowers all reflected a bit of the blue of the sky. It's good advice, and it holds up for painting indoors as well. Just choose any color that will accomplish your intentions for the painting. Warm colors with reds, cool them with blues, brighten them with yellows, deepen them with purples, or subdue them with grays. Withhold this unifying color from any part of the composition you'd like to remain "poppingly" prominent.

And if you find some color transitions within the composition to be jarring—say there's too great a jump between the bunch of very blue blueberries and the adjacent yellow banana, you'll need to shorten that color interval. Look at the color wheel. It's a long way from blue to yellow. A few carefully placed stepping-stones will help the eye go smoothly from one spot to another. Bluish tones in the banana and greenish tones in some blueberries will lead the gaze gently from one fruit to the next.

Creating a Picture Reference File

Perhaps one of the most helpful tips I can share with you is to create a picture reference file—often called a picture morgue. It's never too soon (nor too late) to begin collecting material that can both inspire you and assist you in your painting. A well-stocked file will be an asset in the development of your skills and one of your best self-teaching aids. It can be an invaluable reference as you develop compositions.

Such a file will also answer questions that the season or hour precludes your answering easily. For example, if you are painting blackberries from memory at three a.m. in the middle of winter, your computer is down, you gave your encyclopedias away, and you are not sure whether the margin of the blackberry leaves should be smooth or serrated, a quick glance in your file may answer the question. If it's summer and you're trying to paint a snow scene, check your file. A collection of snowy day pictures will help you determine how to paint color into the snow so your work doesn't look like a flat, white sheet of paper.

Advertisements provide great color scheme inspirations. Pictures of buildings can help you study perspective. Pictures of landscapes and seascapes can provide information on lighting, shadows, and perspective. Pictures of ribbons, musical instruments, and pottery will help you learn to paint believable shading and highlighting on your subjects. Seed packages and garden catalogues are great references for fruits, vegetables, flowers, and tree shapes.

Be greedy in your quest for reference material. Collect everything possible, even subject matter that does not, at the moment, interest you. Three years from now you may be offered a commission to paint a pink flamingo. You'll be glad you saved that picture of 216 of them clustered together—a real opportunity to study poses, knobby knees, and spindly legs so you can get your painting right!

I began my picture morgue in the early 1970's in a single, homemade file folder, clipping pictures from magazine articles. Now, thirty years and thousands of pictures later, my single folder has multiplied to over 400 folders in five tightly crammed, large file drawers. Through the years I've purged the file several times, clearing out duplicate and inferior material as better pictures became available. And I'm still adding to it and learning as I go. Have I actually used all those pictures? No way. But I have loaned many of them to friends and family who paint. And it's satisfying knowing they're there when and if I need them.

The quest for good resource material has led me in recent years to photography, much to my husband Lynn's delight. (He loves any excuse to buy more camera equipment!) With inspiration literally spilling out of my studio, sharing some resource photographs with you seemed like a nice idea. Sharing is certainly one of the aspects of painting, teaching, and writing books about painting that makes it such a rewarding activity. Hopefully, the reference photographs included with each lesson were helpful in expanding your study of the subjects covered in the lessons, and encouraged you to grab a shoe box or file folder and start your own picture collection.

Photographs are great references and inspirational tools, but don't be bound by what's in the photograph. Freely add, subtract, and totally alter the image in order to create the effect you want. And remember: With the exception of the photo images you snap yourself, the copyrights to all printed material you collect in your picture reference files belong to someone else. Use the images only to help you better understand your subject. Then create your own design, incorporating the knowledge you've gained from studying those images.

Some Topics to Include

Flowers	International themes
Fruits	Landscapes
Vegetables	Seascapes
Animals	Folk art
Insects	Skies
Birds	Trees
Babies	Brass items
Children	Glass objects
Adults	Baskets
Holidays	Pottery
Religious themes	Old toys
Transportation	Old books
Buildings	Musical instruments
Costumes	Fabrics
Eras	Ribbons

Waterdrops

One thing my students always want to learn is how to paint waterdrops. Waterdrops can add a magical touch of realism to your painting if they are done properly. Painting waterdrops also provides an opportunity to apply many of the techniques you've learned throughout the book. Refer to the magnolias worksheet on page 269 to see examples of painted waterdrops.

WHERE TO PUT THEM

Because the focal area (see page 62) should contain the sharpest contrasts in color, value, intensity, and detail, and since painted waterdrops scream for attention, it is usually best to place them in the focal area. There, they help draw the eye to what you have developed as the most important part of your work. Too many waterdrops scattered all over the work will send the viewer's eye dashing from detail to detail and will thus water down the effect and lessen the impact. This is truly a case of "less is more."

STUDY THE SUBJECT

To paint waterdrops, the most important thing to keep in mind is that water is clear, not white. A common error is the use of too much white to define the shape of the waterdrop. Take a few minutes before painting to study actual droplets of water on various surfaces. You will notice that the water often causes the surface beneath it to appear slightly darker. While you're studying the waterdrops, notice also the various shapes, where the highlights and shadows fall, what happens when a drop starts to "run." Does the path it leaves behind appear lighter or darker than the surface on which it is "running"? Try controlling the light source so you can see how the light strikes the drop and passes through it; and how the drop casts its shadow. For example, if your light strikes the waterdrop from the upper right, it will create a sharp highlight there, then pass through the drop

and illuminate the lower left portion, creating a lesser highlight there. The shadow of the waterdrop, then, would appear beneath it and to its left. Don't take my word for it, though. Check it out!

FOUR EASY STEPS

1. Undercoat: Select a color slightly darker in value than the color of the surface on which you will be painting the waterdrop. For example, if you wish to paint a waterdrop on a leaf painted Light Avocado, select Avocado for the undercoat color. Thin the paint with water to create a wash. Use a No. 2 or No. 4 flat brush to paint the shape of the waterdrop with this wash.
2. Highlight: Sideload the flat brush with a very thin wash of Light Buttermilk. Start at the upper left inside of the waterdrop on the chisel edge of the brush, with the sideloaded paint edge of the brush facing the bottom of the waterdrop. Pull the stroke down and around the bottom edge of the waterdrop as if you were painting a scroll stroke or partially forming the numeral 6. Use the water side of the brush, if necessary, to soften any distinct edges inside the drop.
3. Shadow: Sideload the flat brush with a very thin wash of a dark value of the background color. Turn the waterdrop upside-down. Beginning at the base of the drop, and with the sideloaded paint edge of the brush facing alongside the waterdrop, paint around the bottom of the waterdrop, then continue along the, now, right side of the drop, tapering the shadow to a narrow edge and fading out.
4. Accent highlights: Use a liner brush to add strong accent highlights in Light Buttermilk. First, apply the main highlight; then remove most of the paint from the brush, thin the remaining paint with water, and paint the reflected light in the base of the waterdrop.

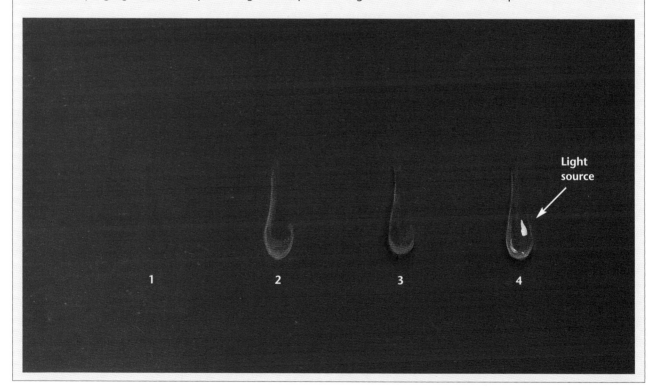

Light source

1 2 3 4

Find a Good Teacher

Although this book is designed for self-teaching, nothing beats a good, supportive teacher. Study under as many teachers and authors as you can, assimilating the techniques that suit your emerging style, and discarding those that don't. Let your individual painting personality begin to evolve, creating your own unique path, not blindly following the path forged by another. Be wary of rules. There is no "only one way to do it." In art, there should be no rules. Artistic expression is unique to each individual. If your teacher appears to feel threatened by your special artistic touches, find another teacher. Beware of teacher-imposed and self-imposed lack of experimentation.

Just as important as a good teacher is an open and receptive student. Be willing to try new techniques, even if you have a preferred way of accomplishing a similar effect. There is a chance, with every new thing you learn, that you can incorporate it somehow, even if for a totally different purpose or effect.

One of the most memorable lessons I learned, in a post-graduate art course, grew out of a three-week-long assignment. The course was led by two professors —one very traditional and precise, the other most untraditional and free-spirited. It made for interesting times, trying to please both simultaneously. The first week's assignment involved setting up a still life at home, then seeing accurately and drawing what we saw. The second week, we drew the still life anew and rendered it in black and white, paying particular attention to establish the values correctly. The third week, we drew the same still life again, and this time rendered it in full color.

I noticed in redrawing the still life, that the angles, positive shapes and negative (empty) spaces had changed considerably. Surely I wasn't that careless in the original drawing. But never mind. I redrew, paying closer attention than ever to the accuracy of my drawing. Then, with pastels, I completed the lesson, paying such attention to detail that I spent nearly forty hours on the piece.

Fully satisfied, I toted the 16- by 20-inch work to class. The traditional professor was very pleased. I glowed. Then the free-spirited professor gave his critique: "If I had wanted an exact picture of your still life I would have asked for a photograph. Take this home and do it again. This time, I want to know how you feel about those pumpkins!" My glow faded.

After three weeks of working on that still life, I was not feeling great about doing it again. But in my frustration, I grabbed the pastels, redrew it for the fourth time, noticing that the negative spaces and positive shapes were slightly off even from my previous drawing. And in twenty minutes—not forty hours—I had completed the picture, an accurate drawing, but rendered boldly in reds, oranges, blues, and purples. The latter two colors had not figured at all in the previous renderings. But the bold reds, purples, oranges and blues, and equally bold lines and slashes reflected how strongly I now felt about my subject. Back in class, the free-spirited professor was well pleased.

And I had learned some good lessons:
1. Don't expect a painting to please everyone.
2. Don't worry about how others will judge your art.
3. Paint to express yourself.
4. Dare to be unconventional. It can be liberating and fun.
5. Be receptive to criticism.
6. Expect to learn from your failures.
7. Be willing to experiment and stretch in order to grow.
8. Jack-o'-lanterns, whose cut-out faces have been turned to face the wall, should be checked from behind periodically; especially if the arrangement is held in a warm studio for several weeks. They "melt" and mold, and grow shorter and squishier. (At least I finally discovered why my drawings from one week to the next appeared increasingly inaccurate!)

May you have the good fortune to encounter a teacher or critic who pushes you beyond your comfortable limits and draws from you capabilities you didn't know you possessed. If you cannot find a class to join, organize a painting group with a few friends. You'll learn a lot from one another just by sharing ideas, critiquing, and group problem solving.

Resources

To locate teachers who teach step-by-step methods of painting, contact:
The Society of Decorative Painters
393 N. McLean Boulevard
Wichita, KS 67203-5968
(316) 269-9300
www.decorativepainters.org

A Style of Your Own

Your personality will guide the development of your particular painting style. Learn as many painting tricks and techniques as you can from as many different artists, authors, and teachers as you can. Be open and receptive to the instruction. Assimilate what works for you, and after giving everything else a good try, shelve it to revisit, perhaps, another time. Then, in the words of noted scholar and teacher Joseph Campbell, "Follow your bliss." Your distinct style will emerge as you depend less on books and teachers, gain confidence in your own abilities, and develop the courage to experiment and be creative.

One Final Exercise

To see how easy and how possible it is to bridge color intervals, try the following experiment in painting an orange. From the local color, orange, shade gradually to orange-red, to red-orange, to red, to red-violet, to violet, to blue-violet, to blue. Highlight from orange to orange-yellow, to yellow-orange, to yellow. We can push the yellow lighter by adding white. If we add a touch of blue to the light yellow highlight, we will have a highlight with a cool, green-ish cast, and that will make our warm colored fruit, appear an even warmer color. And there, we have worked around the color wheel modeling our orange with all the colors on the color wheel. Pick another fruit or vegetable to try this with. Locate its characteristic color on the color wheel. Then work from that point down the wheel and around to shade; and up and around to highlight. Bridging color intervals will help you tie the subjects from the individual lessons together in compositions.

The lessons presented in this book are in a realistic style, a reflection of thirty years as a teacher. From my early years of teaching primary school, I developed the habit of breaking tasks down into easy-to-master segments. That carried over into my teaching of painting to adults, both in the United States and abroad, through seminars, books, magazine articles, videos, and public television programs. With such attention to creating easy-to-follow, step-by-step approaches, a more realistic style of painting became a satisfying and successful way to teach.

Lurking inside my spirit, however, is an impressionist urge, just waiting to burst forth. And, my mind is reeling, much to my surprise, with abstract images I'd like to express. Am I undergoing a personality change? Will I abandon my orderly nature and become a free spirit? Who knows? But it is sure to be a fun and fascinating odyssey. And that is the real joy of painting: so many avenues, media, and techniques to explore; so many opportunities to get inside our shells and unlock our spirits. Perhaps we'll meet somewhere along one of those avenues, pursuing and fulfilling our creative impulses.

I wish you many happy hours in your painting adventures; hope all your artistic experiences are colorful ones; and trust that you'll find great rewards in your new hobby. According to Ralph Waldo Emerson, "The reward of a thing well done is to have done it." I hope that you feel well rewarded by your artistic accomplishments thus far, and that you enjoyed the journey through this book.

Glossary

ACCENT A small application of color to add interest, such as a blush of red on a pear, or a tinge of brown on a leaf.

ACETATE A lightweight, plastic-like transparent sheet; useful for testing colors, strokes, and designs before placing them on a project.

ANALOGOUS Describes a color scheme that includes any two to seven adjacent colors on the color wheel (for example, yellow, blue, and green).

BACKGROUND COLOR The underlying color of a painted piece.

BASECOAT The initial coat(s) of paint applied to an item to prepare it for decorating; the background color.

BRIGHT A type of flat brush with short hairs; sometimes called a chisel brush. Also describes color that is clear, brilliant, intense.

BRISTLES The hairs of a brush; more specifically, the stiffer types of hair such as hog or boar bristles.

BRUSH BLENDING Mixing two or more colors together by picking up a little of each with a brush, rather than a palette knife, and stroking, not stirring, them together on the palette.

CALYX The group of leaf-like sepals at the stem end of a flower or fruit.

CAST SHADOW A shadow caused by an object blocking the flow of light.

CHALK PENCIL A pencil with chalk in place of graphite; used in designing. Chalk can be easily removed with a damp cloth.

CHISEL EDGE The bottom edge of a flat brush.

COMPLEMENTARY COLORS Colors that are located diametrically opposite one another on the color wheel (for example, red and green). They neutralize one another when mixed.

CONTOUR LINES Lines that indicate the dimensional form of an object.

COOL COLORS Colors that appear to recede or move away from the viewer (greens, blues, violets).

CURED Pertaining to the state at which paint, after being applied, has thoroughly hardened through the completion of all internal drying and chemical processes.

DOUBLELOADING The process of loading two colors or values of paint onto one brush so that

each color retains its identity while at the same time creating a mixture of the two colors in the center of the brush.

DRYBRUSHING A technique of applying paint using a brush with very little paint.

EXTENDER A type of painting medium, such as DecoArt's Brush 'n Blend Extender, that, when added to acrylic paints, prolongs the drying time.

FAUX FINISH Fake finish; technique of painting something to look like something else (for example, painting wood to resemble marble).

FERRULE The metal cylinder in which the hairs of a brush are glued and the handle firmly fastened.

FLAT BRUSH A brush having hairs that taper to a flat chisel edge.

FLOATED COLOR A thin layer of color that is stroked onto a film of water or painting medium over a dry undercoat color.

FOCAL AREA The center of interest in a painting.

FULLY LOADED Describes a brush that is thoroughly filled with a single color of paint.

GRADATED Describes an application of paint that progresses from strong to faded color. This effect is usually achieved with a sideloaded brush.

HAIRS The bristles of a brush.

HIGHLIGHT A representation of the bright reflection of a direct light source.

HUE Another word for color.

INTENSITY The pureness or saturation of a color.

INTERMEDIARY COLORS Colors that lie in between the primary and secondary colors on the color wheel (for example, red-orange, yellow-green, and blue-violet). They are created by mixing a primary color with a neighboring secondary color.

LIGHT SOURCE The primary source of illumination of an object; determines position of highlighting and shading.

LINER BRUSH A thin, long-haired round brush.

LOCAL COLOR The dominant color of an object.

MARBLEIZING A faux finish technique in which paint is applied to resemble marble.

MEDIUM A product that is added to paint to prolong the drying time and to render the paint more flexible and easier to work with.

MONOCHROMATIC Describes a color scheme that includes tints and shades of a single hue (for example, light and dark blues).

PALETTE KNIFE An artist's implement used to mix and apply paint.

PIGMENT Material (such as finely ground powder) that adds color to paint.

PRIMARY COLORS Red, blue, and yellow; these three colors are necessary for mixing all other colors in the color spectrum.

REFLECTED LIGHT Illumination that is reflected off of an object rather than coming directly from the light source.

ROUND BRUSH A brush with hairs formed into a cylinder and tapering to a point.

SCUMBLING A technique that involves the loose application of color in unconnected strokes to create a broken-color effect.

SECONDARY COLORS Orange, green, and violet; each secondary color is created by mixing together two primary colors.

SEPAL One of a cluster of small leaves comprising the calyx at the base of a flower or fruit.

SHADING The addition of a darker value or black to any color.

SIDELOADING The loading of paint onto only one side or edge of a brush.

SPLIT-COMPLEMENTARY Describes a color scheme that consists of three colors: a main color and the two colors on either side of the main color's complement (for example, yellow, red-violet, and blue-violet).

SPONGING A faux finish technique of applying paint with a sponge to achieve a mottled effect.

STIPPLING A method of applying paint to achieve a speckled color effect by repeatedly dabbing with the brush.

STYLIZED Describes a design characterized by simplification of form.

STYLUS An implement with a small, rounded point used in transferring designs. A good substitute is a "dead" ballpoint pen.

TAKLON A synthetic filament used as hairs in some brushes.

TEMPERATURE The perceived warmth or coolness of a color. Warm colors advance; cool colors recede.

TERTIARY COLORS Colors that result from the mixture of two secondary colors. Each tertiary color contains all three primary colors.

TINT Color that is created by adding a lighter value or white to any color.

TONE Color that is created by adding black plus white to any color.

TRANSFER To copy a pattern either freehand or by use of a specially treated artist's transfer paper.

TRANSFER PAPER A paper coated with chalk, graphite, or other substance that, when placed between the pattern and the object to be decorated, aids in the transferring of the design.

TRIADIC Describes a color scheme that includes any three colors equidistant from one another on the color wheel (for example, red, yellow, and blue).

UNDERCOAT The first layer of color used to define the shape and basic color of the subject matter, to be followed by highlighting and shading colors.

VALUE A color's relation to white or black or the grays in between; the lightness or darkness of a color.

VALUE SCALE A scale that specifies nine distinct steps of gray between black and white; created by Henry Albert Munsell, an early American portrait painter.

WARM COLORS Colors that appear to advance or move toward the viewer (reds, oranges, yellows).

WASH A layer of thin paint applied over a dry layer of paint to alter its color slightly.

WEATHERED WOOD A DecoArt brand name for a slow drying product that, when overcoated with faster drying acrylics, creates a crackled paint effect.

Index